The Outward Mind

The Outward Mind: Materialist Aesthetics in Victorian Science and Literature

Benjamin Morgan

The University of Chicago Press :: Chicago and London

The University of Chicago Press, Chicago 60637
The University of Chicago Press, Ltd., London
Published 2017.
Printed in the United States of America

26 25 24 23 22 21 20 19 18 17 1 2 3 4 5

ISBN-13: 978-0-226-44211-2 (cloth)
ISBN-13: 978-0-226-46220-2 (paper)
ISBN-13: 978-0-226-45746-8 (e-book)
DOI: 10.7208/chicago/9780226457468.001.0001

Names: Morgan, Benjamin, 1979– author.
Title: The outward mind : materialist aesthetics in Victorian science and
 literature / Benjamin Morgan.
Description: Chicago : The University of Chicago Press, 2017. | Includes
 bibliographical references and index.
Identifiers: LCCN 2016033179| ISBN 9780226442112 (cloth : alk. paper)
 | ISBN 9780226457468 (e-book)
Subjects: LCSH: Aesthetics—Psychological aspects. | Arts—Psychological
 aspects. | Aesthetics, British—19th century. | Authors, English—
 19th century—Aesthetics. | Materialism—England—History—
 19th century. | Neuroanthropology.
Classification: LCC BH301.P78 M67 2017 | DDC 111/.8509034—dc23
 LC record available at https://lccn.loc.gov/2016033179

♾ This paper meets the requirements of ANSI/NISO Z39.48-1992
(Permanence of Paper).

Contents

Introduction: Materialist Aesthetics

Let us briefly visit two experimental scenes. The first takes place in the summer of 1851, when the Edinburgh interior decorator David Ramsay Hay is studying the *Venus de' Medici*. What, he wonders, accounts for its persistent beauty? Why had people in diverse cultural and historical situations found pleasure in viewing this statue? To answer these questions, Hay develops an unusual method. He borrows a skeleton from an anatomist, acquires a plaster cast of the *Venus*, and recruits as many female artists' models as he can find on short notice. The sculpture, the skeleton, and the women take turns in a special box Hay has constructed for measuring in three dimensions the location of anatomical features: nipples, navel, shoulders, chest. When he reconstructs a geometrical model of the statue, Hay discovers that the ratios of its body parts correspond almost exactly to a numerical system of bodily proportions that he had extrapolated from his study of musical harmony (figs. 0.1, 0.2). Finally: a scientific demonstration of exactly why the *Venus de' Medici* is beautiful.[1]

The second experiment takes place about four decades later. In a lecture titled "What Patterns Can Do to Us," the amateur art theorist Clementina Anstruther-Thomson invites her audience to look at an image of a Greek vase and to feel its effect on their bodies (figure 0.3). Anstruther-Thomson tells her listeners that a "lifting pattern" on the

TABLE II.

COMPARING THE THEORY OF SYMMETRICAL BEAUTY EXPLAINED IN THE FOREGOING PAGES WITH ACTUAL MEASUREMENTS TAKEN FROM NATURE. THE FULL HEIGHT TAKEN AS UNITY.

	PARTS MEASURED. (See Table I.)	THEORETICAL VALUES.	ACTUAL MEASURES OF MODELS.						
			No. 1.	No. 2.	No. 3.	No. 4.	No. 5.	No. 6.	Average.
ii.	Length of head,	·12536	·1516	·1359	·1375	·1332	·1206	·1240	·1339
iii.	From summit of head to sternum,	·19020	·1762	·1861	·1916	·1903	·1773	·1800	·1836
iv.	Do. to between nipples,	·26692	·2827	·2761	·2791	·2854	·2760	·2640	·2772
v.	Do. to navel,	·40263	·4200	·3933	·4125	·4080	·3930	·4000	·4031
vi.	Do. to pubes,	·50018	·5081	·5051		·5052	·4990	·4960	·5029
vii.	Breadth across shoulders,	·22832	·2459			·2241	·1974	·2280	·2238
viii.	„ between nipples,	·12582	·1270	·1359	·1250	·1247	·1206	·1240	·1262
ix.	„ across pelvis,	·18090	·1680			·1775	·1828	·1940	·1805
x.	Depth of chest,	·11416	·1229				·1023	·1120	·1124

FIGURE 0.1 David Ramsay Hay's comparison of ideal and actual measurements of models in *The Natural Principles of Beauty. As Developed in the Human Figure* (Edinburgh: William Blackwood & Sons, 1852), 28.

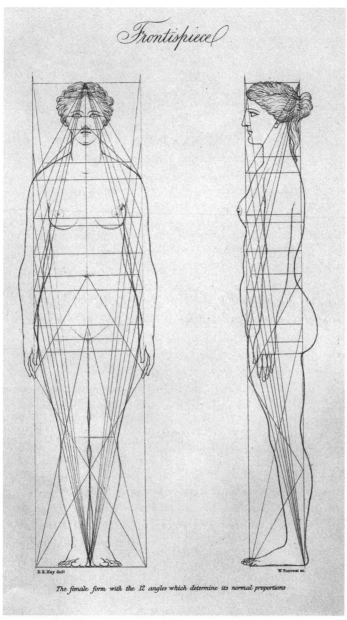

Frontispiece

D.R.Hay del. W.Forrest sc.

The female form with the 12 angles which determine its normal proportions

FIGURE 0.2 David Ramsay Hay's diagram of ideal proportions in *The Natural Principles of Beauty, As Developed in the Human Figure* (Edinburgh: William Blackwood & Sons, 1852), between pp. 23–24.

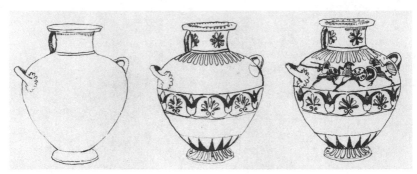

FIGURE 0.3 Clementina Anstruther-Thomson's reproduction of vases for an experiment with the effects of pattern in *Art and Man: Essays and Fragments*, ed. Vernon Lee (London: John Lane, 1924), 138.

vase "thrusts into our own body a feeling of lifting"; she notes that other patterns on the vase are likewise "hammered into us."[2] In great detail, the lecture describes these and other physical effects of the vase on the viewer's body; ultimately the experience of the vase is shown to be somatic as well as optical. Like Hay, Anstruther-Thomson is not particularly interested in what we would call historical context: she never asks whether the vase conforms to a particular style, if it can reveal something about the people who used it, or what is known about the figures painted on it. Instead, a peculiarly agential vase compels one's body to do certain things: to lift up, to change shape, to submit to a hammering intensity. Aesthetic experience is a forceful, bodily encounter of a person and a pattern.

What do these experiments want? What desires are refracted through them? At one level, they reflect a desire to understand art by drawing closer to its physical matter: to touch and measure the surface of a statue or a body, to feel the somatic forces of pattern. But the practical accoutrements of the experiment systematize and scientize this desire: taste seems to be dislocated from the province of cultivated individuals to the domain of natural laws that might be empirically grasped and analyzed. In different ways, both experiments aspire to an account of beauty that would have universal validity, rooted either in mathematical equations or in human physiology. This desire to solve the mystery of beauty—to find some sort of standard or key—places them in conversation with a long tradition of inquiry that originates with Pythagoras and persists today. What would we know if we could, in fact, show that judgments of beauty were reducible to geometry and mathematics? What would be proved if it were demonstrated, as Anstruther-Thomson suspects, that artistic patterns act on bodies in empirically discernable ways?

The work of Hay and Anstruther-Thompson represents part of a lineage of science-based aesthetic theories that thrived in the nineteenth century. The Victorian period has often been described as producing a vibrant "culture of art":[3] from John Stuart Mill's turn to poetry as a cure for utilitarianism to Oscar Wilde's turn to art as a cure for realism, major figures in the art and literary worlds made wide-ranging claims for the power of aesthetic experience, claims that were enshrined as institutions that persist today. This was also a moment when evolutionary psychologists, physiologists, and even physicists inquired into the mechanisms of aesthetic experience—but their research is far less familiar. Their repertoire of questions was unusual, ambitious, and controversial: was a sense of beauty common to humans and animals? Could one study musical harmony by studying the structure of the human ear? Did artworks convey their emotional charge by provoking a physiological response to form and pattern? Rephrasing classic questions of aesthetic philosophy in the language of the sciences often threatened to transform one of the "highest" human capacities, the appreciation of art, into a mechanistic event of a low, animal response. Although they adopted divergent methods and epistemic frameworks, scientific approaches to aesthetic experience often resonated with a close attention to embodiment, the senses, and the materiality of the arts among Victorian writers and artists. Like John Ruskin, Walter Pater, and William Morris, scientists of aesthetics aspired to draw attention to the affective, sensory, and somatic resonances of beauty.

In this book I explore Victorian aesthetic thought from a perspective that places particular emphasis on scientific inquiry, and on the sciences of mind in particular, in order to relocate empiricist, materialist, and positivist thought as central to critical traditions of humanistic interpretation. My discussion is chronologically framed by two important moments in the science of aesthetics: early nineteenth-century natural theology, which often found beauty in divine formal patterns of nature, and the laboratory psychology of the early twentieth century, which transformed aesthetics into an experimental subfield. A premise of this book is that Victorian aesthetic theory was not primarily pursued in the idiom of philosophy; for this reason, it situates aesthetic thought at the intersection of multiple discourses and practices, including art history, the novel, interior design, physiology, and evolutionary biology.

My argument develops two related lines of reasoning. First, scientific and literary accounts of aesthetic experience intersected through a common grounding in a particular version of materialism. If Enlightenment and romantic aesthetic philosophy had often seen aesthetic experience as providing access to a transcendental or spiritual realm, many writers in

nineteenth-century Britain instead described aesthetic experience as an event during which the embodied corporeality of a person and an artwork came into contact. From this perspective, art and literature were phenomena realized as dynamic interactions among nerves, muscles, stone, and ink. A patterned vase, for Anstruther-Thomson, achieves its effect by provoking a muscular response; the *Venus de' Medici*, for Hay, acts directly on the senses to induce a feeling of beauty. This is a "materialism" in which the physical structure of nature offers the primary explanatory principle of life and mind. It was developed in ancient thought by natural philosophers such as Epicurus and Lucretius and prominently espoused in the nineteenth century by scientists including Thomas Huxley and John Tyndall. If many worried that scientific and aesthetic materialisms would render mind and soul mere epiphenomena of nerves or atoms, it was also the case that a nineteenth-century fascination with matter occasioned new speculation about the agencies of physical things that had previously seemed still and inert: in aesthetic objects, matter became spiritualized, animated, and enminded.

Second, the materialist strain within Victorian aesthetics often occasioned nonanthropocentric accounts of affective responses to art, literature, or beauty. Foregrounding materiality tended to de-emphasize the uniqueness of human aesthetic experience and open up nonhuman frames of reference: aesthetic judgment might be explained as a nervous reflex, as an evolutionary adaptation, or as a mechanistic response to pattern rather than as a human act of thought or reflection. Victorian materialist aesthetics becomes "affective" through this attention to events during which bodies or nervous systems are acted on by art or literature: Anstruther-Thomson's sense of "lifting" induced by the shape of a vase, for instance. Materialist accounts of aesthetic affects were often antianthropocentric both in that their unit of analysis was not human subjectivity but elements of the nervous system, material components of the artwork, or unconscious cerebral processes, and in that they often displaced agency from persons to things. Through its materialism and its antianthropocentric conception of affect, Victorian aesthetic thought effected an *outward turn*: an exteriorization of mind, consciousness, and the self into networks of matter, sensations, and objects.

While these claims are grounded in historically situated interpretations of literary and scientific writing, they take Victorian aesthetic thought as a conceptual resource for working through questions about the materialist and affective dimensions of aesthetic experience that extend beyond the nineteenth century. My primary focus in this book

is the Victorian period, but I adopt a wider range of conceptual and philosophical points of reference, taking scenes within Victorian aesthetic thought as a starting point for considerations of the role of the affects in aesthetic experience, of ontologies of human worlds and object worlds, and of the interactions between sciences of the mind and humanistic inquiry. Within this broader context, an experiment like Hay's or Anstruther-Thomson's becomes instructive not only for revealing how a culture reconsidered the function of art and literature as scientific epistemologies were rising in intellectual and cultural authority but also for staging long-standing questions about the difficult relationship between mind and body in aesthetic experience.

Aesthetics as a Philosophy of Embodied Cognition

The most important argument in modern aesthetic philosophy depends on a series of exclusions. In the opening sections of the *Critique of Judgment* (1790), Kant rejects usefulness, sensuous gratification, and moral or formal perfection as criteria for judging whether something is beautiful. Instead, for Kant, aesthetic judgments must be *disinterested*: irreducible to conceptual determinations of correctness (of purpose, design, or morality) or to purely subjective inclinations of pain or pleasure. It is because they are disinterested that apparently subjective judgments make a claim to universal assent: my expectation that you should agree with my judgment of beauty—even though I cannot prove its validity—reveals that this judgment is more than just a private inclination. Situated historically, Kant's argument can be understood partly as a rejection of eighteenth-century British psychologies of taste and with them any philosophy of beauty based on the empirical study of the human mind.[4] Against Edmund Burke, who had found beauty in smoothness and sublimity in the dark, Kant posits that the judgment of taste "must be grounded in some sort of a priori *principle* . . . which one can never arrive at by scouting about among empirical laws of the alterations of the mind."[5] For Kant, Burke could describe how objects gratify a particular person, but he could not account for the normative aspect of an aesthetic judgment—how it is that when I call something beautiful, I make an implicit claim that you should agree. Kant arrives at these key principles of disinterestedness and subjective universality in part by way of a conception of the mind as not available to empirical, scientific study.

Few arguments about beauty have occasioned more philosophical reflection than Kant's exclusion of bodily inclination from aesthetic

judgment. Theodor W. Adorno memorably characterized Kant's aesthetics as a "castrated hedonism, desire without desire"; Kantian disinterest, Adorno argued, does injustice to "sensual interest, the suppressed and unsatisfied needs that resonate in their aesthetic negation and make artworks more than empty patterns."[6] Philosophers and historians of aesthetics have often questioned the centrality of disinterest to aesthetic judgment by returning either to the Greek etymology of *aisthēsis* (sensation and perception) or to Alexander Baumgarten's original characterization of aesthetics as "sensuous knowledge" (*cognitio sensitiva*).[7] When we are reminded of the close relationship between aesthetics and the body, it is often in the spirit of resisting Kantian disinterest, whether it is Nietzsche promoting the "unexplored *physiology of aesthetics*" or William James emphasizing the play of musical form on the "bodily sounding-board."[8]

These alternatives—aesthetic experience as a disinterested judgment that is at once subjective and universally valid or aesthetic experience as the mediation of knowledge through the body—have gained particular significance recently in the wake of powerful Marxist, sociological, and poststructuralist critiques of the notion of autonomous or transhistorical aesthetic value.[9] Recent arguments against the critique of aesthetic ideology—and against the ethos of critique more broadly—have espoused a "return" to form or beauty or reinterpretations of Kantian aesthetics.[10] Echoing Adorno's defense of "sensuous interest," these have drawn attention to aesthetic materiality and corporeality in its various guises, including embodied affects in aesthetic judgments, the aesthetic domain itself as an arrangement of bodies and determination of what they can sense, and even the empirically observable neural responses to art and music.[11] These diverse and often conflicting ways of reconceiving aesthetics represent a renewed attention to what Baumgarten originally called "sensuous knowledge." They extend the domain of a sensuous aesthetic beyond an apolitical concern with beauty and form. In Jacques Rancière's formulation, which develops in a response to critiques of aesthetic ideology in French philosophy and sociology, the aesthetic domain becomes political not because it affords disinterested reflection but because it is a "distribution of the sensible" that arranges bodies and structures that can be perceived.[12]

This long tradition of philosophical questioning about the role of the body and the affects in aesthetic experience can resituate the ways in which British aesthetic thought has been interpreted by highlighting its significant engagements with corporeality and materiality. Simultaneously, the scientific and empiricist orientations of British aesthetic

thought create new and unusual ways of conceptualizing embodiment in the context of aesthetic experience. This is partly because in the English-speaking world, the meaning of the term *aesthetics* and the question of whether it belonged to philosophy or science remained unresolved for much of the nineteenth century. John Ruskin, for example, separated the meanings of the aesthetic that Rancière's notion of "the sensible" combines: Ruskin argues in the second volume of *Modern Painters* for a clear distinction between a moral sublimation of the pleasure of beauty (he named this "theoria") and mere bodily gratification ("aesthesis").[13] Hay's "science of aesthetics," by contrast, unusually described the "media" of aesthetic experience as the human "organs of sense" rather than as the substance of the artwork.[14] Hay's and Ruskin's very different definitions of the aesthetic are two aspects of a conceptually vital field of inquiry into aesthetic sensation, materiality, and embodiment.

To claim that the Victorian period produced innovative philosophies of embodied aesthetics is to depart from a common conception of nineteenth-century Anglo-American aesthetic thought as "derivative" and unphilosophical.[15] It is understandable why philosophers have rarely taken post-Enlightenment British aesthetic theory seriously. Nineteenth-century writers often distinguished their inquiries from unpersuasively abstract German "metaphysics" and theorized the aesthetic in genres that were unsystematic, vernacular, or literary. So, for example, although Walter Pater's important essay on the eighteenth-century art historian Johann Joachim Winckelmann clearly comments on and revises Hegel's lectures on aesthetics, Pater intentionally obscured this aspect of the essay by removing footnotes referencing Hegel as he revised. Similarly, when Herbert Spencer links aesthetic pleasure to an impulse toward play, he pretends to forget that this idea was already widely associated with Friedrich Schiller. As a result of these disavowals and obfuscations, Victorian aesthetic thought has often been interpreted through the lenses of cultural studies or in relation to the history of art and visual culture and has less often been seen as conceptually productive on its own terms. This book instead explores the possibility of reading Victorian aesthetic thought as participating in a tradition of philosophical aesthetics despite the fact that its practitioners often avoided a philosophical idiom. Taking seriously the work of writers who theorized the arts from the perspective of the sciences affords a new understanding of the period as producing significant meditations on the shared materiality of human bodies and their surrounding environments and on the surprising fact that affects, emotions, and thoughts could somehow arise from a seemingly inert world of physical substance.

Mind: A New Object

A fundamental shift that enabled science-based interpretations of art and literature was a new understanding mind and emotion as emerging from the brain and nervous system. In the early and mid-nineteenth century, thought and feeling became objects available to scientific observation and experiment as well as topics of philosophical speculation. This naturalization of the mind was incompatible with—and often explicitly rejected—a Kantian model of the mind as having discrete faculties, a schism that is important to the history of aesthetics. It is often argued that Kantian aesthetics is of central importance to the critical tradition of humanities disciplines because its a priori account of aesthetic judgment transformed eighteenth-century empirical inquiries into the psychology of taste into a philosophical analysis of the conditions presupposed by judgments of beauty or sublimity.[16] This critical history, however, tends to overlook the ways in which empiricist and associationist psychological aesthetics were developed and revised in nineteenth-century mind sciences and continued to constitute an important point of reference. Indeed, by the mid-nineteenth century, Kant's faculty-based account of the mind was widely seen as untenable in the face of physiological studies of mental functions—a development that historians of science have sometimes described as an "integration of mind into nature."[17] The studies of art, music, literature, and beauty that took this scientific model of mind and emotion as their basis have remained largely absent from the stories that humanities disciplines tell about their origins.

This is despite the fact that in nineteenth-century Britain, the physical basis of mind was a common topic not only among the scientific elite but also within generalist periodicals; it was also on public, popular display in demonstrations of phrenological readings, "electro-biological" phenomena, and mesmerism.[18] While Kant's thought remained influential, his faculty psychology was often seen as less scientifically modern than the materialist models of the mind that were developed in the context of mental physiology in the 1830s and 1840s, a field that controversially took anatomy and physiology as the basis for accounts of thought and emotion. Idealists who endorsed Kant's a priori turn found themselves competing with a so-called new psychology: an ambitious account of mind and emotion as generated by the flow of currents through nerve fibers and the brain. Often rejecting Kant's transcendental philosophy outright, many argued that the mind could in fact be observed through the lens of natural science. As George Henry Lewes vividly put it, the

older philosophy of mind "must be crushed into dust, and our chariot wheels must pass over it."[19]

In this book I emphasize three aspects of the science of the mind that were especially significant to nineteenth-century aesthetic thought. First, *embodiment*: by contrast with previous faculty psychologies, sciences of the mind persuasively explained how thought and emotion arose from the brain and nervous system. Second, *reflex*: many extended the concept of the reflex from purely physiological events (e.g., an involuntary knee jerk) to higher-order mental processes such as dreaming, the unconscious, and unwilled trains of thought. This meant that many aspects of mental life could be conceptualized as preconscious or automatic and located in specific activities of the nervous system and brain. Third, *process*: the apparent unity of "mind" might be an artifact of language; mind was not a discrete entity so much as a manifold of processual interactions between an organism and an environment.[20] A useful spatial metaphor for these developments is to describe them as turning the mind "outward": mental life was often conceived in terms of processual interactions of the nervous system and body with extraindividual social and material worlds.[21]

Embodiment, reflex, process: these new ideas about what the mind was and how it worked transformed nineteenth-century understandings of many human experiences, including aesthetic experience. What a science of aesthetics might look like was widely debated, and through these debates a coherent field began to emerge—a field whose existence and significance still remains largely obscure despite the fact that it would have been familiar to many nineteenth-century intellectuals. The physiological language of novel criticism, art criticism, and poetic theory that scholars of the period have recently uncovered are components of a wide-ranging turn to mental science in nineteenth-century aesthetic thought.[22] Especially in the second half of the nineteenth century, books and articles in Britain, the United States, France, and Germany theorized aesthetic experience extensively from a scientific perspective.[23] The optical and acoustical research of Hermann von Helmholtz, the founding of the professional journal *Mind* (1874–), and the inception of psychological laboratories in Germany were major events in the history of psychology. They were also major events in the history of scientific aesthetics. Helmholtz was a music theorist; contributors to *Mind* commonly used their studies of perception to explain the experience of art; some of the earliest psychology experiments addressed poetry and the visual arts. By 1920, Herbert Sidney Langfeld, an early president of the American

Psychological Association who taught at Harvard and ran a laboratory at Princeton, could simply remind his readers that "experiments may be conducted in aesthetics, just as in any other science."[24]

This turn to a physical model of mind coincided with a moment when writers and artists increasingly emphasized the bodily and sensory appeal of art and literature. A lineage of Pre-Raphaelite, aestheticist, and decadent artists and writers placed "open sensory alertness," to borrow Elizabeth Helsinger's phrase, at the center of their artistic programs.[25] While scholars often associate this sensory aesthetic with postromantic literary and artistic movements, the concern with sensation in fact ranged widely. Recent work has begun to draw a more detailed map of the Victorian concern with embodiment and the senses in art, literature, music, and popular culture, which took hold not only within the Pre-Raphaelite and aesthetic movements but also within sensation fiction and drama, realist and naturalist novels, experiments in visual arts, protocinematic technologies, and debates about the corporeal sources and effects of poetic meter.[26] The Victorians have escaped their gray reputation of sober rationalism, reappearing as a culture that at once celebrated and anxiously deplored the vibrant intensities of the senses.

"Materialist aesthetics" is the phrase used in the following pages to capture the relationship between these two significant developments in Victorian aesthetic thought: a literary attention to the matter of the body and of the artwork and a neurophysiological account of mind and emotion. In each chapter I address one aspect of a conceptual framework that structured the shared materialist orientations of aesthetic theory and the science of the mind. Taken together, these chapters show that many scientists and literary intellectuals converged on the idea that aesthetic experience was not in the first place a moment of spiritual elevation (as Ruskin's concept of *theoria* would have it) but an event during which the body of the viewer and the matter of the artwork come into contact. This conception of aesthetic experience is "materialist" in the particular sense of a philosophy of nature that extends from Lucretius to John Tyndall based on an ontology of physical matter as the basis of all phenomena—including those, such as consciousness, that seem immaterial, ideal, or incorporeal. This version of materialism is related to but distinct from a materialist aesthetics that proceeds from a critical tradition of historical materialism extending from Marx's *Theses on Feuerbach* to Georg Lukács, Walter Benjamin, and the Frankfurt School, within which "matter" figures the economic and social relations that condition idealist philosophy.[27] Reintegrating scientific materialism into this account reminds

us that "materiality" includes not only lived social relations but also the mind's physical constitution (in nerves, muscles, and the brain) and the aesthetic object's physical features (in pages, paint, and stone).

In *The Outward Mind* I argue that the intersection of scientific and artistic materialisms took place along the lines of five vectors of aesthetic thought and critical practice: *form, response, materiality, practice,* and *empathy.* The science-based aesthetics of the nineteenth century often defamiliarizes these basic critical categories. Through the lens of empirical aesthetics, form was conceived in terms of geometrical ratios in nature that attuned the embodied mind to its formal environments. The time of aesthetic response was rescaled by physiology and evolutionary theory, which understood aesthetic judgments in relation to reflexes that were at once instantaneous and the product of evolutionary change through deep time. In the wake of new scientific and philosophical conceptions of materiality, Victorian poetry, sensation fiction, aestheticist writing, and psychology often turned to scenes in which one's physical surroundings were—or at least seemed to be—"enminded," bearing consciousness and agency. Practice, represented here by the work of William Morris, encompasses situations in which the making of art afforded de-individuating somatic activities distributed across a community. And empathy, theorized at the intersection of early twentieth-century literary theory and laboratory psychology, involves bodily responses to the rhythmic patterns of music, art, or prose.

These five lines of thought bring into view an expanded critical tradition that was open to multiple and divergent disciplines ranging from poetic theory, evolutionary biology, philosophical materialism, quantitative analysis, physiology, associationist psychology, and socialist aesthetics. This vibrant field had a significant afterlife in a number of twentieth-century intellectual traditions, including Merleau-Ponty's adaptation of the phenomenology of perception to aesthetic experience, I. A. Richards's interest in the significance of neurophysiology and behaviorism for literary criticism, Susanne Langer's project of an affective aesthetics oriented by makers of art, and John Dewey's pragmatist account of art as originating with the experience of a living organism in an environment. But a great deal of the cross-disciplinary critical ferment was rejected as overly concerned with emotion, outmoded, or excessively positivist, especially in the context of certain New Critical defenses of the specificity of literary studies against the sciences. As I will argue in this book's final chapter, many protocols of modern literary and art criticism were established by rejecting the corporeal materialisms of nineteenth-century aesthetic thought.

Our Materialist Aesthetics

Examining how the nineteenth-century interface of science and aesthetics shifts familiar critical categories becomes especially illuminating at a moment when the role of the sciences in relation to literary studies and the humanities is again the object of widespread reflection. In the early 1990s, Eve Kosofsky Sedgwick intimated a controversial opening of humanistic thought to scientific models and concepts with her introduction to a collection of Silvan Tomkins's writings, which mounted an anticipatory defense against accusations of biologism, essentialism, and reductionism: "the antibiologism of current theory assumes . . . that it's the distance of any theory from a biological . . . basis, that alone can make the possibility of doing any justice 'to difference (individual, historical, and cross-cultural), to contingency, to performative force, and to the possibility of change.'"[28] Sedgwick's turn to a biological theory of affect has since been widely recognized as enabling an array of creative adaptations of scientific thought within affect theory ranging from Brian Massumi's "shameless poaching" of scientific concepts to Catherine Malabou's Derridean reading of neural plasticity.[29] But Sedgwick's writing on Tomkins can also be understood more broadly as an early effort to reconfigure the divide between the humanities and sciences that has since taken on many other shapes. Critical thought on humanism and posthumanism has found sympathetic collaborators in the sciences, reencountering the human as a species, as a neurological being, as a "sujet cérébral," or as a microbiome.[30] The sciences have been called on not only for new philosophies of the subject but also for new methods of interpretation as the lenses of cognitive science, sociology, and statistics have brought into focus new objects of analysis: scholars of literature are now likely to study not just novels or authors but also networks and corpuses.

If many see this critical landscape as a place where the sciences have vitalized humanistic inquiry, many others view it as one where scientism has evacuated the distinctive features of humanistic interpretation, substituting instead an antihermeneutic ethos of positivism and quantification or—worse—forcing the humanities to acquiesce to the intellectual authority of the sciences. Important arguments have questioned the scientific (or perhaps merely scientistic) turn, exposing as problematic the idea that literary studies and cultural theory must accept and adapt to truths about mind and body as revealed by the sciences or that the humanities' understandings of human nature must be made "consilient" with those of the sciences. The questioning of biologism that Sedgwick anticipated has been lively, as Ruth Leys, Jonathan Kramnick, and D. N.

Rodowick, among many others, have called for a slower and more careful examination of how humanities research engages with scientific ideas and practices.[31]

In *The Outward Mind* I locate the questions of a materialist, embodied aesthetic theory as central to this vital inquiry into the capacity of the sciences to conceptually and methodologically transform humanistic practice. Issues of materiality and embodiment, as they were framed in the nineteenth century, lie at the heart of many recent critical developments because as literary and cultural studies have reopened themselves to scientific concepts and methods, they have been thrown back into the midst of problems that preceded the professionalization of interpretive humanities disciplines.[32] Not only were many nineteenth-century writers and artists aware of and sympathetic to biologistic conceptions of mind and emotion, they drew on diverse disciplinary frameworks and discourses for transforming methods of interpreting cultural objects and practices. Evidence that humanities disciplines have returned to the questions of an earlier moment may be found in the fact that many of the long-forgotten scientific intellectuals discussed in this book have recently resurfaced as fields ranging from neuroaesthetics to quantitative cultural studies have looked for historical precedents. Gustav Fechner's psychophysical studies of the arts, carried out in the 1870s, are now commonly cited in work on neuroaesthetics. Alexander Bain's physiology of the emotions, developed in the 1850s, has drawn the interest of affect theorists. James Sully's analysis of the cognitive mechanisms of George Eliot's narrative is cited as an early instance of cognitive literary studies. And T. C. Mendenhall's experiments with stylometrics are recognized as a point of origin for quantitative literary studies.[33] Reading this work alongside some of the canonical figures in the Anglo-American critical tradition, including Ruskin, Morris, Pater, Wilde, and Richards, I seek to expand our stories of disciplinary origins to include a wider range of intellectual traditions and discourses. Placing aesthetic theory at the intersection of physiological and evolutionary psychologies, empirical aesthetics, and philosophical and scientific materialisms dislodges a critical history that finds its precedents in the often antiscientific humanism of thinkers such as Arnold or Ruskin and reveals some of the ways in which the humanities have long been "scientistic."

This is not to argue for a wholesale recovery of the essentialism or positivism of the nineteenth century but instead to propose that certain of its terms can be critically invigorating. Examining how nineteenth-century writers adopted, repurposed, and worked with and against scientific models of mind, emotion, and human nature reveals that these

engagements have sometimes yielded more, rather than less, complexity in the interpretation of art and literature. But recovering this complexity requires an interpretive strategy that goes beyond the methods of intellectual or cultural history to closely read the gaps, ambiguities, and contradictions of materialist aesthetics as described and practiced. Scientific accounts of aesthetic experience are often of interest not for their conclusions (e.g., that a particular angle is intrinsically beautiful) but for their method as they encounter surprising questions and adopt unusual strategies for resolving them. While the following chapters discuss and contextualize the work of medical and scientific writers who attended closely to aesthetic experience, they do not constitute an intellectual history of the relationship between science and aesthetics in Victorian Britain. Aspects of this history have been addressed by important works of literary and cultural history such as Suzy Anger's *Victorian Interpretation*, Gillian Beer's *Open Fields*, Peter Allan Dale's *In Pursuit of a Scientific Culture*, Regenia Gagnier's *The Insatiability of Human Wants*, George Levine's *Dying to Know*, and Sally Shuttleworth's *George Eliot and Nineteenth-Century Science*: these and many other books have examined in careful detail the questions and debates that were occasioned in nineteenth-century Britain by the simultaneous rising authority of the sciences and expansion of a public literary and artistic culture. Throughout this book I have placed emphasis on animating this conceptual territory in relation to philosophical and critical traditions that extend beyond the Victorian period. In this respect, my method borrows from Rancière the idea of a "scene" as a unit of analysis: a scene, for Rancière, is not an "illustration of an idea," but "a little optical machine that shows us thought busy weaving together perceptions, affects, names and ideas, constituting the sensible community that these links create, and the intellectual community that makes such weaving thinkable. The scene captures concepts at work."[34] The scenes depicted in this book—from David Ramsay Hay's experiment with the *Venus de' Medici* to Vernon Lee's introspective documentation of her physical response to paintings—are explored in this spirit of capturing "concepts at work."

Science and Literature: Rhetorics, Associations, Objects

While I have been describing Victorian aesthetic thought as encompassing both scientific and literary ways of knowing, the relationship between the cultural formations called "science" and "literature" is far from self-evident. How to historically understand this epistemological

relationship has been a site of rich discussion among scholars of the nineteenth century, and these debates constitute an important critical context for this book's argument and method. Edward Burne-Jones once observed to Oscar Wilde that "the more materialistic science becomes, the more angels shall I paint: their wings are my protest in favour of the immortality of the soul."[35] Here, in compressed form, is a straightforward opposition between science and aesthetics that often structures accounts of the Victorian period: as Huxley, Tyndall, and others increasingly espoused a scientific materialism that left little room for the soul, Wilde, Pater, and the aesthetes offered art as a new religion.[36] But it does not take much work to see that Burne-Jones's comment should properly be seen a disavowal: not only were the wings of his angels made of paint that owed its vibrancy to recent advances in science and technology, "materialism" itself was an accusation leveled against scientists and Pre-Raphaelites alike.[37] Pressured only slightly, Burne-Jones's comment begins to reveal the complexity of a relationship between science and aesthetics that exceeds binary terms.

While this book addresses the relationship between science and literature in Victorian culture, it interprets this relationship in a particular way. I understand science and literature not as domains or fields but as *rhetorics* that might be flexibly and widely called on. Although these rhetorics were institutionally produced and constrained, they were available to popularizers and amateurs as well as to recognized professionals (as much recent work in the history of science has shown).[38] To the extent that it focuses on these shared rhetorics, my approach is in keeping with a field of scholarship that has followed from the work of Gillian Beer, George Levine, and Sally Shuttleworth, which argues that because scientific ideas were expressed in narrative and linguistic forms, they shared, as Beer puts it, "imaginative orderings and . . . narrative formulations" with literature, especially the novel.[39]

Recent work on science and literature has challenged both the dualism implied by this designation (which may reify two categories) and the homogeneity implied by the notion of a "shared discourse" or "one culture" of literature and science.[40] We can move beyond the binary of a one- or two-cultures model by attending not only to shared ideas or narrative patterns across two cultural formations but also to the actual networks and associations that connected thinkers who drew on diverse epistemological practices to give accounts of human experience and its place in the natural world. While my argument attends to Beer's shared "imaginative orderings," it does not rely on textual analysis alone. Science and literature

were not only ideas, texts, forms, or genres; they were also material practices that connected particular *associations* of people whose endeavors were focused through *objects* as well as texts.

An important method of my argument is to describe and interpret these rhetorics, associations, and objects. I open by tracing a network of persons, publications, and things whose node is a multidisciplinary group of intellectuals who constituted the Edinburgh Aesthetic Club in the 1850s. Components of this network include books on color harmony and design theory; amateur practices of observing persons, buildings, and statues; letters among participants; medical treatises; and lecture notes. Taken together, I argue, they reveal a developing conception of how the neurophysiologically embodied mind unconsciously attunes itself to ambient formal arrangements of shape and sound. Exploring this network allows for the drawing of connections between objects, practices, and their conceptual implications that would be invisible to a purely narrative or rhetorical analysis.[41] In the final chapter I similarly interpret Vernon Lee's work on empathy by attending not only to how her writing takes up and transforms particular ideas about corporeal responses to form but also to her involvement with a salon of literary intellectuals, German psychologists, and to the particular artifacts that occasion Lee's reflections. These traceable networks of human and nonhuman actors connect literature to science as meaningfully as do the narrative and rhetorical borrowings that take place at the level of language.

By addressing the relationship between nineteenth-century literature and sciences of the mind in particular, I take up a line of inquiry that has been recently developed by literary scholars including Alan Richardson, Rick Rylance, Sally Shuttleworth, Adela Pinch, and Nicholas Dames.[42] In this book I aim to extend this field of inquiry from its present orientation toward genre (the novel and poetry) to the period's multigeneric conceptual and literary engagements with the arts. If Victorian novelists understood scientific psychology as yielding resources for peering inside the minds of characters, those who inhabited the Victorian cultures of art often found in the new psychology resources for thinking more fully about the perceptual, sensory, and affective experience of objects, surfaces, and environments: exteriority rather than interiority or, sometimes, exteriority as interiority. It is partly for this reason that they offer a particularly clear view of the mind's outward turn.

In a broader sense, this book participates in a project of exploring the cultural emergence of the two-cultures divide. In *The Outward Mind* I focus on one moment in a much longer history of intersections of science with art and literature. In their work on scientific objectivity, Lorraine

Daston and Peter Galison have argued that the relationship between artistic and scientific conceptions of subjectivity became especially pronounced in the nineteenth century: "In notable contrast to earlier views held from the Renaissance through the Enlightenment about the close analogies between artistic and scientific work, the public personas of artist and scientist polarized during [the nineteenth century]. Artists were exhorted to express, even flaunt, their subjectivity, at the same time that scientists were admonished to restrain theirs."[43] Within this context, nineteenth-century aesthetic thought represents a particularly important case because it was a field in which a wide range of knowledge practices competed for authority: scientific fields including physiology and evolutionary psychology; associationist, empiricist, and idealist philosophies; cultural and political theory; and literary essays and fiction. What this field of thought makes especially clear is that the two cultures did not diverge cleanly; debates about the validity of scientific accounts of aesthetic experience, in particular, reveal the intellectual and institutional turbulence that characterized the divergence between the two cultures.

From Embodied Minds to Enminded Matter: The Outward Turn

What does it mean to speak of the mind's "outward turn"? When we think about the relationship of aesthetics to the senses, we often think in terms of a subject who receives impressions from without: *aisthēsis* as embodied sensory perception. But the protagonists of this book complicate this model, highlighting the ways in which aesthetic experience is an active process of perception that has the effect of animating a world of physical things. This is the "outward turn" of this book's title: a dynamic afforded by new physicalist models of the mind in science, philosophy, and literature in which seemingly interior or private states are reconceived as acquiring material existence as interactions among bodies, nervous systems, and things. To describe this turn as a historical development as well as a conceptual dynamic is not to deny that the arts had long outwardly manifested mind or subjectivity (indeed, it was in antiquity that conceptual models for this outward turn were often found) but rather to observe that a literary interest in sensation, a renewed attention to craft and printing, a revival of interest in Lucretian materialism, and new evolutionary and physiological psychologies intersected to make the latter half of the nineteenth century a particularly active moment for seeing the aesthetic domain as a place where matter was invested with mind and emotion.

Perhaps I can best elaborate this characterization of *aisthēsis* as outward oriented—as active and animating rather than receptive—by turning

to three objects from this book's archive: one real, one fictional, and one abstract. The real object I have already mentioned: it is Clementina Anstruther-Thompson's vase, which "suddenly thrusts into our own body a feeling of lifting which we cannot help realizing."[44] The fictional object is a carving done by a character in William Morris's short romance "The Story of the Unknown Church" (1856), who awakens from a dream to find himself chiseling an architectural ornament: "The chips were flying bravely from the stone under my chisel at last, and all my thoughts now were in my carving."[45] The abstract object is described by Walter Pater's character Florian in the short autobiographical story "The Child in the House" (1878), who recalls "the necessity he was under of associating all thoughts to touch and sight . . . a sympathetic link between himself and actual, feeling, living objects."[46] In Pater's story, it not a particular real or fictional object (a vase, a carving) but all objects—the "object" as an abstraction—that takes on qualities of animation or sentience.

Each of these objects has unusual features. Anstruther-Thomson's vase seems to invert the usual active-passive binary of subject and object, acquiring so much agency that its viewer "cannot help" experiencing it as an active force. The carving in Morris's story seems not to invert this binary so much as to animate its suspended middle: we might read the phrase "my thoughts now were in my carving" not only to mean that Walter is thinking about what he is doing (*carving* as a verb—"I was thinking about how I was carving") but also to mean that Walter's thinking is taking place *as* the interaction with the stone (*carving* as a noun—"my thought was not in my head, but in the stone"). Finally, Florian's abstract idea of an object seems to open onto an animistic sense that thinking can only happen in a world where every object is potentially sentient: the very possibility of having knowledge depends on an associative sympathy with "feeling, living objects"—a phrase that challenges readers to consider what it would mean for "life" and "feeling" to be properties of things as well as persons.

These objects bring into view some of the ways in which Victorian accounts of aesthetic experience unsettled distinctions between thinking and making, between the immateriality of the mind and the materiality of things. They teach us that attending closely to the experienced materiality of art required careful reflection both on what matter itself was (here it becomes active, processual, or sentient) and on the nature and boundaries of the mind (here emotive, materialized, associative). To understand these and other Victorian aesthetic objects, I have often found it helpful to turn to a range of recent theoretical and philosophical reflection on materi-

alism, ontology, objects, and things, including, especially, Bill Brown's characterization of "things" as tending at once to recede into the "anterior physicality" of an undifferentiated world of matter and yet also to "exceed" that world by bearing human meaning.[47] How might this formulation be inflected by the things I have just described? One answer is this: these three objects dramatize the thingly qualities not only of things but also of the human mind. They interrupt a story in which aesthetic experience is about retreating to an inner psychical space of thought and reflection. These objects instead effect a turn outward into a world: an extension of mind into substance or a practice of thinking that follows from object-directed sympathy. The notion of the aesthetic seems to facilitate these extensions and movements of matter and consciousness in a distinctive way: it allows one to have the sense that matter is something other than inert substance and simultaneously to recognize the embodied qualities of many instances of aesthetic response.

To describe moments such as these as dramatizing the mind's "outwardness" is to use the conceptual insights afforded by materialist aesthetics to grasp the relationship between two major claims commonly made about Victorian culture: that its dominant aesthetic forms were inward looking, focusing on introspection, self-reflection, and the reproduction of the experiential nuance of mental and emotional life; and that it was at the same time an especially rich material culture, densely populated with books, art objects, property, and commodities.[48] What aesthetic objects make distinctly visible is not just that persons invested meaning and value in objects but that objects often responded in kind. For the protagonists of this book, statues, paintings, and books were not just bearers of affective, political, or financial investments; they were also experienced as curiously, forcefully animated and agential. For many nineteenth-century thinkers, aesthetics is not so much a philosophy of the senses as a philosophy of matter.

This claim that aesthetic objects make visible the outwardness of the mind has implications for a common alignment of Victorian aesthetic discourse with an ethos of liberal self-cultivation. A number of powerful arguments have advanced versions of this thesis: Amanda Anderson, for example, describes Wilde's critical disposition as a "radicalization of Arnold's ideal of disinterestedness"; Andrew Miller reads Pater as inculcating "impersonal intimacy" even across historical distance.[49] But taking into account the pervasive reach of scientific materialism reveals that aspirations toward impersonality and disinterest were often barely tenable responses to a crisis in which the bounded stability of mind, soul, and self was rapidly eroding. In this book I emphasize a countervailing

tendency within Victorian aesthetic thought in which the self is not pains-takingly cultivated and refined but is instead constantly revealed to be on the verge of dissolving outward into its material surroundings, or inward into individual nerves and organs.[50] In this regard, it is sensitive to the antihumanist energies of humanist aesthetics, tracking a counternarra-tive in which the aesthetic denatured rather than recuperated the auton-omy and distinctiveness of human beings. Aestheticism is often described as the apotheosis of Kantian disinterest. But its proponents often staged scenes, like that of Morris's enminded carving or of Pater's living object, that ruptured the coherence of the self and turned mind outward into the physical world.[51] A vase, an architectural feature, an imaginary object: these things matter because they fail to land on either side of oppositions between interior and exterior worlds, between the human and the nonhu-man, between object relations and human relations. Scenes of aesthetic experience often depicted agency as a distributed property of a network of humans and nonhumans rather than as the secure possession of a self-governing subject.

One of the most innovative readings of Kant's third critique treats it, surprisingly, as a political philosophy. In her final series of lectures, given at the University of Chicago and the New School between 1964 and 1970, Hannah Arendt argued that what Kant outlines in the *Cri-tique of Judgment* is not just a philosophy of beauty but a political space of shared reflective judgment. What Kant calls the *sensus communis* is, in Arendt's interpretation, "an extra sense—like an extra mental capa-bility (German: *Menschenverstand)*—that fits us into a community."[52] I mention Arendt in closing because her characterization of aesthetic ex-perience as reflective and communal represents, to my mind, the most powerful account of what might be lost if one theorizes the aesthetic as purely somatic, preconscious, or neurological: the possibility, namely, that deliberative aesthetic judgment offers a point of access to a shared world of human experience rather than returning one to a private, in-ward domain of incommunicable sensations. But for this very reason it is useful to consider an alternative described by the American prag-matist philosopher John Dewey. In *Art as Experience* (1934), a book that indirectly took up many aspects of the materialist aesthetics of the nineteenth century, Dewey made an argument almost exactly opposed to Arendt's: for Dewey, aesthetic experience was not a special form of reflection in a separate sphere of thought but a kind of "ordered rela-tion" between an organism and an environment.[53] "Order," for Dewey, was something like a biological principle, a situation of natural synchro-nicity that grounded the experiences we call aesthetic: "Life goes on in

an environment; not merely *in* it but because of it, through interaction with it. No creature lives merely under its skin; its subcutaneous organs are means of connection with what lies beyond its bodily frame."[54] From this biological perspective, it is not a mental faculty but bodily organs that open aesthetic experience outward.

In these formulations, we find ourselves returned to the question of sense: is sense, as Arendt proposes, a "mental capability" or is it, as Dewey suggests, the point of mediation between interior and exterior? To read Arendt and Dewey together is to hear the resonance of questions that were powerfully articulated in the nineteenth century and that have recently returned to us. Does aesthetic experience create a community by revealing a shared capacity for reflection or by calling on shared biological materiality? What new forms of association might become available if we place emphasis on the latter? What is it that Clementina Anstruther-Thomson and her audience held in common as they together felt the corporeal effects of a patterned vase—and what was left unanalyzed? In the following chapters I refract these questions through the writings and practices of Victorian intellectuals who felt both enthusiasm and anxiety as they turned aesthetic experience outward to the movement of thought, sensation, and affect across networks of human bodies and the matter that surrounded and constituted them.

Part One: Toward a Science of Beauty

1

Form: Harmony and Attunement in Empirical Aesthetics

On November 1, 1853, the day of his first public lecture, John Ruskin walked down Edinburgh's Queen Street and counted the windows.[1] There were 678 along one side of the street, and all were nearly identical square-cut openings topped by a heavy lintel (fig. 1.1). When Ruskin reported this fact to his overflowing audience that evening, he invited them to consider the advantages of a more varied architecture: "It is by no means a bad form," he observed, "but I cannot say it is entertaining."[2] This was the subversive argument of the recently completed *Stones of Venice* writ small: the rational symmetry of the Renaissance was inferior to unruly gothic expressiveness.

During Ruskin's visit, James Young Simpson, a well-known anesthesiologist, offered to arrange a meeting between Ruskin and David Ramsay Hay, Edinburgh's most famous interior decorator, whom Simpson knew through a club that meet monthly to discuss how scientific thought could be brought to bear on questions of taste. There is no record of whether this meeting took place—but if it did, it cannot have gone well. Then near the end of a successful career, Hay had published over a dozen books expounding what he called "the science of beauty," a system of rules for color harmony and architectural design that had gained purchase throughout Britain: the interiors of Walter Scott's Abbotsford and of Holyroodhouse Palace in

Fig. 1

FIGURE 1.1 John Ruskin's drawing of a window in Queen Street, Edinburgh, in *Lectures on Architecture and Painting*, vol. 12 of *The Works of John Ruskin*, ed. E. T. Cook and Alexander Wedderburn (London: George Allen, 1904), 17.

Edinburgh had both been designed according to Hay's principles (fig. 1.2). Hay's theory, taking a cue from Pythagoras, was that visual beauty was subject to definite rules. These rules were discoverable through geometry, mathematics, and empirical observation, and they ought to be understood by practitioners of the fine and decorative arts. They explained not only complex instances of beauty, such as classical sculpture, but also the more rudimentary feeling that a room or environment was pleasing. Some angles induced such feelings of comfort and some did not; the proper mathematical and geometrical models could explain why. "If you can kindly come and bring some sketches or diagrams with you . . . , [Phillip] Kelland will be there and assist in the mathematics if required," Simpson suggested in a letter to Hay, as he anticipated explaining the math to Ruskin.[3]

Ruskin, though he had rules of his own, understood them to have a very different origin and force: social rather than mathematical; organic rather than transcendental. Ruskin's rules were not about which architectural angles were objectively most perfect but rather about the most perfect social conditions under which architecture might serve as a medium of individual expression. Hay's notion that decorators should execute designs based on a rigid system of color and formal harmonies represented the exact sort of thing that dismayed Ruskin when he saw the uniform windows lining Queen Street. In fact, Ruskin parodied systems like Hay's in his lecture when he presented an image of what a tree

branch would look like if it grew "according to the received Attic architectural rules" (fig. 1.3).[4]

In this chapter I examine a widely shared aspiration in mid-nineteenth-century Britain to develop an empirical science of beauty. This project represents a significant alternative to Ruskin's thought and can be traced through a network of intellectuals related to Hay. For many who wished to transform aesthetics into a science, superstructures such as culture or society were understood as secondary determinants of aesthetic judgment—mere inflections of the permanent and universal natural laws actually governing taste. Scientific aesthetics participates in what Robin Collingwood described as a history of attempts to develop an empirical "science of human nature" (in his view, impossible), which had been an object of aspiration among philosophers including Locke and Hume since the advent of Newtonian physical science.[5] And the notion that harmonious beauty creates a mood of attunement to a milieu or atmosphere has an even longer lineage in Western thought, which has been traced by Leo Spitzer's histories of the ideas of ambiance, milieu, and *Stimmung*.[6] Between the 1840s and 1860s, these ideas gained purchase among scientifically minded intellectuals ranging from Hay and George Field (a color manufacturer) to Thomas Laycock (physiologist), John Addington Symonds Sr. (physician), and Eneas Sweetland Dallas (literary critic). The following pages approach the history of aesthetics

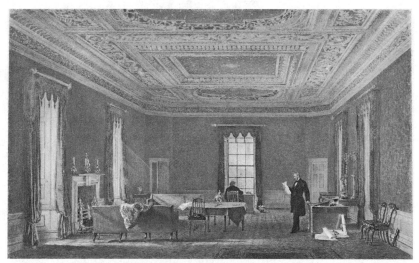

FIGURE 1.2 Interior designed by David Ramsay Hay painted by George M. Greig, *Palace of Holyroodhouse: Secretary of State's Room, or West Drawing-Room as used by the Prince Consort*, 1865. Royal Collection Trust / © Her Majesty Queen Elizabeth II 2016.

FIGURE 1.3 John Ruskin, parody of geometrical principles of beauty in *Lectures on Architecture and Painting*, vol. 12 of *The Works of John Ruskin Volume*, ed. E. T. Cook and Alexander Wedderburn (London: George Allen, 1904), between pp. 26–27.

from an oblique angle, focusing on vernacular attempts to understand the aesthetic that were parallel but ultimately also peripheral to the more influential projects of Ruskin and the Pre-Raphaelites.

The idea of aesthetic form takes on an unusual cast in the context of empirical aesthetics. It is simultaneously a complex structure or pattern that must be discerned through careful contemplation and analysis and an ambient effect of a lived environment apprehended automatically and sometimes even unconsciously. Reconceived as an arrangement of one's

surroundings that induces a physiological response, form draws near to a topos in philosophies of aesthetics and of the emotions from which it usually seems very distinct: the idea of *Stimmung*, an atmosphere or mood that takes place as the attunement of a being to an environment.[7] If we recognize geometrically oriented work such as Hay's as an attempt to mathematize *Stimmung* or atmosphere, we can understand it as an unusual conflation of the empirical and the ineffable. By tracing a lineage of scientific thought about the aesthetic, I show how this aspiration to uncover a formal patterning in nature eventually extended to an interest in a physiological patterning of the body and the nervous system, whose attunement or nonattunement to nature's forms provided one explanation for the experience of beauty or ugliness.

What is conceptually intriguing about a notion of form as simultaneously ambient and geometrical is the apparently conflicting nature of its guiding assumptions: even as these writers embraced the idea that beauty and taste are susceptible to highly systematic and rational explanation, they simultaneously attributed a central role to nonconscious or semiconscious states of awareness, which are rarely imagined as contributing to rational thought. Complex order could be automatically apprehended and decoded by the body. Importantly (and perhaps surprisingly, for post-Freudian readers), the unconscious therefore came to represent a domain of hidden rationality where beauty and reason coincide. The aesthetic unconscious was multifaceted. It involved a concordance between mind and nature whose subjective manifestation is a feeling of pleasure, a peripheral apprehension of surrounding environments that do not fully come into awareness, and physicalized cerebral activity described by mental physiologists as "unconscious cerebration." These aspects of the unconscious allow us to understand how aesthetic form could be thought of as inaccessible to the conscious mind even as this process of apprehension was imagined as *more* rational than most of conscious thought.

This conception of form provides a basis for a counter-Ruskinian framing of artistic modernity in which the artistically modern is not allied with anti-industrialist or progressive political positions but rather with forward-looking scientific theories. A significant critical context for my argument in this chapter is a line of reasoning about the political valences of design and aesthetics in the context of mid-nineteenth-century British industrialism. The displacement of the mimetic function of human-made art by machine-made photographs; new evidence that the human eye was incapable of faithful transmitting the surrounding world; a system of industrial manufacture that was rapidly replacing

handicraft; the rise of print as a mass medium and the literary eclipse of poetry by the novel: all of these changes demanded new ways of thinking about how art should be defined and what role it could play in an emerging technological and scientific modernity.[8] It has therefore often been observed that writing about aesthetics was in many cases a proxy for much larger questions about industrial modernity, especially for Ruskin. In his two major early works, *Modern Painters* and *The Stones of Venice*, Ruskin repeatedly placed a high value on individual expression within the context of collective labor and emphasized what humans can make and perceive that machines could not. To make this argument, Ruskin constructed a periodized historical narrative that is physically legible in architectural style; in principles of design one can also read principles of social organization. This is an elegant and famous formulation; alongside Marx, in Raymond Williams's account, it is Ruskin, Augustus Pugin, and William Morris who invent an idea that is now almost taken for granted: art is historically produced from a given "way of life"; "aesthetic, moral, and social judgements are closely interrelated."[9] More recently, Jacques Rancière has described Ruskin's thought as reconciling an opposition between art as decorative object (Kant) and art as symbolic expression (Hegel) by finding in decoration itself symbolic value.[10] Ruskin has often been understood as originating a critical tradition in which the formal features of cultural objects make legible historical situations.

Scientific and empiricist aesthetics defamiliarize these narratives about the nineteenth century. If Ruskin made aesthetic form the index of a culture, many others imagined instead that it spoke to human capacities entirely unconditioned by history. Particularly insofar as scientific aesthetics draws on studies of the body and the nervous system, its desire to reconcile the human sense of beauty with natural laws resonates more fully with recent aesthetic and cultural theorists who have drawn on neuroscience and evolutionary psychology than with the historicist and politically oriented cultural and aesthetic theory of William Morris, E. P. Thompson, Raymond Williams, Terry Eagleton, and many others who take up aspects of Ruskin's thought.[11] Hay, by contrast with Ruskin, called on principles from design theory, medical research, and natural philosophy to prove his hypotheses. If aesthetic judgments are grounded in unchanging, lawful principles, then a notion of individual freedom such as Ruskin's in "The Nature of Gothic," which rejects rigid systems, is a false freedom. Tracing the antihistoricist logic of scientific aesthetics, in which laws of beauty are permanent and universal, therefore brings

into view a different set of assumptions about what it meant to be aesthetically modern: not a politically inflected modernism in which art modeled or prefigured a transformed society but a scientific modernism in which advancing understandings of the natural world would finally produce a definitive explanation of the human experience of beauty.

Distinctive conceptual possibilities became available within the scientific tradition, particularly with regard to the relationship between aesthetic form and aesthetic feeling. As recent literary scholarship has reclaimed the value of attending closely to aesthetic and literary form, it has often focused on the recovering the political potential of form and formalism, which might be located in an attention to how seemingly self-contained aesthetic forms falsely resolve entrenched social and political contradictions, in explorations of dissonances or "collisions" between social and cultural forms, or in the idea that seemingly formalist "reflection on the precise way things are said or shown" should itself be understood as a politically engaged practice.[12] This recent work usually understands the practice of attending to form as requiring complex and sophisticated acts of reflection and cognition. Empirical aesthetics, which values laws of proportion and harmony, reveals a complex and unpredictable relationship between politics and form in the context of British aesthetic thought in which identifying the formal patterning of nature originally accorded with natural theology but eventually became surprisingly and uncomfortably allied with a materialist (and potentially antitheological) neurophysiological conception of the human mind and emotions. Accounts of form as ambient often generated dialectical movements between abstraction and materiality, between form as an ideal, unseeable pattern and as a physiologized mood or emotion produced by concrete arrangements of sound, shape, or color. The conceptual richness of scientific aesthetics lies in part in its capacity to yield an idea of form not as the structure of a discrete object but as an interaction between the formal patterns of the nervous system and of its environments.

Harmony and Form in Natural Theology

If you place a piece of black metal on a speaker, pour some salt on it, and play a constant pitch, something remarkable happens: the salt organizes itself into perfectly regular geometric patterns. Even more remarkably, if you raise the pitch, the patterns will become increasingly ornate (fig. 1.4). This demonstration, first popularized in the late eighteenth century by the German physicist Ernst Chladni, was later used to

FIG. 65.

FIGURE 1.4 John Tyndall, reproduction of Chladni patterns in *Sound: A Course of Eight Lectures Delivered at the Royal Institution of Great Britain* (New York: D. Appleton, 1867), 148.

demonstrate a key principle of natural philosophy: that there was, as the editors of a recent book on science and romanticism put it, "a direct analogy between aesthetic intuition and the intuition of nature."[13] Visible order, symmetry, and regularity bespoke a world that was divinely organized; aesthetic pleasure could be felt by apprehending that regularity whether it took the form of knowledge about the natural world or the more visible patterns on Chladni's plates. Robert Richards describes romantic biology in Germany as developing Kant's account of the "logical similarity between teleological judgment and aesthetic judgment. . . . Artistic experience and expression might operate in harmony with scientific experience and expression: the basic structures of nature might thus be apprehended and represented by the artist's sketch and the poet's metaphor, as well as by the scientist's experiment and the naturalist's observation."[14]

The notion of an affinity between aesthetic form and the formal structure of nature was the basis for a variety of European theories that aimed to naturalize the sense of beauty. Chladni's popular demonstrations inspired the Danish scientist Hans Christian Ørsted's essays on the relation between acoustic and visual beauty. Ørsted ultimately theorized that the apprehension of beauty was largely unconscious, an idea that, Lorraine Daston has argued, later reappears in Hermann von Helmholtz's seminal writing on tone and music, though shorn of natural-philosophical mysticism.[15] The idea that the underlying formal structure of the natural world was in itself beautiful persisted throughout the nineteenth century: in 1865 and 1866, John Tyndall, drawing on Helmholtz's research, gave public demonstrations at the Royal Institution of the work of Chladni and others who had made sound visible as pattern, including Friedrich Strehlke, Franz Emil Melde, and Charles Wheatstone (who had invented a "kaleidophone" that, when struck, projected vibrating light patterns on the ceiling). Demonstrating these objects, Tyndall invited his audience to share his aesthetic judgments: the play of light was "extremely beautiful," "exquisitely beautiful" (fig. 1.5).[16] But by the time Tyndall gave his demonstrations, this vision of order was, by contrast with Chladni's, framed by a discussion of the basis of perception in the nervous system—a matter of "motion imparted by the sunbeams to the optic nerve"—rather than by speculations about the divine organization of nature.[17]

Tyndall's subtle reinterpretation of Chladni, which emphasizes the agency of sunbeams on the optical nerve rather than what goes on in the viewer's mind, highlights a particular kind of unconscious apprehension that is implied by a model of beauty as harmony with nature: the

FIG. 56.

FIGURE 1.5 John Tyndall, reproduction of Chladni patterns in *Sound: A Course of Eight Lectures Delivered at the Royal Institution of Great Britain* (New York: D. Appleton, 1867), 135.

experience of beauty is often imagined as a concordance between the human mind or body and the order of nature. This order may be susceptible to demonstrations of the sort Chladni and Tyndall offer, but it is immediately felt whether or not it is scientifically uncovered and explained. This model of an orderly, harmonious, unconscious experience can be traced through vernacular attempts to adapt philosophies of nature to aesthetic theory in the early nineteenth century, where the framework of natural theology often produced explanations of beauty as a moment of concordance between human beings and natural surroundings. In a chapter of *Natural Theology* on animal bodies, William Paley had explicitly argued that the fact that ugly viscera were hidden from view by

skin provided evidence of divine design, "convert[ing] the disgusting materials of a dissecting-room into an object of attraction to the sight," but even more telling was the pervasive appeal throughout the treatise to the notions of harmony, order, and symmetry as intrinsically beautiful: it is God's ingenious contrivance, for instance, "which constitutes the order and beauty of the universe."[18] Furthermore, the sense of beauty bespoke an affinity with God. Thomas Chalmers wrote in the first Bridgewater Treatise that "when we look to the beauty which overspreads the face of nature . . . we cannot doubt, either the taste for beauty which resides in the primeval mind that emanated all this gracefulness; or the benevolence that endowed man with a kindred taste."[19] Along similar lines, William Whewell wrote in the third Bridgewater Treatise that "the sense of beauty both animates and refines [man's] domestic tendencies; the love of art is a powerful instrument for raising him above the mere cravings and satisfactions of his animal nature; . . . the cloud-capt mountain, the boundless ocean, seems intended to direct our thoughts . . . to the Infinite author of All."[20] Later commentators on natural theology would draw an even closer connection between design and formal appearance; Richard St. John Tyrwhitt's *The Natural Theology of Natural Beauty* argued that the external beauty of nature provided further evidence of William Paley's argument from design.[21]

The pervasiveness of this logic can be measured by the fact that it appears not only within the writing of these prominent philosophers of nature but within amateur treatises as well. In 1806, the glee composer Henry Harington put forth a theory about musical harmony and the Christian holy trinity. Played simultaneously, Harington observed, the notes C, E, and G are audibly inseparable, transformed into something new: the unity of a pleasing sound. To listen to the chord, Harington proposed, is to witness evidence of the consubstantiality of the divine trinity of father, son, and holy spirit. Just as God is one and three, so too is the chord. On Harington's view, this was not merely a metaphor or an analogy. Rather, God provided chords—and other instances of harmony—so that human beings might understand his nature.

The book Harington wrote to promote this notion, *Symbolon Trisagion; or, the Geometrical Analogy of the Catholic Doctrine of Trinity, Consonant to Human Reason and Comprehension; Typically Demonstrated and Exemplified by the Natural Invisible Trinity of Certain Simultaneous Sounds* (1806), was not universally acclaimed.[22] The eminent *Critical Review* poked fun at Harington, comparing him to the "labouring man" who found proof of God's Trinity in the element of

water "as exhibited under the three forms of hail, snow, and rain."[23] This was a common objection against the form of reasoning espoused by natural theology or natural philosophy: Harington substitutes a natural relation for one that is in fact only analogical; the fact that the physical states of water, the notes of a chord, and the Christian trinity share "three-ness" makes them similar, but the crucial question is whether that similarity is a human imposition. Analogies must acknowledge their grounds. But the idea that relations among sounds revealed divine concepts found at least one eager and influential follower who did his best to prove Harington's idea scientifically: a creator of artist's pigments named George Field. Inspired by Harington, Field developed a complex theory not only of the analogy of sound and color but of analogy itself. Analogy, Field argued, was not a weak form of proof or a leap of reasoning; it was a hidden key that allowed humans to understand the orderliness of a seemingly disordered nature.

Field is now known among historians of British art mainly for developing pigments that allowed nineteenth-century painting to retain its colors; he created some of the colors that made Pre-Raphaelite paintings so distinctively vibrant.[24] His advances in the theory and production of color were recommended by Ruskin and used by many important nineteenth-century British painters, including Joseph Turner, John Constable, William Holman Hunt, John Everett Millais, and Dante Gabriel Rossetti. "If you wish to take up colouring seriously, you had better get Field's *Chromatography* at once," intoned Ruskin in *The Elements of Drawing* (1857).[25] Field also invented optical instruments, which he used to develop theories about color and light. His books on these topics were widely used and reprinted.[26] He was a friend of Constable and Turner, and Field's theory that rainbows are produced by the refraction of light through hemispherical (not, as was generally supposed, spherical) raindrops may have influenced Constable's representations of the atmosphere.[27] By showing how industrial techniques and optical theory could invigorate painting, Field's theoretical and technical work is literally on the surface of much nineteenth-century British visual art.

Field used his research in optics and pigments to inductively develop highly formalized theories of color and music harmony whose commitment to precision and regularity characteristic of natural philosophy are evident in the many visual demonstrations Field provided in his books. One important diagram of the analogous scale of sounds and colors in Field's first book expresses the relationship between the chromatic musical scale of twelve notes and the visual system of primary and secondary colors (fig. 1.6).[28] What Field means to express in this diagram is

EXAMPLE XVI.

ANALOGOUS SCALE OF SOUNDS AND COLOURS.

FIGURE 1.6 George Field, analogy between scales of sound and colors in *Chromatics; or, An Essay on the Analogy and Harmony of Colours* (London: A. J. Valpy, 1817), 33. Courtesy University of Chicago Special Collections Research Center.

that chromatic and musical systems have a mathematically perfect relationship to one another; the taxonomy of the scale is equally appropriate to colors because, on Field's account, sound and color are analogous orders. The note C, corresponding to the color blue, repeats at lighter shades as one moves up the scale; so also for E (red) and G (yellow). What looks like an invented system for composing music is not a culturally dependent symbolic structure with its own history; rather, it expresses an absolute relationship that evidences a divinely organized world.

The implication is as simple as it is radical: seemingly individual aesthetic preferences are in fact governed by an extraindividual logic of nature. But where this analogy between sound and color had long been an object of speculation, natural theology afforded ever wider analogies— not just of sound and color, but of vowels, shapes, even language and poetry (figs. 1.7, 1.8). Field's method of reading is one that submits the literary object to the same types of scrutiny that can be applied to simple

EXAMPLE.

XXXVIII.

FIGURE 1.7 George Field, system of primary shapes, *Chromatics; or, The Analogy, Harmony, and Philosophy of Colours* (London: David Bogue, 1845), 96. Courtesy John Hay Library, Brown University Library.

FIGURE 1.8 George Field, system of primary vowels, *Outlines of Analogical Philosophy: Being a Primary View of the Principles, Relations and Purposes of Nature, Science, and Art* (London: Charles Tilt, 1839), 1:85.

forms: there are primary vowel sounds; meter represents a regularization of verse; one can therefore read literature by substituting colors for words that refer to them. When Field writes that "poets, like painters, are comparatively good or bad colourists," he imagines that one might evaluate the quality of poetry by judging its success at harmonizing colors within his system.[29] Shakespeare "harmonizes with the primary colours, as thus:—'Thou shalt not lack / The *flower that's like thy face,*

pale *primrose*, / Nor the *azured* harebell, like thy veins' "; Shakespeare has appropriately placed shades of yellow and blue in proximity with one another.[30] The phrase "*green and yellow* melancholy" in *Twelfth Night* is equally successful, according to Field: "with what truth and effect he avails himself of the chromatic discord of *green and yellow*, which he uses metaphorically for youth and jealousy, as though he theorised in colours."[31] This commitment to natural order is implicitly political. Field writes that a "principle of *union* pervades and holds all nature together; and to it is to be attributed not only *physical* and *sensible*, but also *moral and intellectual harmony;* not only the harmony of colours and sounds, but domestic and social harmony result from *subordinated union.*"[32] That this harmony is a principle linking aesthetic and political order becomes especially apparent when Field turns to Pope's *Essay on Man* (1734–35), quoting the lines "Th' *according music of a well-mixed state*. / Such is the *world's great harmony*, that springs / From order, *union*, full consent of things."[33] What harmony made visible, then, was not just an image of formal perfection but also the image of perfect social order. Form thus explicitly effects a movement between political and aesthetic order that Caroline Levine has recently argued is one of its key features. But where Levine emphasizes the political value of "collision" between forms, harmony might instead be understood as a formal principle whose politics involve wishing collision out of existence.[34]

Field's account of Shakespeare's supposed harmonizing tendencies represents the limits of an aesthetic theory that must equate beauty with formal perfection. Perhaps one reason that the attempts of Field and others to develop deeply systematic accounts of the sense of beauty did not find a wider audience (Ruskin, recall, admires Field's technical skill but not his theoretical account) was that this conception of beauty as perfection is ultimately too thin to account for the complexity of aesthetic objects or of the human experience of them.[35] These limitations become especially apparent in the attempt to read Shakespeare, but they hint that even the simpler forms to which Field turned his attention could not fully sustain the idea that beauty was truly a matter of a few simple geometrical formulas and analogies.

In this regard, natural-theological accounts of beauty can be understood as trapped within a problem characteristic of natural theology more generally. Reasoning by analogy, Neal Gillespie has observed, was deeply "characteristic of more traditional forms of natural theology."[36] Paley observed that the eye's "coats and humours [are] constructed, as the lenses of a telescope are constructed."[37] But, famously, analogical reasoning was as controversial as it was characteristic; as Hume

memorably argued, God is less analogous to man "than the sun to a waxen taper," a proposal that highlighted the groundlessness of analogical reasoning.[38] An aesthetics developed from these kids of analogies therefore at once appealed to the authority of a divinely ordered nature but then also inherited many of the conceptual impasses that were endemic to that model. The complexity of Shakespeare, like the complexity of the eye, could not be fully explained by making an analogical leap.

Psychologies of Beauty

Field's work intersects with many questions framed in British empiricist and psychological traditions of accounting for judgments of taste. In a classic account of eighteenth-century British aesthetic theory, Walter Hipple describes three basic questions that received different configurations depending on the stance of the writer: What kind of mental effect is beauty? What property of an object can produce that effect? And how is it that cause and effect are linked?[39] More recently, Timothy M. Costelloe similarly divides the eighteenth century aesthetics into three thematic categories that notably also name basic presuppositions about how the human mind works: "internal sense," "imagination," and "association" theorists.[40] As these divisions suggest, British psychologies of the sense of beauty often turned on the question of whether beauty was a property of a mind or of an object. In his *Philosophical Enquiry into the Origin of Our Ideas of the Sublime and Beautiful* (1757), Edmund Burke praised and extended William Hogarth's well-known account of a perfect curvilinear "line of beauty" to explore the particular properties, such as smoothness or smallness, that characterize beautiful things, arguing that "beauty is a thing much too affecting not to depend upon some positive qualities" and that "beauty is, for the greater part, some quality in bodies acting mechanically upon the human mind by the intervention of the senses."[41] David Hume, by contrast, opened "Of the Standard of Taste" (1757) with the paradox that while on the one hand "beauty is no quality in things themselves: It exists merely in the mind which contemplates them; and each mind perceives a different beauty," it was nonetheless also the case that "whoever would assert an equality of genius and elegance between Ogilby and Milton, or Bunyan and Addison, would be thought to defend no less an extravagance, than if he had maintained a mole-hill to be as high as Teneriffe."[42] While Burke's and Hume's claims are evidently incompatible, both can be contrasted with Field in the sense that the former thinkers are interested in the moment

of apprehension, while Field often aspires to describe structures that exists in things themselves rather than as mental experience.

Accounts such as Field's are similarly distinct from those developed by adherents of faculty and associationist psychology, who looked to emerging scientific accounts of the mind as a basis for describing the human sense of beauty. For faculty psychologists who took the mind to be "a unitary, self-activating, self-sustaining, and ontologically independent structure," to borrow Rick Rylance's characterization, one could refer judgments of beauty to an innate, or "internal," sense of beauty.[43] By contrast, associationist psychology offered a framework for describing the feeling of beauty not as the operation of a given property on the mind (e.g., Burkean "smoothness") but as the effect of a given person's contingent associations. Archibald Alison observed, for instance, that "The valley of Vaucluse is celebrated for its beauty, yet how much of it has been owing to its being the residence of Petrarch!"; here what is perceived as a property of the landscape is, Alison suggests, more properly understood as the psychological result of contingent associations.[44]

The explanatory power of associationist psychology with regard to judgments of beauty is taken up by John Stuart Mill's early essays on literature, including "What Is Poetry?" (1833), which not only explores the relationship between associationist psychology and the sense of beauty but also directly addresses the difference between aesthetic and scientific knowledge. Mill argues for a strong distinction between the poetic and the prosaic, affiliating one with private emotion and the other with eloquent conviction; later that year, "The Two Kinds of Poetry" drew a similar distinction between poets whose "mental and physical constitution" meant that intense feeling was primary and those for whom poetry was primarily propositional. Mill's essays were crucial for later discussions of the social role of the poet; as Isobel Armstrong notes, Mill's opposition "was to have consequences for the rest of the century" insofar as it placed value on poetry that spoke, as Mill put it, "itself to itself," isolated from society.[45] But we should recall that for Mill, "poetry" often stands in for a more general category of aesthetic experience. In the first essay, he repeatedly observes that his topic is not poetry as such but the poetry *of* various art forms: the poetics of the novel, "the poetry of the painter's or sculptor's art," the "poetry of architecture"; similarly, in "The Two Kinds of Poetry" the poet often serves as a figure for an artistic "impassioned nature."[46] With this in view, Mill's essays, which drew their understanding of an individual's nature or constitution from the "adolescen[t]" science of psychology, can be thought of as pursuing an aesthetic theory that, like Field's, would be in keeping with

scientific principles.[47] But if Mill implied that a poetic sensibility could be understood through an emerging science of the mind, the kind of truth conveyed by poetry nonetheless differed fundamentally from that which could be scientifically known. As Mill puts it in a famous example, scientific and poetic accounts of a lion will differ in that the former describes "bare and natural lineaments" while the latter recounts "the state of awe, wonder, or terror, which the spectacle naturally excites."[48] The truth of one is portable, the other personal.

A central problem with describing beauty either as a positive quality or as the effect of associations, is, as Kant had proposed in the *Critique of Judgment* (1790), that it more or less gives up on the most difficult question about taste: if I genuinely happen not to find curves or smoothness beautiful, how do you explain both my diverging preference and your expectation that I should agree? It is certainly not adequate to say that I am mistaken about my feeling: sensations of agreeability ("this curve relaxes me") are not available for debate in the same way as are propositions ("this curve is beautiful"). Kant therefore explicitly rejects any geometrically oriented aesthetic: "geometrically regular shapes—a circle, a square, a cube, etc.—are commonly adduced by critics of taste as the simplest and most indubitable examples of beauty"; but in fact, Kant writes, such claims mistakenly make rules govern a type of judgment that is seemingly lawful but defined by its very resistance to lawful formulations.[49] This is why Kant describes Burke's views as a "merely empirical exposition" grounded on no a priori principles (and similarly he rejects, in the *Critique of Pure Reason*, Alexander Baumgarten's "futile" project of "bringing the critical estimation of the beautiful under principles of reason").[50] Kant assents that "A mere color, e.g., the green of a lawn, a mere tone (in distinction from sound and noise), say that of a violin, is declared by most people to be beautiful in itself," but these claims are not pure aesthetic judgments—they are only assertions of "agreeableness or disagreeableness."[51] Kant's well-known formulation of aesthetic judgment as "subjective universality"—the notion that the kinds of subjective pleasures that we call aesthetic are those that we expect everyone else to share—can be understood, in part, as countering the associationist and empiricist psychological accounts given by Hogarth, Burke, and Alison. And, indeed, while Kant calls on metaphors of proportion and *Stimmung* in his discussion of aesthetic pleasure, it is not to describe the beautiful object but to describe the experience of subjective universality as one in which faculties of understanding and intuition inhabit a "well-proportioned disposition" (*proportionierte*

Stimmung).[52] Harmony is a relation of the mind rather than an empirically discerned feature of the object.

These accounts of the operation of the mind in the context of aesthetic judgments delineate the conceptual territory of Field's natural-theological ideal of aesthetic harmony, which operates against both the Kantian account of aesthetic pleasure as a proportioned *Stimmung* of the faculties and the associationist account of beauty as the result of contingently accrued pains and pleasures. Field aspires fully to subsume the lawfulness of the aesthetic domain under the universal lawfulness of nature. The notion of beauty as perfect, harmonious forms tends to make the strongest possible claim on behalf of determining structures and also to imagine that a sufficient degree of reasoned analysis will uncover the principles that determine which things are and are not beautiful.

Sensation and Abstraction in George Field's Color Theory

Field's commitment to order may seem to render his aesthetic theory conceptually rigid, but the material qualities of Field's published books stage dialectical shifts between notions of aesthetic form as disembodied ideal structures and as inducing embodied experiences of pleasure or displeasure. This is a conceptual problem often encountered in ancient writing on beauty (including for Pythagoras, Plato, and Plotinus), which Monroe Beardsley explicates in his reading of Plotinus's notion of "absolute beauty" as inaccessible to the senses: "it must be remembered that Absolute Beauty itself is invisible: the 'Authentic Beauty' is 'Beyond-Beauty,' since it surpasses shape and form, without which beauty cannot be experienced. Thus, paradoxically, to achieve absolute Beauty is not to see it."[53] The paradox Beardsley describes plays out in the form of Field's books, which materially instantiate the ideal order he imagines and thus make a direct appeal to the body—even as they claim to translate beauty into a higher order.

Field's writing was addressed to a Victorian audience for which distinctions between the sensory and intellectual appeal of art were a matter of lively debate with clear moral valences. Such alternatives were often framed in binary terms: Arthur Henry Hallam's sensation or reflection; John Stuart Mill's emotional or scientific knowledge; John Ruskin's *theoria* or *aesthesis*. Scholars of British art history and visual culture have extensively explored the ways in which color itself became polarizing within this context both as a locus of critical response to the paintings of Turner and the Pre-Raphaelites and by way of a romantic poetic tradition from

Keats through Rossetti and Morris that was closely attuned to bodily sensation, especially the perception of color and sound. Rachel Teukolsky has argued, for instance, that even as many art critics in the 1840s rejected the perceived sensualism of painting that privileged color over form, "the English school of painting was known for its mastery of color," especially for using color as a Goethean symbolic language that produced meaning by way of psychological associations.[54]

These debates were closely related to developing ideas about an artistic avant-garde. That color might have a politics or be in itself radical; that a poetry of emotional intensity was inward oriented and therefore socially isolating; that *aesthesis* implied abasement: these were positions that linked aesthetic and political programs at the level not only of content but of form as well. If color has a politics, it would seem that Field's theory lands clearly on the side of conservative formalism as opposed to sensuous appeal. Everywhere in Field's work one finds regular structures and repeated systems that look like the afterlife of an earlier classical aesthetics of perfection and uniformity. Elizabeth Helsinger has described in detail the tension between scientifically conservative and aesthetically radical color theories in the 1840s and 1850s. Color scientists and theorists in Britain, Europe, and the United States and the continent—Goethe, Michel-Eugène Chevreul, Field, and (later) Ogden Rood—developed accounts of color that attempted to ascertain universal systems and rules for harmonizing. By contrast, Helsinger argues, followers of Ruskin resisted this scientific systematism, rejecting through their poetry the simple opposition of sense and intellect: "color, both intensely sensuous and a form of sensuous or imaginative thinking requires acts of abstraction and completion from readers and viewers . . . to produce aesthetic satisfaction. . . . Lyric color was a powerfully expressive vehicle, embodying particularly a sense of alienation or displacement they identified as modern."[55] Color revealed the power, aesthetic as well as political, of dissonance.

But a close reading of Field's writing on color begins to reveal the difficulty of maintaining these binaries: scientism, too, could become dissonant, though often unintentionally. Field's "aesthetical science" reveals how an aesthetics based in a conception of nature as fundamentally ordered and patterned tends to shift unpredictably between registers of ideal mathematics and of physical sensation. In Field's writing, this movement takes place as a result of the distinctive way in which Field understands the term *aesthetics*. Like the Ruskin of *Modern Painters*, Field sees aesthetics as a way of explaining the pleasures of sensory

FIGURE 1.9 George Field, placement of aesthetics as genus of "physiological science" in *Outlines of Analogical Philosophy: Being a Primary View of the Principles, Relations and Purposes of Nature, Science, and Art* (London: Charles Tilt, 1839), 2:104.

experience. But unlike Ruskin, Field does not balk at reducing the theory of art to a theory of its mechanistic effects on the senses. "Aesthetics," we learn in Field's *Outlines of Analogical Philosophy*, is a branch of physiology focused on how the human sensory apparatus mediates a material environment, falling between "orexetics," the science of appetites, and "pathetics," the science of passions. Field calls aesthetics the "medial genus of physiological science," which encompasses "whatever belongs to the philosophy of sense, as distinguished from matter and intelligence" (fig. 1.9).[56] Field was among the first British writers to use the term *aesthetics* in an extensive and systematic fashion. His 1845 edition of *Chromatics* designates "aesthetical science" as that which addresses how sound, music, and language please the senses by becoming harmonious.[57] Field notes that "aesthetics" has recently come to be affiliated with what the eighteenth-century debated as "taste," but he rejects this connection; the term "*aesthetical* . . . in its original meaning denoted the whole science of *sense*. . . . We have . . . employed the term in its original signification generically . . . whereby *aesthetics* denote all the sensible sciences, as *physics* do the material, and *ethics* the moral."[58] Field takes the sensory, physiological response to art as the basis for a conceptual account of aesthetic pleasure.

"Science" and "aesthetics" are both polemical terms here aimed squarely at what Field calls "the narrow and devious views in which the aesthetical subject of *taste* and *beauty* has been regarded"—views that have left the subject "ambiguous and obscure."[59] Field calls on a new language standing for precision, clarity, breadth, and straightforwardness. Field positions his thought, grounded in the manufacture of paint,

experiments with optical instruments, and speculative mathematics and geometry, as an alternative to ways of talking about beauty that prefer a philosophical idiom. But this use of harmony is paradoxical. At the same time that it affirms the order of nature and, by analogy, an orderly society, it also names a relationship between organism and environment that does not depend on thought. Even as harmony appeals to divine hierarchies, it locates aesthetic experience in bodily experience.

Field's theoretical books on beauty, read carefully, also reflect a very real engagement with what Rick Rylance has described as a "risk" of natural theology: that physical evidence will usurp metaphysical evidence, that the ultimate ground of proof will become the physical body rather than divine ineffability. As Rylance puts it, describing British psychology before the 1850s, "arguments from Natural Theology are compelling in so far as they are reassuringly purposive (everything is well in a designed world), and enlist as supportive testimony nature's spectacular beauty and efficiency. But, potentially, these are also high-risk arguments, because the metaphysical case is so firmly attached to the physical one, and evidence produced in the latter area might compromise the former."[60] George Levine similarly remarks on the work that natural theology had to do to remain coherent: "Natural theology is an effort of containment. Multiplicity . . . is not itself a confirmation of the presence of a creator; the wonder of Whewell's world is in the way multiplicity is always joined with order."[61] When Field uses his optical theories as support for the claim that "domestic and social harmony result from *subordinated union*," he appears to be offering such a "reassuringly purposive" or "contain[ed]" view of nature. But the binary of ideal mathematical rationality (a 3:5:8 ratio of intensity among primary colors, according to Field) and embodied sensory pleasure (aesthetics as a physiological science) continually reveals itself to be highly unstable.

This conflict between ideal and sensuous form is evident in reviews of Field's books, which criticized the central place afforded to color and even extended these criticisms to the books' material formats. The *Athenaeum* called *Chromatography* "a most unwise pandering to the public taste for that gay lady—Colour. Instead of the first, colouring is the very last among the great requisites. Expression, design, invention, are all before it."[62] Multiple periodicals commented on the physical size of the lavishly illustrated *Chromatics*, which seemed literally to give too much weight to Field's speculative theories about color and music harmony (fig. 1.10). The *Athenaeum* noted that "A quarto which comes forth with such pomp and pretension, cannot be passed over like a modest effusion of ignorance or folly in octavo."[63] And the *Court* magazine

FIGURE 1.10 George Field, title and facing page of *Chromatography; or, A Treatise on Colours and Pigments: And of Their Powers in Painting* (London: Tilt & Bogue, 1841). Courtesy University of Chicago Special Collections Research Center.

lamented, "we find it woefully defective in theory. . . . There is a great deal of pretension, and many high-sounding and inflated periods in this magnificent volume of large dimensions, but very little available knowledge"; the book, notes the reviewer, "might be compressed into an octavo of modest size."[64] What these reviewers see is that Field's book, with its copious illustrations, is not just a schematic explanation of beauty; it is an instance of it as well. The path toward a purely idealized aesthetics— the transformation of beauty into rationality—begins with an object that cannot help but be sensuously pleasing.

Field's books make available a mode of reading them against the grain of their stated theories, a mode of reading in which one finally arrives not at divine order but at the material qualities of page and illustration, which appeal directly to a sensing body. This is especially evident in a series of "harmonic diagrams" in *Chromatics*. The diagrams

FIGURE 1.11 George Field, chromatic equivalent of chords in *Chromatics; or, The Analogy, Harmony, and Philosophy of Colours* (London: David Bogue, 1845). Courtesy John Hay Library, Brown University Library.

describe, in increasing complexity, the relation between a musical chord and its chromatic equivalent (figs. 1.11, 1.12). Unlike the scale of sound and color or the schematic shapes, Field superimposes these chromatic representations on a landscape. This is a surprising decision. All other elements of the illustration—the triangles forming the star, the circle, the particular colors, the musical scale—are selected according to analogies

FIGURE 1.12 George Field, chromatic equivalent of chords in *Chromatics; or, The Analogy, Harmony, and Philosophy of Colours* (London: David Bogue, 1845). Courtesy John Hay Library, Brown University Library

extrinsic to the diagram. The point of the image is to make the physical marks on the page disappear into mathematical and geometrical truths of a Platonic order. The landscape, by contrast, is entirely arbitrary and contingent. Why place the diagram in such an unusual context? To introduce a landscape behind the schematic diagram is to represent the diagram as literally free floating, unmoored from the world of physical laws that implicitly exists in the background. The denaturalized schematic inadvertently analogizes Field's own work, simultaneously beautiful and free floating, colorful and abstract.[65] The landscape below thus occupies a double relation to Field's argument. Presumably it is there to remind the reader that Field's principles are principles of nature. But it works against this reminder by visually creating a disjuncture between the harmonies of color scales and the real or natural world. The diagram fails to apply to the colorless landscape. These sorts of disjunctures can be tracked across Field's work and represent a paradox intrinsic to natural-theological accounts of beauty. Even as Field's work presents itself as coincident with the stability of natural theology, it is often internally disrupted by the high value it places on sensuous and embodied aesthetic experience. Field's theory initially appears to be a hyperrationalization of the aesthetic domain, committed to conservative values of order, quietude, and subordination. But his views on literature and his ambiguous illustrations gesture toward a different reading: Field lays the groundwork for an aesthetic theory that is simultaneously committed to practices of precision, reduction, and mathematicization and is also highly aware of the non- or partially reasoned modes of responding to beauty.

Ambient Formalism at the Edinburgh Aesthetic Club

The conceptual difficulty encountered at the level of illustration in Field's *Chromatics* persists more generally in other versions of empirical and scientific aesthetics. It is a defining problem among a cohort of intellectuals who took up and transformed a version of Field's project in the 1850s, the Edinburgh Aesthetic Club, led by the interior designer David Ramsay Hay. The club, which explored the possibility of a new science of beauty, attracted the attention of some of Britain's leading scientific minds: William Hamilton, David Brewster, Michael Faraday, Lord Kelvin, James Clerk Maxwell, and John Scott Russell expressed their approval of Hay's efforts to discover systematic prescriptive and descriptive principles governing the human sense of beauty.[66] Hay's papers and the club's records record the results of their scientific inquiries

into aesthetic form and aesthetic feeling; among the members' findings were that properly "masculine" facial features are "governed by the triangle of $33°45'$, $56°15'$, and $90°$" and that the Gothic Lincoln Cathedral was beautiful because the angles inscribed into its elevation had ratios corresponding to tonic, dominant, mediant, subtonic, and supertonic intervals of a musical scale.[67]

How to distinguish between what Mill, in "What Is Poetry?," had phrased as a distinction between scientific and poetic truth was a question that Hay's group often engaged with, though their answers intersected with Mill's associationist model in unpredictable ways. On the one hand, Hay's cohort developed in great detail the notion that the creation and reception of art should be traced to bodily sensitivities, as Mill's essay had done when it referred the quality of Shelley's poetry to the fact that "the susceptibility of his nervous system, which made his emotions intense, made also the impressions of his external senses deep and clear."[68] Mill had given an associationist turn to an aesthetic tradition that distinguished rationality from emotion, aesthetic from scientific judgment: Mill's example of differing scientific and poetic descriptions of a lion directly recapitulates Kant's observation that "hardly anyone other than the botanist knows what sort of thing a flower is supposed to be; and even the botanist, who recognizes in it the reproductive organ of the plant, pays no attention to this natural end if he judges the flower by means of taste."[69] But Hay's club developed arguments that sought to collapse the distinction between the botanist and the layperson, between the scientific and the poetic. Truths about beauty were not to be separated out into the private emotional domain of poetry, they argued, but fully encompassed within the scope of scientific knowledge.

Formed in the context of a thriving scientific and club culture in mid-nineteenth-century Edinburgh, the Aesthetic Club transformed Field's concern with divine harmony into a physiological conception of orderly harmony. If, as the Scottish philosopher William Hamilton put it in a letter, Hay persuasively "reduces the beautiful to the symmetrical and harmonious," he also begins to see symmetry and harmony as principles that proceed from the organization from the human body as much as from transcendental axioms.[70] Even as scientific aesthetics adopted a commitment to mathematical rationality, it simultaneously developed ways of thinking about experiences that seem to evade reason: states of partial consciousness, the interpenetration of sensation and thought, and the material effects of ambient elements of environments. This lineage of aesthetic thought can be interpreted in part as an attempt to develop an empiricist account of *Stimmung*: qualities of tone or atmosphere that are

FIGURE 1.13 David Ramsay Hay's reproduction of Field's scale of sound and color in *The Laws of Harmonious Colouring, Adapted to Interior Decorations, Manufactures, and Other Useful Purposes* (Edinburgh: William & Robert Chambers, 1836). Courtesy University of Chicago Special Collections Research Center.

analogous to music in their capacity to surround and happen to the body and that manifest as moods or states of attunement between a person and the world.[71] Hay's work aspires to analyze systematically how any lived spaces produce such a *Stimmung*.

Hay's technical writing almost inadvertently theorizes a phenomenology of aesthetic perception. Much like the French color theorist Michel-Eugène Chevreul, Hay was committed to the theoretical aspects of his profession: not just which colors should be used together but the scientific reasons that certain color combinations feel more pleasing than others. Hay's first book, *The Laws of Harmonious Colouring, Adapted to Interior Decorations, Manufactures, and other Useful Purposes* (1828), outlines a program of interior design that is based on Hay's own experiments as well as his study of Field (whose diagram of the musical analogy begins Hay's book [fig. 1.13]).[72] First, one uses the furniture to establish the "key-note," or leading color of the rooms. Then, according to a number of factors (including the light source and purpose of the room), the house painter "harmonizes" on that key by varying hue (e.g., the redness or yellowness of orange) and tint (its lightness or darkness).[73] In the drawing room, for example, "vivacity, gaiety, and light cheerfulness should characterise the colouring. This is produced by the introduction of light tints of brilliant colours, with a considerable degree of contrast

and gilding."[74] Although Hay's writing is oriented toward practical application, it also engages in extended attempts to conceptualize relationships between arrangements of color in space and the mood that such arrangements induce.

Although Hay himself would not have put it this way, theorizing the aesthetic from the starting point of interior design allowed a new set of categories to emerge, less focused on moments of intense concentration or emotional transport than on atmospheric effects that barely rise to the level of consciousness. If Mill, taking Wordsworth and Shelley as his examples, had defined the poetic as the product of an "intense sensibility" and "strong feelings," Hay is ultimately more concerned with ambient qualities of environments: moderate sensibilities and diffuse feelings.[75] His books often pay more attention to the distributed effects of lived spaces than to particular works, developing quasi-physiological theories about the mechanisms of aural and optical stimuli. In his discussion of the effects of individual colors, a theory of the room as a sensory field is always hovering at the margins. Depending on how they are painted and furnished, rooms become alternately "violent," "harsh," and "cold" or "soft," "lively," and "cleanly."[76] As suggested by Hay's epigraph from Joshua Reynolds—"every opportunity should be taken to discountenance that false and vulgar opinion, that rules are the fetters of genius: they are fetters only to men of no genius"—Hay's work seeks to establish a rigorous framework divorced from individual preference that would explain these sensory effects of an interior space. Hay's adjectives broaden the experience of color from a merely optical phenomenon to one whose bodily effects exceed the eye. Color is tactile ("harsh," "violent," "soft"), thermal ("cold," "warm"), and even energetic ("lively"). A similar logic was commonly adopted by Victorian drawing and design manuals. John Clark's 1838 *The Elements of Drawing* cited Hay, Field, and the phrenologist George Combe to support a physiological explanation of the felt effects of color: pale indigo can "reduce [the] violence" of warm tones; conversely, "the eye is quiet, and the mind soothed and complacent, when colours are opposed to each other in equivalent proportions chromatically," and so forth.[77]

Hay's theories are highly self-instrumentalizing in relation to science and industry, which meant that many scientists found them to be an appealing alternative to literary and philosophical discussions of taste. David Brewster, at the request of the editor of the *Edinburgh Review*, Macvey Napier, wrote an article in 1843 praising Hay for adopting rather than renouncing science, as did most writers on taste.[78] Brewster saw Hay as an intelligent outsider who was making a useful intervention not

only in home decoration but against associationist mental science more broadly. Unlike associationists, who understood the sense of beauty to develop out of essentially contingent associations of sensations and ideas, Hay's work promised an absolute set of values that could be represented mathematically.[79] Brewster saw it as a bulwark against the unruly instability of associationist psychology: "the sovereignty of association in matters of taste had never been recognised by practical men, who study nature principally through the eye; and the painter, the sculptor, the architect, and the landscape gardener, had been striving in their respective spheres to discover those 'Laws of Harmony,' both in colour and form, which ought to regulate the taste, and direct the hand of the artist. In so far as we know, Mr Hay is the first and the only modern artist who has entered upon the study of these subjects without the trammels of prejudice and authority."[80]

The records of the Edinburgh Aesthetic Club, formed by Hay with the mathematician Philip Kelland and the anatomist John Goodsir following the Great Exhibition in December of 1851, illustrate how mid-Victorian scientific intellectuals aspired to resolve philosophical questions about beauty by calling on scientific principles. The club's minute book describes its aim as "to elucidate the principles of beauty, and reduce them into a science."[81] Hay and his colleagues met seven or eight times a year between 1851 and 1857. The club follows the pattern of the scientific fraternities that Hannah Gay and John W. Gay have described as central to Victorian scientific culture; Edinburgh was then home to one of the most important scientific fraternities, Edward Forbes's Universal Order of the Brotherhood of the Friends of Truth, which shared members with the Aesthetic Club.[82] Its members included the stained glass producer and poet James Ballantine, the anesthesia researcher James Young Simpson, and the literary critic Eneas Sweetland Dallas. Several members of the club were also members of the Royal College of Physicians of Edinburgh and fellows of the Royal Society of Edinburgh, of which Kelland was later president.

The activities of the club reflect an aspiration to uncover the universal principles that governed seemingly individual aesthetic judgments by joining physiology with mathematics. Among the papers presented were "The Aesthetics of Smell," an "Inquiry into the General Principle Which Regulates the Approbation or Disapprobation of Sounds," and "On the Natural Principles of Beauty."[83] The club's minute book describes the various principles and axioms that the participants together developed: "expectancy," or the "instantaneous response" of the mind to pleasing harmonic ratios; "aesthetic conscience," a sense of the beautiful

analogous to the sense of the good; even a protocomputational theory of beauty, which proposed "that certain parts of the Ear (the cochlea for instance) possess a structure by which the succession and combination of notes are detected with such nicety as at once to enable the Aesthetic Faculty to appreciate them independently of intellectual analysis in the same matter as the results arrived at by the use of Babbage's calculating machine are assented to by the intellect."[84] This last comparison between human physiology and Babbage's computing reflects with particular clarity the Aesthetic Club's notion that not only was beauty ultimately reducible to mathematical models but also that the human body unconsciously decoded these models. Aesthetic response occurred out of the reach of awareness but was also perfectly analogous to the most complex, computational mental processes. This logic relocates natural-theological canons of formal perfection in nature to the human body, physiologizing the musical staves that had appeared in Field's color theory.

The club's work thus elucidates the immanent principles of a pleasure that is always at the margins of awareness. Hay's writing frequently returns to the notion that humans have an instinctive sense that something is beautiful without being able to explain precisely why and that great artists are those who have most successfully cultivated this intuition. In *The Harmonic Law of Nature*, Hay observes, for instance, that "an intuitive knowledge of, or feeling for this law [of harmony], is an inherent quality of the human mind."[85] In *The Natural Principles of Beauty*, Hay goes further—aesthetic pleasure is the harmony produced by the unconscious coincidence of the laws of the human mind and those of nature, both of which have been lawfully, divinely created: "the pleasurable sensations which arise out of man's witnessing the phenomena, can be traced to the power which he unconsciously possesses of appreciating simplicity, and of being influenced by its exhibition—thus proving that He who made the external world impressed on the mind the stamp of those very fingers which had left the creating work, and fixed there just such powers of apprehension as would harmonise with nature."[86] As for Field, "harmony" serves as the name for a felt resonance with a physical environment, the pleasurable concord of a divinely ordered physical body and a divinely created world. Aesthetic pleasure, by extension, is not a moment of contemplation—the pleasure does not come from the recognition that mind and nature conform to the same rules—but an immediate experience, the "impression" of an "influence." As one reviewer of Hay observed, "It must not be forgotten that the truth of Mr Hay's theory is perfectly compatible with the fact, that of such theory the Greek

may have been utterly ignorant."[87] Hay's diagrams appear to represent things: bodies, statues, and buildings. In fact, however, they are diagrams of responses—of secret resonances and harmonies between the sensorium and its surroundings.

Geometries of the Body

An important implication of the Aesthetic Club's exploration of the semiconscious apprehension of form is that it yields a highly rule-oriented and even rigid account of embodied aesthetic perception that runs counter to the usual ways in which the intersection of embodiment and aesthetic experience has been understood in the period. It has often been argued that what was controversial about the protomodernist artistic programs of the nineteenth century—from Turner's quasi-representational washes of color to what Robert Buchanan dismissed as the "fleshly" school of poetry—was their insistence on the body as the locus of aesthetic experience. This new attention to embodied perception has often been associated with progressive politics and self-conscious modernism: poets scandalously moved the human sensorium to the center of their poetic practice while conservative critics reacted against the impropriety of collapsing aesthetic and bodily forms of pleasure. As Jason Rudy observes, for conservative commentators "the conjunction of physiological affect with poetic form loomed as a threat warranting firm censure."[88] Writers of popular fiction made a similar move, first with gothic and Newgate novels and then with sensation fiction. Here the scandal had much to do, as Nicholas Daly and Jonathan Loesberg have each shown, with a class-based suspicion of public spectacles of sensation: "the novels, plays and paintings of the age of sensation seemed to appeal too much to the crowd, providing a series of shocks and frissons rather than any more elevating aesthetic experience," Daly writes.[89]

Hay's theories interrupt this narrative by situating the body not only as a scandalous site of sensation but as a source of lawful regularity and symmetry. Where bodily pleasure was scandalous in so many cultural domains, Hay's writing never aroused accusations of impropriety. Scientific accounts of aesthetic pleasure called on the detached ethos of the scientist to de-eroticize the body. Disintegrating every object of perception into an amalgamation of curves, angles, planes, and color, Hay's aesthetics renders human bodies as objects to be apprehended on the same plane as the inanimate objects of art.

This can be seen most clearly in an experiment done by Hay and his colleagues that aimed to prove that ancient Greeks had discovered a

"definite law of beauty" in nature, which did not depend on contingent associations but on the "law of harmonic ratio," equally applicable to acoustic and visual phenomena.[90] In the summer of 1851, Hay set out to test the applicability of the harmonic ratio to human forms by measuring actual statues and persons. Hay first hired several artists' models and measured key proportions: "the full height of the figure, the vertical length of the head, the vertical position of the superior end of the sternum or breast-bone, of the nipples, of the navel, and of the horizontal branch of the pubes. To these were added, the width between the nipples, width across the pelvis, and depth of the chest below the breasts."[91] Hay and his colleagues compiled their results in a table that showed that these proportions were close enough to those of the harmonic ratio to suggest that there was in fact a perfect version of beauty and that observed deviations from it could be treated as imperfections. The researchers then turned their attention to a second question: whether Greek sculptors had made their statues according to the ratios Hay had discovered. But answering this question, they believed, required a way of measuring not the statue itself but how it would appear if it were to stand upright. To accomplish this feat, the men constructed a machine consisting of an open box containing a set of pointed rods that slid back and forth to mark points in three-dimensional space. They placed a cast of the *Venus de' Medici* in the box and adjusted the rods so that they were all touching the statue, clamped them firmly in place, and removed the statue. They then selected the model most similar in size and placed her in the box: "it was found that, by standing on a board one inch thick, this female was enabled to assume most accurately the required position, and to continue in it by means of supports."[92] But even this was not entirely sufficient: it was still difficult to ascertain the exact position of the joints, key to Hay's theory. The anatomist Goodsir had the solution. He had "a natural skeleton of a young female prepared, with all its ligaments and cartilages entire, by which were enabled to find the points required, and more accurately to ascertain the extent and nature of the vertebral column and other parts of the frame."[93] The skeleton satisfactorily bore out the system of mathematical proportions that Hay's schematic diagrams presented.

It is striking to consider the contrast between Hay's attempt to discover the principles of harmony necessary to make ambient spaces pleasing and the discomfort likely felt by the model who entered this strange apparatus to have her body clinically measured by these Edinburgh men of science. The episode almost exactly reverses Ovid's Pygmalion myth, in which the lifeless object of desire is animated by Pygmalion's prayer

to Venus. Here, instead, a statue of Venus herself cedes place to a living model and then a lifeless skeleton. Where Pygmalion's desire is erotic, Hay, Goodsir, and Kelland systematically divorce erotic and aesthetic pleasure. Their experiment attests to a tripled layering of distancing gazes—male, scientific, and aesthetic. As they look at the *Venus de' Medici,* the statue does not represent the elusive promise of a real person, a deficient version of a human that could satisfy desire if only it were flesh instead of marble. Instead, the statue as well as the real person are fungible aggregates of angles, curves, and shapes; human beauty is deficient precisely as it fails to satisfy the ideal proportions that rule nature and that are encoded within the statue's form. Pygmalion's fantasy is that lifeless beauty might be animated; Hay's project instead reduces the living model to interconnected but autonomous parts. If anything, Hay's schematic diagrams of women and statues call to mind uncanny robots and automata rather than natural human forms (figs. 1.14, 1.15). Geometrical rigor mortis signals the death of romantic vitality; the final transformation of the statue is not into a living person, but into "a natural skeleton of a young female."

The strangely inhuman qualities of these human diagrams reveal an almost paradoxical quality of Hay's theory. On the one hand it takes up ancient or neoclassical aesthetics in which the human is the measure of all things: the proportions of the human body express a regularity that pervades the known universe. Hay's images obviously echo earlier works—Leonardo da Vinci's Vitruvian man or Dürer's *Vier Bücher von menschlicher Proportion*—that similarly mapped Greek canons of proportion onto the human form. But by contrast with these works, Hay's images produce a schematic erasure of the human body. This mechanistic erasure is an unintended effect of Hay's objections to the associationist aesthetics with which he opens the treatise: his work means to contest the notion that beauty is "a feeling of admiration originating in the mind of the observer through association of ideas, habit, natural affection, or some other similar cause": this was the position adopted by Alison's *Essays on the Nature and Principles of Taste* (1790).[94] Hay aspired toward a more stable and permanent explanation than those of associationist psychology, but describing the sense of beauty as a response to a systematic order of angles, curves, and numbers opened the possibility that aesthetic judgment was largely mechanical.

Hay's notion that beauty was strictly lawful created controversy among diverse intellectuals, whose attacks symptomatically reflect a desire for a strong distinction between the domains of science and aesthetics. *The*

PLATE I

Fig. I.

Fig. II.

P. D. R. Hay del.ᵗ

Erratum

In the text P.14 the words 'through a draw af parallel to AM are superfluous

FIGURE 1.14 David Ramsay Hay, diagram of ideal proportions in *The Natural Principles of Beauty, As Developed in the Human Figure* (Edinburgh: William Blackwood & Sons, 1852).

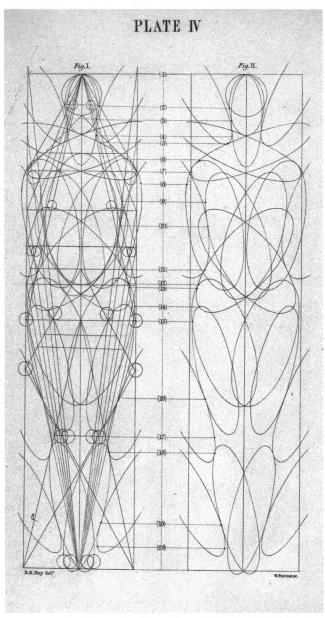

FIGURE 1.15. David Ramsay Hay, diagram of curves in *The Natural Principles of Beauty, As Developed in the Human Figure* (Edinburgh: William Blackwood & Sons, 1852). Courtesy Lilly Library, Indiana University, Bloomington, Indiana.

Art Union published an anonymous article in 1844 (in fact by the editor and Hay's friend C. H. Wilson) attacking Hay.[95] The painter Thomas Purdie published an 1849 pamphlet, *Form and Sound: Can Their Beauty be Dependent on the Same Physical Laws?*, arguing that Hay had manipulated his results and that the entire theory was suspect because the nerves of hearing and of vision were fundamentally different.[96] (Notably, Purdie does not take aim at the approach but only at the accuracy of its data.) In 1850, the *Art Journal* published similar objections in a column by the popularizer of science Robert Hunt, who had elsewhere argued that science's "poetry" consisted of how it inspired humans to reflect on nature.[97] Hunt's objection has to do with the scope of the rules that Hay identifies: "Since poetry signifies creation, so it will be found that its laws spring from the conditions of the time, and they are vast, variegated, and interwoven with the activities of the human soul, in its most energetic passages."[98] Hunt admits that rules of wave motion govern harmonious sounds and that colors are composed of basic primary constituents, but he objects that because these simple elements can produce "an infinite variety of effects," they cannot in themselves explain the pleasure afforded by beauty. Caught up in the particulars of Hay's theory, these reviewers often miss its more significant implications. Hay promised a model of aesthetic pleasure that at once made it an irreducibly physiological experience but avoided the imputations of sensationalism that attached to parallel aesthetic theories.

The Politics of Empirical Aesthetics

It could be argued that Hay's work plays out a script of the normative heterosexual male viewer that is endemic within the history of Western art. Whitney Davis discerns in Hay's writing, for instance, a suppression of homoeroticism: while "British empirical aesthetics after Kant had *re*introduced the sensuous pleasurability of corporeal beauty," it affirmed that "human communities of canonical taste remain sexually dimorphic."[99] From this perspective, the political valence of scientific aesthetics lies in its disavowal of the "homoerotic libertinism potentially embedded in academic idealism."[100] The politics of empirical aesthetics can be discerned more broadly in its resistance both to the artistic socialism adumbrated by Ruskin's writing and its participation in what scholars including Tamara Ketabgian and Joseph Bizup have described as the understudied complicity of certain domains of Victorian culture with proindustrialist politics.[101] Tracing both of these political valences begins to reveal how surprising it is that the privileging of harmony and

order eventually came to underwrite a physiological aesthetics whose attention to the materiality of the human body was perceived by many contemporary readers as theologically dangerous.

The reaction against Ruskin is most clearly on display in the *Edinburgh Aesthetic Journal*, a short-lived periodical published by affiliates of the Aesthetic Club in 1850 and 1851. The journal's fifth issue contained an extremely negative review of *The Seven Lamps of Architecture*, proposing that Ruskin "has given way to his poetic hallucinations, and passed off upon us poetry instead of principle. . . . It was expressly to meet and cope with such delusions that our *Aesthetic Journal* took the field; and though we should stand alone, we are pledged and bound to stand up for the true science, and to strip the false of its tinsel wherever we shall find it."[102] The review makes explicit the extent to which the club saw itself as promoting a scientific alternative to Ruskin's thought. Hay and his followers described Ruskin as ineffectual, given to poetry and rhetoric rather than science and mathematics, and therefore unable to advance serious artistic principles. This difference of theoretical principles had concrete political implications; while Ruskin often positioned the sense of beauty as a refuge from Victorian industrialism and utilitarianism, for the Aesthetic Club, beauty took on nearly the opposite political implications.

This political distinction is reflected in the model of aesthetic education produced by the scientific orientation of the Aesthetic Club, which involved training the body to trace mechanically perfect shapes—a mode of drafting that represented exactly what Ruskin had decried in *The Stones of Venice* as an "unwholesome demand for *perfection*, at any cost."[103] Hay, by contrast, defended precision as a value, arguing that aesthetic pleasure could be explained as the fact that "the impression made upon the mind through the eye meets an immediate response, and this is the foundation of that species of beauty which *can* be subjected to rules, and which we can apply with precision and certainty."[104] In practice, this conception of the aesthetic was conducive to a faith in mechanization and regularity that ran counter to Ruskin's critique of the effects of industrialization. In an 1836 hearing with William Ewart's House of Commons Select Committee on the Arts and Their Connexion with Manufactures, a wide-ranging inquiry into the state of British industrial art, Hay had described his views on aesthetic education in detail.[105] Children, Hay argued, should be made to draw triangles, squares, and octagons freehand until they can do so perfectly; then they should proceed to curves, semicircles, and crescents. This practice, rather than copying from

nature, would produce a generation of workers who could make orna-
mental goods capable of competing with those produced in France. Hay
again elaborated on his aesthetic pedagogy in an 1852 letter reflecting on
the Great Exhibition, where Hay and others felt the French demonstrated
their superiority in the decorative arts. Hay wrote to the London Society
of Arts urging them to do their part to ameliorate the situation in Britain
by conveying "the simple and teachable laws of visible beauty."[106] If, as
George Landow observes, Ruskin's view is that "art concerns itself with
man and his human, phenomenological relations to his world," convey-
ing the "deeper truth of mental vision" rather than the "physical facts,"
as Ruskin had put it in the fourth volume of *Modern Painters*, Hay's
ideal artist is skeptical of what Levine glosses as "phenomenological rela-
tions."[107] Hay's "deeper truths" are not mental but mathematical. Har-
mony is not an airy aesthetic ideal but a practical mechanism for render-
ing British industry more competitive in economic markets.

At the same time, Hay's mathematical aesthetic can be understood
as aligned with a longer lineage of scientized aesthetic theories that un-
subtly inscribed value-laden hierarchies of race and gender. In his book
on the beauty of the human form, Hay adapts his rules to a system of
triangles and curves that explains how certain facial features display ei-
ther "feminine delicacy" or "masculine power."[108] In a number of plates,
Hay diagrammed for his readers "the purely masculine proportions" of
the face (fig. 1.16).[109] Furthermore, if, as Hay believes, aesthetic plea-
sure is a divinely ordained harmony of mind and world, then the fact
that non-European faces do not conform to his set of angles makes them
ugly in absolute terms. Hay's book on the ideal proportions of the hu-
man head observes that harmonic ratios "are invariably found most
prominently developed in the highly refined and most intellectual races
of men, while the most barbarous tribes present the greatest departure
from them, their heads being distinguished by compression of the ante-
rior portion of the skull, and the consequent prominence of the mouth,
generally accompanied with flatness of the nose."[110] This kind of rea-
soning affirmed theories of "facial angles" as an index of racial identity
that had first been proposed by the eighteenth-century Dutch naturalist
Petrus Camper and that continued to form a part of drawing instruction
and anatomy in the mid-nineteenth century.[111] The controversial anthro-
pologist Robert Knox, one of Hay's colleagues at the Royal Society of
Edinburgh, had reproduced Camper's drawings of facial angles as part
of his widely influential *The Races of Man*, which claimed to offer proofs
of Anglo-Saxon racial superiority. Knox's work on artistic anatomy

FIGURE 1.16 David Ramsay Hay, diagram of masculine facial proportions in *On the Science of Those Proportions by Which the Human Head and Countenance, as Represented in Works of Ancient Greek Art, Are Distinguished from Those of Ordinary Nature* (Edinburgh: Blackwood, 1849). Courtesy John Hay Library, Brown University Library.

described Hay's work as a "failure"—but an "ingenious" one.[112] Along with the suppression of homoeroticism that Davis identifies in British empirical aesthetics, proindustrialist and racialized strains of thought informed the aspiration toward aesthetic order. The moment before the two cultures divide is sometimes characterized as a moment of desirable cross-pollination between literary and scientific discourses.[113] But a world where, as Gillian Beer puts it, "the common language of scientific prose and literary prose . . . allowed rapid movement of ideas and metaphors" was also a world where the instability of distinctions between

fact and value, between the natural and the normative could, with equal rapidity, allow aesthetic values to easily underwrite an array of political values. In this way, racism acquired the veneer of rationality in the form of aesthetic ideals of proportion.[114]

Laycock, Symonds, and the Patterned Nervous System

If empiricist aesthetics treats the human body as potentially capable of reflecting formal perfection, this is a logic that operates at the expense of those bodies that are taken to be formally imperfect. In this regard, perfect human form functions as an ideal from which aesthetic deviations are political deviations as well. I have emphasized this aspect of empirical aesthetics both to trace the political work that can be done by discourses that idealize formal perfection and also in order to highlight how surprising it is that in the case of scientific aesthetics, this emphasis on the body ultimately led to political and intellectual ends that were not predicted by those who originally formulated these conceptions of harmony. In order to begin to trace these unpredictable effects, I turn now to some of the ways in which the aesthetics of proportion and form were taken up within medical writing that was exploring the controversial possibility not only that much of human mental life was not available to conscious awareness but that it was also taking place as physical reflexes within the nervous system and the brain. Ultimately, I will suggest, it was not natural theology's emphasis on formal harmony that gained most lasting purchase but the alliance of aesthetics to a physiology of perception. The tension in Field and Hay's work between rationality and instinct, between knowledge and semiconscious awareness, reappeared in a different form as physicians looked to the science of aesthetics to understand how unpredictable physiological processes might be regulated by the regularity of beauty. I turn now to two writers, both physicians, who made use of aesthetical science in surprising and revealing ways. John Addington Symonds Sr. and Thomas Laycock both saw in Hay's thought something other than a transcendental key to ancient theories of beauty: they viewed Hay's work as important for its potential contributions to the rapidly changing field of mental physiology.

Symonds's *The Principles of Beauty* (1857) promotes Hay's work by showing how his arguments rested on physiological—and not just geometrical or mathematical—principles by tracing aesthetic pleasure to eye movement: "Neither a general survey of an object, nor a minute examination of it, is possible,—no curves can be followed, nor spaces

traversed—without muscular movements of the eyeball. Muscular action gives birth to pleasurable or uneasy feelings—seldom, however, in the muscles themselves—according as they are accomplished with ease or difficulty. Rhythmical muscular action is more easy and agreeable than that which is irregular."[115] This represents a fundamentally different explanation: where Hay explains pleasure in terms of geometrical concordance, Symonds locates pleasure in terms of embodied movement. Like Field and Hay, Symonds observes that harmony subsists not only as a relation among elements in an object but as a relation between a person and his or her surrounding environment: "The Ego sent into the world to feel pleasure is set in tune to the various harmonies in nature, and to thrill with responsive pleasure."[116] Symonds's choice of words here—aesthetic pleasure as a feeling of being "in tune" with nature—calls to mind Enlightenment and romantic inflections of *Stimmung* as an attunement within the mind or of the listener's soul with that of the artistic genius. But instead of framing attunement as a concordance of faculties of imagination and understanding (as for Kant) or of soul with nature (as for Fichte), here aesthetic attunement is understood as an empirically discernable event in the body.[117]

Symonds's version of attunement hopes to impose order on the seemingly disordered or unperceivable internal processes of the human body. For Symonds, Hay's highly regulated system of aesthetics offered a way of finding pattern in physiological processes; it seemed to provide evidence that what looked like an unruly body in fact obeyed a set of eternal, fixed principles. Symonds's writing reveals that it was not only the case that scientific principles explained the experience of beauty; the ideal of aesthetic order simultaneously reacted upon scientific thought:

> Our neurological conditions at first sight seem antagonistic to, or inconsistent with, mechanical arrangements. We talk of spiritual forces superseding the mechanical arrangements of matter: but the probability is that even those forces obey the same laws to which the whole world is subordinated. Thoughts, sentiments, and emotions do not seem measurable in space and time. But the aesthetical arts are those which bring the operations of the mind into contact or co-existence with rhythmical sensations or actions. What is the difference between poetry and prose? The thoughts, images, and emotions called forth may be identical. But in poetry there is a measured arrangement of the sounds of which the words are constituent. The pleasure of sense is

combined with the pleasure of thought and emotion, and makes poetry aesthetical.[118]

Ideals of formal order were powerful in relation to an emerging physiology of the mind. At the very moment that "neurological conditions" seem to exempt thought from the neat arrangement of mechanical order, "aesthetical arts"—those that obey order and please the body by so doing—reveal that human bodies do, in fact, partake in an ordered universe. Aesthetics returns attention to the materiality of poetry as well as the materiality of the thinking body. Form becomes a point of contact between body and milieu.

The physiologist Thomas Laycock used Hay's aesthetics similarly in the *British and Foreign Medical Review*, a journal where it would at first seem an unlikely topic. Laycock's "Further Researches into the Functions of the Brain" (1855) builds on his previous research into the reflex activity of the brain. Reflexes were understood as automatic reactions that took place independently of consciousness or volition but could still appear to be responsive and intentional: a decapitated frog, for example, "tries" to brush away a pin pricking its leg, even though it has no capacity either to feel or to move intentionally. Laycock had previously argued that these automatic responses also occurred in the brain—which was "a congeries of ganglia" just like the rest of the nervous system.[119] In his 1855 article, Laycock ventures into "more metaphysical and obscure regions of consciousness and thought" with the goal of laying the groundwork for a scientific study of the mind, which, as it encroached on philosophy, would eventually, as Lorraine Daston has argued, call into question the boundaries of science itself.[120] This "new psychology" would explore what Laycock calls the "unconscious soul" or the "unconscious mind": how it was that specific arrangements of nerve cells "lead to the evolution of new masses of vesicular neurine, and new modes of mental action."[121] Ideas and feelings depend on "substrata," specific arrangement of nerve cells. "Vesicular neurine," the particular kind of matter that was thought to constitute the nervous system, offers Laycock a way to imaginatively physicalize the operations of unconscious mental processes.[122] The figure of writing is central to explaining how the material of the brain can contain and transmit ideas: "fixed ideas become deeply writ, as it were, on the vesicular neurine"; memory is "the unconsciously written record in the vesicular urine [*sic*] of the successive operations of the mind."[123] Thought is figured as material inscription of language on nervous matter.

For Laycock, the apprehension of beauty is among the human experiences that can be newly explained by a neurophysiological conception of the mind—and Hay's work, which Laycock had become familiar with as a member of the Aesthetic Club, represents a crucial step toward this explanatory framework. The pleasure afforded by "perfect" beauty of the female form is evidence of appropriately functioning substrata. Hay and others who have studied the geometry of beauty have effectively proven that "changes in the vesicular neurine, occurring during consciousness, have a definite relation to geometry and dynamics."[124] Concerning Laycock's view, Hay does the same thing as a geometrician studying honeycomb. Just as the eighteenth-century natural philosopher Colin MacLaurin had mathematically shown the architectural perfection of the shape of honeycomb, so Hay has described the principles by which humans instinctively construct pleasing forms. Hay's research thus becomes evidence for the "substrata" model of the unconscious. But viewing Hay from this physiological perspective leads to an interesting reversal that likely would have given Hay pause. Where Hay's discussion of facial angles shores up the idea that human beauty increases with its distance from subhuman, animal features, Laycock's reasoning returns the appreciation of beauty to animal instincts. There is no difference of kind between the human and animal sense of beauty, only difference of degree. The *Venus de' Medici* is as the honeycomb of a bee—an instinctive construction of a nervous system operating according to principles of reflex action.

Laycock's line of reasoning is closely related to William Carpenter's better-known account of involuntary mental activity, described by Carpenter as "unconscious cerebration" and first proposed in the fourth edition of his *Principles of Human Physiology* (1853). Carpenter's notion was that by extending the operation of the reflex from the spinal cord to the cerebrum, one could explain many peculiar scenarios in which a variety of thought seems to go on independent of consciousness.[125] "Unconscious" here is adjectival, a characterization of a mode of mental activity more than a domain or a territory. Carpenter proposed that just as a stimulus could produce an automatic response without being sensed, so could reflex activities in the cerebrum "evolve *intellectual products*" (rather than physical effects) without the intervention of consciousness.[126] A familiar example is when, after trying and failing to recall a name, it "flash[e]s . . . before the consciousness" a few moments later, seemingly of its own agency.[127] Because, as Carpenter observes, " 'unconscious reasoning' is a contradiction in terms," he proposes "unconscious cerebration" as the name for this process.[128] Carpenter's

ultimately rejected term *unconscious reasoning* reflects a crucial differ-
ence between the Carpenterian and Freudian unconscious: the former
is more like a hidden process of reasoning, while the latter is often de-
scribed as a domain of seemingly irrational condensations and associa-
tions that demand interpretation.

The similarity between Carpenter's and Laycock's accounts of the
unconscious and reflexive operations of the mind led Laycock, in an ap-
pendix to his 1860 *Mind and Brain,* to assert that he had discovered
what Carpenter influentially described as unconscious cerebration "twelve
years before Dr. Carpenter knew anything of it whatever"—a claim of
priority to which, according to Laycock, Carpenter himself later as-
sented.[129] Recent literary scholarship has primarily focused on tracing
how Carpenter's unconscious cerebration was either widely taken up by
or served as a crucial context for Victorian novelists including George El-
iot, Wilkie Collins, and Elizabeth Gaskell, especially following the pub-
lication of Carpenter's 1874 *Mental Physiology,* a popular expansion of
the parts of his work focused on the mind.[130] Here, however, I want to
highlight a point that is rarely noted: that Carpenter's notion of uncon-
scious cerebration directly follows from a discussion of the particular
ways in which art and literature are created. In this regard, unconscious
cerebration can be understood not only as a scientific idea that was taken
up within a literary field but as a notion that originally emerged as, in
part, an explanation of the particular kinds of mental states required by
aesthetic practices.

In the paragraphs immediately preceding his well-known formula-
tion, Carpenter discusses not only the everyday example of how names
are recalled but also how it is that poetry and music come into being.
Coleridge, Mozart, and Southey are Carpenter's examples. Coleridge,
Carpenter suggests, was especially given to nonvolitional reasoning. "His
train of mental operations, once started, went on *of itself,* sometimes for
a long distance in the original direction," writes Carpenter, as evidenced
not only by Coleridge's conversation: "the composition of the poetical
fragment 'Kubla Khan' *in his sleep,* is a typical example of automatic
mental action."[131] Mozart illustrates a similar point for Carpenter, for
whom "the spontaneous or automatic development of musical ideas,"
once set in motion, "flowed onwards without any effort of his own."[132]
Southey, finally, provides the counterexample: by contrast with Mozart
and Coleridge, Southey's talents are "comparatively mediocre," but this
deficiency is overcome by "a determined Will, acting under a strong sense
of duty."[133] In all three cases, Carpenter highlights a variety of mental
activity that is unavailable to conscious thought but nonetheless agential

and self-directing. This type of activity, importantly is physicalized and localized; what we learn from these examples of unconscious artistic creation is that "much of our highest Mental Activity [is] thus to be regarded as the expression of the *automatic* action of the Cerebrum."[134] Carpenter's notion of unconscious cerebration can thus be seen as the refraction of a romantic notion of involuntary genius through the physicalizing and localizing lens of mental physiology.

Laycock's writing on aesthetics combines this kind of physiological model of the unconscious with notions of harmony inherited from natural theology and acquired through his affiliation with Hay and the Aesthetic Club. This integration is evidenced at the level of the sentence, as Laycock draws on rhetorics of congruity and nerves alike. In a convoluted but suggestive definition of aesthetic pleasure, Laycock's prose labors to transform "harmony" into a physiological principle: "According to the doctrine I wish to establish, the psychical substrata (the work of the unconscious mind), by and through which the beauty of the human form is felt and perceived, will be correlative with the constructive ideas and conceptions of the unconscious principle of intelligence (or nature as it is usually designated); so that when the visual impression of a perfect human form reaches substrata perfectly evolved, there is congruity between the latter and former; and the resulting changes in the consciousness in reference to the visual object are accompanied by that change in the consciousness termed pleasure."[135] Although this passage is difficult to decipher, it articulates a foundational principle. Aesthetic pleasure is the consciously felt side of a physiological operation unavailable to the conscious mind in which the material structures of the nervous system inhabit a harmonious relationship with similarly perfect formal proportions. The ideal of perfect formal congruity, then—a central principle of Field's natural-theological aesthetics—resurfaces in Laycock's physiological model, which is otherwise quite divorced, as Ruth Leys has argued, from Paleyan thought.[136] But *congruity* no longer describes relations *within* a mathematically perfect formal structure but rather *between* the nervous system and its stimuli. Form extends beyond the externally perceived object to the interior of the human body.

Laycock thus makes explicit an interplay between conscious and unconscious experiences of formal perfection that remains usually only implicit in the work of Field and Hay: indeed, one of Laycock's papers at the Aesthetic Club expounded on the basis of aesthetic pleasure in the nervous system.[137] Laycock's account of aesthetic pleasure is in the first place unconscious, an event at the level of nerve fibers, and has as a secondary effect the production of subjective pleasure. This version of the

aesthetic reception is the perfect analogue to the unconscious principles of aesthetic creation that Hay believes sculptors and architects unconsciously follow. From this perspective, the world of art becomes a domain in which bodies communicate with one another by way of instinct: a sculptor crafts the *Venus de' Medici* not knowing why it is beautiful but sensing that it is; a viewer looks at it centuries later, similarly unable to explain its beauty, but immediately certain that it induces a sense of pleasure. As Laycock and Hay interpret this story, human bodies "know" something that minds faintly grasp: that there are potential concordances between bodies and the surroundings that induce pleasure. For Field, this concordance is divine; by the time of Laycock's 1855 article, it has become neurophysiological. The discovery that a body can be said to have knowledge separate from the conscious mind, inscribed in "vesicular neurine," and "unconscious cerebration" renders the apprehension of aesthetic objects as an event that takes place first in the matter of the brain and the nerves.

This scientifically forward-looking position renders it difficult to read scientific aesthetics simply as the opposite of Ruskin, Turner, and the Pre-Raphaelites and as the neoclassical academy as opposed to the avant-garde. It suggests instead that we should think of two parallel versions of modernism; one that emphasized stylistic innovation and a progressive politics of aesthetics, and another that saw aesthetic experience in light of an emergent neurophysiological conception of mind. Laycock's and Symonds's use of Hay makes it apparent that the meaning of terms such as *harmony* and *regularity* are not politically fixed to a conservative wish for order. They can equally speak to the forms of scientific materialism—the physiological rather than philosophical explanation of consciousness—that would become a flashpoint by the time of Tyndall's 1874 Belfast address. Perhaps the best illustration of the unpredictable cultural energy of scientific aesthetics is Hay's diagram of a beautiful woman, reproduced by Laycock in the context of an article committed to elaborating a physiological psychology. Laycock's decision to reproduce Hay's diagram in the *British and Foreign Medical Review* reveals how a purportedly objective set of data can serve very different cultural meanings (fig. 1.17). The version in Hay's *Proportion* presents the image of a rational classicism that promises to tame an unruly debate about irreducibly personal taste; the version in Laycock's essay serves a materialist physiology committed to showing the many ways in which the body evades the conscious mind. Equally important, we can now see this image in its networked relations: it is a quotation of Hay, who had, in turn, often quoted Field's harmonies of tone and color. In the turn to

FIGURE 1.17 Thomas Laycock, reproduction of Hay's system in "Further Researches into the Functions of the Brain," *The British and Foreign Medico-Chirurgical Review, or Quarterly Journal of Practical Medicine and Surgery* 16, no. 31 (July 1855), 140.

physiology, natural theology is not so much left behind as transmitted and transformed.

The Elusive Matter of Literature

One of the most intriguing conceptual difficulties within these attempts to develop an empirical science of aesthetic experience is the problem of accounting for art whose medium is language and therefore not obviously susceptible to the positivist empiricism of mental physiology. This issue is not unique, of course, to these scientific accounts of beauty; in Hegel's lectures on aesthetics, poetry represents the most universal art precisely because it sheds its attachment to sensuous materiality: Hegel argues that "poetry is the universal art of the spirit which has become free in itself and which is not tied down for its realization to external sensuous material; instead, it launches out exclusively in the inner space and the inner time of ideas and feelings."[138] But it is precisely what Hegel describes as "freedom" from sensuousness that becomes problematic for a scientifically oriented mode of aesthetic thought in which sensuousness constitutes the primary level of analysis. Tracing attempts to resolve this difficulty offers insight into how and why nonconscious mental activity comes to occupy a prominent role within attempts to develop a science of beauty.

Symonds attempts to explain the sensory aesthetics of poetry as "a measured arrangements of sounds" whose regularity produces a "pleasure of sense" as well as of thought and emotion.[139] Laycock adopted a very similar strategy. In a series of unpublished lectures delivered to medical students in 1861 on "The Aesthetic Faculties," Laycock argued that repetition and rhythm were the formal principles that linked mental physiology to dancing, music, drawing, painting, sculpture, and poetry as well.[140] In *Mind and Brain*, Laycock had argued that a principle described as the "transference of force" linked emotional and mental experience to chemical and nervous mechanisms.[141] His lectures used the principle of the transference of force to explain why the repeated sounds and structures of poetry were pleasing: not only in canonical works such as Spenser's *The Fairie Queene* and Petrarch's *Il Paradiso* but also in the juvenile repetitions of nursery rhymes ("Pussycat, pussycat, with a white foot") and in pathological speech termed "*morbid* repetition" that Laycock had encountered in his work with mentally ill patients.[142]

These ideas about the unconscious basis of poetic pleasure and its susceptibility to scientific study were given a fuller treatment by the literary critic E. S. Dallas, who was a young member of Hay's Aesthetic Club.[143] In the early part of his career, Dallas was an important member

of Edinburgh intellectual culture. He founded and wrote reviews for the *Edinburgh Guardian*. His mentor was the mental philosopher William Hamilton, a supporter of Hay. Shortly after publishing his first book in 1852, Dallas moved to London, where he continued to correspond with Hay. In London, Dallas became an influential reviewer and wrote two difficult theoretical books, *Poetics* (1852) and *The Gay Science* (1866). These books have been of interest to literary scholars for their sophistication and surprisingly wide range of reference. Nicholas Dames observes that Dallas adopts an Aristotelian theory of affect while turning to the machine as a metaphor for reading. Adela Pinch sees in Dallas the influence of German idealists (Schelling and Hegel) as well as of mesmerism; and Gowan Dawson has explored how Dallas's theory of the unconscious "frequently drew on explicit parallels with the reconstructive practices of Cuvierian paleontology."[144] Dallas's prismatic relation to Victorian intellectual life (especially to the sciences), his theoretical disposition, and his prominent relation to major novelists, all combined with his relative obscurity, have made him as attractive as he is elusive. His work has been described by various critics as "abstruse," "brazenly mystifying," and "vertiginously . . . theoretical."[145] But understood in relation to Victorian scientific culture, the impulses driving Dallas's theories begin to seem much less strange or obscure.

Situating Dallas's work in relation to his intellectual development as part of the Aesthetic Club allows us to understand better the kind of project he saw himself as pursuing in *Poetics* and *The Gay Science*—namely, an extension of aesthetical science to literature and literary criticism—as well as the difficult problems that arise for the science of literature as opposed to the visual or musical arts. Physical sciences of optics and acoustics can lend their findings relatively directly to the sensory media of visual arts and music. But, as we have seen, the modes of materialism and immaterialism—reduction to the body or transformation of matter into mathematics—that form the basis for scientific aesthetics encounter difficulties when they turn to poetry. Instead of treating literature via physiological reduction (Field's treatment of green and yellow as interchangeable with actual perceptions of green and yellow) or by simply excluding literature from the science of aesthetics (Hay's approach), Dallas takes the central psychological principle of aesthetical science—unconscious concord—and translates it into literary theory.

Dallas's two major books share the project of rendering criticism "scientific." Dallas opens *Poetics* by proposing that science can bring order to the "labyrinth of confusion" that characterizes literary criticism; he opens *The Gay Science* by stating his solidarity with the modern

"rage for science."[146] He enthusiastically describes how sciences of meteorology, electricity, photography, and geology have rapidly spread in England. This has led not only to achievements such as the Crystal Palace and the first major suspension bridge at the Menai Straits but also to London tailors who "cut their shirts scientifically."[147] So when Dallas writes that he wants to develop a "science of Fine Arts, including poetry," he is not thinking of "science" merely as systematic knowledge in the broad sense of *Wissenschaft*, and even less as Paleyan natural theology, but rather as something like technological progress.[148]

Reading *Poetics* as the product of a member of Hay's Aesthetic Club elucidates a number of its features that might otherwise seem obscure. Dallas's central argument is that criticism can be rendered systematic by discerning the fundamental rules that structure the creation and reception of poetry as well as poetic beauty. Both the method (the aspiration to reduce the seeming complexity of the art object to a few underlying rules) and the content of these rules reflect the influence of Hay's cohort. Dallas's fundamental argument in *Poetics*—one that he recapitulates in *The Gay Science*—is that the fundamental purpose of poetry is to produce pleasure and that pleasure can be understood as "*the harmonious and unconscious activity of the soul.*"[149] This proposition is a direct adaptation of Hay's idea of aesthetic pleasure as the partially conscious apprehension of ordered environments. As one biographer notes, "the most original suggestions offered in this early essay [*Poetics*] arise from Dallas' emphasis on poetic experience in the widest possible sense rather than on poetic process or technique."[150] Dallas—like Mill—takes as his object not poetry per se but what he calls "poetic feeling," which might be aroused equally by nature itself or by a poem about nature: "by poetry is meant poetic feeling, however it may have been awakened, whether at first-hand by contact with nature, or at second-hand by converse with a poet."[151] Poetry thus serves a mediating function between the external world and the mind of the reader; as Dallas argues in a chapter on the "Law of Harmony," poetry displaces into an imaginative realm the concords— sensuous or imaginary—that characterize beauty in all of its forms.

While *The Gay Science* takes up the same problem—that "criticism does not yet rank as a science"—in it Dallas grapples far more deeply with the philosophical complexity of developing any science of human nature.[152] Dallas positions the project of developing a scientific criticism as part of the nineteenth-century's broader aspiration toward a science of human nature, which in Dallas's view is nascent but not philosophically impossible to conceive. Dallas laments that "as a scientific object, the shard-borne beetle is of more account than man: the cells

of the bee and the cocoons of the silk-worm, than all the efforts of human genius."[153] Dallas's response is to align the project of developing a science of criticism with the project of mental science more generally. The great promise of mental science, Dallas proposes, is that it might yield a systematic account of the arts: "the great fault of criticism is its ignorance—at least its disregard of psychology."[154] The science of the mind thus becomes central to Dallas's argument not only because aesthetic experience is to be counted among its subfields but also because it is the most promising way to transform human nature into an object of scientific knowledge. This line of reasoning shifts the object of a science of criticism from particular artworks or poems to the subjective state of the viewer: as Dallas puts it succinctly, "criticism, if it is to be a science, must be the science of pleasure."[155]

The two key principles that guide *The Gay Science* reflect the dialectical relationship between materiality and the unconscious that in this chapter I have identified in Dallas's predecessors. On the one hand, Dallas repeatedly argues that producing pleasure is the fundamental object of the arts, reporting that "for almost two thousand years pleasure of some sort has been almost universally admitted to be the goal of art."[156] This kind of claim would seem to make embodied sensation central to the arts: we might expect Dallas, like some other proponents of scientific aesthetics, to mount an empirical study of the proportions or arrangements most likely to yield pleasure. But Dallas instead aligns pleasure with the *absence* of self-consciousness. In its simplest form, Dallas's thesis is that consciousness implies pain; the happier we are, the less we think and reflect.[157] This syllogism allows Dallas to describe criticism as the explication of rules according to which art provides access to a sense of self-loss. Dallas outlines a complex psychological mechanics based on William Hamilton's psychology (which also guided other members of the Aesthetic Club).

Through these logical moves, Dallas develops a significant account of the role and nature of unconscious mental life that draws on both mental science and literary history. Central to this account is what Dallas describes as a "hidden soul," which he characterizes in terms that clearly resonate with Carpenter's account of unconscious cerebration as hidden thought. As for Carpenter, Dallas's hidden mind is agential and productive: "the hidden efficacy of our thoughts, their prodigious power of working in the dark and helping us underhand" is compared to "a willing but unknown and tricksy worker."[158] Dallas, however, highlights a different way in which this hidden mind acquires a bodily location, de-emphasizing the brain-based qualities of the Carpenterian unconscious

(as "cerebration") and instead turning to instances in which it seems to guide practices of artistic creation or performance that evade conscious intention. Dallas notes, for instance that the artist "can trust to his hand . . . to render with unfailing accuracy subtle distinctions of tone and shades of meaning with which reason seems to have nothing to do" and that a singer has the "instinctive power" to "divide the tension of her vocal chords [*sic*] into 12,000 parts of an inch."[159] It is similarly the case that art acquires its power by accessing this second hidden self in ways that Dallas often describes by way of physical metaphors: "The poet's words, the artist's touches, are electric; and we feel those words, and the shock of those touches, going through us in a way we cannot define, but always giving us a thrill of pleasure. . . . Art is poetical in proportion as it has this power of appealing to what I may call the absent mind."[160] *Poetry* thus becomes the name for the way in which art achieves material effects (shocks, touches, thrills) by accessing the second, nonconscious mind. While Dallas's model to some extent takes up the Aesthetic Club's interest both in a science of art and in nonconscious and bodily modes of aesthetic apprehension, he calls on a litany of literary examples as well as his knowledge of mental science in order to evolve a far more robust account of how, exactly, the unconscious should be understood.

Dallas's claim that poetry conveys its effects unconsciously was for a pre-Freudian audience sometimes difficult to grasp. In *Blackwood's*, one reviewer found the connection of poetry to the unconscious contradictory, predicting that most readers would respond with "unmitigated astonishment" to Dallas's notion of unconscious thought.[161] Readers, the reviewer writes, "will hardly perhaps believe that Mr. Dallas is quite serious. . . . What is meant by *unconscious life* we all know; it is the life of the tree or the plant, or of the human body regarded only as a vital organism, the molecular movements of which are supposed to be intimately connected with feeling and thought. But *unconscious thought* will fall upon the ears of most as a quite unintelligible phrase, involving the same contradiction as if we were to speak of *motionless motion*."[162] These comments are evidently premised on a pre-Carpenterian model of the mind in which clear distinctions can be drawn between the conscious mind and the nonconscious operations of the body, but they also reveal how challenging it was for some audiences to come to terms with the possibility that there was a vast domain of mental activity that only occasionally broke into conscious awareness. Dallas's alliance of poetry with the unconscious recapitulates a move that originates with Hay's visual aesthetics. As we have seen, Laycock explains aesthetic pleasure by proposing the existence of substrata governing its mechanics—substrata

whose "inscriptions" in vesicular neurine might readily be called unconscious thoughts. Laycock explicitly advocated the idea that the unconscious lives of trees, plants, and humans all obeyed the same basic principles of reflex action. Dallas, learning from Laycock and Hay, extends this model to poetic experience.

Dallas is a lively, engaging writer, and his books met with many positive reviews. But certainly the most illuminating responses are those of the skeptics, who balked at Dallas's enthusiasm for science and promotion of pleasure. The objections to Dallas echo earlier negative responses to Field's and Hay's positioning of pleasure as a central aesthetic principle even as they also anticipate responses to aestheticist valorizations of the pleasures afforded by art. The *Spectator*, known in part for its hostility to science, challenged Dallas on his two central points: that producing pleasure is the purpose of art and that criticism might be rendered scientific. Less enthused than Dallas about the spread of scientific thinking, the reviewer begins with a dismissive question: "What next? We have had sciences of the mind. . . . We have had sciences of morals and of history; we have geology, and all the 'ologies, tumbling over the old idols. . . . We eat and drink, we read, we vote, we pray even, on what are termed scientific principles. One leafy nook . . . has remained to us,—where Art dwelt, we fondly thought, Science would scarcely care to venture."[163] A few paragraphs later, the despairing reviewer wonders, "Did science ever run so wild?"[164] The *Spectator* argues that the point of art is not to produce pleasure but to achieve "spiritualization"; pleasure is a side effect, not the goal. In this view, criticism does not make judgments by measuring the amount of pleasure but by estimating the height of spiritualization—quite elevated in *King Lear*; rather low in the sensation novels of Mary Elizabeth Braddon. The Methodist *London Quarterly Review* published a lengthy, religiously inflected response to Dallas that similarly objected that pleasure should not be taken as the end of art. That publication darkly warned, quoting the Bible, that "pleasure is not to be made, of and by itself, an end. Those who 'live in pleasure are dead while they live.' "[165]

Comments such as these move beyond accusations (as in *Blackwood's*) of intellectual incoherence. Their register is ethical: theories like Dallas's are socially, even theologically, dangerous. But what is the nature of the fear provoked by Dallas's project of materializing poetry in order to render it susceptible to the lens of materialist science? It is in fact of two types, not necessarily compatible. On the one hand, the *Spectator* reviewer worries that something about the systematicity of science destroys the pleasure of art. This fear is evidenced in the topography of his comments: art dwells in a "leafy nook," away from a mechanized

world where the infiltration of science into everyday life has become fatiguing. "Science," as it provides rules for how to eat, pray, and vote, represents a determining artificial force that eliminates the possibility of naturally doing as one likes. Science is work and art is play, but Dallas has conflated the two: "The fault of Mr. Dallas's mind is that it is too circular, has been regulated to carefully . . . moving in a hard and unsympathetic orbit. If Mr. Dallas gave his nature more play . . . he would be less scientific, but perhaps more sincere."[166] Evocatively portraying the futility of the scientizing gesture, the reviewer imagines the natural world resisting Dallas's destructive science with its beautiful fecundity: "where he sets his emphatic heel a flower grows and mocks him"; "pleasure," the reviewer notes, "won't be put in a crucible."[167]

But at the same time, a science of art also threatens to make beauty *too* pleasurable precisely by substituting body for soul. By claiming that Dallas's project ignores the importance of "spiritualization," the *Spectator* implicitly raises the specter of its opposite, *materialism*, a charged term whose connotations included atheism and hedonism. Although the culture had not quite reached the level of anxiety reflected by Robert Buchanan's 1871 accusations of materialism in the "fleshly" poetry of Swinburne and Rossetti, the resonances are clear. The *Spectator* criticizes Dallas in terms that forecast Buchanan's worries about the body's centrality to Pre-Raphaelite and aestheticist art and poetry: "The exquisite sensation, which Mr. Dallas would call her [art's] aim, is a means, and not an end. It is a consequence of the divine system on which she works; and she produces it as much for its own sake, as Nature creates a butterfly for the sake of the down on its wings."[168] Scientific aesthetics, originally an affirmation of nature's divinity within the paradigm of natural theology, is now in violation of two separate norms. On the one hand, it transgresses the proper boundary of science and art: the "leafy nook" of Art falls prey to the same systematization that enables commercial success; the inexplicable pleasure of beauty is decisively explained away. But on the other hand, scientific aesthetics discovers that bodies make meaning in ways that evade awareness, enabling a view of the arts as sophisticated technologies for pleasuring unconscious bodies. Paradoxically, hyper-rationalized aesthetic theory finds itself at a point where aesthetic pleasure consists of not thinking at all.

Ambient Form

In this chapter I have aimed to describe and situate an archive of material that reveals the complexity of a nineteenth-century attempt to develop a

science of aesthetics as it was formulated within natural-theological theories of color and sound harmony and then persisted within early neurophysiological accounts of aesthetic experience. I have suggested that a curious feature of these attempts to construct a science of aesthetics was that they tended to attribute special significance to non- or semiconscious aspects of aesthetic experience even as they also aspired to render such experience fully susceptible to rational explanation. Although these scientifically minded intellectuals often saw themselves as committed to a regime of rationality and order that defied associationist aesthetic theories that appeared to make taste a matter of random contingency, they ultimately arrived at an apparently paradoxical notion of unconscious thought—as strange a concept, to certain contemporary readers, as "motionless motion."[169] While these scientists wanted a model of aesthetic pleasure that was clear, geometrically precise, and mathematical, they inadvertently arrived at one in which the most important responses to art and beauty were those that evade conscious awareness. Instinct and heredity begin to emerge as central components within this model of aesthetic experience rather than rational deliberation or judgment. As Hay adopts Field's mathematical system and shifts his attention to the perceptual mechanisms of the body, he necessarily introduces the idea that the human senses apprehend visual and aural mathematical resonances with an immediacy that can only later be painstakingly reconstructed by geometry and acoustics. Even though scientific accounts of beauty presented themselves as modern and forward looking, they also worked through persistent philosophical questions about the role of sensuous materiality in the perception of beauty. If the somatic level of aesthetic experience sometimes threatened to rupture harmonious formal structures, aesthetic harmony also provided a way for some medical writers to reintroduce order into the human body.

One might describe this history as a repeated encounter with the problem that there is a kind of knowing of which bodies seem capable but that the nature and logic of this knowledge tends to evade reason. For the affiliates of the Edinburgh Aesthetic Club, this bodily knowledge becomes particularly evident in a basic sense of formal consonance or dissonance: the mere experience, for instance, of a room whose shades of paint evidently do not go together, or of a building whose proportions do not feel right, or of two notes whose dissonance seems to demand harmonic resolution. If Field and Hay schematically formalize these modes of preconscious embodied rationality, Laycock and Symonds begin to offer physiological accounts of it in the language of muscular ac-

tivity and vesicular neurine. Through their work, we can begin to see a much longer natural-theological lineage of a physiological model of aesthetic experience that has often provided a context for the interpretation of late nineteenth- and early twentieth-century literature. Form's ambience is a predecessor, for instance, of what Douglas Mao has eloquently described as the "stealthy environments" central to late-Victorian and modernist descriptions of aesthetic experience, "the countless physiochemical transactions shaping each one of us, only a fraction of which can be analyzed or known."[170] In the following chapter I will develop an account of this scientific lineage of the aesthetic in more detail by turning to the close relationship between physiology and aesthetic theory beginning with major works on physiological psychology in the 1850s.

In this chapter I have also reconsidered the conceptual implications of the work of thinkers such as Field and Hay by dwelling on the internal frictions, the puzzling ambiguities, and the conceptual possibilities of their thought. Empirical aesthetics defamiliarizes ideas of form by encountering the paradoxical coexistence of a highly mathematized conception of beauty reducible to numerical order on the one hand and the partially conscious apprehension of one's surroundings on the other. It may be useful, then, to briefly reflect on the salient features of this unusual conception of form by way of a series of propositions:

> If form can be thought of as relations among parts, then the
> form at stake in these conceptions of beauty is made up of
> *mathematically perfect* relations, the name for which is
> *harmony*.
> While this conception of form depends on mathematical and
> geometrical abstractions, it unavoidably implies and in-
> volves the senses. The reproduced models in Field's books,
> as a materialization of the theory, acquire the capacity to
> induce sensory pleasure even as they purport to represent a
> realm beyond the senses.
> Form is ambient not only in that it everywhere structures the
> natural world (as Field's and Hay's ambitious analogies pro-
> pose to reveal) but also in that human design also shapes the
> lived experience of domestic and public spaces.
> Because the human body is able to apprehend the mathemati-
> cal perfection or imperfection of form, the body can be con-
> ceived of as engaging in a mode of semi- or nonconscious
> rational thought by means of the nerves or the senses. The

human ear as it perceives harmony, for instance, can thus be described as wholly analogous to Charles Babbage's calculating machines.

This means that the formal patterns of nature may be displaced or extended into the human body itself: ambience names not only a *surrounding* but also a *zone of indistinction* between self and world: we arrive finally not only at a conception of form as ambient, but of form as ambience.

Writers committed to empirical aesthetics unfold an account of embodied aesthetic experience from within the domain of scientific rationality that works against other available ways of describing the importance of sensory experience in Victorian aesthetic thought. Ambient form is not an aesthetic of impassioned feeling or elevated sensibility but of supremely rational order displaced from nature onto the body. It is not intentionally dissonant or subversive; instead, it espouses harmony as a primary value, and its political work, accordingly, is often to preserve hierarchies of race and gender. But if we also understand this conception of form as a series of propositions, we can begin to recognize the portability of this conception of form, which bears a relationship not only to nineteenth century British thought but also to a longer history of aesthetics. In this respect, I have suggested that the attempt to describe form as an ambient and physiological effect can be usefully understood in relation to philosophical accounts of *Stimmung*, both resisting Kant's proposition that the subjective universality of a judgment accounts for aesthetic pleasure and reinterpreting Hegel's hierarchy of the individual arts in which each successive art increasingly sheds its relationship to sensuous materiality.

A conception of form as the layering of patterned nature on the neurophysiologically patterned body represents one way of giving an account of how it is that the arts acquire their power: not by inducing thought or reflection but rather by directly moving the nervous system. Recent explorations of the relationship between aesthetic or cultural forms and aesthetic affects have often explored a version of this question by drawing on William James's later conception, in "What Is an Emotion?" (1884), of emotions, affects, and moods as "constituted by" rather than causes of bodily states.[171] This proposition is a touchstone for Charles Altieri's argument against a "cognitivist" view of the emotions (including by elaborating a conception of "moods" as inflections of experience rather than its content); it provides a starting point for Brian Massumi's exploration of "the irreducibly bodily and autonomic nature of affect."[172] The

predecessors of James that I have discussed participated in an extensive exploration of similar relationships between forms and feelings, between atmospheres and affects. Affect is often said to operate transpersonally or "atmospherically," including in Teresa Brennan's *The Transmission of Affect*, which begins with an arresting question that might easily be described as a question about the *Stimmung* that Leo Spitzer associated with concepts of milieu and ambience: "Is there anyone who has not, at least once, walked into a room and 'felt the atmosphere'?"[173] For Brennan, this question grounds an inquiry into the unconscious circulation of affects among crowds and groups through mechanisms that she understands as physiological, biological, even hormonal. Hay and his colleagues open a different door into Brennan's room that reveals the nonhuman agencies of aesthetic form. Brennan means for us to understand that the room has people in it and that this is where its affective "atmosphere" comes from. But for the writers affiliated with Hay and the Aesthetic Club, it could just as well be the nonhuman patterns and colors of the room—its wallpaper, paint, floors, and furniture—that sustained an atmospheric, ambient transmission of affect as they conveyed aesthetic forces through harmony and dissonance. This conception of affect is not so much a phenomenology of subjective states as a physical movement of unconscious rationality through the body occasioned by the pattern and rhythm of ordered forms.

It is in order to explore more fully this conception of embodied aesthetic affects that in the following chapter I turn to a question that is adumbrated by writers such as Laycock, Dallas, and Symonds—writers who were laying the groundwork for a theory of aesthetic response that would forego philosophy for the scientific idiom of physiological psychology. If, as work on empirical aesthetics was beginning to suggest, aesthetic experience could be described in physiological terms—if form could be thought of as an ambient effect on the body rather than an object of thoughtful contemplation—then what might this mean for a competing notion that art afforded access to transcendent experiences of freedom, imaginative sympathy, or even signaled the divide between human and nonhuman mental capacities? The implication was that a type of experience that had long been imagined as distinctively human might in fact be nothing more than an evolved, animalistic response. Taken to its logical end, this possibility threatened altogether to erase the human distinctiveness of aesthetic experience.

2 Response: The Scale of Affect in Physiological Aesthetics

Would it be possible to read a poem by tabulating whether its individual words induce pleasurable sensations? This was the gambit of the science writer and novelist Grant Allen, who asserted in his first book, *Physiological Aesthetics* (1877), that "the object of Poetry is to arouse the largest possible volumes of the ideal aesthetic thrill."[1] To support this claim, Allen encouraged his readers to engage in the simple introspective experiment of focusing their attention either on some lists of "poetical" words that Allen had provided or on the reader's favorite lines of verse: "The reader will observe that on attentively conning over any of the above lists, or still better some familiar descriptive passage in his favourite poet, he is conscious of a faint emotional wave, varying in intensity according to the number of pleasurable sensations ideally aroused. . . . This thrill is the office of the poet to arouse, to sustain, and to economise."[2] This account of poetry as a technique for producing waves of pleasure grounds an analytical interpretive practice that requires disaggregating poems—and indeed all works of art—into their constituent elements. Allen repeatedly offers lists of which words and forms and colors are beautiful and which are not according to their capacity to produce thrills: "All such words as *cool, fresh, buoyant, warm, easy, pure*, and those relating to health, repose or sleep are poetical. *Hot, close, weary,*

cold, *chilly*, and words relating to disease, hunger, thirst or restlessness are the opposite."[3] Similarly, the beauty of a painting can be partially explained by the pleasing nature of its constituent elements; painters tend to avoid "shapeless animal forms, such as the bear, the cart-horse, the goose, and the slug," instead preferring "animals like the fawn, the panther, the Arab charger, the swan, and the butterfly."[4] As these passages suggest, Allen's argument frequently risks disintegrating into a list. It will come as no surprise, then, that Allen defines artworks as "great synthetic totals"—sums of stimuli that work in concert to produce complex somatic effects.[5]

Allen presented this theory of art and literature as a direct rebuttal to John Ruskin's claim, in the first volume of *Modern Painters*, that any inquiry into why humans take delight in beauty is futile; Ruskin had argued with regard to the exact mechanism of aesthetic pleasure that "no farther reason can be given than the simple will of the Deity that we should be so created."[6] To this line of reasoning, Allen responded that "the questions thus summarily dismissed by our great living authority on Aesthetics are exactly the ones which this little book asks, and, I hope, answers."[7] Allen derived his framework from the two leading scientific accounts of the mind in mid-Victorian Britain: Alexander Bain's physiological associationism and Herbert Spencer's evolutionary psychology. Allen's account of the mechanism of aesthetic pleasure and displeasure was well received by some of the most influential progressive intellectuals of the 1870s, both in Britain and abroad, in part because it exchanged metaphysical abstraction for physicalist description that was often perceived as more intellectually valid. Allen's book was assigned by George Santayana in his Harvard philosophy course on aesthetics and the "psychology of taste" in the early 1890s. William James, in an unsigned review of Allen's volume for the *Nation*, praised Allen's theory on principle (but expressed reservations about whether its laudable ambitions were fully realized).[8] In their 1922 survey of aesthetic philosophy, Charles K. Ogden, I. A. Richards, and James Wood noted that "the only English contribution to the theory of Aesthetics widely read on the continent in the century and a half which elapsed between Hogarth's *Analysis of Beauty* and the essays of Vernon Lee and Clive Bell is Grant Allen's *Physiological Aesthetics*."[9]

Allen's account of poetry develops a neurophysiological and affective characterization of aesthetic experience that, I have argued in the previous chapter, began to emerge with some clarity for medical writers and literary critics such as Thomas Laycock, John Addington Symonds, and E. S. Dallas, who sought to understand the ways in which the

experience of beauty could be explained as the effect of "muscular action" (Symonds) or of the movement of "vesicular neurine" (Laycock).[10] As the new, antimetaphysical scientific psychology espoused by Laycock, Symonds, Bain, Spencer, Henry Maudsley, and William Carpenter gained wider purchase in progressive intellectual circles, the experience of art and literature was often explained in terms of the body's physical response to discrete stimuli. Art historians—including Jonathan Crary, Robert Brain, and Martha Ward—have traced the effects of scientific psychology on late nineteenth-century painting and aesthetic theory, especially for avant-garde painters such as Seurat and Pissarro, who drew amply on new sciences of perception to restructure the visual space of representation. Sciences of the mind yielded two key principles: first, the experience of art was to be understood as an encounter in which physical response took primacy over meaning; and second, the time of aesthetic perception was contracted and dehistoricized, reduced to the single moment of this encounter. As Crary succinctly puts it in a discussion of Seurat and Nietzsche, the infiltration of physiology into aesthetic theory meant that "the question of meaning in art was not about representation but a relation of forces, and that art is not a semiology but a physics." Ward observes with regard to the imagined temporality of this physical encounter that "just as the psychophysical aesthetic obviated, in theory, the need for history or memory, so it anticipated an ideal state of being in a timeless future."[11] This idea of art as a timeless physics had been extensively explored in conceptual terms by British writers including Allen, who, between about 1850 and 1880, began to rescale and redefine the appropriate unit of analysis for aesthetic theory as something other than a human subject. In keeping with emerging physiological and embodied models of mind and consciousness, many of these theorists abandoned the rhetoric of human faculties in favor of a more fragmented and materialist rhetoric of nerves and emotional waves with the aim of a fuller depiction of the body's participation in the production of aesthetic meaning.

In this chapter I explore how five writers—Alexander Bain, Herbert Spencer, Grant Allen, Walter Pater, and Thomas Hardy—rescaled and physicalized the primary units of analysis of aesthetic thought, turning from the human faculties to the nervous system and from the artwork to its material elements. A shared logic of aesthetic response can be discerned across these diverse writers, all of whom were interested in new neurophysiological models of subjectivity. This logic can be described in two moments. First, their writing often disintegrates both the human being and the aesthetic object into discrete, immediately interacting

elements such as nerves, muscles, colors, or curves (e.g., Allen's lists of words). Second, it then reconsiders the apparent immediacy of this aesthetic experience by describing it in terms of deep or nonlinear scales of time (e.g., Allen's account of the aesthetic "thrill" as an adaptation).[12] Aesthetic response can thus be thought of as at once instantaneous and temporally deep, occurring in a single instant that is itself the effect of millennia of evolutionary adaptations. To characterize aesthetic experience in terms of these responses, I will argue, was to give a particular kind of inflection to a notion common within aesthetic philosophy: that aesthetic experience exercises an educative effect. Rescaling aesthetic response shifts this effect from the training of mental faculties to a direct shaping of the nervous system or the body.

The apparent diversity of intellectual orientations and discourses represented by the protagonists of this chapter may require a word of explanation. Insofar as physiological aesthetics emerged as a confrontation of aesthetic and scientific discourses, it requires attention both to how the period's leading scientific psychologies addressed aesthetic emotions as well as to how scientific rhetorics inflected literary writing on aesthetics. In the context of this chapter, then, Bain's and Spencer's psychology textbooks of the 1850s (expanded, revised, and frequently reprinted through the 1880s) highlight a distinction between associationist and evolutionary physiological psychologies. Allen's *Physiological Aesthetics* (1877) and Pater's *Renaissance* (1873) instead reveal a convergence of scientific and literary languages of aesthetic response. I turn in closing to Hardy's aesthetics in order to explore how figures of the nerves within *The Return of the Native* (1878) formally routed the kind of aesthetic perception explored by the chapter's four other writers through vivid sensory intensity as it registered at the level of the body. This chapter's structure reflects the necessity of understanding physiological aesthetics not only as the use of physiology by scientists and science writers to explain aesthetic experience but also as a literary turn to rhetorics of physiology and the nervous system. I thus develop an account of a conceptual and figural territory at the points of contact between scientific and literary thought where aesthetic experience was both routed through the bodily substrate of consciousness and disintegrated into small interactions with the aesthetic object.

To focus on the science of the mind is to diverge from the terrain that has usually drawn the attention of studies of British science and aesthetics during these decades. Important work has focused on how Darwin's evolutionary theory generated new ways of thinking about the sense of beauty as an evolutionary adaptation; on Ruskin's aspiration

in works such as *Proserpina* and *Deucalion* to craft an aesthetic epistemology of nature that yielded knowledge distinct from that available to scientific observation; and on the British reception of Hermann von Helmholtz's psychologies of optical and acoustical perception.[13] Turning instead to Bain, Spencer, and Allen highlights the significance of the period's science of the mind to aesthetic theory; as physiological aesthetics emerged as a transatlantic field toward the end of the century, it was the thought of Bain and Spencer that often grounded science-based inquiries into aesthetic experience.[14] These writers outlined a strongly materialized aesthetic theory that remained both a touchstone for later attempts to develop a science of beauty and a flashpoint for those who resisted what they saw as an encroaching scientism. In later chapters, I will trace the resistance to the physiological aesthetics described in this chapter by turning in more detail to accusations of materialism that accrued around a physiological aesthetics as well as by exploring how William Morris crafts a somatic alternative to physiological aesthetics. I will also suggest that the physiological aesthetics here described eventually received its most influential and nuanced elaboration by Vernon Lee, whose scientific inquiry into aesthetic judgment involved an extensive refinement of the physiological and evolutionary models espoused by Bain, Spencer, and Allen.

My aim in attending to accounts of minimal aesthetic responses is not only to depict a Victorian intellectual scene but also to use nineteenth-century physiological aesthetics as a means for pursuing this book's broader inquiry into the conceptual challenges that are generated by physicalized scenes of aesthetic encounter. As I will suggest by turning to some recent work on affect and aesthetics in the close of this chapter, these nineteenth-century physiological inflections of aesthetic theory make available unfamiliar points of entry into a familiar Western philosophical narrative about the sensuous and educative dimensions of aesthetic experience. Philosophical writing on aesthetics is often careful to distinguish between immediate sensory response and a higher level of thought or reflection in part because one role imagined for the aesthetic is the conversion of immediate sense experience into something that can be shared and discussed, thus facilitating social and political life. Hegel makes this claim especially clearly in his lectures on aesthetics, where it provides the basis for his account of a historical progression from classical architecture to romantic poetry as an increasing alienation of sensuous materiality from the work of art. For Hegel, "the poorest mode of apprehension, the least adequate to spirit, is purely sensuous apprehension."[15] Such an appetitive relation, Hegel goes on to say, is not

appropriate to art: "Now this relation of desire is not the one in which man stands to the work of art. He leaves it free as an object to exist on its own account; he relates himself to it without desire, as to an object which is for the contemplative side of spirit alone."[16] The writers in this chapter often resist this association of sensuous apprehension with unfreedom by emphasizing that what Hegel describes as the "poorest" mode of apprehension is the unavoidable basis of all aesthetic experience. This concern with sensuousness becomes a resource for offering a history of the arts that diverges from Hegel's, in which aesthetic sensibilities have their origins in a deep time that extends far beyond the Greeks to include animal behaviors that predated humanity itself. Aesthetic response thus animates an oscillation between two scales: the immediate time of apprehension and the deep time of adaptation.

Beauty as Event: Alexander Bain's Physiological Associationism

Historians of science have often described Alexander Bain's writing on the mind as effecting a transition from eighteenth-century associationist philosophies of mind to nineteenth-century physiological psychology. L. S. Jacyna characterizes this transition as an "integration of mind into nature" that took place between about 1840 and 1880.[17] To claim that the study of the mind should be grounded in human or comparative physiology was controversial in part because it potentially called into question ideas of the self as a consciously volitional, unified whole.[18] At stake was not only a potential unraveling of the self as a coherent entity, as Roger Smith has observed, but also an antidualist account of emotion that, according to Thomas Dixon, "privileged physical facts and methods in a way that had never been done before."[19] Aesthetic feeling was among the emotions transformed by this naturalization of mind. Not only had aesthetic judgment long been a significant matter of concern within British philosophies of mind; poetic and literary theory had also often grounded themselves in scientific accounts of the mind, including those of Hartley and Priestley.[20] It was perhaps to be expected, then, that when Bain took on the project of giving a physiologically based account of sensation, emotion, will, and the intellect that aesthetic judgment would register for him as a key area of human experience that deserved special consideration.[21]

Bain's two major works, *The Senses and the Intellect* (1855) and *The Emotions and the Will* (1859), were innovative and remarkable in part because they began by imagining the human being as a fundamentally incoherent organism: largely disaggregated body parts that were

subject to local pains and pleasures and organized to reflexively respond to stimuli. From here, Bain constructed a number of stories about how humans develop into cohesively intentional, moral, conscious beings. What begin as mechanistic bodily responses to an environment, according to Bain, are slowly coagulated by the repeated experiences of pain and pleasure into behaviors, thoughts, and emotions. The nervous system of a cold and unhappy infant, in one important example, eventually fuses random movements that have moved her closer to her nurse into a chain of intentional actions. What the three-month-old does by accident, the six-month-old does on purpose, because connections have been forged within consciousness and, perhaps, also within the nervous system.[22] To understand whether these connections were physical or mental remained, as J. A. Cardno has observed, a defining challenge for Bain throughout his career.[23] The example of the infant's acquisition of volition is important not only for succinctly illustrating the logic of physiological associationism, in which all action can be traced to the primary pleasures and pains, but also because it illustrates how Bain's psychology is invested in situating particular physiological events as elements within the emergence over time of more complex forms of thought and reflection. The temporal scale of reference is, in other words, at once the physiological event and the individual life.

One major resource Bain's physiological associationism provided was a way of disaggregating complex emotions into their smaller, constitutive units. This took place by way of an account of emotion that repeatedly gave primacy to its physical dimension; Dixon observes that Bain "reduced 'emotions' to involuntary, non-cognitive feelings and their aggregations."[24] For Bain, emotions have physical manifestations because they are the product of waves or currents flowing through the nervous system: "Exactly as we increase a pleasurable or painful stimulus do we find the diffused expression of the bodily organs become more energetic. The hardly perceptible smile rises to the animated distension of all the features, and at last convulses and agitates every member into ecstatic violence. . . . It must be in the nature of a state of emotion to cause the brain to diffuse or transmit currents to the various muscles and secreting organs."[25] This wave theory of emotions means that emotion is always theoretically, if not empirically, measurable on the surface of the body, leading Bain to speculate at one moment that fine enough instruments might make it possible for persons literally to read one another's emotional states.

The arts played a significant role in both of Bain's major works on the science of the mind. In *The Senses and the Intellect*, Bain described

literary tropes as particularly well suited to "convey scientific notions and abstractions" and described Bacon and Shakespeare as especially rich with illustrations of the principles he was describing as abstractions.[26] He also proposed that the central principles of his associationism, contiguity and similarity, could explain the different roles played by the intellect in various arts; and he viewed the creation of any work of art as an effect of "constructive association," the "power to form combinations or aggregates different from any that have been presented to it in the course of experience."[27] Bain expounds most fully on the arts in *The Emotions and the Will*; in a chapter on "The Aesthetic Emotions," Bain deployed this new way of describing emotion to explain judgments of beauty. Within Bain's taxonomy of the emotions, some emotions, such as wonder, terror, and love, are so fundamental that they are hardwired into the nervous system; others, such as vanity or moral sensibility, are the result of succeeding circumstances and associations. Aesthetic feeling is of this latter category. Bain begins his account of aesthetic feeling by observing that no single property can possibly be shared by all beautiful objects, but his conclusion is not that it is incorrect to search for such defining properties. Rather, based on things commonly recognized as beautiful, the investigator must simply develop a catalog of aesthetic stimuli and accept that they may not share a single common trait. Performing on the fine arts a similar sort of analysis that he performs on the human mind, Bain sets out to catalog what he calls "aesthetic prime-movers," the "agents" that produce impressions of sublimity, beauty, grace, harmony, and proportion.[28] The purpose of this exercise has to do with Bain's broader program of physiological associationism, which seeks to ascertain which feelings or emotions result from associations and which are intrinsic to the human organism.

This model of the aesthetic both displaces agency from the observer to the aesthetic object and disaggregates persons and things into their constituent elements. For Bain, elements such as curves and angles take on an important role because they illustrate the difference between the kinds of things that are beautiful naturally and the kinds of things that become beautiful by association. Bain argues that curves appeal to the "primitive sensibility" of the eye.[29] Straight lines are unnatural and difficult for the eye to follow; curves, by contrast, appeal to the organic capacities of the human body. Music is a compound of discrete elements each of which is "calculated" to pleasurably thrill the human organism: "The elaborate music of modern times is a vast aggregate of harmony, with the union of numerous voices of instruments, and is calculated to sustain a current of various and prolonged excitement."[30] Similarly, with

regard to poetry, "some consonants, as the liquids, *l*, *m*, *n*, *r*, are soft upon the ear; while the mutes, *b*, *p*, *t*, *k*, are abrupt and hard"; words such as *bed*, *dip*, and *cut*, as well as most slang, are "harsh utterances" appealing only to "children and savages."[31] When Bain describes painting, the unit of analysis is not the painting as a unified composition but the much smaller elements of illumination and darkness as they interact with the viewer's eye: "light and shade give pleasure by the alternation of the excitement and repose of the eye. The agreeable effect of this alteration skillfully managed is often great, taking its character from the eminent susceptibility of the eye as an organ of sense."[32] As he crafts this argument, Bain departs from a previous generation of physiological or associationist aesthetic theorists who had looked for the principle of beauty in a perfect curve; Bain ignores ancient Greeks and Michelangelo in favor of anatomical mechanism. In *The Senses and the Intellect*, Bain draws attention to the pleasures of aesthetic form in a discussion of Archibald Alison's associationist aesthetics. Here, Bain claims that Alison fails to recognize many of the instances in which fundamental properties of objects, rather than contingent associations, account for their enjoyment. Curves and waves are a primary example; Bain writes, "There is, I am satisfied, a primitive influence in Form to produce a certain amount of emotion of the kind that enters into the compositions of Art. Curved forms and winding movements yield of themselves a certain satisfaction through the muscular sensibility of the eye. . . . The free movements of the arm make circular figures; to draw a straight line requires a painful effort."[33]

But this does not mean that angular objects cannot give aesthetic pleasure, only that they please by a different mechanism. On Bain's account, viewers tend to associate rigid lines and angles with the satisfying principles of utility, convenience, calculation, and human power. The pleasure viewers take in angles and lines therefore reveals that every response is not physiologically predetermined (thus also making possible divergences of taste). Buildings are made up of many lines and angles, and the beholder therefore "regard[s] with a certain satisfaction the straight outline, even when the eye in consulting its own primitive sensibility would turn away from it."[34] Similarly, "a curvilineal movement, as the flight of a projectile, or a bird, or the strides of a graceful dancer, is intrinsically pleasing: straight movements are rendered artistic only by associations of power, regularity, fitness, or some other circumstance that commends them to our regards."[35] There are two explanations of aesthetic pleasure, then, in accordance with the two basic mechanisms of Bain's psychology: "primitive sensibility" (the beautiful curve) and

"association" (the powerful angle). In both cases, Bain translates what Jules Law has called the "physiological drama" of the senses in Edmund Burke's *Philosophical Enquiry into the Origin of Our Ideas of the Sublime and the Beautiful* into the language of mental science.[36]

An important effect of Bain's physiological aesthetics is that it emphasizes the experience of art or literature as an *event*. For Bain, feelings and emotions are not conveyed to or experienced by a disembodied mind; rather, they have their existence as currents transmitted through nerves, muscles, and organs: "It must be in the nature of a state of emotion to cause the brain to diffuse or transmit currents to the various muscles and secreting organs."[37] As *The Emotions and the Will* imagines what this diffusion of energy looks like, the "wave" serves as Bain's fundamental trope. When we see someone whose face is distended and crying in agony, we witness the effect of a painful stimulus that has caused the brain to transmit a "wave" of high energy and amplitude through the facial muscles and tear ducts. It is no coincidence that a text in which waves are the grounding metaphor of emotion turns to curved lines and cyclical movements in order to define what is beautiful. Bain writes, "we have seen that a curved line is intrinsically pleasing, like a waxing or a waning sound, and that a varying curvature is preferable to the rigid uniformity of the circle. The oval is thus a pleasing curve, and still more so is a waving or changing curve."[38] At first glance, this looks like a version of Burke's empiricist reduction of beauty to a property of an object. But for Bain, it is precisely the psychophysical *interaction* between the waxing and waning form and the waxing and waning of emotion that induces aesthetic pleasure. Because Bain's psychology insists on the physical existence of feeling and emotion, a new kind of interaction becomes available as the object of aesthetic theory.

The significance of this account of emotion—including aesthetic emotion—was widely recognized and debated. When Bain's close friend John Stuart Mill reviewed his work for the *Edinburgh Review* in 1859, Mill proposed that Bain's eleven categories represented a fundamentally new taxonomy of the emotions and described Bain's chapter on the aesthetic emotions as "the most complicated of all the eleven classes."[39] Mill further praised Bain's physiological and nerve-based account of the sense of beauty as possibly placing Ruskin's theories on surer philosophical footing. Mill observed that where Ruskin had proposed in the second volume of *Modern Painters* that the capacity of beauty to elevate (Ruskin called this *theoria* as opposed to a purely sensory *aesthesis*) was a "preestablished harmony, ordained by the Creator, between our feelings of the Beautiful and certain grand or lovely ideas," Bain's work offered a

causal explanation grounded in the nervous system.[40] For Bain, the connection between feelings of beauty and elevated ideas is not an "arbitrary dispensation of Providence . . . but a case of . . . mental chemistry."[41] Ideas of beauty, "when they have sunk sufficiently deep into our nervous sensibility, actually generate by composition with one another and with other elements, the aesthetic feelings which so nicely correspond to them."[42] One imagines, however, that Ruskin would object. Mill's speculation about the relationship between Ruskin's and Bain's theories emphasizes the extent to which discrete "elements" and material "nervous sensibility" displace the human aesthetic subject who is at the center of Ruskin's theory.

We are now in a position to begin to discern an important effect of redefining the unit of analysis of aesthetic theory as very small elements of the body or of the aesthetic object: to do so both powerfully occludes social or cultural determinants of aesthetic pleasure and takes as the relevant temporal frame of inquiry the ontogenetic development of the individual organism. Bain's psychological aesthetics would thus seem to instantiate a particularly intractable version of what theorists in the 1980s and 1990s often described as the "ideology" of the aesthetic: the idea that by aspiring toward universal validity, the discourse of aesthetics tends to naturalize and obscure the contingent cultural and historical foundations of aesthetic judgment. But in contrast with Kant, for whom universality obtains at the level of communal assent, Bain locates universality at the level of developmental physiology. This shift has the effect of deriving aesthetic norms from nature. Because social norms constrain action, for example, pent-up emotional waves can become a source of pain. In this context, art serves a special function: it makes available the freedom that, for Bain, constitutes pleasure: "The effusive arts of song, the drama, music, the dance . . . guide the expression of feeling into appointed channels, and the effect is to heighten or prolong the genial influence of the diffusion. . . . When they chance to fit in with an emotional wave they take the place of the wild and transient outburst of untutored nature. . . . The free flow of articulate utterance peculiarly satisfies the outgoing impulses of passionate excitement, heightening pleasure, and assuaging pain."[43] Bain argues, in other words, that because so much of everyday life is characterized by the painful constraint of an unchecked flow of emotion, art becomes an artificial (or "tutored") way of opening an outlet for the nervous waves emanating from the brain. The beautiful curve makes available a safe form of ease and abandon.

If in moments such as these, the social milieu of the human organism is vaguely adumbrated, in others it is subtly encoded. Regularly arranged

objects, for example, afford a pleasure related to subordination and rule following: Bain writes, "Analogous to Time and Beat in music, is the Repetition of objects at *regular intervals*, as in rows, tiers, ranks, and uniform array—in mosaic work, the patterns of a design, or the petals of a flower. Such regularity of repetition is highly grateful to the eye, and any gross violation of it is very painful to a mind sensitive on that score."[44] Groups of regular objects induce a similar pleasure: "a new occupation is given to the mind in tracing subordination, as well as in discovering regularity."[45] In moments such as these, the powerfully normative dimensions of Bain's account of the mind reemerge symptomatically as the pleasures of regularity, order, and subordination.

But even while we recognize that Bain's metaphors are ideological in the sense that Christopher Herbert has described—"cognition and theory-spinning are bound to be expressive of densely patterned systems of imagination, . . . [and] these systems are to an overwhelming degree culturally dictated"—it is equally important to observe that Bain was adopting a view of the human that often ran counter to those "patterned systems" that were mainstream within Victorian thought.[46] Bain had to work to contain and justify what looked like radically materialist implications of his theory insofar as rejecting an aesthetics organized around the concept of a soul or disembodied mental faculties looked very much like mechanistic reductionism.

Contemporary objections to Bain's psychology highlight the extent to which his account of emotion attributed a disturbing degree of autonomy to disaggregated, physicalized emotions that circulated through the body. Primary detractors included those who saw Bain's account of the mind as a threat to a religious conception of human agency (notably J. C. Shairp, James Martineau, and J. D. Morrell) as well as less-physicalist psychologists who envisioned only a correlation or a parallel between mind and matter without giving either causal priority.[47] Martineau, a Unitarian who prominently took on the task of defending religious belief from the threat of scientific materialism beginning in the 1850s, objected with particular clarity to Bain's method.[48] Acutely sensing the implications of a postintrospective empirical psychology, which did eventually lead to the harder materialisms of John Tyndall, T. H. Huxley, Henry Maudsley, and W. K. Clifford, Martineau wrote that Bain was wrong to identify emotions with electrical waves or physical movements within the body:

> If we could turn the exterior of a man's body into a transparent case, and compel powerful magnifiers to lay bare to us all that happens in his nerves and brain,—what we should see would

not be sensation, thought, affection, but some form of move-
ment or other visible change. . . . When we are told of the 'high
charge of nervous power' needful for 'susceptibility to delicate
emotions,'—of the 'numerous currents of the brain' involved in
'wandering of the thoughts' . . . we lose all sense of psychological
truth, and no more know ourselves again than if, on looking in
the glass, we were to see an anatomical figure staring at us. There
is no more occasion for such phraseology, than for an artist to
paint his Madonna with the skin off.[49]

That Martineau objects by presenting his reader with an image of a skin-
less body in a painting or a mirror is telling in that it takes Bain's psy-
chology to encounter problems of representation. Bain's psychology
claims to provide a portrait of the human mind, but by locating mind
in nervous currents, Martineau suggests, Bain has not explained human
experience so much as he has erased its distinctiveness. For Martineau,
identifying "sensation, thought, [or] affection" with movements that
take place within the body or the nervous system is a gesture that fun-
damentally misunderstands the distinction between interior and exte-
rior. What Martineau discerns is a dynamic that I will explore in more
detail in the second part of this book: to characterize mental experience
in terms of physical events is to in a certain respect turn the mind "out-
ward," rendering properties that had once been thought of as contained
within the self as legible on the surface of the body. Martineau's image of
a human body as a transparent case aptly figures this turn.

Bain's writing about the physiological and nervous mechanisms of
aesthetic pleasure rescales aesthetic response as "minimal" in that it fol-
lows a logic in which historical or cultural context can appear either only
as an unexamined context (as, e.g., the condition requiring nervous waves
to be vented through listening to music or dancing) or as a symptom (as,
e.g., the underexamined value placed on regularity and repetition). The
paradigmatic scene of this aesthetic theory is not one in which a per-
son contemplates a painting but one in which curves or lines or vowel
sounds act on nerves and muscles, producing chains of responses that
aggregate into complex emotions. The temporality of this encounter at
first seems instantaneous, but if we understand it in the context of Bain's
conceptual framework, we see that it also implies a future moment at
which, for instance, the association of a rigid angle with a feeling of re-
spect will be recalled and reaffirmed. In this regard, Bain renders a famil-
iar philosophical narrative about aesthetic education in the language of

early neurophysiology, imagining that art might train the individual by directly forming his or her nervous system. If aesthetic experience offers an avenue to a new kind of self, this self does not take the form of an abstract subject engaged in complex acts of rational deliberation; refracted through the language of physiology, the aesthetic domain is transformed into a series of minimal responses that appear as points of contact between the human nervous system and the materiality of the perceived object.

Deep Time: Herbert Spencer and the Reflex

Bain's writing on aesthetic pleasure makes visible a contraction to very small units of aesthetic experience—the nerve, the emotional wave, the curve. But at the same time that a physiological account of the mind was effecting these kinds of contractions and reductions, emergent evolutionary conceptions of the mind moved in the opposite direction, situating what Bain described as discrete physiological events as evolutionary adaptations. The most influential instigator and proponent of an evolutionary rewriting of physiological psychology was Herbert Spencer, who, as Rick Rylance puts it, "jettisoned the detailed analysis of mental contents that had been the task of associationists from Locke to Bain," arguing instead that "the mind must be seen as a relational and developing process."[50] In a lengthy essay that praised Bain's work but envisioned an even more ambitious natural history of the mind, Spencer described a psychology that would not merely describe how the physical side of emotions can be traced within the nervous system of the individual but that would comparatively trace the gradation of emotions across three spectra: "the evolution of emotions up through the various grades of the animal kingdom"; an analogous gradation from "lower" to "higher" human races; and a gradation from infants to adults.[51] Spencer proposed the aesthetic emotions as a significant area of inquiry for a comparative psychology that would take both human and nonhuman consciousness under its purview, arguing that "there are aesthetic emotions common among ourselves, that are scarcely in any degree experienced by some inferior races; as, for instance, those produced by music."[52] Spencer's scalar expansion situates aesthetic experience as one of the phenomena that Wai Chee Dimock, glossing Fernand Braudel, describes as requiring "hundred, thousands, or even billions of years to be recognized for what they are: phenomena constituted by their temporal extension, with a genealogy much longer than the life span of any biological individual."[53]

Spencer's writing situates art within this expanded frame of evolutionary time, transforming the two features I have highlighted in Bain's account of aesthetic experience: its instantaneity and its role as a shaping force within the individual life. Where Bain remains focused on the individual, Spencer, by contrast, explores the extent to which what are experienced as immediate responses or mental states can in fact be understood as the outcome of an extraordinarily long series of adaptations within the deep time of the species. This is in keeping with Spencer's highly teleological evolutionary theory, which, as Robert Richards has observed, "attempted to demonstrate scientifically that nature, particularly human nature, inexorably moved toward perfection, which in the case of man [Spencer] interpreted as complete adaptation to the social state."[54] A feature of this ideal state, we shall see, was a proliferation of aesthetic practices and experiences.

To understand Spencer's views about art and aesthetic experience requires piecing together his various writings on architecture, gracefulness, music, and beauty, which reflect a recurring line of reasoning about the arts.[55] As biological organisms improve as the result of progressive evolutionary adaptations, they no longer need to spend all of their energy staying alive. This excess energy is dissipated at first in mere play, an activity shared by humans and animals. But as civilizations also progress, play becomes ever more refined into the practices of the fine arts. A widespread cultural investment in beauty, which is characterized by uselessness, therefore also signals a link between evolution and civilization. In crafting this line of reasoning, Spencer follows Bain in attending to the smallest or most "primitive" elements of aesthetic response, but, by contrast with Bain, he situates them within much longer scales of time. In his earliest sustained treatment of art, "The Origin and Function of Music" (1857), Spencer traces the pleasures of art to the phenomenon of reflex action, the automatic response of a living organism to its environment. The essay begins with a dog (Spencer names him "Carlo"), who sees his owner approaching, begins to bark, and wags his tail. What Carlo teaches the reader, according to Spencer, is that there is an intimate physiological connection between feeling, action, and expression: excitement is not a purely interior mental state but one that takes place as muscular movements of the tail and vocal cords. All feelings are "muscular stimuli"; mental excitement always corresponds to muscular excitement; the link between the two forms of excitement is "the principle known among physiologists as that of *reflex action.*"[56] This is a gloss of Bain's physiological associationism, and Spencer here

refers his readers—the nonspecialist audience of the monthly miscellany *Fraser's*—to Bain's work on emotion.

But at this point in the essay, Spencer transforms the physiological single-moment perspective into a basis for speculation about human and species history, drawing evidence from Greek poetry and Asian boatmen (whose songs are taken to be survivals of ancient chants) to show that Western art is the latest development in a connected series of animal activities originating with Carlo's wagging tail and playful cavorting. It is here that we can begin to see how Spencer rebuilds the minimal physiological event into a new kind of sweeping aesthetic narrative, one that is ostensibly based on natural science instead of transcendental metaphysics. While Spencer is modest about whether his model can explain any given work of art—he acknowledges that "it is not to be supposed that the more special peculiarities of musical expression are to be definitely explained" by reflex theory and that "it is impracticable to trace that principle in its more ramified applications"—he believes himself to have made some progress in answering (1) how aesthetic responses came to exist in the first place and (2) their long-term effect on the species.[57] This effectively resituates the sense of beauty within deep time, where a concept of play not limited to the human emerges as a partial explanation for aesthetic pleasure.

We might usefully understand Spencer's account of play as an evolutionary reinterpretation of Bain's emotional wave. Play, for Spencer, serves much the same purpose as the wave's discharge of energy except that it gestures outward from the organism to culture at large. That is to say, if for Bain aesthetic pleasure is a safe venting of excess emotion, then for Spencer play does the analogous work of discharging "energies" that are left over from previous stages of evolution. Play adumbrates the biological genesis of the sense of beauty. In a chapter on the "Aesthetic Sentiments" added to the 1872 edition of *Principles of Psychology*, Spencer argues that aesthetic pleasure, experienced as small muscular adjustments and physical feelings, reveals that the species is advancing toward ever more refined possibilities of feeling: "activities of this order [i.e., the aesthetic] begin to show themselves only when there is reached an organization so superior, that the energies have not to be wholly expended in the fulfillment of material requirements from hour to hour. Along with occasional surplus nutrition . . . there occur the conditions making it possible for the states of consciousness accompanying the actions of the higher faculties."[58] Spencer maps an evolutionary development from play to simple mimetic dances, to the "more-developed aesthetic

products" of ancient civilizations to, finally, the current state of affairs, "decreasingly predatory and increasingly peaceful," in which excess nervous activity has to be discharged through the fine arts.[59]

Spencer's claims reflect both the extraordinary ambition and extraordinary difficulty of an evolutionary explanation of human aesthetic endeavor. It may well be the case that looking at a painting or reading a book calls on human mental capacities that have adapted over millennia. (Indeed, it is impossible that they do not.) But as Spencer recognizes, the scale of this explanation is not necessarily capable of elucidating what he describes as "ramified applications" and "special peculiarities"—in other words, the particular qualities of given works of art.[60] Spencer, one of the first major evolutionary psychologists, was well aware that the theory might be correct in its broad outline and yet still be too coarse to offer satisfactory explanations of certain objects or experiences.[61]

To understand neurophysiological aesthetic response as an evolutionary adaptation is to open the possibility for speculation about long pasts and futures of aesthetic experience that extend well beyond the domain of human history. Any present version of aesthetic pleasure—or, indeed, forms such as the novel or entire domains of art such as music—becomes recognizable as nothing more than a transient moment within an almost unimaginably long series of adaptations, raising the question of what aesthetic practices or pleasures might have looked like in the distant human past and what they might look like in the future. Both for Spencer and those who adapted Spencerian evolution to speculation about the arts, these possibilities often took the shape of racialized narratives of progress in which certain non-Western cultural practices were taken to represent moments within the history of aesthetic evolution. In the essay "Personal Beauty," Spencer argues that inward character is essentially linked to outward beauty and that outward beauty is essentially linked to evolutionary progress. Spencer argues that unattractive facial features—protruded jaws, laterally extended cheekbones, small heads—characterize lower races: "It will be admitted that the projecting jaw, characteristic of the lower human races, is a facial defect—is a trait which no sculptor would give to an ideal bust."[62] This, Spencer says, is because supposedly "lower" races have to use utilize their bodies as tools more than do "higher" races, and Spencer ultimately imagines a "pure race" in which there would be a "constant connection" between "external appearance and internal structure."[63] These kinds of views were disseminated by writers inspired by a Spencerian model of evolutionary progress, including the Scottish writer W. Proudfoot Begg, who begins his book *The Development of Taste* (1887) as follows: "Where

in the scale of creation does a taste for beauty begin to be shown? Is it confined to man, or do we share it with the lower animals? And if we do share it with them, with which of them do we share it?"[64] As such questions imply, for Begg and his sympathetic readers, the capacity for aesthetic feeling marked a stage of evolutionary progress. Applying Ernst Haeckel's theory of recapitulation, Begg argues that the development of taste in the individual—from the child who delights in gaudy colors to the adult who appreciates the "emotion of sublimity"—reflects the evolution in human taste from a "savage" predilection for ornamentation to Wordsworth and Shelley.[65] Evolutionary theories of aesthetic response effect a double movement, revealing highly cultivated taste to be nothing more transcendent than an animal adaptation but simultaneously making the arts encode racist hierarchies of value.

The physiological event operative in Bain's aesthetics thus becomes for Spencer a symptom of evolutionary progress. Spencer optimistically sees no end to the upward path hewn by the capacity to appreciate beauty: "the aesthetic activities in general may be expected to play an increasing part in human life as evolution advances. . . . The order of activities to which the aesthetic belong . . . will hereafter be extended by it. . . . A growing surplus of energy will bring a growing proportion of the aesthetic activities and gratifications."[66] When any organism has excess energy that it is not required to expend on basic life-maintaining functions, it must expel it somewhere. This is evident, Spencer says, when one sees animals playing: "Play is . . . an artificial exercise of powers which, in default of their natural exercise, become so ready to discharge that they relieve themselves by simulated actions in place of real actions."[67] Aesthetic feeling, Spencer argues, operates according to a similar principle. The color of a painting or the smell of a perfume does nothing to help an individual survive, but they allow for the exercise of excess energy. Art, Spencer writes, "exercise[s] the faculties affected in the most complete ways, with the fewest drawbacks from excess of exercise. Joined to this comes . . . the diffusion of a normal stimulus in large amount, awaking a glow of agreeable feeling, faint and undefinable."[68]

Spencer recognized but suppressed the connection between his theory of aesthetic play and Friedrich Schiller's in the form of a disavowal: "Many years ago I met with a quotation from a German author to the effect that the aesthetic sentiments originate from the play-impulse. I do not remember the name of the author; and if any reasons were given for this statement, or any inferences drawn from it, I cannot recall them."[69] It is worth exploring the connection that Spencer seeks to suppress not only because a Spencerian aesthetic gives a dramatically different

inflection to the idea that play is a central component of the appreciation of beauty but also because major psychologists, including Jean-Marie Guyau, Giuseppe Sergi, and Karl Groos, recognized Spencer's account as having rendered a more persuasive account of Schiller's play theory.[70] This notion of aesthetic play originates in the "Analytic of the Beautiful" in the *Critique of the Power of Judgment*, where Kant distinguishes between "mere agreeableness in sensation" and the pleasure felt in judgments of the beautiful; the latter involves the "free play of the faculties of cognition."[71] "Free play" is Kant's preferred metaphor because it describes a lack of determination by ideas about what a thing should be; this play is understood to produce pleasure because, as Kant explains in the *Critique*'s first introduction, the faculties of imagination and understanding become during the judgment of beauty "reciprocally expeditious."[72] This account of aesthetic pleasure as a harmonious relation among faculties is distinct from pleasures of the senses (i.e., the agreeable), which, for Kant, are not "free."

This link between aesthetic judgment and free play is taken up by Schiller in his *Letters on the Aesthetic Education of Man* (1794), but it is given such a different inflection that Schiller's letters are often described as a creative misreading of Kant. In the fourteenth letter, Schiller proposes the existence of a play instinct or drive (*Spieltrieb*) that opens a space between two domains of law: physical necessity and moral necessity. Play suspends these laws, rendering "our formal as well as our material disposition . . . contingent."[73] It is because play offers access to this domain of autonomy that Schiller makes the famous assertion that "man only plays when he is in the fullest sense of the word a human being, and he is only fully a human being when he plays."[74] For Schiller, this domain of fully human free play is interestingly foreshadowed within the domain of nonhuman nature, which seems to betray certain capacities for play—including, surprisingly, among trees whose fecundity and "joyful movement" seem to mirror the higher freedoms of human play.[75] In a brief aside, Schiller observes that trees produce more seeds and branches than are necessary for their preservation and seems to suggest that even a tree might experience something like play: "The tree puts forth [*triebt*] innumerable buds which perish without ever unfolding. . . . Such portion of its prodigal profusion as it returns, unused and unenjoyed, to the elements, is the overplus which living things are entitled to squander in a movement of carefree joy. Thus does Nature, even in her material kingdom, offer us a prelude of the Illimitable."[76] In a little-remarked moment of Schiller's letters, he imagines that trees also drive [*treiben*] toward play. The realm of freedom opened up by play

ultimately provides the basis for Schiller's well-known and controversial aestheticization of political life: the aesthetic state is the only means for "realizing" a society that can be made "merely possible" by leveraging the forces of nature or "merely (morally) necessary" by leveraging ethical laws.[77]

The significance of this account of aesthetic play has often been located in its politicization of what, for Kant, was a relation among the mind's faculties. In an essay on Kleist, Paul de Man argues that Schiller's notion of the "aesthetic state" cannot be read merely as a state of mind, emphasizing that the aesthetic state must be understood as a "principle of political value and authority." In another lecture, de Man pushed this reasoning further by suggesting that Schiller's account implies a "political institution" resulting from aesthetic education.[78] It is only from this perspective, for de Man, that it is possible to understand how Schiller reveals the aesthetic "as a political force that . . . still concerns us as one of the most powerful ideological drives to act upon the reality of history."[79] The content of this ideology is a particular kind of humanism: "art is in fact what defines humanity in the broadest sense. Mankind, in the last analysis, is human only by ways of art."[80] Schiller's understanding of the aesthetic state has been revitalized more recently by Jacques Rancière, for whom Schiller's account is not to be critiqued as ideology but rather used as the means for articulating anew the relationship between aesthetics and politics. Rancière argues that Schiller describes a "plot" within which "primitive man gradually learns to cast an aesthetic gaze on his arms, tools and/or body."[81] This capacity for aestheticization is not, for Rancière, a withdrawal from the political domain but the shadowy promise of a "nonpolemical, consensual framing of the common world."[82] If for both de Man and Rancière, Schiller represents a powerful articulation of the relationship between aesthetics and politics, it is revealing of the difference between their intellectual orientations that this relationship appears as ideology for de Man and something closer to utopianism for Rancière.

Spencer's account of aesthetic experience as a nervous or muscular discharge of pleasurable energy facilitated by many millennia of biological developments—the kind of experience Kant would have called "mere," confined to the individual, unsusceptible to a claim to universal assent—both participates in and transforms philosophical accounts of aesthetic experience as affording access to a domain of freedom and providing a point of entry into political life. Spencer's aesthetic anthropology works with a strikingly similar story to Schiller's, but one that tends to emphasize the continuities rather than the distinctions between

human and nonhuman realms and whose political implications are thus fundamentally different. Spencer would diverge from both Schiller and Kant insofar as he would characterize the moments when the mind seems to be most free as nonetheless susceptible to explanation under the rubric of scientific naturalism; there is far less room in the wake of the rendering of mind as a scientific object to imagine that faculties operate in a fundamentally autonomous or free domain. But Spencer also leverages the language of evolutionary development to rewrite what Rancière describes as Schiller's "plot" within the context of deep time. Adaptation over time generates a series of improvements that will eventually lead to universal happiness and pervasive play; deep time extends not only into the past but also into the future.

Ultimately, rather than opening onto the kind of "consensual framing of the common world" that Rancière draws from Schiller's *Letters*, Spencer's evolutionary aesthetics instead reinscribes cultural hierarchies all the more deeply, making the refinement of aesthetic sensibility an index of progress.[83] If Spencer uses the phenomenon of aesthetic pleasure to affirm distinctions between high and low human races, it is also the case that Spencer opens up an alternative way of framing Rancière's conception of a "common world" as not limited to humans. Precisely because Spencer invites readers to recognize human capacities for aesthetic experience in terms of gradations that extend deep into the natural world (and might yet transform in such a way that what now seem like the "highest" forms of aesthetic experience will someday seem rudimentary), he invites questioning about who or what might be a participant within the common world to which Rancière often refers, and he occupies a conceptually adjacent position to what de Man describes as Schiller's humanist ideology. Spencer, who begins an essay on aesthetics by examining the wagging of a dog's tail, identifies a position from which one may see this world as open to nonhuman participants, exploring more fully the possibilities suggested by Schiller's exuberant, quasi-aesthetic trees. It is from this perspective that we can see that the radical expansion of the temporal scale within which minimal aesthetic responses are situated by Spencer transforms the aesthetic itself, rendering its association with human autonomy highly unstable.

History and Immediacy: Walter Pater with Grant Allen

Reading Bain and Spencer into a history of aesthetics that has maintained a distinction between science and philosophy reveals a new, if controversial, object for aesthetic theory: a physiomotor response to

beauty that bears the traces of individual development and species his-
tory. If the neoclassical and psychological aesthetics of the eighteenth
century often located beauty in a given faculty of the mind or in essen-
tial qualities of objects (curves, angles, colors, harmonies), new psycho-
physiological and evolutionary accounts often took as their basic unit a
semiconscious interaction between an embodied mind and an environ-
mental stimulus. This turn to the minimal elements of aesthetic response
afforded new ways of conceiving the intersection between a science of
the human and a theory of the arts. Bain and Spencer's writing on aes-
thetics instantiates a broader reconsideration of the apparently dual sta-
tus of aesthetic experience during the period: it could serve as both an
index of cultural refinement and of animal sensibility. On the one hand,
refined taste continued to signify social distinction. The reformist "mis-
sionary aestheticism" described by Diana Maltz depended on the idea
that taste was socially elevating; when aestheticism was exported to the
United States, Jonathan Freedman has argued, it became the means of
creating a new cultural elite.[84] But at the same time, scientists increas-
ingly emphasized the connection between human aesthetic pleasure and
its nonhuman analogues. Darwin famously catalyzed a debate about
whether birds make aesthetic judgments by observing in *The Descent
of Man* (1871) that "on the whole, birds appear to be the most aesthetic
of all animals, excepting of course man, and they have nearly the same
taste for the beautiful as we have."[85] Grant Allen published two pieces in
1881—"Butterfly Psychology" and "Butterfly Aesthetics"—that inquire
into whether the butterfly's lived experience is purely "mechanical" or
whether its visual, olfactory, and gustatory senses are similar enough to
humans that we can imagine it as experiencing "amusement," feeling
"cheerful," or having a "standard of taste."[86] As the psychologist James
Sully noted in an 1879 essay titled "Animal Music," "man can no longer
boast of being the sole artist."[87] Hence, a recurrent paradox in a wide
array of Anglophone writing about aesthetic pleasure in the mid- and
late-nineteenth century was that aesthetic pleasure evidenced cultural
refinement but at the same time could be traced to nonhuman or "pre-
civilized" desires and instincts.

Discussions of aesthetics gained purchase not only within biology
and physiology but within scientific epistemology and the philosophy of
science. As Suzy Anger has observed, Victorian discourses of science and
aesthetics often converged on issues of interpretation; for post-Kantian
philosophers of science—including Karl Pearson, William Carpenter,
and G. H. Lewes, who learned from Kant the inaccessibility of the thing
itself—the apprehension of scientific facts, as human constructions,

could sometimes appear analogous to aesthetic judgments.[88] Pearson, especially, was attentive to the close relationship between aesthetic and scientific reasoning both in his lectures and in *The Grammar of Science*.[89] In order to defend the sciences against the charge that they were "destroying the beauty and poetry of life" by rationalizing it (a charge we saw leveled against E. S. Dallas in the previous chapter), Pearson characterized aesthetic judgment as also concerned with truth. Pearson renders aesthetic judgment almost entirely intellectual in a way that runs counter to Kant's characterization of aesthetic judgment as searching for but not finding a concept, revealing that if Pearson had adopted Kant's epistemology, he had not adopted Kant's aesthetics: "when we see a great work of the creative imagination, a striking picture or a powerful drama, what is the essence of the fascination it exercises over us? Why does our aesthetic judgment pronounce it a true work of art? Is it not because we find concentrated into a brief statement, into a simple formula or a few symbols, a wide range of human emotions and feelings? . . . Does not the beauty of the artist's work lie for us in the accuracy with which his symbols resume innumerable facts of our past emotional experience?"[90] If this is a defense of aesthetic judgment, it is one that evacuates the aesthetic of its sensory dimensions, a point that the novelist Olive Schreiner made forcefully to Pearson in her correspondence with him.[91] "It is among wild birds that the sex feeling seems to become really aesthetic," Schreiner proposed; "anyone who could watch [the mating ritual of cock-o-veets] and fail to see that it was entirely aesthetic . . . must be a singularly bad observer."[92]

Two important books published on aesthetics in the 1870s—Walter Pater's *Studies in the History of the Renaissance* (1873) and Allen's *Physiological Aesthetics* (1877)—rhetorically intersect on questions about the scale of aesthetic response even as their idioms appear widely separate. Pater and Allen have usually been associated with distinct scientific and literary or art-historical lineages of aesthetic thought.[93] Biography alone forecasts a divergence between Pater and Allen. Pater's thought reflects his training at Oxford, where he had studied Greek thought with Benjamin Jowett and had read extensively in German philosophy and French literature. Allen, by contrast, was a Canadian popular science writer and novelist who had studied in New Haven, Dieppe, and Birmingham before becoming a professor of mental and moral philosophy in Jamaica, where, emulating Herbert Spencer, he developed theories about evolution.[94] Richard Le Gallienne offers a rare comparison of the two, writing in Allen's 1899 obituary that his accessible style was the opposite of Pater's, who wrote prose "as though it were merely a Morris

wall-paper."[95] Where Allen follows Bain in offering an only very attenu-
ated account of human or cultural aspects of the artwork, Pater's model
of aesthetic criticism is avowedly oriented toward historical periods as
contexts. Where Allen begins by announcing his personal insensitivity
to art, Pater begins by making a certain sensibility the very condition of
aesthetic criticism.[96] And where Allen's interlocutors are Victorian scien-
tists (Bain, Spencer, Huxley), Pater's occupy the other side of a nascent
science/humanities divide: John Ruskin and Matthew Arnold.[97]

Physiological Aesthetics synthesizes the work of Bain and Spencer
so as to deploy the language of scientific materialism against Ruskin-
ian aesthetic criticism.[98] Dismissing the latter as "transcendental rhetoric
and vague poetical declamation," Allen writes of his desire "to exhibit
the purely physical origin of the sense of beauty, and its relativity to
our nervous organization."[99] Allen combats this tendency toward rhet-
oric and poetry with a fierce positivism that pays homage to Bain and
obeisance to Spencer. Allen argues that "when we exercise our limbs
and muscles . . . merely for the sake of the pleasure which the exercise
affords us, the amusement is called Play. When we similarly exercise our
eyes or ears, the resulting pleasure is called an Aesthetic Feeling."[100] The
building blocks of Allen's aesthetic theory are material entities rather
than a priori principles—ether waves, nerve fibers, and bodily tissues—
culminating in a definition of aesthetic pleasure as "the subjective con-
comitant of the normal amount of activity, not directly connected with
life-serving function, in the peripheral end-organs of the cerebro-spinal
nervous system."[101] Artworks, similarly, are accumulated bits and pieces
of stimuli rather than coherent representations or narratives; curves are
pleasing for inducing "unimpeded action of the muscles and other tis-
sues concerned," while an angle "involves a considerable expenditure of
muscular energy."[102] With the beautiful curve come the attendant beauty
and ugliness of vowels and consonants, light and shade, sudden blasts
and gradual crescendos. In music, vocalized Italian song is more beau-
tiful than guttural German because it "stimulates our nerves of hearing
within the normal limits."[103] In literature, poetry succeeds in direct pro-
portion to its quantity of stimulating words: the phrase "lily of the val-
ley," for example, "excites in us . . . a very slight wave of that pleasur-
able feeling which an actual lily produces."[104] Allen's theory of language
is that it is a marginally successful technique for recreating what we
would feel if we were to experience whatever language describes: "the
faint emotional waves generated by language exercise in a minor degree
the same nervous plexuses which would be exercised more fully by the
original vivid waves of which they are copies."[105] So, Allen concludes,

the words "*scarlet, crimson, pink, orange, golden, green, blue, azure, purple*, and *violet*" are "poetical."[106] The words "*grey, brown, dun, black, bay*, and *drab*" are not.[107]

In all of these examples, Allen's logic is one of fragmentation, analysis, a preference for the part over the whole—an elaboration, in other words, of the disaggregated units of stimulus and response that are central for Bain and Spencer. Just as a painting is reducible to curves, lines, and patches of color, so too is its viewer treated as a loosely associated set of parts: aesthetic feeling is the exercise of "eyes and ears"; displeasing forms "exhaust" the "muscles"; and song appeals to the "nerves of hearing," or to "the auditory apparatus."[108] The primary unit of analysis in Allen's aesthetics is not an individual who makes judgments about particular works of art; instead, his work elaborates the minimal units of aesthetic response: nerves, muscles, and organs that depend on a unifying consciousness only to deliver the stimulations that cannot be experienced directly. The aspiration of Allen's writing on aesthetics is to understand complex judgments of beauty and ugliness by starting from their minimally discernable elements: not only the minute interactions between body and world but also the "primitive" or the "simple" as opposed to the complex. This logic obtains at an anthropological as well as a physiological level: Allen describes his object of analysis in "Aesthetic Evolution in Man" as the "primitive germ of aesthetic sensibility in man," "those simpler and more universal feelings which are common to all the race."[109] Sensing bodies index civilization as the degrees and types of pleasure signal various strata of taste available to insects, animals, "savages," children, the uneducated, and, finally, cultivated British adults.[110] Both in *Physiological Aesthetics* and the book that followed, *The Colour-Sense: Its Origin and Development* (1879), Allen takes color theory as an important avenue into the deep time of aesthetic experience. The preponderance of green foliage and blue skies in nature, Allen argues, have caused eyes to evolve such that these colors are easy to look at but not very stimulating. Rarer hues—red, yellow, and purple—are instead highly stimulating but also exhausting. The more developed a culture becomes, the less its refined inhabitants can stand bright colors. "Savages, children, and uneducated adults" love bright flowers and shining jewels: "men of culture . . . prefer the more delicate tints, neutral colors, and pale or subdued primaries."[111] Because Allen views these as at once ontogenetic and phylogenetic developmental designations, the reader's own taste becomes legible as an expression of both individual development and species history within deep time.

In an important passage in "The Nature of Gothic," Ruskin entreats

his readers to adopt an interpretive relation toward domestic objects that take them as legible signs of economic relations: "Examine again all those accurate mouldings, and perfect polishings, and unerring adjustments of the seasoned wood and tempered steel. Many a time you have exulted over them, and thought how great England was, because her slightest work was done so thoroughly. Alas! if read rightly, these perfectnesses are signs of a slavery in our England a thousand times more bitter and more degrading than that of the scourged African, or helot Greek."[112] This is a moment that Jonah Siegel has described as one of "inescapable intimacy," in which treasured domestic objects are exposed as symptoms of industrial dehumanization.[113] In both *Physiological Aesthetics* and *The Colour-Sense*, Allen echoes Ruskin but with a markedly different inflection. He invites his readers to engage in a similarly practice of defamiliarizing domestic observation, but what that practice reveals are not economic relations but the deep time of evolutionary adaptation. For Allen the appetite for fine color is to be understood not as an index of industrial "slavery" but of Spencerian biological and cultural development. In *Physiological Aesthetics*, Allen invites his reader to consider domestic interiors, where "it will be found that reds and yellows are far more conspicuous than in external nature."[114] He expands on this point in *The Colour-Sense*, where he evokes the drawing room of the reader: "In the drawing-room where we sit, every object has obtained its colour entirely with reference to the likes and fancies of humanity. Not only have the pictures and ornaments been painted so as to please our eyes, but the carpets, the wall-paper, the curtains, the table-covers, the embroidery, the damask on the chairs and sofas, the clothing of the women and children, have all been dyed on purpose to stimulate and gratify the sense of sight." Allen then guides his readers through several steps "down" in the scale of life, arguing that the very existence of color can be attributed to "the agency of insects" in selecting blossoms, and he proposes to "[trace] the perception of colour from its first faint beginnings in palaeozoic seas or carboniferous forests down to its latest developments in the palaces or galleries of civilised man."[115] Like Ruskin, Allen invites readers to reinterpret domestic objects, but the parameters of this reinterpretation are to be found in the deep history of the earth rather than the human history of British industrialism. Bernard Lightman has argued that Allen's characteristic genre is the "evolutionary epic," a type of sweeping, cosmic narrative that "mov[ed] through vast expanses of time," thus offering a "gripping cosmic story."[116] These moments in *Physiological Aesthetics* and *The Colour-Sense* might be said rhetorically to overlay evolutionary epic with Ruskinian exhortation.

Allen invites his reader to become a direct participant within this epic by recognizing that the pleasure offered by particular colors could put the reader into immediate contact with the ways in which far-reaching forces of evolution and culture have shaped what feel like immediate judgments. His writing not only situates aesthetic modes of perception within evolutionary deep time; aesthetic experience itself becomes a paradigmatic mode of perceiving deep time.

We would expect to find ourselves in very different territory indeed when we turn to the most lastingly influential book on aesthetics published in the 1870s, Pater's *Studies in the History of the Renaissance*. And yet, *The Renaissance* often shares Allen's project of rescaling the unit of aesthetic response, as Pater urges readers to discern particular elements and qualities of artworks as the starting point for what he describes as "aesthetic criticism." In this regard, Pater and Allen emerge as surprisingly sympathetic to one another's projects, which both develop aesthetic theories based on the highly specific and sensuously discernible qualities of art and literature while resisting or deeply revising metaphysical philosophies of art. Just as Allen begins *Physiological Aesthetics* by avoiding "transcendental rhetoric and vague poetical declamation," so Pater introduces his essays by observing that "many attempts have been made by writers on art and poetry to define beauty in the abstract . . . to find a universal formula for it" and observing that these "metaphysical" attempts have failed.[117] As Pater scholars have observed, Pater's rhetoric in the "preface" to *The Renaissance* is remarkably scientific, describing beautiful objects as "powers or forces producing pleasurable sensations," enjoining the reader to identify "the property each has of affecting one with a special, a unique, impression of pleasure" and framing aesthetic criticism as based on "original facts" or "primary data."[118] Like Allen, Pater's aesthetic critic takes on the project of disengaging discrete elements of a given instance of beauty in order to examine these elements on their own terms. "His end is reached," Pater writes, "when he has disengaged that virtue, and noted it, as a chemist notes some natural element."[119] This critical practice—focused on "distinguishing," "separating," and "disengaging"—implies that the critic is discovering something that is already there, an aesthetic pleasure that exists among "adjunct" qualities. As John Morley observed in his review of *The Renaissance*, Pater paid unusual attention to "minute suggestions," to "bits of work other than the gigantic or sublime," to "faintly marked traces," phrases that foreground the disintegrating energy of Pater's critical disposition.[120]

What it meant for Pater to turn to a scientific rhetoric at key moments within *The Renaissance* has never been a settled question among

scholars, who have debated whether it is a rhetorical strategy or a genuine engagement with scientific empiricism.[121] Scientific reductionism is named as such but not clearly rejected in the first paragraph. Pater, having asked what physical life is, if not "a combination of natural elements to which science gives their names," observes that one possibility is that life is a "perpetual motion" of physical elements such as lime and phosphorous, a motion that is made up of "processes which science reduces to simpler and more elementary forces."[122] Ian Small has argued that Pater was likely familiar with the discourse of physiological aesthetics, citing as evidence Pater's terminology and the periodicals in which he published. Small writes that "Pater's vocabulary—*impression, pleasure, relative* and *discrimination*—was culled in the first place from a debate about the physiology and psychology of aesthetics," and he describes the "general interest in psychological issues" evident in periodicals such as the *Westminster Review*, the *Contemporary Review*, and the *Fortnightly Review*.[123] Using similar evidence, Jeffrey Wallen has argued that Pater's characterization of aesthetic sensitivity borrows from physiological models of development and influence: physiologists and Pater alike use the figure of being " 'played upon' like a musical instrument."[124]

These are astute and careful readings, but they may understate Pater's engagement with physiology and, especially, physiological aesthetics. It is not just vocabulary or pages of Victorian periodicals that are shared by Pater and scientific aestheticians but a particular set of argumentative moves around critical practices of isolation and disaggregation in relation to the aesthetic object: a precise elaboration of discrete responses to disaggregated features of the artwork. Like the physiologists, Pater views aesthetic experience as a *moment* (a term that appears over a dozen times in the five-paragraph "Conclusion") in which something discrete and significant happens at a sensory level. Among the most famous passages in *The Renaissance* are those that either theorize or describe such moments: the portrayal of experience, for example, as passing from "point to point"; the description of life as "a counted number of pulses"; the capacity of art to "to give nothing but the highest quality to your moments as they pass, and simply for those moments' sake."[125] Pater's discrimination of peculiar "qualities" and "elements" throughout *The Renaissance* presumes a conceptual framework in which the individual properties of artworks are separable. Pater opens his essay on Botticelli by asking a question that could have been drawn directly from Allen's volume: "What is the peculiar sensation, what is the peculiar quality of pleasure, which his work has the property of exciting in us, and which we cannot get elsewhere?"[126]

Reading *The Renaissance* and *Physiological Aesthetics* together brings into relief the extent to which Pater's model of the aesthetic critic depends on the physicality of human sense experience. It also allows us better to understand the relationship between immediate sensation and historicity that has long occupied scholars of aestheticism, a movement that at once aimed to revitalize a classical past and bring that past into direct contact with the senses.[127] Writers affiliated with the aesthetic movement have long been seen as occupying two distinct temporal planes: on the one hand, they subscribe to what might be called a presentist version of aesthetic experience in which the surface qualities of an object provide unmediated pleasure. But at the same time, aesthetes also turn their attention to and often revive aspects of distant historical periods: the Renaissance for Pater, John Addington Symonds Jr., Arthur Symons, and Oscar Wilde; the eighteenth century for Vernon Lee; medieval art and architecture for Dante Gabriel Rossetti, William Morris, and other Pre-Raphaelites. An aesthetic logic committed to the immediacy of response would seem to utterly detach human beings from their history insofar as it portrays aesthetic experience as a physiological interaction between a person and a thing. But in fact, both Pater and Allen imagine that this sort of immediate response puts one in closer touch with some version of the past.

Perhaps the most difficult question addressed by *The Renaissance* is not how to discriminate the relationship between particular aesthetic qualities and the viewer's "peculiar" sensations but about how to understand the relationship between such finely discriminated moments of aesthetic experience and the historicity of the artwork that provokes them. Pater was often criticized for what appeared to be the radically ahistorical gesture of defining the Renaissance not as a historical period but as a transhistorical "feeling" or "desire for a more liberal and comely way of conceiving life."[128] Here too, we can usefully read Pater from the perspective of physiological aesthetics. In the first essay in *The Renaissance*, "Two Early French Stories," Pater, following the practice described in the preface, asks what quality lends interest to the medieval story of Aucassin and Nicolette. How do we find meaning across historical distance? We might imaginatively project ourselves into the past, through a practice Pater calls mere antiquarianism: "Antiquarianism, by a purely historical effort, by putting its object in perspective, and setting the reader in a certain point of view, from which what gave pleasure to the past is pleasurable for him also, may often add greatly to the charm we receive from ancient literature."[129] Ultimately, though, this practice

is only a prosthetic, a means to the end of accessing a "real, direct, aesthetic charm in the thing itself."[130]

The best "antiquarianism" can do is to help one see what is already materially there in the object. Pater posits that aesthetic value is an essential quality of the object and that the critic's task is to identify "a real, direct, aesthetic charm in the thing itself. . . . This quality, wherever it exists, it is always pleasant to define, and discriminate from the sort of borrowed interest which an old play, or an old story, may very likely acquire through a true antiquarianism."[131] Antiquarianism, the imaginative habitation of a historical period, is one possible response to the question about immediacy and historicity, though not entirely satisfactory, as it requires "effort" and operates as a mere adjunct to the immediacy of aesthetic charm, which is an intrinsic quality of the object independent of historical periods.

A central project of *The Renaissance* is to craft a new way of experiencing the cultural artifacts bequeathed by history: not by imagining oneself into the psyche of their makers, so to speak, but by cultivating a sensibility to the immediate, or "aesthetic" charm of the object. The most successful critic is the one who is able to sense the past immediately through the sensory, tactile qualities of the object, a complex notion that Pater elaborates in an essay on the German art historian Johann Winckelmann. In Pater's view, Winckelmann was a great art historian because he understood Greek culture not by thinking about it but by coming into immediate contact with it. As Pater traces Winckelmann's biography, he describes Winckelmann's visits to Dresden to view Greek antiquities. As opposed to philological study, something about the presence of the object itself conveys meaning: "Hitherto he had handled the words only of Greek poetry, stirred indeed and roused by them, yet divining beyond the words an unexpressed pulsation of sensuous life. Suddenly he is in contact with that life, still fervent in the relics of plastic art. . . . On a sudden the imagination feels itself free. How facile and direct, it seems to say, is this life of the senses and the understanding, when once we have apprehended it! . . . Here, then, we see in vivid realisation the native tendency of Winckelmann to escape from abstract theory to intuition, to the exercise of sight and touch."[132] In short, Winckelmann's apprehension of Greek antiquity takes place by way of what Pater (quoting Hegel) calls a "new sense" or a "new organ" that understands the past via spontaneous aesthetic response instead of depending on historical reconstruction as the *condition* for aesthetic response. In short, this new sense uses the momentary model of experience described in the "Conclusion" to

effortlessly achieve the same effect as the "merely antiquarian effort" described in "Two Early French Stories."[133] Winckelmann's new sense depends on "excitement, intuition, inspiration, rather than the contemplative evolution of general principles. . . . [Winckelmann] apprehended the subtlest principles of the Hellenic manner, not through the understanding, but by instinct or touch."[134]

This historically sensitive "instinct or touch"—a moment of sensory as well as epistemic contact—reveals the "moments" and "pulsations" of the "Conclusion" to be outlining a model in which pleasure serves as the vehicle of a historical sensibility. The promise of the "aesthetic" as distinct from the "antiquarian" is that it offers immediate and semipassive access to a past that can be literally touched: experienced, that is, at the level of the body or instinct. Winckelmann's sense has history built in in much the same way that any physiological response also bears the mark of ontogenetic and phylogenetic development. Instinct is momentary, but it is also biological heritage. Pater's interaction with physiological aesthetics, then, is not legible merely through his focus on moments and impressions, the types of experiences that Bain understands as physiological events. Rather, it is visible as he negotiates, like Spencer and Allen, the problem of how to understand the temporality and historicity of aesthetic sensation.

The important point, then, is not that the central writer of the aesthetic movement happened to borrow tropes from the field of physiological psychology. Rather, it is that Pater's writing represents an active engagement with and, in some sense, a culmination of a topos of active questioning about the scale of aesthetic responses in British aesthetic theory that can be traced back through Allen, Bain, and Spencer to Field, Dallas, and Hay. Although Pater's immediate points of reference in the Winckelmann essay are Hegel and German art history, the set of argumentative moves that he is making equally derive from this alternate genealogy of physiological aesthetics. Its central principles are not humanity, freedom, and judgment but response, reflex, reaction, and impression. This focus on the "impression" has been a starting point, recently, for reading Pater as an early modernist; Jesse Matz argues that "the impression marks Pater's place in the advent of modernity. . . . His Impressionism [is] a decisive (if not fully strong) precursor to modernist aesthetic innovation."[135] However, it is also the impression that links Pater to previous explorations of the physiology of aesthetic experience.

To make this claim is to put some pressure on a usual distinction between physiological aesthetics and aestheticism. Regenia Gagnier argues

that Allen's is a "heterosexual aesthetic, with its beautiful body formed for sexual selection," a claim that discerns an opposition between Allen's heterosexual and Pater's homosexual aesthetics (manifested nowhere more clearly than in the Winckelmann essay).[136] But a reading that aligns Pater's aesthetics with homoerotic desire and Grant Allen's heterosexual reproduction obscures the wider philosophical context of their positions. Reading Allen and Pater together reveals that they share a project of elucidating the relationship between corporeality and temporality, between the seemingly inert body of the artwork and the longer histories that it is capable of making sensible. If for Pater these histories go back to the Renaissance (as both a period and a sensibility), then for Allen the experience of art makes present the past of the species. As a result, to scale an aesthetic response as minimal rather than maximal—to simply discriminate a particular quality or to register the sense of a curve—is not to arrive at some higher plane of subjective freedom but to feel the specific corporeal limitations that follow from inhabiting a body. The solace that art offers, in its sensuousness, is not a liberation from human corporeality but the possibility that corporeal limitations might momentarily become the source of a minor pleasure.

Hardy's Nerves: The Return of the Native

Evidence for the wide dispersion of this model of aesthetic experience—as grounded in the nervous system and the senses and separable into the minimal elements of bodies and artworks—can be found in its appearance within Thomas Hardy's novels, which often understand aesthetic experience in terms derived from the sciences. Many literary scholars have elucidated Hardy's novelistic engagements with the epistemological challenges that emerged within nineteenth-century biology, geology, and astronomy. Suzanne Keen recently argues for Hardy as a "reader of neurology."[137] At the same time, Hardy has also often been read beyond this historical context as distinctively concerned with the formal capacities of literary language to produce vivid sensory effects.[138] In *Dreaming by the Book*, Elaine Scarry often turns to Hardy's writing as an important case for exploring "by what miracle is a writer able to incite us to bring forth mental images that resemble in their quality not our own daydreaming but our own (much more freely practiced) perceptual acts?"[139] For Scarry, this is a question about how particular narrative techniques "bring about acute mimesis of perception" in the minds (and sensoriums) of readers.

In the following pages I attend to the "acute mimesis of perception" that Scarry identifies in Hardy's writing, but I understand this stylistic feature in relation to the physiologized conception of feeling and emotion that writers across disciplines were exploring in the 1870s—and, by extension, as a literary articulation of the neurophysiological minimal aesthetic response theorized by scientists of the mind.[140] Certain features of Hardy's novels adopt as a formal principle of naturalist description the minimal aesthetic responses that I have traced in this chapter within sciences of the mind. Hardy's writing thus affords a transition from the first part of this book, which has been primarily interested in the scientific context of aesthetic theory, to its second part, in which I will explore in more detail how literary writing and literary theory articulated an aesthetics of the "outward mind" that extended the mind's processes into the physical substance of the world.

Early in *The Return of the Native* (1878), readers encounter a striking, perhaps even disturbing description of Eustacia Vye, the unhappy resident of Egdon Heath whose frustrated desire to leave counters her lover Clym Yeobright's ill-fated attempt to return. In a chapter titled "Queen of Night," Hardy writes of Eustacia that "her nerves extended into those tresses, and her temper could always be softened by stroking them down. When her hair was brushed she would instantly sink into stillness and look like the Sphinx."[141] Eustacia's nerves strangely extend beyond her body. As much a late-romantic set piece as is Pater's description of *La Gioconda* (and similarly singled out by critics as having the unsavory aroma of French literature), this chapter is one among many moments in which Hardy uses the language of neurophysiology to describe embodied feeling. It was a feature recognized even by contemporary scientifically minded readers of Hardy; in a review essay on Hardy's novels, Havelock Ellis observed that Hardy "is only willing to recognize the psychical element in its physical correlative. This dislike to use the subjective method or to deal directly with mental phenomena is a feature in Mr. Hardy's psychology which has left a strong mark on his art."[142]

What Ellis calls the "physical correlative" of the psychical often appears within Hardy's novels as a synecdoche of brain for mind, or of nerves for temperament. Hardy describes a night as "an eventful one to Eustacia's brain"; surprise is phrased as an event that "affected her brain as a sudden vacuum affects the body."[143] In *Tess of the d'Urbervilles*, Tess's effect on Angel Clare is to send "a breeze through his nerves, which well-nigh produced a qualm; and actually produced by some mysterious physiological process, a prosaic sneeze"; Grace Melbury of *The Woodlanders* is described as an "elastic-nerved daughter of the woods."[144]

These nervous figures manifest an epistemic shift: by the 1870s, a neurophysiological model of consciousness had been disseminated not only by textbooks but also within popular print culture, spectacular scientific demonstrations, and cultural fascination with phrenology, physiognomy, and mesmerism. But what is most notable about Hardy's description of Eustacia's hair is that it makes poetic use of neurology rather than merely transcribing its principles. If Hardy has learned that emotions are materialized in the nervous system, he also invents his own science of the mind in which nerves strangely extend into the hair, one of those regions of the human body where the boundary between self and world, interior and exterior is least evident.[145]

Hardy's novels often adapt the strategies of scaling aesthetic response that operate in Bain's account of the emotions, in Pater's impressionism, and in Allen's physiological aesthetics by using moments of sensory intensity to temporally suspend the forward movement of the narrative. Often taking place at dawn or dusk, in darkened rooms or in dim carriages, these moments have often been understood as visual effects, but in fact they are more properly described as somatic, engaging the sensorium via multiple vectors. When Henry Knight finds himself clinging to a cliff in *A Pair of Blue Eyes*, Hardy emphasizes that Knight's perception of time, space, distance, and color are transformed by his sense of bodily peril: "The sea would have been a deep neutral blue had happier auspices attended the gazer: it was now no otherwise than distinctly black to his vision."[146] Reviewers saw in such passages "intense minuteness and vivid concentration" comparable to that of French novelists.[147]

One of the most unusual aspects of Hardy's first published novel, *Desperate Remedies,* is that it often breaks sensation fiction's rule of a breakneck narrative pace in order to describe, for instance, the "silvery and spangled radiance" of "pulpy creatures" in a tide pool or to compare the bright light gleaming unevenly under a door into a dark room to "the phosphorescent streak caused by the striking of a match."[148] Hardy has the eye and the ear of a natural historian; his observations of the natural world are refracted through what Scarry has described as a flower-like "high ratio of intensity to extension," which isolates a great amount of perceptual detail within a narrowly circumscribed object.[149] Though these lyrical moments violate the narrative law of the sensational plot, they redouble the sensations of sensation fiction, supplementing the excitement of pace with the vividness of perception. In moments that focus on the textures of multimodal perception, Hardy explores by means of his fiction a version of the minimal physiological responses that were at stake in the scientific writing of Bain, Spencer, and

Allen and in the critical essays of Pater, placing sensory detail in tension with narrative form.

These moments allow Hardy to examine how forfeiting the idea that some quality of mind or soul qualitatively distinguishes humans from animals and matter could lead to a philosophical position other than the bleak determinism that critics such as Martineau or Green had anticipated when reading Bain. Even as many strands of scientific thought were subsuming mind and emotion under biological and physical explanations, Hardy, like Pater, turned to the senses to investigate how a world governed by physicalist determinism could still be one in which human experiences were enriched, though in a different, perhaps more immediate way than under the older "metaphysical" or religious views of life. Many readers have understood Hardy's attention to sensory perception in terms of the realist novel's commitment to recreating worlds rich with detail—some of the phrases that have been used to describe this aspect of Hardy's style are "scenic realism," "pictorial realism," and "naturalistic fidelity."[150] James Krasner incisively describes Hardy's conception of vision as "an anthropomorphic struggle for aesthetic existence that humans invariably win"; for Krasner, Hardy's visual aesthetic is one that always comes to rest on the human.[151] But Hardy's attention to discrete, intense qualities of sensory experience should also be understood as an engagement with new sciences of the mind. It is well known that Hardy was an early enthusiast of Darwin's *On the Origin of Species* (1859), but his commonplace books and letters reflect a very wide engagement with scientific ideas. Hardy was familiar, for example, with Theodule Ribot's *Psychology of the Emotions*, including its discussion of aesthetic feeling.[152] His literary notebooks contain passages from a wide range of nineteenth-century intellectuals: Oxford Hegelians, positivists, philosophers of mind, and psychologists, including Bain and Spencer.[153] Hardy copied into his notebook Bain's description of the mind as "one substance with two sets of properties, two sides, the physical & the mental—a *double-faced unity*."[154] Among Hardy's close friends was Henry Head, the prominent neurologist and founder of the journal *Brain*.[155]

The Return of the Native translates the problematic question of mind-body relations into an issue of landscape aesthetics. The opening description of Egdon Heath attributes mind to landscape in such a way as to subtly refute Ruskin's argument against the pathetic fallacy. Readers learn that the heath is "full of a watchful intentness" and bearing "a lonely face"— the very aspects of humanity that Ruskin had described

as "false appearances . . . entirely unconnected with any real power or character in the object, and only imputed to it by us."[156] The heath becomes the site where Hardy works out a post-Ruskinian landscape aesthetics in which questions about pleasing visual appearance and "orthodox beauty" have been left behind—the heath "could best be felt when it could not clearly be seen"—in favor of a new kind of beauty for which *beauty* may not even be the right term.[157] What Hardy describes is a "congruity" or "accord" between the mood of a dawning technological modernity—the 1840s, when the novel is set—and an "intensity [that] was more usually reached by way of the solemn than by way of the brilliant."[158] This scene presents, as J. B. Bullen and Norman Page have argued, a new kind of aesthetic that Hardy called "beauty in ugliness"—an extreme version of Gerard Manley Hopkins's imperfect, dappled things—while also connecting this new aesthetic vision to an exploration of conventional boundaries between the human and the nonhuman as well as between the senses of sight, sound, and touch.[159] This is a world that self-consciously violates expectations about such boundaries: Eustacia's hair has nerves; the heath has a face.

The first appearance of Clym Yeobright in the novel lends credence to the notion that the novel is centrally concerned with a new form of aesthetic perception as embodied, subtly animalistic, and unmoored from classical canons of beauty. Hardy stages a complicated moment of mutual observation. Eustacia, doubly disguised as a working-class boy and a Turkish knight within a Christmas play put on by a group of rural performers, has devised a stratagem for seeing the recently returned native, Clym. When her character dies, the roles of actor and spectator suddenly reverse; as she lies on the ground, Eustacia is able finally to see Clym's face for the first time even as he is unaware that she gazes at him. What she sees, framed, it seems, by the eye holes in her mask, is portrayed by analogy with European painting. "The spectacle constituted an area of two feet in Rembrandt's intensest manner," Hardy writes, priming the reader for an ekphrastic lyrical moment:

> The face was well shaped, even excellently. But the mind within was beginning to use it as a mere waste tablet whereon to trace its idiosyncrasies as they developed themselves. The beauty here visible would in no long time be ruthlessly overrun by its parasite, thought, which might just as well have fed upon a plainer exterior where there was nothing it could harm. Had Heaven preserved Yeobright from a wearing habit of meditation, people

would have said, "A handsome man." Had his brain unfolded under sharper contours they would have said, "A thoughtful man." But an inner strenuousness was preying upon an outer symmetry, and they rated his look as singular.

Hence people who began by beholding him ended by perusing him. His countenance was overlaid with legible meanings. Without being thought-worn he yet had certain marks derived from a perception of his surroundings, such as are not unfrequently found on men at the end of four or five years of endeavour which follow the close of placid pupilage. He already showed that thought is a disease of flesh, and indirectly bore evidence that ideal physical beauty is incompatible with emotional development and a full recognition of the coil of things. Mental luminousness must be fed with the oil of life, even though there is already a physical need for it; and the pitiful sight of two demands on one supply was just showing itself here.

When standing before certain men the philosopher regrets that thinkers are but perishable tissue, the artist that perishable tissue has to think. Thus to deplore, each from his point of view, the mutually destructive interdependence of spirit and flesh would have been instinctive with these in critically observing Yeobright. . . .

The effect on Eustacia was palpable. The extraordinary pitch of excitement that she had reached beforehand would, indeed, have caused her to be influenced by the most common-place man. She was troubled at Yeobright's presence.[160]

Hardy's elegy for Yeobright's rapidly fading beauty is doubly bound up with the arts of painting and drama: readers are directed to understand Eustacia's visual perception of Yeobright's face by analogy with a Rembrandt painting. This is not immediate seeing but seeing as: aesthetic perception. Hardy further overlays human practices of writing and sign making (inscribing on a tablet, laying paint on a canvas) with metaphors drawn from biology and physics (oil burning into luminousness, disease, the law of the conservation of energy that seems to operate on Yeobright's face). These layers make this key scene of first encounter one of doubled aesthetic perception. Eustacia sees Yeobright's face as a painting; Yeobright, in turn, sees Eustacia as a dramatic mask. But it is equally a portrayal of the mind-body problem that occupied physiologists. This conceptual palimpsest takes physical form: Eustacia's masked face obscures the process by which biology writes emotion on human

skin; the mask interposes an artificially sculpted face between her flesh and Yeobright's eyes.[161]

In this regard, we can read this moment as a literary translation of Bain's famous expression that the embodied mind is a "double-faced unity," a phrase that Hardy had copied into his notebook. And if it is true that this is not just a scene of perception but specifically of aesthetic perception, it is worth asking what it would mean to consider the "palpable" effect of Yeobright's appearance on Eustacia as an aesthetic experience. Characters often respond to Yeobright in ways that resonate with visual and textual interpretation: Hardy tells us that others tend to behold and peruse him. But Eustacia fails to maintain such interpretive distance; Yeobright's "palpable" effect suggests that Eustacia is physically touched. She does not disinterestedly study his beauty but is "troubled" by his "presence." In these multiple registers, Hardy emphasizes the physicality of visual experience and aesthetic response—appropriately, given the materialist psychology that suffuses the account of Yeobright's physical appearance.

Hardy therefore suggests in this passage something that will be developed throughout the novel in similar moments: that visual perceptions are inseparable from tactile or physical perceptions; as Elaine Scarry puts it in her essay on the working body in Hardy's novels, "human consciousness is always, for Hardy, embodied human consciousness."[162] One might transpose Scarry's claim: aesthetic experience is always, for Hardy, embodied aesthetic experience. Hardy sets out from the same premise as Pater but arrives at a different conclusion. Pater invites readers to recall "the moment, for instance, of delicious recoil from the flood of water in summer heat. What is the whole physical life in that moment but a combination of natural elements to which science gives their names?"[163] But Pater moves on from there; by the end of the "Conclusion," it is not the taste of cold water but the love of "art for its own sake" that will give "the highest quality to your moments as they pass."[164] Like Pater, Hardy invites readers to consider human life as a combination of natural elements, but Hardy generalizes the type of discriminating responsiveness that Pater attributes to the aesthetic critic as a condition of all sensory perception.

The Duration of Affect

Consider five scenes. An eye responds to a curve, sending a wave of pleasure through the nervous system. A dog's tail wags, forecasting millennia of adaptations that may someday lead to a dog-made olfactory

symphony. The word "lily" appears in a poem and catalyzes a pleasurable memory of a real flower. A student of ancient Greece touches a statue and senses something about the Hellenic spirit. An actor is troubled by the worry that she sees written into the lines of a spectator's face. These five scenes—drawn, of course, from the writing of Bain, Spencer, Allen, Pater, and Hardy—reflect intersecting inquiries into the scale of aesthetic response. Each tends to suspend or sideline the human as a unit of analysis, foregrounding instead nerves or animals or parts of the body. Each recognizes as problematic the question of how seemingly instantaneous aesthetic responses may be situated within biological or historical scales of time. Each routes aesthetic experience through the matter of the body and of the object, not entirely foreclosing activities of thought or reflection but momentarily suspending them or insisting on their physical correlates. Together, these events reveal a territory of values for the aesthetic that are grounded in the immediate processes of the body and the nervous system rather than in what John Ruskin would have described as a "theoretical" elevation of mere sensibility or Arnold as the "free play of the mind."[165] The diversity of idioms within which these accounts are formulated—physiological and evolutionary psychology, aestheticism, popular science writing, and the novel—reflects a situation in which heterogeneous knowledge practices shared an aspiration to reshape the unit of analysis for aesthetic theory.

In this chapter I have argued that when the mid-nineteenth-century "naturalization" of the mind that has often been described by historians of science was taken up within aesthetic thought, it called into question the notion that aesthetic experience evokes a higher or distinctively human mode of conscious reflection that would ideally prepare spectators, listeners, and readers to become fully formed subjects within a society or a political state.[166] Instead, various rescalings of aesthetic response had the effect of disintegrating artworks and persons into their constituent, quasi-human elements. This shared questioning reveals a liminal territory between the human and the animal, between the person and the nervous system, and, disciplinarily, between science and literature. While these theories rescaled and redefined the units of analysis within aesthetic theory, they did not abandon the far-reaching narratives of Enlightenment and romantic aesthetics—Kant's account of a distinctively human "free play" of the faculties; Schiller's narrative of an aesthetic education to be realized as an aesthetic state—but rewrote them within the language of scientific naturalism. The new narratives that emerged often addressed the shaping force of aesthetic experience within the deep time of evolution rather than the comparatively shallow time of human

history and explored the capacity of such experience to valorize the animal qualities of human life rather than to offer an escape from them.

From this perspective, nineteenth-century literary and scientific accounts of aesthetic response can be seen as actively questioning what is at stake in structuring aesthetic or cultural theory around bodily affects. Many recent theorists of the relationship between affect and aesthetic experience have examined how affects operate both materially and before consciousness by turning to thinkers who were closely engaged with nineteenth-century scientific psychology and philosophies of mind and perception—including Henri Bergson, William James, and Alfred North Whitehead—but the earlier origins of the physiology of affect and emotion in Victorian intellectuals including Spencer and Bain is rarely explored.[167] The writers addressed in this chapter represent a previous generation of intellectuals whose work on the nervous and physiological basis of emotion addressed issues that have become central to critical and theoretical accounts of the materiality and temporality of affect and emotion. Victorian conceptions of minimal aesthetic response shift this conceptual framework by examining how the apparent immediacy of aesthetic affect either exists within or provides access to scales of time that far exceed that of the individual human life.

This claim can be specified by briefly examining how Victorian theories of aesthetic response approach from an oblique angle a central account of aesthetic affect: Gilles Deleuze and Felix Guattari's chapter "Percept, Affect, and Concept" in their final collaboration, *What Is Philosophy?* Deleuze and Guattari's essay theorizes the distinctions among "thought in its three great forms—art, science, and philosophy" and characterizes the type of thought done by artworks as an ordering of the chaotic world through sensations (rather than through philosophical concepts or scientific functions). The artwork, on this account, is *"a bloc of sensations, that is to say, a compound of percepts and affects."*[168] Exploring epistemological distinctions among art, science, and philosophy and locating the specificity of art in its constitution by sensation (rather than concept or function), Deleuze and Guattari take up a set of questions that were salient to the nineteenth-century scientific inquiry into the arts that I have explored in this chapter. To describe the work of art as a "bloc of sensations" is both to detach affects from an individual subject ("percepts" and "affects" differ from perception or affection in that they exist independently of any individual person) and to dislocate affect into the material domain of art, thereby making affect "durable" through time.[169] Deleuze and Guattari's argument can be understood as a rereading of the notion of aesthetic autonomy in which it is not so much

that art itself is autonomous from extra-aesthetic norms but that art does the work of rendering affects autonomous from subjects. As an instance of this version of autonomy, Deleuze and Guattari refer to the landscapes of Hardy's novels, which dislocate percepts and affects from perceiving or affected human beings:

> The novel has often risen to the percept—not perception of the moor in Hardy but the moor as percept. . . . The landscape *sees.* Generally speaking, what great writer has not been able to create these beings of sensation, which preserve in themselves the hour of a day, a moment's degree of warmth (Faulkner's hills, Tolstoy's or Chekhov's steppes)? The percept is the landscape before man, in the absence of man.[170]

What I have described as Hardy's adaptation of a neurophysiological conception of aesthetic as a feature of nonhuman space here registers for Deleuze and Guattari as an instance of art's capacity to transform "warmth," "sensation," or daylight into a self-sufficient "being of sensation" rather than psychological contents.

This notion of affect as autonomous from individualized subjects has been widely taken up both for its capacity to materialize aesthetic experience as "a reaction in/on the body at the level of matter" rather than as activities of contemplation or reflection and for its unfolding of the possibility that aesthetically reorganized sensations might defamiliarize and even undo a received "sensory-motor delimitation of the perceptual world."[171] Elizabeth Grosz's Deleuzian readings of Darwin and the biologist Jakob von Uexküll have explored how nineteenth- and early twentieth-century biology, refracted through Deleuze, can become the basis for a conception of the arts that reconnects human and animal practices of making things and framing territories. For Grosz, Darwinian sexual selection offers a conception of art as an "intensification" of sensation and as "visceral" rather than "conceptual."[172] Uexküll similarly provides a basis for Grosz's claim that "art is that which most directly returns us to the animal lineage to the extent that art's qualities are not purely bound up with the concepts, meanings and values art represents but instead primarily reside in its capacity to affect and transform life—that is, in what it does more than what it means."[173] Grosz's argument inhabits a distinction between aesthetic force and aesthetic meaning whose complexities were explored by the writers discussed in this chapter—a distinction analogous to that which Jonathan Crary phrases

as a divide between a "semiology" and "physics" of art that was occa-
sioned within French impressionism by nineteenth-century sciences of
perception and attention.[174]

Nineteenth-century inquiries into the temporal scale and material sub-
strate of aesthetic response render what contemporary theorists would
describe as the autonomy of affect in relation to significantly different
temporal scales and relations to the human body. Victorian writers and
theorists not only depict aesthetic activity as a dynamic, embodied, pre-
conceptual event of the sort that Grosz discerns in Uexküll and Darwin;
they also begin to envision the possibility of detaching this event from
a cohesive human subject. But this detachment takes a significantly dif-
ferent shape than it has for recent theorists: not as rendering affect as
autonomous by way of the artwork but rather by conceiving aesthetic
experience itself in terms of events that are partially detached from in-
dividual persons, a detachment effected by the intersection of a neuro-
physiological account of the body with an evolutionary account of deep
time. The types of response framed at the intersection of physiology and
aesthetics are never fully the property of the person who undergoes them
because they are either neurophysiological events whose relationship to
something like a cohesive self can only ever be one of adjacency or they
are evolutionary events that have been transmitted through deep time
by way of millennia of developments and that will therefore persist and
change long after the person who momentarily hosts them. When Spen-
cer asks readers to imagine what it would look like for a dog's aesthetic
sensibilities to evolve, he dislocates the discourse of aesthetics from in-
dividual judgments of taste. It is not just that affect and emotion must
be understood as "hard-wired" (in Bain's physiology) or as evolution-
ary adaptations (in Spencer's psychology) but that, according to writers
such as Spencer and Allen, aesthetic affect makes available an immediate
sense of inhabiting deep time. This makes available a way of understand-
ing the durational scale of affect as both deep and multiple. Where for
Deleuze and Guattari the duration and autonomy of aesthetic affect are
guaranteed by the persistence of the artwork through time, by the pos-
sibility that it can be reanimated at any moment—"in a novel or a film,
the young man will stop smiling, but he will start to smile again when we
turn to this page or that moment. Art preserves, and it is the only thing
in the world that is preserved"—the scientific tradition described in this
chapter instead began to identify the duration of neurophysiological aes-
thetic affects with the time of the species.[175] We can perhaps more fully
understand, from this perspective, why contemporary readers objected

so strenuously to Alexander Bain's identification of "sensation, thought, [and] affection" with events that took place within the nerves, the muscles, and the brain.

From a Science of Beauty to the Outward Mind

In this and the previous chapter, many of the central terms that I have developed—ambience, sensation, response, reflex—might seem to imply a model of the aesthetic in which a human sensorium receives and processes stimuli. This possibility of a physiological, reflexive aesthetics emerged from a natural-theological concern with the ordered relationships between human beings and nature. Among a wide range of intellectuals, it was found to be both conceptually generative and largely unconcerned with an abstract language of faculties. The aspiration toward a science of beauty was often in close dialogue with much broader revisions of nineteenth-century understandings of human emotion, volition, and mental action. A language of the soul was displaced by a language of electrical waves, nervous currents, and adaptations over millennia; this displacement reverberated especially deeply within those discourses, like that of the aesthetic, that had often been called on to distinguish human from animal capacities. In a certain sense, to arrive at a science of beauty was to arrive at a science of the human being as an organism susceptible to stimuli, including aesthetic stimuli.

But if we return momentarily to Hardy's images of Eustacia's hair as an extension of her nerves or of the heath as having a face, we might observe that what is most unsettling about them is not that they reject human specificity outright but that they challenge usual ways of distinguishing between interior and exterior, human and nonhuman: they raise questions about whether subjectivity ends at the limits of one's skin and about the sense in which seemingly nonhuman features, such as landscapes, can take on human qualities. This suggests there is a further possibility within this scientific model of the aesthetic to be explored, one that is not fully captured by what I have here described as a rescaling of aesthetic response or, in the previous chapter, as an idea of form as both mathematical and ambient. To render aesthetic response animalistic or mechanistic, or to think of form as apprehended semiconsciously, might also require a consideration of the ways in which the surrounding matter and objects of the world could themselves become animated or bear human traits. Aesthetic experience might be that experience in which physical things themselves respond to acts of human perception. If one aspect of a physiological language of aesthetic experience is that it draws

attention to the materiality of the human body, it also raises questions about how one conceives nonhuman materiality. In the following three chapters I explore the uncertainty figured by Eustacia's hair. A science of aesthetics not only led to a model of the human as a live sensorium, nor did it merely reveal that thought and emotion were processual, reflexive, and physically embodied. It also began to turn the mind outward into its physical surroundings. Matter itself—hair, landscape, nerves—might become strangely "enminded" (as Walter Pater will reveal); crafted objects might become fungible extensions of the mind (a possibility we will explore by turning to William Morris); and the sense of form might involve transactional projections and introjections of shape across human bodies and aesthetic objects (a notion powerfully articulated by Vernon Lee).

Part Two: The Outward Turn

3 Materiality: Walter Pater and Late-Victorian Materialisms

What did Walter Pater mean when he called the protagonist of his only novel an "Epicurean"? It was not that Marius hedonistically pursued pleasure. In the chapters describing Marius's philosophy, readers are reminded that Epicureanism is also a theory about how one is to live if one takes seriously Heraclitus's doctrine that the "world of . . . objects" is not "stark and dead," but "full of animation, of energy, of the fire of life."[1] But if this world of "sustained, unsleeping, forward-pushing vitality" is intellectually exciting, it is also epistemologically and ethically disorienting: can one really know or care about anything if everything is in constant flux?[2] Pater warns that "the theory that things are but shadows and that we, like them, never continue in one stay, might indeed have made itself effective as a languid, enervating, consumptive nihilism."[3] The resolution of this impasse comes via what Marius calls his "'aesthetic' philosophy," an attempt to counter nihilism by "maintain[ing] a harmony with that soul of motion in things."[4] Marius, Pater observes, is fortunate to live "in an age, still materially so brilliant, so expert in the artistic handling of material things."[5] As it emerges in these key passages of the novel, "aesthetic philosophy" captures the possibility of inhabiting a transformed relationship to a world of vital, animated, and energized

matter. Pater's Epicurus is not a philosopher of pleasure only but of matter as well.

The psychologist James Sully, a contemporary of Pater, contemplated a related question in "Poetic Imagination and Primitive Conception," an 1876 essay on aesthetics that similarly addressed the boundary of life and matter in ancient and modern thought. Extending an argument he had found in Edward Burnett Tylor's foundational anthropology text, *Primitive Culture* (1871), Sully argued that when poets attribute human qualities to natural objects, they participate in the survival of an ancient animistic view according to which "inanimate objects are supposed by the primitive man to be inspired with conscious feeling and will."[6] Animism was not just a feature of poetry, Sully argued; any time one perceives nature aesthetically, one feels it to be "quasi-human."[7] Insofar as this represents a survival of a primitive belief, one might expect Sully to expose it as irrational, but instead he suggests that it is a psychological effect proceeding from the basic nature of human perception and from early childhood experience of mind and matter as inseparable. Even more remarkably, Sully, a close acquaintance of George Eliot, argues that the ability to perceive inanimate objects as alive grounds human capacities for sympathy: "The inanimate object may interest us . . . by seeming to need, if not to make a demand for, our human help, or to appeal to our impulses of caressing love and consolatory pity."[8] For Sully as for Pater, aesthetic experience unfolds a new kind of relationship between the mind and the objects it perceives, a model of consciousness not as dualistically opposed to the inanimate but as suffused by and inseparable from it such that physical things can become objects of sympathy and love.

Within late nineteenth-century portrayals of intense aesthetic experience, it is not uncommon to encounter these transformed affective relationships to a world of things. Indeed, this heightened sensitivity to inanimate objects was regularly parodied. The ironic motif of Henry James's *Spoils of Poynton* is Fleda Vetch's deep attachment to her possessions: "They're living things to me; they know me, they return a touch of my hand," she protests, comically outraged by the possibility of losing them.[9] As though she has read Sully or Tylor, Vetch continues, "There's a care they want, there's a sympathy that draws out their beauty."[10] If, as Bill Brown has argued, James's novel represents one version of modernism's desire to invest things with ideas, in this case by transforming objects into "congealed actions, passionate acts of seeking, selecting, and situating," Fleda Vetch's passion also allows us to understand something about an earlier moment in which the sensitivities of the aesthete

rendered things literally responsive.[11] Nobody more than an aesthete such as Fleda Vetch knows how deeply one might feel what Sully called "caressing love" toward objects.

This frequently repeated scene, in which aesthetic sensitivity seems to endow nonhuman things with agency or consciousness, speaks to many of the issues that I have addressed in previous chapters, but in a different register. Thus far, I have described how discussions of aesthetic experience often served as a means for coming to terms with a significant transformation of nineteenth-century concepts of mind: human consciousness is not immaterial and disembodied but is physically rooted in the brain, nerves, and ganglia of the human body. This notion was both controversial and conceptually generative: it translated Burkean and empiricist models of the aesthetic (as grounded in sensation and perception more than in judgment and rationality) into a concrete language of physiological events potentially susceptible to scientific analysis and perhaps therefore shared by other animals. Here, "the aesthetic" is receptive, physiological, and sensory.

But it was not just that mind was "embodied." Those who explored the physical basis of mind were making a more ambitious claim than had a previous generation of phrenologists and physiologists who had also located mental processes in the brain or the nervous system. That consciousness was the outcome of nervous activity was not in itself a new insight; the more precise formulation would be that "mind" was no longer seen as a bounded, static entity but as a dynamic process of interaction between the physiological system of the human body and its environment. This latter version of a processual and interactive embodied mind was explored by novelists as well as psychologists. Sally Shuttleworth has traced George Eliot's adaptation of George Henry Lewes's theory that mind "comprised the processes of interaction between the organism and medium," especially in *Silas Marner*, which portrays the "disjunction" between mind and environment. Vanessa Ryan has recently observed that "the innovation at midcentury . . . is not simply an ontological one, suggesting that the mind and body are one or that the mind is embodied" but that the mind is a "relational process" of "continuous, learned, and adaptive interplay between organism and environment."[12] The key implication of the new physiological psychology has been widely understood as a powerful dislocation of conscious thought from a realm of abstract rationality to one of physiological processes in ways that had purchase on wide-ranging intellectual endeavors: it mattered not only for the novel but also for political economy; on Catherine Gallagher's account, the new psychophysiology meant that "even the

most cerebral economic operation was assumed to be *sensational*, tinged with actual or anticipated suffering or enjoyment."[13]

Within this line of reasoning, the cultural significance of the embodied, processual model of the mind is understood to be the way that it shifted attention from abstract faculties toward human corporeality. But there was another aspect of the Victorians' increasing awareness of the processual mind that was perhaps even more radical and that we have begun to see in the writing of Pater and Sully. If the erosion of mind-matter dualism meant that even higher-order thought was the product of an interaction between an organism and an environment, it also opened the possibility that those environments might in some sense be sentient. One needed a new understanding not just of mind but of matter as well. Consider how remarkable is the position taken by Sully, an utterly mainstream psychologist, who states that neither common sense nor science can fully "disprove the existence of the mental" behind inanimate objects found in nature, which we commonly experience as a "conviction."[14] Instead of disavowing the animism Tylor described as primitive, Sully makes it central to sympathy, a capacity that according to many distinguished modern, civilized Victorians. At the very moment when scientific materialism began offering explanations of the natural world that conflicted with religious dogma, thus rendering its proponents subject to accusations of materialist atheism, it simultaneously opened onto startlingly speculative theories about matter that were often no less dependent on belief than the religious systems they eschewed. The atheist poet Constance Naden collaborated with the philosopher Robert Lewins to develop a philosophy of "hylo-idealism," which explained the relationship between mind and matter with the figure of "a porous vessel of ice, filled with water, immersed in an infinite ocean" as being as mutually interpenetrating as the "mystic Athanasian Trinity."[15] John Tyndall's Belfast address speculated that human consciousness had evolved from the inanimate matter of the universe in a moment when matter had acquired a sense of touch.[16] In such cases, what was at stake was not merely a notion of embodiment in which mental phenomena are linked to the human body's tissues, nerves, and brain, but an understanding of matter itself as bearing qualities of consciousness.

In this chapter I explore these Victorian notions of materiality as bearing qualities of mind, or as "enminded." The seemingly inanimate stuff of the world could, in certain cases, also be understood as potentially conscious; or, at least, the line between the conscious self and its nonliving surroundings could seem philosophically difficult to draw. Aesthetic theory became particularly significant for this question because it was a

source of potent *Bildung* narratives about how physical environments shaped individual consciousness. As Douglas Mao observes, by the end of the nineteenth century, "aesthetic transactions between subject and world could come to seem paradigmatic of the subtle, secret processes that change the character of every person from minute to minute."[17] While most have approached questions about embodiment from the perspective of human bodies, here I seek to shift that perspective: we ought also to think about implications of the new psychology for the seemingly inanimate matter that surrounds and permeates human beings. To say that physical environments exert shaping power is to attribute to matter itself new forms of agency, new capacities for mediating human action. Philosophers, professional psychologists, poets, artists, and novelists often saw aesthetic experience as opening onto this sometimes animistic world of enminded matter.

Because important articulations of this idea took place at the boundaries of literature, philosophy, and science, I examine a diverse field of late-Victorian writing, from sensation fiction to psychology journals, that shares an engagement with the conceptual problems raised by the notion of enminded matter. At the crux of my argument is a type of short narrative that Walter Pater called the "imaginary portrait." These were vignettes describing imaginary historical persons in which the causal sequence of plot receded in favor of an extended exploration of a mental disposition or personal philosophy. A genre that distilled a person into a linguistic medium, the portrait was especially suited to addressing the complex boundaries of the self and often allowed Pater to consider various accounts of subjectivity. If, as is sometimes noted, Pater's portraits exemplify tendencies common to aestheticist genres—they evoke a relationship between disparate media (narrative and painting), they focus intensely on the surface appearance and sensuous qualities of a surrounding environment, they nostalgically turn to past epochs as more attractive than the Victorian present—then they may also reveal the ways in which the prose genres of aestheticism addressed and transformed key formulations within the debate over materialism.

Readers may be surprised by this claim that one of aestheticism's primary intellectual energies is a resistance to mind-body dualism. Aestheticism has often been associated with irony, disinterest, and detachment, stances that deepen the chasm between subject and object and that strongly articulate distinctive subjectivity by means of highly individualized aesthetic judgments. Amanda Anderson, for example, views Oscar Wilde's epigrams as exemplifying "reflective distance and radical freedom"; the Wildean aesthete pursues an Arnoldian ideal of disinterestedness in such

an extreme fashion that this pursuit itself becomes an expression of self-cultivation.[18] In a parallel line of reasoning, the autonomy of art is often associated with the autonomy of the bourgeois consumer, as in Peter Bürger's account of the avant-garde or Regenia Gagnier's description of the secret intimacy of aesthetic value with economic value.[19] Related readings of Pater often use terms such as *solipsism, subjectivism,* or *impressionism* to emphasize a withdrawal from the world into an inner space of consciousness.[20]

But at the core of Pater's aesthetic thought is an attempt to think beyond oppositions between persons and things. The perceiving aesthete, made up of currents of energy that course through muscle fibers, nerves, eyes, and skin, is often so radically physicalized that it is able to experience genuine forms of sympathy, community, and affective attachment to a world of objects. Pater's injunction to discriminate the aesthetic properties of an object commonly inhabits a tension with his awareness that the self is not a metaphysical entity apart from the world of physical matter but a contingent image overlaid on that world. His writing keeps in play the possibility that the "clear perpetual outline of face and limb is but an image of ours."[21]

These powerful transformations of ideas about matter become especially clear when Pater's work is read alongside related positions regarding materialism that were taken up by late-Victorian philosophers and psychologists. Not only for Pater but also for many of his sympathetic contemporaries, the turn to aesthetics was less about cultivating and performing a distanced stance than about directly experiencing the fascinatingly elusive cohabitation of mind and matter. In the portraits, this takes place at the level of writing. Even as Pater explores the complexities of philosophical materialism, his prose transforms its precepts into a readerly experience both through the cognitive difficulty of his accretive style and his tendency to linger over ekphrastic description. Attending to these features of Pater's writing, in this chapter I reconsider the relationship between Pater's materialism and impressionism. Most readers have understood Pater's materialism as a reinforcement of solipsism: the network of physical forces displaces a network of social relationships. By contrast, I argue that to experience oneself as a point of matter within a network is to experience the world of things itself as a social world.

It is not by accident that these aesthetic models of subject-object relations—or, rather, of the failures of this binary—strikingly resonate with recent work in anthropology, science studies, and cultural theory that has argued for a reexamination of assumptions that nonhuman things are passive and inert. When Sully considered the implications of Tylor's

discussion of animism for aesthetic theory and poetics, he was taking part in a foundational disciplinary moment that has recently been revisited by theorists including Bruno Latour and Philippe Descola, who have argued that an originary gesture of anthropology was to portray as alien those cosmologies that differently configured the relationship between human and nonhuman.[22] Also at this moment, George Levine has argued, an ethos of self-effacement aligned Paterian aesthetic judgment with forms of scientific objectivity that intensified distinctions between subject and object in observation and experiment.[23] But the aesthetic attitude was not always a direct analogue of detached scientific judgment. It also gave access to modified experiences of animism that were increasingly excluded by scientific epistemologies. Even as anthropology was describing alien configurations of the human/nonhuman divide and scientific practice was moving toward modes of observation and experiment that valued the effacement of individual subjectivity, the aesthetic preserved a place where one could think the Latourian thought that "in addition to 'determining' and serving as a 'backdrop for human action,' things might authorize, allow, afford, encourage, permit, suggest, influence . . . and so on."[24]

Beyond Embodiment in Sensation Fiction

When Pater and Sully considered the close relationship of aesthetic experience and materialism, they were taking up a question that had been powerfully raised, though in slightly different form, within discussions of sensation fiction in the 1860s. Most famously, Henry Mansel's 1863 review of twenty-four sensation novels warned that the novels were "usurping . . . a portion of the preacher's office . . . by 'preaching to the nerves.' It would almost seem as if the paradox of Cabanis, *les nerfs, voilà tout l'homme*, had been banished from the realm of philosophy only to claim a wider empire in the domain of fiction."[25] A regular reader of the *London Quarterly Review* might well have recognized in this passage an accusation of a specific type of materialism. *Les nerfs, voilà tout l'homme* was an eighteenth-century slogan of those who denied the existence of soul or spirit. A few years prior, the same magazine had published an article on eighteenth-century French philosophy (perhaps also by Mansel) that described the "monstrous conclusions" of Pierre Jean George Cabanis as dangerously attractive. Developing Julien Offray de La Mettrie's more famous notion of the "man-machine," Cabanis resolved the mind/body problem by arguing that mental causes were of the same nature as physical causes. It is Cabanis who invented a notorious

metaphor of thought as a mere secretion of the brain, described by Thomas Henry Huxley as a "shibboleth of materialists."[26] Thinking was as physiological as digestion; the brain worked like the stomach: Cabanis wrote all of this "with a power and depth of observation that make us regret all the more that so eminent a thinker should have endorsed opinions destructive alike of morality, religion, and liberty," lamented the *Review*.[27] Or a reader might have recalled G. H. Lewes's 1857 history of philosophy, which praised Cabanis as an early pioneer of physiological psychology whose insights provided the point of transition from Enlightenment psychology to Franz Josef Gall's phrenology.[28] The genre of sensation fiction can be understood by way of its subject matter (bigamy, incest, madness, adultery), its formal qualities (the privileging of plot over character, the adaptation of gothic to domestic realism), or even its success at converting the novel into a market commodity.[29] Mansel begins one of the most important descriptions of the genre by reminding us that sensation fiction purveys a philosophy.

But what, exactly, was this philosophy? Mansel's phrase "preaching to the nerves" has been widely interpreted as linking the genre to a nerve-based model of mental life: as Alison Winter has shown, many Victorian readers felt that *The Woman in White* was a compelling novel in a very literal sense. It was seen as directly engaging "lower" mental processes of the nervous system, thereby producing a state of rapt, involuntary attention that "extended over a vast population to form one giant reflex in the social body of readers": mesmerism at a distance.[30] Among literary critics, this process has frequently been understood from a Foucauldian perspective in which reflexive reading does significant ideological work. D. A. Miller memorably described sensation fiction as performative rather than narrative; it is not so much that you read the book as that it happens to you physically, and it thereby short-circuits distanced, reflective judgment.[31] The inclination to read sensation fiction as subtly purveying ideologies of gender and mental health partly stems from the fact that a critical reevaluation of sensation fiction took place in tandem with a political turn in literary criticism that drew on Foucault's conception of bodies as sites of textual inscriptions of legal, sexual, and psychiatric power—"a social-constructionist view of the body as a text and gender as a reading," as Pamela Gilbert described her approach to the sensation genre.[32] This literary-critical coincidence has had a lasting effect on what it has meant to talk about "embodiment" in these texts.

But perhaps the very features that made sensation fiction a productive site for Foucauldian critics also make it amenable to newer ap-

proaches to materialism and ontology, which in Jane Bennett's terms pivot from Foucault's "conglomerates of *human* designs and practices ('discourse')" to further consider "the active role of *nonhuman* materials in public life"—and, the literary scholar might add, in fiction.[33] What this might mean is that beyond thinking about how the human bodies within sensation novels bear normative discursive constructions, one might turn attention to how the genre equally tends to produce antidualistic accounts of mind and body, human and nonhuman, organic and inorganic. Sensation fiction would begin to look less like a genre that embodies minds and more like one that enminds matter.

Recall, for example, the first appearance of Laura Fairlie in *The Woman in White*, the genre's most famous scene. "Appearance," however, is the wrong word. The woman in white, despite the title's emphasis on the visual, enters the narrative in a tactile fashion. Walter is, like La Mettrie's man-machine, moving mechanically, visually withdrawn from his surroundings as he imagines the appearance of other women, and in this state, he recounts, his blood is stopped by Laura's touch:

> I had mechanically turned in this latter direction, and was strolling along the lonely high-road—idly wondering, I remember, what the Cumberland young ladies would look like—when, in one moment, every drop of blood in my body was brought to a stop by the touch of a hand laid lightly and suddenly on my shoulder from behind me.[34]

Is this a physiological or a mechanistic model of consciousness? To be sure, Collins describes Walter's blood, but he also portrays forces resonating through bodies in ways that reconfigure and even challenge distinctions between the animate and inanimate. What is literally described is notably absent of any notion of psychological interiority; indeed, physical interiority ("blood") displaces an expected description of what Hartright might think or feel. The scene that Collins stages is one in which a causal sequence of events takes place almost fully independent of interiorized notions of volition or consciousness, from the "mechanical" turn to the stopped blood, itself a direct result of the contact of a hand that remains divorced from the person for which it is a metonym. It is almost as though the scene is narrated by a thing rather than a person.[35] This, perhaps, is what Mansel had in mind when he accused the genre of resuscitating eighteenth-century mechanism. Mansel was a philosophically sophisticated literary reviewer who defended Oxford idealism and

who had been pondering the unity of the self since childhood, according to one biographer.[36] When he accused these novels of revitalizing mechanistic models of the human, then, he did more than reveal their investment in physiological psychology; he situated sensation fiction within a philosophical lineage investigating the boundary between physical cause and human action.

Sensation fiction has so often been read in relation to the signature features of nineteenth-century cultural and technological modernity—the proliferation of print, the rise of railway travel, what Collins called the "unknown public" of working-class readers, the commodification of the novel as a form—that scholars have usually overlooked what Mansel states directly in the opening sentences of his review: the genre is equally a return to a philosophical conception of the human as machine that had guided mechanistic strands of Enlightenment psychology. What might it mean, then, to take Mansel at his word and read the genre of sensation fiction as inhabiting the logic of eighteenth-century mechanical models of the self? Throughout popular sensation novels, descriptions of physical events, such as this famous one in *The Woman in White*, displace psychic interiority. In Mary Braddon's *Lady Audley's Secret*, when Lady Audley is fatigued by her servant Phoebe's extortionate demands, she "put her hands to her forehead, clasping her slender fingers across her brow, as if she would have controlled the action of her brain by their convulsive pressure."[37] In Ellen Wood's *East Lynne*, when Barbara Hare is kissed by Mr. Carlyle, we read that "all her veins were tingling, all her pulses beating; her heart was throbbing with its sense of bliss."[38] Adopting language that Robert Buchanan would also use to describe Pre-Raphaelite poetry, Margaret Oliphant (in a review that happened to precede an article on atomic physics) objected to the intense corporeality of sensation fiction, whose heroine typically "waits now for flesh and muscles, for strong arms that seize her, and warm breath that thrills her through, and a host of other physical attractions."[39] Like many Victorians, the first thing many contemporary readers see within these passages is a barely repressed eroticization of bodies.[40] But perhaps equally scandalous—as Mansel suggests—was the way in which they call attention to the mechanical actions of human bodies, insistently reminding readers of their thingly being. The action in any given scene is as often the movement of matter or of strangely autonomous body parts as it is the behaviors of a recognizably unified person motivated by disembodied volition. Beyond the Foucauldian insight that bodies are discursively constructed, sensation fiction begins to reveal the uncanny activities and agencies of a nonhuman world.

The Return to Lucretius

If the materialism of sensation novels had to be called out, there were many materialisms in the following decade that announced themselves more directly. Many late-Victorian intellectuals who embraced scientific naturalism, who published in free-thinking, progressive journals such as the *Westminster Review*, and who publicly or privately renounced religious belief made a further speculative leap: they attributed mind to physical matter itself.[41] Their reference points were both modern and ancient, but a common touchstone was Lucretius's *De rerum natura*, which celebrates the Epicurean view of the world as made up of tiny atoms of matter. If, as Lucretius proposed, all action was caused by the physical collisions of these atoms with one another and not by fate or divine intervention, then religion was superstition incompatible with natural philosophy. For this reason, his name became an especially controversial reference point in late-Victorian debates over scientific materialism.[42] When the classicist Hugh Munro produced a new translation of Lucretius in 1864, the product of fifteen years of research with manuscripts at the Vatican and other libraries, his work was widely anticipated among scholars, but few initially imagined that the text would become central to broader intellectual debates. The *Contemporary Review* concluded its notice of Munro's translation by remarking that *De rerum natura* contained "subject-matter deficient in human interest. . . . Lucretius will be a popular writer when Virgil, Horace, and Ovid are forgotten—'and not till then.'"[43] The *Spectator*, however, sensed that Munro spoke to a very modern question "which is debated in France at this moment every day, viz., 'Whether poetry in the highest sense and materialism are compatible.'"[44]

The *Contemporary* reviewer could not have been more wrong. Lucretius was soon widely popular because his theories appeared just as prescient to Victorians as they had to Renaissance humanists. Early in the century, John Dalton had theorized that tiny, indivisible atoms bonded together to make a finite number of elements that, in turn, formed the basis of all matter. In 1874, John Tyndall delivered his famous Belfast address, in which he connected the atomic theory to Lucretius, Epicurus, and Democritus, presenting it as a reawakening of ancient thought. Numerous articles on Lucretius marveled at the Roman's prescience: prominent men of science espoused Lucretian thought, while religious thinkers cleverly argued that flaws in Lucretius's reasoning exposed, by extension, flaws in the scientific materialisms of the 1870s. Fleeming Jenkin, a pioneering telegraph engineer, wrote that Lucretius's theories

are "either certainly true, or . . . foreshadow in a remarkable way doctrines since held by most eminent naturalists." John Addington Symonds, Jr., wrote that "the most modern theories of evolution and of molecular structure . . . [are] singularly like that of Lucretius. . . . The Roman poet has expressed . . . the lines of thought adopted by our most advanced theorists."[45] Alfred Tennyson read Munro's translation and notes before writing "Lucretius" (1868), which imagines the ancient poet so haunted by his materialist philosophy that he commits suicide—a moment that is commonly read as taking the implications of the scientific view of nature described in *In Memoriam* as "red in tooth and claw" to its dismal conclusion.[46] By 1876, when Robert Buchanan published one of the most important essays on the subject, "Lucretius and Modern Materialism," these ideas were utterly familiar. Buchanan makes reference to an entire "literature of Atomic theory newly set before us . . . all, doubtless, fresh in the minds of our readers"—so fresh that "it would be supererogatory to describe the atoms in further detail."[47] The audience of the *Fortnightly* is not only familiar with Greek atomism; their intellectual environment is thoroughly saturated by it.

Lucretius's thought, as we see in Tennyson's poem, seemed peculiarly resonant with ethical, religious, and scientific questions that otherwise seemed specific to the self-consciously modern nineteenth century.[48] (Lucretius continues to generate theoretical resonance. Lucretius's notion of the *clinamen*, or unpredictable swerve, plays a key role within the thought of Gilles Deleuze and Michael Serres, and literary scholars including Jonathan Goldberg, Stephen Greenblatt, and Gerard Passannante have turned to Lucretius to reconsider histories of sexuality, secularism, and the early modern transmission of knowledge.)[49] Even as Lucretius was praised for anticipating Dalton's theory, detractors pointed out the slipperiness of the slope from Lucretian materialism to hedonistic atheism. William Hurrell Mallock's novel *The New Republic*, which pillories aestheticism, also takes aim at materialism, portraying it as piggish irreverence. One scandalized character remarks that " 'the Bishop . . . told us that all the teachings of modern irreligious science were simply reproductions of . . . Epicurus and Democritus—which had long ago been refuted.' 'Ah!' " replies another, " 'materialism once came to the world like a small street boy throwing mud at it [and] it has now come back again dirtier than ever.' "[50]

Although discussions of the Lucretian revival have tended to focus on its significance for physics and ethics, it also inflected changing conceptions of the human mind.[51] Negative responses to Lucretius strikingly mirrored the negative responses to physiological psychology that I have

described in the previous chapter, and, at a moment when psychology was still disciplinarily porous, proponents of atomic materialism often speculated with authority about the nature of the mind. In 1878, the Cambridge mathematician William Kingdon Clifford proposed that the entire universe was made up of what he called "mind-stuff." In his essay "On the Nature of Things-in-Themselves" (1878), Clifford explained that "a moving molecule of inorganic matter does not possess mind, or consciousness; but it possesses a small piece of mind stuff. . . . When matter takes the complex form of a living human brain, the corresponding mind-stuff takes the form of human consciousness."[52] Clifford thus tweaked a classic idealist position that mind is the ultimate reality. What we experience as our immediate "material universe" is merely an "imperfect representation," a "picture in man's mind of the real universe of mind-stuff."[53]

This conceptual framework affords a conception of a thinking person as an assemblage of matter and forces. John Masson, a proponent of Lucretius's thought, described Clifford's views in a way that reveals the close intimacy between the physiological theory of mind that was elaborated by scientific psychologists and the speculative theories of philosophical materialists: "along with every fact of consciousness in our mind, there goes some disturbance of nerve-matter. When a man is conscious of anything, 'there is something outside of him which is matter in motion, and that which corresponds inside of him is also matter in motion.'"[54] Clifford, Masson writes, "builds up Mind of a multitude of mind-atoms, that is to say, of elementary feelings which can exist by themselves as 'individuals,' . . . much as can the Lucretian atoms. . . . The reasoning of both [Clifford and Lucretius] is substantially the same."[55] Lucretius did not only signify atheism. He represented a bold scientific theory that the mechanisms of life are not fundamentally different than the mechanisms of inanimate physics.

This dynamic conception of matter represents one facet of a wide-ranging reconsideration of the nature of materiality itself. This was most extensively formulated by John Tyndall, whose 1874 address in Belfast to the British Association for the Advancement of Science constructed a teleological intellectual history of materialism that began with Democritus, Epicurus, and Lucretius and received its most sophisticated formulation in the thought of Charles Darwin and Herbert Spencer. Taking inspiration from Giordano Bruno, Tyndall theorized matter as "not the mere naked, empty *capacity* which philosophers have pictured her to be, but the universal mother who brings forth all things as the fruit of her own womb."[56] Importantly, as Ruth Barton has argued, this was

not unvarnished mechanistic materialism but a "particular pantheistic version of scientific naturalism" that left ample room for "the universe as living and mysterious."[57] Tyndall's lecture culminated with a tour de force account of the phenomenon that would seem most difficult to materialize: human intelligence. In fact, Tyndall argues (following Spencer) that consciousness is an evolutionary refinement of "a kind of tactual sense diffused over the entire body" that is possessed by even the smallest organisms.[58] The human power of thought has evolved from the sense of touch; when Lady Audley makes the attempt to "control the action of her brain by [her fingers'] convulsive pressure," she appears to sense the relationship between touch and thought that grounds Tyndall's schema.[59]

The poet Constance Naden (remembered by Herbert Spencer as second only to Eliot among female intellectuals) joined the philosopher Robert Lewins to propose an even more speculative doctrine called Hylo-idealism, an antidualistic theory of mind and body. Like Tyndall, Naden and Lewins figured matter as the matriarch of the universe; like Clifford, they suggested that human perception gives matter its existence. In her poem "The Nebular Theory," Naden rewrites Genesis from a Lucretian perspective:

> This is the genesis of Heaven and Earth.
> In the beginning was a formless mist
> Of atoms isolate, void of life; none wist
> Aught of its neighbor atom, nor any mirth
> Nor woe, save its own vibrant pang of dearth;
> Until a cosmic motion breathed and hissed
> And blazed through the black silence; atoms kissed,
> Clinging and clustering, with fierce throbs of birth,
> And raptures of keen torment . . .
> .
> . . . and thus the world was formed.[60]

Naden glosses the opening sentences of Genesis, resituating the biblical verses within the intellectual matrix of atomism. In part, this poem reflects Naden's habit of situating materialism itself as a new system of belief. As Charles LaPorte has noted, Naden's philosophy "does not merely describe reality, but redeems it."[61] Naden's lines repeatedly shift emphasis from divine performatives to the causal agency of atoms. Life is not called into being by the breath of God but violently erupts from a

hissing "cosmic motion" that recalls Lucretius's unpredictable swerve, described in *De rerum natura* as a similarly violent origin of the world. Without the swerve, "no clashing would have been begotten nor blow produced among the first-beginnings: thus nature never would have produced aught."[62] But a key difference between Naden and Lucretius is that for Naden, the atoms themselves bear the kernels of consciousness; even before the world-producing swerve, they are aware of their own "vibrant pang of dearth." The violent clash of atoms is eroticized: biological and physical generativity collide as atoms, "clinging and clustering," undergo Swinburnean "raptures of keen torment." As had Swinburne in several infamous lines of *Anactoria*, Naden provocatively heightens the conflict between materialism and Christianity: emphasis in the poem's first line falls on "this" new genesis revealed by science rather than some other. Here and elsewhere, Naden and Lewins embraced unabashed irreligious materialism of the sort denounced by believers. In an essay on Hylo-idealism, they argue that readers should "behold in the orderly arrangements of the Cosmos only a supreme glorification of matter, the universal mother of man and her child. In the gray cells of the cerebral cortex are generated not only the visible heaven, 'this majestical roof . . . ,' but the poetic sense of its beauty and harmony."[63] Hylo-idealism gained enough currency that Oscar Wilde subtitled his short story "The Canterville Ghost" "a Hylo-Idealistic Romance."

Like sensation novels, whose materialism extended well beyond physiology, responses to Lucretius adumbrated a new way of thinking about matter at the limits of embodiment. Atoms were imagined to think; the heavens were an artifact of the gray matter of the brain. Recent scholarship has most often understood Victorian concepts of embodiment in terms of the relationship between consciousness and the human body. William Cohen, for example, opens his book on embodiment in Victorian literature with the question "what does it mean to be human?" and continues to describe the subversively antihumanist effects of Victorian writing that located the essence of the human in the physical body rather than the soul or mind. But writers such as Clifford, Tyndall, Naden, and Lewins reveal a further turn of the screw, taking up a perspective from which "embodiment" may not be a sufficient term. They suggest that the questions at stake for many forward-looking thinkers had to do with what we might call "enminded bodies" or even "enminded matter." What is at stake in these theoretical positions is not just the notion that thought is reducible to the brain or a Cabanisian "secretion" of it. Instead, it is that matter itself bears qualities of mind, a possibility that,

though perhaps difficult to imagine, remains an area of inquiry among contemporary philosophers of mind including Thomas Nagel, David Chalmers, and Galen Strawson.[64]

For many, physicalist explanations represented an avenue from older superstitious or "metaphysical" systems of knowledge to the modern scientific positivism described by Auguste Comte, whose work had been widely taken up by Victorian intellectuals following Harriet Martineau's 1853 translation of the philosopher's writings. On Comte's account, later derided but widely influential at the time, metaphysics was a middle stage of knowledge in which "personified abstractions" took the place of an earlier belief in supernatural beings; a third moment would turn exclusively to inductive, verifiable explanation.[65] Crucial to positivism, Peter Melville Logan points out, was not just induction from empirical observation but a recognition of the relative status of scientific knowledge: science was not certain but predictive.[66] Comte's tripartite model allowed writers to dismiss many philosophical positions as "metaphysical" and therefore retrograde: these included Kant's categories of space and time that conditioned our knowledge of the world as well as associationism and faculty psychology. In his magnum opus, *Problems of Life and Mind*, George Henry Lewes, an avid reader of Comte, explained that new sciences of the mind do not wish to enter into a dialogue with previous philosophy; they wish instead to destroy it. Lewes writes, "at present Metaphysics is an obstacle in our path: it must be crushed into dust, and our chariot-wheels must pass over it."[67] Throughout the pages of *Problems of Life and Mind*, Lewes associates metaphysics with sorcery, seduction, forbidden fruit, and secrecy. Science, by contrast, is figured as the bright light that promises to eliminate metaphysical obscurity and nebulousness. The German psychologist Wilhelm Wundt called metaphysical philosophy a "remnant of earlier stages of development."[68] As one might expect from his antipathy toward sensation fiction, Mansel was on the opposite side of this debate, having written the entry on "metaphysics" for the *Encyclopedia Britannica*, a subject that he described in an 1883 book as having its "foundation in some of the deepest needs of human nature."[69]

Walter Pater's first published essay, "Coleridge's Writings" (1866), reveals his affinity with a version of the antimetaphysical position. The essay portrays Coleridge as having been unfortunately committed to abstract systems and laws at a moment when the modern "relative" spirit was taking the place of the "absolute."[70] Coleridge tries "to apprehend the absolute, to stereotype one form of faith, to attain, as he says, 'fixed principles' . . . refusing to see the parts as parts only."[71] In a later revision

of the essay, Pater made clear what *absolute* meant, using language that Lewes certainly would have agreed with: Coleridge, Pater writes, was in thrall to "the abstract and metaphysical fashion of the transcendental schools of Germany."[72] Although Pater was himself a careful reader of these "transcendental schools," he also worked to revise and transform metaphysics by way of what he called the relative spirit. This was less a theory than a temperament or personality that valued dynamism and contingency over ideological purity: "The relative spirit, by dwelling constantly on the more fugitive conditions or circumstances of things, breaking through a thousand rough and brutal classifications, and giving elasticity to inflexible principles, begets an intellectual finesse,"[73] and, even, a more generous ethical sensibility. This is a Comtean sentiment that would be echoed just over a decade later by Naden and Lewins, whose anti-Kantian Hylo-idealism "deals alone with the relative, ignoring the absolute as utterly beyond human *gnosis*."[74] Physicalist theories of mind reveal a bridge between two points that are usually widely separated on maps of Victorian literature: sensation fiction and aestheticism. Sensation fiction resisted metaphysics by substituting a bodily state for the thought or feeling to which it corresponded, attenuating the distinction between mind and matter. Pater did so by way of a "relative spirit" that resisted coarse classifications. This may lead one to wonder: what kind of sensation fiction would an aesthete write?

Zero Equals Zero: Abstraction and Self-Effacement in Pater's Portraits

It would be difficult to imagine a narrative genre further removed from sensation fiction than the one that Pater called the "imaginary portrait." Pater explained the genre to his publisher as one that frustrates a reader's expectation of narrative sequence: "it is not, as you may perhaps fancy, the first part of a work of fiction, but is meant to be complete in itself; though the first of a series . . . with some real kind of sequence in them. . . . I call the M.S. a portrait, and mean readers, as they might do on seeing a portrait, to begin speculating—what came of him?"[75] If sensation fiction such as Collins's *Armadale* had taken the causal sequence of plot to extremes never before seen—one review called it a "lurid labyrinth of improbabilities"—Pater's portraits follow a paratactic sequence that Pater himself cannot even define; they are beginnings without ends or even middles, ambiguously related by "some . . . kind" of sequence.[76] And yet, if one's aim is to understand the relationship between mind and matter or the boundaries of consciousness, then a descriptive genre

focused explicitly on the nature of personal identity might also seem uniquely appropriate.[77]

In one sense, almost all of Pater's writing can be thought of as portraiture; much of *The Renaissance*, for example, describes the temperaments of individual artists, and his first essay, "Diaphaneitè," likely inspired by Pater's friend Charles Shadwell, describes a beautiful individual who transcends his historical moment. But Pater wrote about ten explicitly fictional portraits, and they were popular, at least by the standards of Pater's work; by 1910 they had been translated into more foreign languages than any of his other writing.[78] As a genre, the portrait is suspended between opposites. The subjects are fictional, but they live in historical contexts and interact with people who did actually exist. Max Saunders describes the originality of Pater's genre as its "fusing specifically of the fictional and the auto/biographical."[79] The portrait is a linguistic medium, but it strives toward the condition of painting by way of repeated descriptions of scene and landscape. Pater's portraits are formally similar to a popular feature of Victorian periodicals, brief biographies of famous historical personages, but they also transform this genre by fictionalizing persons who stand in for ideas or philosophical positions.

Reviewers recognized many of these unusual features of Pater's fictional narratives. Writing about *Marius the Epicurean*, Pater's longest portrait, J. M. Gray observed in the *Academy* that "the visible, the tangible, its descriptions of men, of landscape, are especially varied and beautiful"; one chapter is "a very Tadema in its perfection of finish"; each sentence "has been often touched by the file."[80] G. E. Woodbury wrote for the *Nation* that Marius's "is not a vital life, but a painted one; and there is an inconsequence in the series of pictures—they do not seem to follow one another by any iron necessity."[81] Readers saw that Pater had refused the forward motion of plot in favor of a painterly, sculptural style that evoked sight and touch. Pater's friend Andrew Lang likely had him in mind when he wrote his "Ballade of Railway Novels" (1884), which repeats Gray's metaphor of "filed" prose and suggests that the sensation novelist Mary Elizabeth Braddon might be a better companion for a train journey: "Let others praise analysis / And revel in a 'cultured' style," Lang writes, and then asks,

> Oh, novel readers, tell me this,
> Can prose that's polished by the file,
> Wet days and weary ways beguile
> . ?

No, Lang answers; it is writers like Braddon who have "made the slow time fleetly flow."[82]

But Lang's opposition is too simple. Pater's portraits had somatic effects on their readers; it is just that they were different from those that ensued from exciting plots. Margaret Oliphant's 1862 essay on "Sensation Novels" abhorred "the violent stimulant of serial publication."[83] In 1885, John Addington Symonds inverted this concern as he worried about the effect of Pater on his nerves. Reluctant to read it, Symonds complained to the poet Mary Robinson, "My brain is so badly made . . . that I cannot easily bear the sustained monotonous refinement."[84] Writing from Switzerland, Symonds tells Robinson that he is waiting to read the novel in a Venetian lagoon, whose "languor" and "largeness" accord better with Pater's style than the mountains, where "everything is jagged & up & down & horribly *natural*."[85] A week later, he complained to the philosopher Henry Sidgwick, "I shrink from approaching Pater's style, which has a peculiarly disagreeable effect on my nerves—like the presence of a civet cat."[86] Like Henry Mansel, Symonds knows that fiction can preach to the nerves. But with regard to Pater, it is not the jarring movements of plot that disturb; it is the very placidity of the prose.

At a formal level, then, sensation fiction and the imaginary portrait both seem to invite reflection on the somatic dimensions of reading. In this sense, they return attention to the materiality of the immaterial, but as a matter of form more than of philosophy. The philosopher Cynthia Freeland has recently suggested that one characteristic of the portrait as an artistic genre is that it persistently raises the mind-body problem: portraits make viewers think about how something like personality or identity is rooted in skin, tissue, eyes, even clothes and possessions.[87] This is often true of Pater's literary portraits as well. They are frequently about the ways in which minds are attached to bodies and about how individual persons sometimes inhabit a permeable relationship to their physical surroundings.[88]

In the portraits, aesthetic objects often function as a privileged site for working out the points of connection between consciousness and matter. If for Hegel art is a reflection of subjectivity in sensuous form, for Pater this means that the arts extend one's inward life into surrounding substance. In "Duke Rosenmold," Pater describes the title character as "thrown the more upon such outward and sensuous products of mind— architecture, pottery, presently on music" while finding in books "a dulness, a distance from the actual interests, of the warm, various, coloured life around and within him."[89] And yet, even as Rosenmold draws on a Hegelian notion of art as subjectivity made sensuous, he also echoes a

Victorian resistance to Teutonic metaphysics: he wonders, "was German literature always to remain no more than a kind of penal apparatus for the teasing of the brain?"[90] This opposition of physicalism and abstraction is frequently at stake in these short pieces and is articulated especially clearly in "The Child in the House," an autobiographical account of Pater's suburban childhood, and "Sebastian Van Storck," a depiction of the life and death of a young seventeenth-century Dutch idealist who aspires to reject sense experience and live only in the mind.

"The Child in the House" has long held a privileged position among Pater's writings both because it offers a glimpse of the famously reticent Pater's own childhood and because it articulates a theory of subject formation that represents a point of origin for modernist literary impressionism. Pater himself accorded it special significance on one of the scraps of paper he used for taking notes: "Child in the House: voilà, the germinating, original, source, specimen, of all my imaginative work."[91] The framing device hints at its autobiographical tenor; Florian Deleal, about forty years old, like Pater, is walking down a road one day when he meets an old man who tells Florian his life story. The man happens to mention the suburb in which Florian grew up, which causes Florian later to vividly dream of his childhood house and, upon waking, to take up "a certain design he then had in view, the noting, namely, of some things in the story of his spirit—in that process of brain-building by which we are, each one of us, what we are."[92] The ensuing narrative is not a causal sequence of events but a layered set of descriptions of Florian's childhood thoughts and feelings that recounts experiences alongside statements of Florian's beliefs about philosophy, religion, and beauty so as to constitute what Carolyn Williams has described as a "little parable of identity formation."[93]

At the core of what is often described as the impressionism of "The Child in the House" is an attempt to work out some of the questions about the relationship between self and substance that were framed in more polemical terms by writers such as Tyndall, Clifford, and Naden as they positioned themselves against "metaphysics."[94] Pater describes the process of becoming an aesthete as involving a heightened sensitivity to objects of all sorts: "the realities . . . of the greater world without, steal in upon us, each by its own special little passage . . . and never afterwards quite detach themselves from this or that little accident . . . in the mode of their first entrance to us."[95] This process is as contingent as it is inevitable. Pater writes that Florian's childhood had "determined" in him a "peculiarly strong sense of home" and in general that "so powerful is this instinct, and yet accidents like those I have been speaking of so

mechanically determine it. . . . Out of so many possible conditions, just this for you and that for me" happens to decide what physical objects—a white curtain, a shaded lamp, a folding tent—will induce nostalgia.[96] The material accretion at the center of this theory of subjectivity is most evocatively expressed by the metaphor that Florian uses to describe his personal history, "brain-building." On the one hand, this implies that the personality is in some sense the organization of physical substance, that to know one's history is to know one's nervous system. But placed within a story titled "The Child in the House," this metaphor of brain-building connotes not only a process but also an edifice: perhaps we are all "brain-buildings." Instead of a personality, spirit, or soul, Pater is thinking about *Bildung* in a way that includes corporeal architecture.

The corollary of the idea that one's mental life is produced through susceptibilities to surrounding persons and objects is that agency in subject-object relations is reversible. Pater often describes beautiful objects as exerting a sort of pleasurable "tyranny" over Florian (Pater often refers to beauty as tyrannical). Pater notes that Florian recognizes a sensitivity developing during his childhood to "the visible, tangible, audible loveliness in things, as a very real and somewhat tyrannous element in them" and later finds that he experiences an "at times seemingly exclusive, predominance in his interests, of beautiful physical things, a kind of tyranny of the senses over him."[97] Beauty therefore becomes a mechanism for physicalizing thought; Pater writes of "the necessity he was under of associating all thoughts to touch and sight."[98] This notion that thinking occurs in relation to a physical environment—rather than (only) in one's head—represents one of Pater's characteristic reversals: against religious and philosophical traditions that privilege abstract thought over mere sense, Pater locates thinking itself in the world of "touch and sight."[99] Appearance is not the deceptive mask of essence, but its expression.

This story of aesthetic development is significant not only at an autobiographical or literary level, as revelatory of Pater's youth, or as a key to later forms of impressionism. It also provides the means for revising an Enlightenment alignment of freedom and autonomy with human value. For Pater, this idea depends on a mind/body dualism that nineteenth-century thought has eroded. But Pater is able to articulate the promise of materialism in terms that diverged from many scientific materialists. For the aesthete, at least, recognizing the corporeal mediation of thought enables a fuller relationship to surrounding objects that share this physical existence: Pater writes that Florian has developed a "sympathetic link between himself and actual, feeling, living objects."[100] If materialist

determinism erodes freedom, then, Florian is compensated by finding himself in a world where objects, enlivened and invested with feeling, become sympathetic companions. Against someone like Mallock, whose novel denigrated materialism as a philosophy of dirt, Pater shows that Florian's materialism heals a modern split between mind and world, subject and object. This philosophy inheres in the genre of the literary portrait, as Wilde—who would later write the Western literary canon's most famous portrait—pointed out in his review of Pater's *Imaginary Portraits*: "it is to a desire to give a sensuous environment to intellectual concepts that we owe Mr. Pater's last volume. For these Imaginary . . . Portraits of his, form a series of philosophic studies in which the philosophy is tempered by personality."[101] Similarly, Arthur Symons described the subjects of the portraits as "puppets of an artist and a philosopher" rather than as fictional characters that "live and move."[102] These were discerning readers. At the core of Pater's new genre was the formal principle that fiction materialized abstraction.

The contrasting fate of the unfortunate protagonist of another imaginary portrait, Sebastian Van Storck, reinforces the notion that the genre is distinctively suited for working out new modes of relation to sensuous materiality. A seventeenth-century Dutch noble, Sebastian is part of a family that patronizes artists and holds salons, but Sebastian himself is unable to care for art or beauty. This is because, unlike Florian, Sebastian experiences the world of physical matter in opposition to the world of ideas and deeply prefers the latter. In this regard, Sebastian is a sort of antiaesthete: "in truth the arts were a matter he could but just tolerate. Why add, by a forced and artificial production, to the monotonous tide of competing, fleeting existence?"[103] Sebastian is a metaphysician, entranced by a world of abstractions and systems, and where Florian allows objects to become part of the texture of his mind, Sebastian, by contrast, strives to keep them at a distance:

> The most vivid of finite objects, the dramatic episodes of Dutch history, . . . that golden art . . . ; all this, for most men so powerful a link to existence, only set him on the thought of escape— means of escape—into a formless and nameless infinite world, evenly gray. The very emphasis of those objects, their importunity to the eye, the ear, the finite intelligence, was but the measure of their distance from what really is.[104]

Based on his interpretation of Spinoza, Sebastian concludes that ideas are more "real" than things, that things thereby pull one away from

truth, and that to escape as far as possible into a world free from sub-
stance is a form of perfect living. Mathematical abstraction enters as
an alternative domain of the real, as Sebastian stops feeling and aspires
to the perfection of a mathematical equation. He experiences "the only
sort of love he had ever felt," a love for his "difficult thoughts"; trium-
phantly, Sebastian "felt, all had been mentally put to rights by the work-
ing out of a long equation, which had zero equals zero for its result.
Here one did, and perhaps felt, nothing; one only thought."[105] Identity
verges on the perfection of mathematics. The zeroes of the first sentence
enter a mathematical relationship with the ones that follow, transform-
ing "one" from a subject into symbol: pure thought zeroes one out. This
is not the opposite of Florian so much as a transposition: if Florian's
identity, once examined, dissolves into the texture of myriad physical
encounters, Sebastian's dissolves into pure concepts.

"Sebastian Van Storck" is difficult to interpret because it seems to
embrace conflicting positions with regard to aesthetic sensuousness.
Sebastian's love for equations such as "zero equals zero" and his abhor-
rence of "vividly-coloured existence" lead him to the conclusion that
his own "proper function was to die."[106] He considers this his "genuine
theoretic insight," and he is saved from suicide only by the fact that he
dies in a flooding incident first.[107] If the "Conclusion" had warned read-
ers away from adhering to any philosophy too systematically, Sebastian
outlines the potentially self-destructive implications of dogmatism. But
it would be wrong to see a binary in which Pater fully promotes the ma-
terialist tendencies of someone like Florian and wholly impugns the rigid
idealism of Sebastian. In fact, "Sebastian van Storck" reveals that Pater
can find a kind of sublime beauty even in nihilistic or "rigidly logical"
thought, which the portrait compares on nearly every page to a frigid
landscape: the portrait opens with an ekphrasis of a wintry Adrian van
de Velde painting of skaters; Sebastian fantasizes about becoming an
arctic explorer; the eventual cooling of the sun, which Sebastian anach-
ronistically contemplates, exercises a "tranquilizing influence."[108] The
portrait is dense with cool descriptions of intellectual or emotional states:
an influence is "freezing"; truth is "chilled" out of Sebastian; the absence
of hope is "icily" felt.[109] If as Pater suggests, "the cold and abstract" are
associated, then even the most intellectualized mode of being is poten-
tially linked to sensation.[110] The ascetic retreat from sensory experience
itself acquires a flavor of sensory pleasure.

This oscillation between abstraction and sensuousness conceptually
animates Pater's longest portrait, *Marius the Epicurean*, which exam-
ines the possibility that metaphysical abstraction offers a mechanism for

arriving at the kind of sensory experience that Florian enjoys. At an important moment in the novel, Pater provides a blueprint for how readers might transform themselves from someone like Sebastian into someone like Florian:

> Abstract theory was to be valued only so far as it might serve to clear the tablet of the mind from suppositions only half realizable, or wholly visionary, and leave it, in flawless evenness, to the impressions of a direct and concrete experience.[111]

Alluding to Locke, what Pater has in mind is an attempt to think oneself out of thought: a willed return to the tabula rasa. This is a version of "zero equals zero" that accords with aestheticism because it renews the possibility of receiving "impressions." The suicide that haunts Sebastian is metaphorized and inverted in *Marius*: Marius, Pater writes, effects a "suicidal dialectic" by which "a great metaphysical acuteness was devoted to the function of proving metaphysical speculation impossible"; one can "neutralise the distorting influence of metaphysical theory by an all-accomplished theoretic skill."[112] The one attraction of metaphysics is that it alone contains the tools to undermine itself. Taking up Comte's philosophy, George Henry Lewes had argued that positivist science could do away with metaphysics by crushing it into dust. Pater, a reader of Hegel, has something more dialectical in mind: he aspires to turn metaphysics against itself.

Pater's portraits invite two interpretive modes that sometimes come into conflict and that can be said to correspond to the relationship between mind and matter that the portraits themselves often address. From one perspective, they must be understood as containers of philosophical concepts. Florian, Sebastian, Marius: in a sense, these names refer not so much to characters as to philosophical stances, as Wilde and Symons recognized in their reviews. But on the other hand, these are also literary texts that communicate by way of metaphor, language, and form: meaning emerges from tropes such as "brain-building" or from the subtle interplay of zeroes and ones in the description of Sebastian's thought. As a result, Pater has often been subject to readings that evaluate his philosophical acumen. Much of the critical discussion of "Sebastian van Storck," for example, has focused on Pater's very strange association of Spinoza with idealism when in fact Spinoza's insight was, in Stuart Hampshire's words, to counter Cartesian dualism with a "doctrine of the single substance conceived under two attributes [which] implies that there can be no idea without something extended of which it is the idea."[113]

Resolving these alternatives requires attention to what many reviewers of Pater understood: that these short narratives seek to invest language with tactility, sensuousness, and materiality less by making finely crafted books (as would other aesthetes) than by making prose style itself a site of durable resistance to thought. Pater's prose conveys somatic forces that are perhaps difficult to talk about because they operate at the level of what Hans Ulrich Gumbrecht has called "moments of intensity," amplifications of "cognitive, emotional, and perhaps even physical faculties" similar to what Symonds described when he compared reading Pater to being silently stared at by a civet cat.[114] The portraits thicken their semantic density by taking the shape of highly stylized philosophy: in this, if in nothing else, they resemble Nietzsche's contemporary anti-metaphysical project of making ideas inhere in the rhetorical operations of language itself. Much as Florian experiences materialism as a return of mind to the objects that surround him, Pater's densely accretive style returns language to bodies. From this perspective, the portrait can be understood as a transposition of a literary problematic that had arisen in a much more widespread way in the wake of sensation fiction: Pater also preaches to the nerves, but his message is different. When Pater gives *Marius the Epicurean* the subtitle *His Sensations and Ideas*, he modulates into a philosophical key the somatic effects that had animated sensation fiction at the level of plot twenty years prior.

James Sully and the Visibility of Character

Thus far I have argued that a key aspect of Pater's intellectual project in the portraits was a consideration of materialist theory as it pertained to the shaping of individual psychology and aesthetic experience. Pater obliquely developed a materialist conception of literary character that had also been central to the genre of sensation fiction, and his opposition to metaphysics placed him in the company of contemporaries such as Tyndall and Huxley, who sought to extend the explanatory force of material causes to human action. A significant analogue to the portraits is to be found in the writings of professional psychologists who were following the paths laid out by Bain and Spencer and sympathetic to the anti-metaphysical and materialist positions of scientists. Writers including James Sully, Grant Allen, Edmund Gurney, George Henry Lewes, and others who wrote for Bain's journal *Mind* approached many of the same questions as Pater, exploring the ways in which dualisms of thought and matter might be differently configured in the wake of new research about the mind and nervous system. Often drawing on the research of German

psychophysiologists including Wilhelm Wundt, Gustav Fechner, and Hermann von Helmholtz, these thinkers introduced controversial alternatives to the immaterial soul or will, instead emphasizing the nervous, somatic, and physiological causes of thought and action. The possibility that the will was largely an illusion, aftereffect, or superstition was widely contested—as we have seen in the responses to Bain and Spencer discussed in the previous chapter—by many who wished to retain some version of a mind/body distinction or a governing human essence.

A basic supposition was that the scientific study of the mind should begin by focusing attention on the most basic processes of sensation and perception. Thomas Dixon writes that the new psychology "pioneer[ed] the belief that the science of the mind should, centrally, also be a science of matter."[115] What did this mean? One of the most important instances of this belief is a law discovered by Gustav Fechner: there is a logarithmic relationship between the objective magnitude of a stimulus (e.g., how loud a sound is, measured in decibels) and its subjectively perceived intensity (e.g., how loud it sounds to a listener). That the quantification of human sensations counted as psychology—that it was even possible— was partly what made the field "new."[116] Such research might seem to be far removed from Pater's semiautobiographical reflections, but in fact aesthetic experience was a natural area of interest for many of these new psychologists who shared with Pater a skepticism of metaphysics. Fechner wrote a foundational work of psychological aesthetics, *Vorschule der Aesthetik* (1878), frequently cited today among proponents of neuroaesthetics, which applied various tools of empirical analysis to the arts, including a quantitative analysis of the sizes of 10,558 paintings and surveys that asked respondents to describe which colors they associated with vowel sounds.[117] The interest on the part of Fechner and the psychologists can be traced to the way that aesthetic philosophy had developed as a field of inquiry following Baumgarten's *Aesthetica/Ästhetik*. Aesthetics was the branch of philosophy that should have been most closely allied to physiological psychology: it addressed immediate, sensuous experience in its relations to pain, pleasure, and the imagination. But in practice, aesthetic theory was the very field of philosophy that appeared *most* caught up in metaphysical abstraction. As Sully wrote in 1876, "To speak of an aesthetic inquiry is to the ordinary mind to refer to the densest stratum of nebulous thought. To call a subject aesthetic is to claim its exemption from a clear and searching investigation."[118] Edmund Gurney began his book on musical aesthetics by avowing his ignorance: "I have not read any of the German systems of aesthetics, general or musical," he writes; these are "confessedly in the clouds," and

"replace scientific enquiry by barren systematisation or abstract metaphysics."[119] Like Florian, like Marius, these writers wished to develop a closer relationship between aesthetic experience and empirical forms of knowledge.

Aesthetic theory played a role in the professionalization of British psychology for many of the same reasons that it appealed to someone like Pater: aesthetic experience staged many of the questions about the relationship between mind and body that had become central to scientific psychology following Fechner and Wundt (note that the subtitle of Pater's *Marius the Epicurean: His Sensations and Ideas* chimes with Sully's major work, *Sensation and Intuition*). Through ongoing debates with Grant Allen and Edmund Gurney, Sully advanced the cause of psychological aesthetics in late-Victorian Britain. Now most often associated with his work on dreams and child development, Sully initially built his reputation by publishing articles on musical, literary, and artistic experience that drew heavily on the idiom of scientific psychology. Having studied in Berlin, Sully was versed in Goethe, Heine, Lessing, and Schiller; he was also a proficient pianist whose teacher had introduced him to Robert Vischer's influential aesthetic theory.[120] On this basis, he had written articles on musical aesthetics for the *Fortnightly Review*. With the support of his mentor, Alexander Bain, Sully returned to Berlin to study with Hermann von Helmholtz, whose physiological studies of optics and acoustics were widely influential in Britain, including for George Eliot, John Tyndall, and Charles Darwin.[121] Sully's *Sensation and Intuition*, which extended Helmholtz's thought, was well received internationally by eminent men of science including Théodule Ribot, Herbert Spencer, G. H. Lewes, and Charles Darwin.[122] At this time, Sully also wrote the first entry on "Aesthetics" for the *Encyclopedia Britannica*, which impressively synthesized the history of Western aesthetics from the vantage point of the late-nineteenth century. Sully informed readers that there were "diametrically opposed methods" of reasoning about beauty: the "metaphysical or *a priori*" of Kant and Hegel, which treats the world as an ideal construct of the mind, and the "scientific or empirical," which inductively reasons from "a series of phenomena."[123] Sully's allegiance to the latter is signaled by the fact that his entry on aesthetics concludes not with Ruskin—who "appears wanting in scientific accuracy"—but with Bain and Spencer.[124]

When Bain founded the journal *Mind* in 1876, Sully became a frequent contributor. He wrote an important article for the first issue of *Mind* on "Physiological Psychology in Germany" (Charles Darwin thrilled Sully by praising this article to Lewes in front of George Eliot)

and continued to publish articles and reviews on the general topics of sensation, pleasure, and pain. In a general sense, Sully's psychological aesthetics can be described as extending the conceptual implications of Wundt's and Helmholtz's research on the physiology of optical and auditory perception. Wundt, for instance, had studied "how his own sensations of pleasure, tension, and excitement varied with the tempo of a metronome."[125] Helmholtz was widely understood to have bridged acoustical science and music theory by linking the physiology of the ear to the relationships among beats and overtones that produced dissonance and harmony.[126] In *Mind*, Sully refined many of the assertions he had made in *Sensation and Intuition*; an important essay "Art and Psychology," simultaneously published in translation in the French *Revue Philosophique*, elaborated the concluding chapter of *Sensation and Intuition*, "On the Possibility of a Science of Aesthetics." As distinct from the book chapter, which merely promised a future quantification and hierarchical classification of impressions, "Art and Psychology" aspires to demonstrate that psychology was suited to resolving long-standing questions about the arts: can psychology tell whether immoral art can be good art? Can it explain whether music and poetry must follow prescribed forms or whether composers and poets may invent forms to fit their expression? In each case, psychology would turn to its own scientific principles (e.g., the "organic basis of equal rhythmic distribution of impressions in the structure of the sensuous organs") to find an answer.[127]

Many of Sully's essays aim to bring a new psychological perspective to bear on existing critical debates about the arts. "Pleasure of Visual Form" (1880) investigates how empirical psychology might resolve a long-standing controversy about the relative intellectual values of line and color. "Poetic Imagination and Primitive Conception" (1876) rereads what Ruskin would have termed the *pathetic fallacy* as an animism intrinsic to the human mind: the sea murmurs because "we instinctively seek to realise our object of thought by conceiving it under the form of a quasi-human presence"; moreover, "neither the intelligence gleaned from common life nor the teaching of science can directly disprove the existence of the mental behind every object in nature."[128] The physiological conception of stimulation and relaxation elsewhere informs Sully's response to Wagner, who displeases by overtaxing the spectator's body: "The whole series of effects is too sensuous and too emotional. One longs for moments of comparative repose when each sense, no longer distracted by so gorgeous a simultaneous impression, might enjoy its own world of beauty in perfect purity, and when, too,

the quiet play of the understanding . . . might relieve and supplement the overstimulated-activities of sense and emotion."[129] In these and other essays, Sully illustrated how a new psychology of sensation and perception could transform aesthetic theory. The color debate had been suffused by questions about the propriety of the pleasures afforded by color; Sully, characteristically, shifts the plane of judgment from conventional morality to a science that understood itself as objectively detached from social norms. As Kate Flint has observed, Sully often emphasized the interaction between the embodied mind of the viewer and the visible qualities of the artwork: he "privileges . . . the inescapable duality—intellectual and emotional, physiological and mental—involved in the practice of spectatorship itself."[130] Sully elaborates the implications of a position that had been adumbrated by George Henry Lewes's *Principles of Success in Literature* (1865), which extended positivism to aesthetic theory and literary criticism. Sully, with the additional armature of German psychophysics, transforms scientific positivism into a critical practice so portable that it is equally able to respond to debates about color and to Wagner's dramaturgy.

It is within this context of an aspiration toward a broad reevaluation of aesthetics that Sully addresses the question of how literature, too, might come under the lens of empirical psychology. For Sully, it becomes an object of interest to the psychologist by way of what he called the "aesthetic aspects of character." The logic is as follows. Humans' most primitive aesthetic experiences are tied to the sensory perception of physical stimuli: the auditory pleasure of musical harmony, for example, or the color of paint. But as humans have evolved, they become increasingly able to perceive not only objects but also other minds. One's aesthetic perception of things, in a sense, becomes the basis for a quasi-sensory perception of a person's character. But modern humans still have a vestigial attachment to physical appearance, so to perceive a person is to shuttle between perceiving them as fleshy substance and as a disembodied mind: "While we are all apt to see in a movement of face the beauty of an expressed feeling, we tend, by a reverse process, to discover in certain mental qualities the charm of their physical embodiment."[131] Sully retains the focus on perceptual experience that was key to early physiological psychology by asking how we might literally perceive character. If Grant Allen had reduced literature to component words in *Physiological Aesthetics*, Sully reduced it to component aspects of character such as "clearness," "transparency," and "volume."

Sully developed these positions in the context of an ongoing dialogue in the pages of *Mind* and other periodicals in the 1870s and 1880s over

how far one could extend experimental methods of perception psychology. In these debates, Sully charted a middle position between Allen's reductionism and Gurney's tendency toward faculty psychology. Allen, Sully wrote, too readily separates "sensuous elements" from the "intellectual and emotional factors with which they are inextricably woven," and he objects more fundamentally that Allen offers an inadequate "inductive basis" for his generalizations. Sully wants to retain a role for the "co-operation of the social sentiments," because he sees sympathy as crucial to the arts.[132] But at the same time, Sully viewed Gurney's musical aesthetics as still too closely tied to faculty psychology: Sully's 1881 review of *The Power of Sound* objected that Gurney goes too far in the direction of proposing an abstract "faculty" of musical perception, which he calls an "unnecessary *deus ex machina*."[133] For Sully, the resistance of certain kinds of aesthetic pleasure to scientific analysis is a contingent, not an intrinsic problem: "the exquisite and inexplicable beauty of certain forms does rest on discoverable grounds even though these cannot yet be assigned."[134] The implication is that one must pursue a more refined psychophysiology, not retrench in an older model of the faculties.

What is most striking about Sully's literary theory is something that he never quite states fully, perhaps because it is so deeply assumed, namely, that the perception of character (real or fictional) takes place in the same register as the perception of physical objects: Sully uses the metaphor of reading to describe how we derive knowledge about another person's internal state merely by looking at them. One's character can "shin[e]" or be "picturesque"; character might be of a large quantity or a small quantity; characters have discrete parts that can show "monotonous regularity" or "balance, symmetry, and unity."[135] These are not for Sully moral judgments; bad characters can be aesthetically pleasing if, for example, they present a fascinating contrast. This mode of literary perception is in many respects the inevitable outcome of Bain's physiological psychology, which treated emotions as electrical currents or waves that registered on the outward surface of the body: Sully develops Bain's model by pushing the language for describing literary characters as well as people toward the most tangible register possible. This model of character as perceptible generates an unusual evaluative matrix for the novel. Writing on Eliot, Sully evaluates her novels for their success at making characters vividly present: they "stand out as solid shapes" and are like a "gallery of portraits."[136] Sully suggests that it is realism rather than aestheticism that is most adapted to psychological inquiry; he describes those who "[repeat] the shibboleth" art for art's sake as "erecting

art into a metaphysical absolute." If, as some scholars have recently argued, Sully anticipates aspects of cognitive literary and cultural studies, this account of character as substantial serves as a reminder that his version of cognitivism is committed to a deeply materialist conception of the mind.[137]

Sully's version of materialism returns us to the concerns that Pater had approached in the portrait. Though they arrive by different routes, Pater and Sully each find themselves confronting the same question: to what extent is aesthetic experience reducible to its sensory components, and how can literature operate as a medium that might be immediately perceived? Pater's *Marius the Epicurean* takes up these questions directly by extending the genre of the imaginary portrait to the length of a novel partly in order to explore relationships between consciousness and materiality.[138] In this respect, *Marius* allows Pater to represent as a literary character aspects of sensuous aesthetic experience that Sully, Gurney, and Allen portray analytically in the pages of *Mind*. But taking up this question as a problem of style and genre allows Pater not only to conceptualize the relationship between ideas and sensations but also to reproduce that relationship as the experience of reading.

Webs of Matter: Pater and Eliot

Although Pater and his cohort have usually been thought of in opposition to the intellectual circle surrounding Sully, Spencer, Eliot, and Lewes (Eliot memorably called *The Renaissance* "quite poisonous in its false principles of criticism and false conceptions of life"), this resonance between Sully and Pater places us in a position from which we can begin to understand a shared interest among aesthetes and realists in how positivism and physiological psychology might transform the criticism and theory of art and literature by drawing attention to the physical plane of aesthetic experience.[139] *Marius the Epicurean* represents a virtuoso exploration of many of the philosophical and aesthetic problems having to do with oppositions between idealism and materialism that were of concern across a wide range of late-Victorian idioms. Like Clifford, Tyndall, Huxley, and other scientific materialists, Pater's novel, as the reference to Epicurus signals, is significantly focused on ancient materialism, particularly the Epicurean tradition that drew ethical principles from the thought of Lucretius but also turning to other treatments of materialism including those of Democritus and Heraclitus. Furthermore, like those who were developing a scientific psychology of art or beauty, Pater was cognizant that aesthetic experience, at once intellectual and sensuous,

threw into sharp relief questions about the relationship between seemingly disembodied mental processes and a world governed by physical causality. But unlike many of the forward-looking psychologists who consciously avoided making reference to German aesthetics, Pater's articulation of a materialist aesthetics in *Marius* is informed by his interpretation of Kant and Hegel and, more generally, by a conception of historical time as recurrence rather than linear progress by contrast with scientists such as Tyndall, whose Belfast address charted a straightforward teleology from Lucretius to Herbert Spencer.

Pater's novel—particularly a pair of early chapters—has commonly been read as an apologia for the perceived hedonism of the "Conclusion" to *The Renaissance*. But Pater does not retract so much as refine and develop the "elegant materialism" Oliphant had identified in her review. By contrast with Pater's notorious volume of essays, *Marius* draws on the fictional resources of the imaginary portrait in order to treat the coherence of the self not only as a philosophical problem that might be propositionally stated but as a formal quality that might be conveyed through style and structure. Writing a novel-length portrait that formally privileged the depiction of temperament over the narration of events required deforming the genre of the novel itself in ways that rendered the work almost unreadable to many who first encountered it.

Pater's interpreters have often suggested that his model of subjectivity is paradoxically doubled: Pater repeatedly focuses attention inward but then always finds a self in the process of dissolving, vanishing, or unweaving. As Carolyn Williams observes in her reading of Pater's "Conclusion" to *The Renaissance*, what initially looks like an image of solipsism figured by a "wall" surrounding the self immediately reverses into its opposite when Pater describes the self as a nexus within the Heraclitean flux: "In a certain sense, the problem is the very opposite of solipsism. When the mind turns to reflect upon itself, all it can observe are these 'passages' of impressions, until the mind itself seems nothing more than the site of their passage. What, then, is the mind?"[140] To read *Marius* in relation to other articulations of Victorian materialism can give us some purchase on this question. What the Epicurean self dissolves into, Pater suggests in *Marius*, is not nothingness or absence but a new, permeable state in which the continuity between a world of consciousness and a world of physical substance is vividly, pleasurably felt. At the same time, aspects of the novel's style and structure imprison the reader within the individual sentence or phrase so as to make the formal totality of the novel always recede: the experience of reading *Marius* mirrors

Marius's own physicalist dissolution; Lucretian materialism becomes a principle of form.

From a distance, the structure of *Marius* is clear. The narrative consists of a series of events and intellectual positions that coalesce into an antiteleological quest narrative. The novel does not so much culminate as trail off in a famously ambiguous scene in which Marius seems passively to accept conversion to Christianity. This is the last of three conversions that structure the novel. As Marius moves from place to place (his childhood home White-nights, Pisa, Rome), he forms intimate attachments to a series of companions (his childhood friend Flavian, a Christian named Cornelius, Marcus Aurelius, and Saint Cecilia) and inhabits various religious and philosophical beliefs (Paganism, Epicureanism, Cyrenaicism, and ultimately Christianity). Pater reiterates this structure architecturally: these shifts map on to the novel's four "parts." *Marius* itself represents the first installment in what Pater projected as a "trilogy, or triplet, of works of a similar character; dealing with the same problems, under altered historical conditions."[141]

What is remarkable, however, is not this highly structured architecture but the persistent failure of readers to see it. The organizational scheme that is visible from a distance seems to disappear at the scale of the chapter or the paragraph as the novel migrates across a wide range of subgenres (translation, dialogue, oration, diary) apparently at random; many have concurred with the characterization, if not the tone, of T. S. Eliot's "Arnold and Pater" (1930), which saw in the novel evidence that Pater was a sentimental moralist: "*Marius* itself is incoherent; its method is a number of fresh starts; its content is a hodge-podge of the learning of the classical don, the impressions of the sensitive holiday visitor to Italy."[142] Eliot's comment is especially striking because it was precisely the "incoherent" qualities of Marius that struck later readers of Pater as anticipating the fragmented intertextuality of modernist poetry. If, as Stephen Arata observes, *Marius* has been regularly cited as evidence of Pater's failure as a novelist, recent decades have seen a reevaluation of the novel as formally inventive.[143] Williams interprets what Eliot thought of as a "hodge-podge" in more positive terms: *Marius* is an "encyclopaedia of genres" whose "massive achievement" is its "overt, self-conscious intertextuality"; Gowan Dawson sees in it a reflection of the "form of public conversation pioneered in journals like *Macmillan's* and the new monthly reviews"; and for Laurel Brake, the novel "cunningly finds a vehicle for autobiography in the fictional genre of *Bildungsroman*."[144] What these critics describe as the novel's flickering between structural

unity and complete dissolution formally instantiates the intellectual prob-
lem on which its protagonist often focuses: is it possible to conceive of
the self as having metaphysical unity?

The novel's serial architecture is complemented by a layered narrative
structure: although the narrative is closely focalized through Marius, fre-
quently in the form of free indirect discourse, its narrator speaks from the
perspective of the late-nineteenth century. The result is a thick analogical
multivalence: Marius and Pater stand in for one another; paganism and
nineteenth-century materialism stand in for one another; even Heraclitus
and Tyndall in some sense are figures for each other.[145] By refracting a
second-century world through a nineteenth-century narrator, Pater alerts
readers to a key resonance between the replacement of pagan materialism
by a Christian privileging of soul over body in the second century (repre-
sented most prominently by Marius's friend Flavian) and, inversely, the
erosion of a belief in the soul or spirit effected by scientific materialism
in the nineteenth.[146] Like Tyndall and Clifford, who had seen Lucretius's
thought as an uncanny anticipation of Dalton's atomic theory, Pater finds
in ancient natural philosophy and early Christianity resources for engag-
ing with nineteenth-century materialism.

Marius returns to questions raised by the famous "Conclusion" in
The Renaissance not by rejecting materialism but rather by redefining it.
Pater's most pointed response to critics of *The Renaissance* is articulated
in the chapter "New Cyrenaicism," which describes Marius's develop-
ment of a coherent notion of "aesthetic culture," and attacks his contem-
poraries' incorrect tendency to disparage Epicureanism as a hedonistic
pursuit of pleasure for its own sake. The object of Epicureanism was
"not pleasure, but fulness of life, and 'insight' as conducting to that ful-
ness."[147] In a parallel move, Pater defines the aesthetic as a "refinement"
of the capacities of "sensation and emotion" through which one appre-
hends "those aspects of things which affect us pleasurably through the
senses," especially but not only art.[148] Marius arrives at his enlightened
Epicureanism as he is coming to terms with the death of his boyhood
friend Flavian, which he is unable to imagine as the transcendence of the
soul to some other realm: Flavian's death "came like a final revelation
of nothing less than the soul's extinction"; "the various pathetic traits
of the beloved, suffering, perished body of Flavian, so deeply pondered,
had made him a materialist."[149] Surprisingly, Pater revisits the hedonis-
tic philosophy that had been scandalously associated with his name by
embracing rather than eschewing another of the culture's most charged
epithets, materialism.

This newly materialist Marius recognizes that what prevents him from seeing the way in which matter is animated is the extremely limited perspective of human time within which objects seem fixed even as they are in fact constantly being reshaped by natural processes. Evoking the resonance of nineteenth-century science with the ancient materialisms of Epicurus, Heraclitus, and Lucretius, the simple clause "then as now" introduces a dizzying series of nested reflections about the relationships of mind, objects, matter, and vitality, whose complex interactions take on qualities of musical harmony:

> Then as now, the philosophic and illuminated mind might apprehend, in what seemed a mass of lifeless matter, the movement of the universal life, in which things, and men's impressions of them, were ever "coming to be," alternately consumed and renewed. That perpetual change, which an attentive understanding could discover where common opinion found fixed objects, was but the sign of a subtler but more universal motion—the sustained, unsleeping, forward-pushing vitality—of the divine reason itself, ever proceeding by its own rhythmical logic, and lending to all mind and matter, in turn, what life they had. In this "perpetual flux" of minds and things, there was, as Heraclitus conceived, a continuance, if not of their material or spiritual elements, yet of orderly intelligible relationships, like the harmony of musical notes, wrought out in and through the series of their mutations—ordinances of the divine reason, maintained throughout the changes of the phenomenal world: and this harmony in their mutation and opposition, was a principle of sanity and reality in things.[150]

Here, the aesthetic inheres not only in a certain mode of perception but also in the "harmony" of the world of constant physical change and material complexity that Marius, through Heraclitus, becomes capable of apprehending. Even as the world shifts and decays, the laws governing decay remain themselves permanent, the "principle of sanity and reality in things." Ancient materialisms are synthesized by Marius and made available by the narrator as possibilities that a Victorian audience might also entertain. Along similar lines, Pater describes an error within "the current mode of thought" (i.e., Victorian) of assuming that objects are lifeless in terms that surreptitiously imply that a nineteenth-century audience might translate what Marius experiences as a philosophy into the

idiom of Christianity: "Imaging forth from those fleeting impressions a world of firmly outlined objects, it [contemporary thought] leads one to regard as a thing stark and dead what in reality is full of animation, of energy, of the fire of life."[151] An expanded scale of time becomes Pater's means for revealing the secretly animated world of physical matter.

In these moments, the form of Pater's novel allows him to bring ancient philosophical resources to bear on nineteenth-century engagements with questions about how mind might be understood to inhere in matter, revitalizing ancient thought as something other than a discarded earlier stage. As his interpretation of Heraclitus suggests, Pater, like many who wrote on materialism, was acutely aware of how questions about whether matter was better understood as animate or inanimate also opened onto questions of psychology, here termed in Heraclitean language the "'perpetual flux' of minds and things."[152] Pater reveals that materialism can make available a model of mind that is enriched rather than evacuated by the constant flux of the physical world. Encountering the thought of Heraclitus, Epicurus, and Lucretius leads Marius to develop an "eager interest in the real things so close to him, on the lowlier earthy steps nearest the ground."[153] This is in clear contrast to the position taken by Pater's student Gerard Manley Hopkins, who found in Heraclitus's permanent change a "joyless" philosophy that had to be resolved into Christian resurrection: "But vastness blurs and time | beats level. Enough! the Resurrection, / A heart's-clarion! Away grief's gasping, | joyless days, dejection."[154] It is as though Marius stopped reading after the ninth line of Hopkins's poem, simply delighting in "the bright wind boisterous" and "squeezed | dough, crust, dust."[155] If there is no soul to be resurrected—Marius's belief—then there need not be the antagonistic relationship between human beings and matter that appears in the middle section of Hopkins's poem, when the speaker suddenly recognizes that the seemingly delightful flux of nature in fact reveals the minuteness of human existence, "drowned" in "an enormous dark," to be rescued only by the "eternal beam" of Christ.[156] Marius embraces rather than rejects what Hopkins calls "the lowlier earthy steps nearest the ground," an echo of the Epicurean philosophy of dirt parodied by Mallock.

Reading Marius's development of a self-consciously Epicurean aesthetic culture as a product of his encounter with Heraclitus allows us to see that a key aspect of Pater's return to the philosophy articulated in the "Conclusion" to *The Renaissance* was an extended engagement with concepts of mind and matter. In later chapters of the novel, Marius continues to explore new kinds of relationships to matter, which becomes

a flexible, lively medium. As Marius aspires to become a rhetorician, he understands language as unusually tactile. The narrator compares the ancient rhetorician to "the public lecturer or essayist . . . who knows how to touch people's sensibilities on behalf of the suffering"; Marius observes that "with men of his vocation, people were apt to say, words were things. Well! with him, words should be indeed things. . . . Virile apprehension of the true nature of things . . .—words would follow that naturally."[157] Language becomes a vehicle for bringing its listeners into closer contact with things rather than a superstructure floating above them.

This reconsideration of the opposition of solipsism and materialism culminates in a moment of reverie that concludes the novel's third part. Just outside Rome, Marius has a vivid vision in which he sees the progress of his own life as though at a remove. Pater slyly hints that this scene is key to the novel by alluding to the novel's full title: "Himself—his sensations and ideas—never fell again precisely into focus as on that day."[158] At this point where Marius and *Marius* coincide, we are given, appropriately, a scene of self-reflection: Marius hallucinates his life passing before him as he travels on a road—a reverie so deep that Marius sees himself "through a dreamy land . . . as if in another life, and like another person." But Pater reinterprets dreaming and reverie such that they return Marius both to his physical body and to a feeling of companionship. Marius instinctively wants to "share his joy" with someone else. What he realizes is that he has never really been alone in the first place; his capacity to enjoy any experience has always depended on imagining it as shared with another: "In his deepest apparent solitude there had been rich entertainment. It was as if there were not one only, but two wayfarers, side by side."[159] Pater describes a version of nonsolitude that cuts across a conception of the social as limited to humans; instead, Marius finds community with materiality and energy. The second part of Marius's reverie consists of a feeling of companionship with the physical universe:

> In this peculiar and privileged hour, his bodily frame, as he could recognize, although just then, in the whole sum of its capacities, so entirely possessed by him—Nay! actually his very self—was yet determined by a far-reaching system of material forces external to it, a thousand combining currents from earth and sky. Its seemingly active powers of apprehension were, in fact, but susceptibilities to influence. The perfection of its capacity might be said to depend on its passive surrender, as of a leaf on the wind, to the motions of the great stream of physical energy without it.[160]

If we think of aestheticism as always intensifying individualist subjectivity, then we will be primed to read this moment of reverie as the most extreme form of retreat into the self: the aesthete, in a state of total isolation, submits to the flux of sensation even as he experiences his own life at a remove, extracted from reality into the realm of the "as if." But perhaps the insight of Paterian aestheticism is that solipsism is always undone by the pervasiveness of influence and "energy."[161]

One way to understand the distinctive qualities of Pater's materialist "system of forces" is to consider its relation to George Eliot's conception of the "web," which is perhaps the most significant alternative trope of the social. Pater and Eliot are often conceived as espousing antithetical models of subjectivity: the apparent solipsism of Pater's "Conclusion" to *The Renaissance* can be contrasted with the sympathy that is at once an ethical and formal principle of Eliot's fictional project. But Pater's vision of a social world that includes physical matter is better understood as a transposition of Eliot's networks and webs. In *Middlemarch*, the figure of the web circumscribes the novel's area of concern by describing it as focused on "unravelling certain human lots, and seeing how they were woven and interwoven, that all the light I can command must be concentrated on this particular web, and not dispersed over that tempting range of relevancies called the universe."[162] This mode of figuration has been described by Sally Shuttleworth as Eliot's "organic conception of society" based in physiological theory and by Fredric Jameson as the space in which Eliot unfolds a "logic of dereification" that affirms systems thinking against ideological assertions of pure individuality.[163] For Eliot, natural phenomena such as physiological systems and organic tissues produce the salient metaphor for the organic, systemic interconnectedness of human relationships.

How should we understand the relationship between Eliot's organic figurations of social webs and Pater's interest in the "far reaching system of material forces" that "determine[s]" Marius's sense of self?[164] Reading *Middlemarch*, Laura Otis discerns a direct connection between Tyndall's atomic materialism (implicitly at stake in Pater's *Marius*) and Eliot's social web: Tyndall's "descriptions of nature," Otis observes, "closely resemble Lewes's depictions of the nervous system and Eliot's representations of social relationships" in that all three conceive of complex systems as interactions among elements.[165] From one perspective, then, we can think of Marius's perception of a "'perpetual flux' of minds and things" as a radical expansion of the webs and tissues of *Middlemarch*. But Pater's version is informed by a Heraclitean materialism

within which the web of relationship is expanded to include a "universal life" that suffuses animate and inanimate matter alike.

But perhaps a further distinction needs to be made here between atomic and organic networks. Eliot's dialogic philosophical poem "A College Breakfast-Party," which depicts Oxford and Cambridge intellectual life in the early 1870s, responds directly to Pater's intellectual milieu.[166] Eliot's use of the web metaphor in the poem tracks closely with Pater's own concern with the mind as materially interwoven with (and therefore not clearly distinguishable from) the surrounding world. The character Rosencranz, who stands in for a skeptical position that rejects the apparently autonomous "self" or "I" as nothing more than an artifact of language, depicts the web not as weaving connections within a community but as dissolving the coherence of the subject or self:

> I grant you ample leave
> To use the hoary formula "I am"
> Naming the emptiness where thought is not;
> But fill the void with definition, "I"
> Will be no more a datum than the words
> You link false inference with, the "Since" & "so"
> That, true or not, make up the atom-whirl.
> Resolve your "Ego," it is all one web
> With vibrant ether clotted into worlds:
> Your subject, self, or self-assertive "I"
> Turns nought but object, melts to molecules,
> Is stripped from naked Being with the rest
> Of those rag-garments named the Universe.
> Or if, in strife to keep your "Ego" strong
> You make it weaver of the ethereal light,
> Space, motion, solids, & the dream of Time—
> Why, still 'tis Being looking from the dark,
> The core, the centre of your consciousness,
> That notes your bubble-world: sense, pleasure, pain,
> What are they but a shifting otherness,
> Phantasmal flux of moments?—[167]

To assert that the "Ego" is "one web / With vibrant ether clotted into worlds" is to figure the web not as producing cohesion but "resolving" (in the sense of dissolution, dispersion, nullification) into indistinction from ethereal matter. Hence Rosencranz finds in the web not a tightly

woven fabric, but an assemblage of "rag-garments." The poem's figural register makes clear that Eliot is inhabiting the same philosophical and rhetorical space as Pater's "Conclusion" to *The Renaissance*, which likewise opens by staging the alternatives Eliot describes: that the self (as Eliot puts it) either "melts to molecules" or "weave[s]" a subjectivity that is ultimately nothing more than a "bubble-world" or "Phantasmal flux of moments."[168] The poem highlights distinctions among the available valences of the web: webs can "resolve" (dissolve) as well as bind. If in *Middlemarch* the web is a figure for circumscribing a particular set of human relationships, in "I grant you ample leave" it stands in for the resolution of the "I" into molecules, rag-garments, or the atom-whirl. Within the poem, Rosencranz's web is treated as a fruitless metaphysical abstraction compared with the recurrent figures of webs, tissues, and fabrics in *Middlemarch* that powerfully figure the social.

Reading Pater's and Eliot's webs together reveals not an opposition between materialism and idealism but a complex array of positions regarding how webs of relations might be reconceived and refigured in response to principles put forth by scientific materialists. Richard Menke captures Eliot's particular mode of interest in the physical plane of human experience when he describes Gwendolyn Harleth as less a character than a "responsive text of internal motions and pulsations": Eliot's concern is less with the cosmological dimensions of sweeping physical theories of materialists from Lucretius to Tyndall, who had speculated about the continuities between human and nonhuman matter, and more with the ethical dilemmas that unfold if the will is conceived as having a physiological substrate.[169] If Eliot's impulses drive toward interactions with other characters—impulses are impulses to action within a social world—then Paterian pulsations drive outward to a world of substance.

This to say that in *Marius*, Pater outlines a philosophical basis from which the apparently asocial gestures of aestheticist withdrawal, which often took the shape of directing attention toward beautiful things rather than persons, can be taken instead to represent a different configuration of the "social" that encompasses things and persons alike. This possibility opens up a new conception of the self-involved Paterian aesthete who struck Eliot as "poisonous." The image of solipsistic withdrawal is often merely the outward appearance of a deeper reconfiguration of the social to include matter; Pater's characters regularly find companionship in their relationships with earthly stuff of the world and experience the sphere of the intellect as fundamentally isolating—not as a space of intellectual community (as for Matthew Arnold) or imagined sympathy (as for Eliot). For this reason, the psychological theory that Sully adapts

in order to read Eliot's fiction might be equally illuminating with regard to Pater: when Sully argues that human interaction always takes place within a sphere of embodied experience, he allocates a central role to the pure physicality of the social. Pater takes this model a step further by showing the difference between the human and the nonhuman to be a faint, evanescent "outline," as he puts it in the "Conclusion" to *The Renaissance*, rather than a stable ontology.

Through his close engagements with ancient and modern materialisms, Pater reveals aestheticism to be a philosophy of matter—and of enminded matter in particular. What looks like an antisocial celebration of the surfaces of things, parodied through characters such as James's Fleda Vetch or George du Maurier's Jellaby Postlethwaite (who is obsessed with teapots and lilies), may be better understood as the expression of an ethics of care that extends beyond the human insofar as it is premised on a sense of the potential enmindedness of surrounding matter and of the unavoidable materiality of human beings. This version of aestheticism reinvolves things in the sphere of human action by encountering objects as what Bruno Latour calls "actants" (human or nonhuman beings that make a difference in the domain of the social) and by reconstituting aesthetic culture as, to borrow a phrase from Bill Brown, an "object culture." [170] Pater's portraits—and their late-Victorian context—remind us that it is worthwhile to think of materialism as a recurrent intellectual and cultural tendency; doing so enables us to consider what has been at stake in other moments and cultures when the relationship between networks of human relationships and networks of nonhuman physical causality have been experienced as unstable or as a matter of significant concern. If at present the stakes of paying closer attention to objects often has to do with seeing things in a different light, moving beyond a new historicist or Marxist materialism that too easily found a commodity everywhere it encountered an object, Paterian animism, taking its cue from Lucretius and Heraclitus, longs for an alternative to abstractions whose guise was more often understood as "metaphysical" than as economic. Pater's thought opens up a version of the aesthetic that, rather than cultivating detachment, embraces the enmindedness of matter and the materiality of persons. A reconciliation of aestheticism and materialism, positions that are often seen as antithetical, is made available by placing Pater in relation to late-Victorian scientific materialisms; Pater recognizes heat and beauty, rather than destruction and loss, as "Million-fuelèd, ' nature's bonfire burns on." [171]

4

Practice: William Morris's Socialist Physiology

One of the strange things about William Morris is that even though he never stopped working, he also never seemed to be trying very hard. Morris's friend Richard Dixon recalled that when Morris read his first poem, "The Willow and the Red Cliff," Dixon and Edward Burne-Jones were impressed. Morris's response? "Well," he said, "if this is poetry, it is very easy to write."[1] Evidence abounds that Morris wrote quickly and easily, working habits that were the polar opposite of Walter Pater's constant refining and rewriting. Morris's first biographer recalls that his short stories were "written very swiftly, poured out, as it were, from a brain overloaded and saturated with its pent up stores of imagination."[2] Morris later admitted that he wrote some introductory verses to his poem *The Earthly Paradise* only to fill blank space on the page. It is no surprise, then, that many have compared Morris's writing to his wallpaper designs. This observation is as old as Morris himself: "It was the fashion to say that his poetry and his prose romances were like his wall-papers," observed the *Times Literary Supplement* in 1912.[3] The following year, G. K. Chesterton paid Morris a string of backhanded compliments: "If his poems were too like wallpapers, it was because he really could make wallpapers. He knew that lines of poetry ought to be in a row. . . . [Morris] felt the hard limits of creation as he

would have felt them if he were not working in words but in wood."[4] Morris's mode of working appears to model the combination of labor and ease that he promoted as a political value in his lectures of the 1880s and in utopian fictions such as *News from Nowhere* and *The Dream of John Ball*.

If comments such as Chesterton's implicitly demote Morris from poet to craftsman, they also intuit something important about Morris's art. Morris, along with many Pre-Raphaelites, sensed an intimate connection between making things out of wood (or wool or paper) and making things out of words. In his fiction, poetry, and essays, Morris invested language with materiality, repeatedly and creatively. Jerome McGann writes that Morris "exploit[ed] as completely as possible all the resources of the physical media that were the vehicular forms of his writing," treating "poetry as language incarnate"; in Morris's writing, "'meaning' is most fully constituted not as a conception but as an embodiment."[5] This careful attention to the ways in which thought happens not as a disembodied mental activity but as concrete interactions between bodies and things aligns Morris with many of the literary and philosophical projects we have seen in the previous chapter. Less cosmically speculative than Constance Naden or W. K. Clifford, Morris attends to the materiality of language in ways that aspire to reunite, in practice, mind and matter.

Scholars have recently come to understand Morris's interest in the materiality of language and of art as an aspect of his socialist politics. It is no longer possible to dismiss Morris's utopianism, with Lionel Trilling, as a regressive idealization of "childhood and rest" or to reduce arts and crafts, with Adorno, to a "pedantic . . . mentality devoted to tracing out stencils."[6] Key to this reevaluation has been a reconsideration of the conversion narrative that structures E. P. Thompson's magisterial *William Morris: Romantic to Revolutionary*; revolutionary possibilities are now often said to be implicit across Morris's aesthetic practice, often by way of his investment in bodily materiality and sensation. Michelle Weinroth argues that Morris's fine press publishing is not an aestheticist turn away from politics but "a new development in his political propaganda in which meditative dreaming and restful beauty in art are reconciled with energizing thought and militant speech."[7] Caroline Arscott links this aspect of Morris's work to his boxing instructor Archibald MacLaren as well as to theories of ornament in Victorian anthropology.[8] And Elizabeth Helsinger has shown how Morris and Rossetti articulated a relationship between the "open sensory alertness and active imaginative projection" distinctively required by their painting and poetry and

"social and cultural health in ordinary, everyday activities."[9] From perspectives such as these, the intensities of sensory experience become the basis of a politics.

This reinterpretation of the place of corporeality and the body for Morris raises a question: does Morris's interest in "sensory alertness" and "restful beauty" develop or depart from a parallel interest in the physiology of aesthetic experience that was pursued by many of Morris's scientifically minded contemporaries? In this chapter I explore Morris's interest in bodily states of pleasure and discomfort from a perspective that is informed by the period's scientific aesthetic theory, which similarly took a pleasure/pain binary as primary. I pursue this relationship not by arguing for direct connections between Morris's work and mental science but by encountering Morris's thought as challenging for this book's larger project of developing an account of a version of materialist aesthetics that emerged at the interface of nineteenth-century science and literature. This challenge arises from the fact that Morris is at once deeply sympathetic to the project of rendering the aesthetic domain in strongly physicalist terms but, by contrast with many versions of physiological aesthetics, resists any account of aesthetic experience that would leave to the side its social and political coordinates.

From one perspective, Morris can be described as offering a finer, sympathetic articulation of problems that had occupied writers who sought to return aesthetic experience to the sensing body. In previous chapters, we have encountered a range of ways in which aesthetic experience could be fruitfully described as a physiological response. Alexander Bain argues that sinuous curves produce pleasing emotional waves, Spencer that art is a kind of play that releases pent-up energies, and James Sully and Hermann von Helmholtz that music can be studied as a physiological stimulus. Morris, too, sees a clear connection between bodily pleasure and aesthetic experience; his writing about the relationship between language and materiality can be thought of as a proxy for the questions about the relationship between mind and body that occupied aestheticians who worked in a more explicitly scientific mode. Just as psychologists investigated the extent to which consciousness was reducible to the nervous system, Morris asks how far literature is reducible to ink and paper.

But Morris's work also appears to counter key aspects of physiological aesthetics precisely because of its acute awareness of the social milieu of the sensing body. If physiologists often conceived of aesthetic experience as a stimulus-response relationship that took place at the level of the evolved biological organism, Morris is committed instead to situating

these experiences within social and economic contexts. I will argue in this chapter that Morris treats aesthetic experience from the perspective of relational environments rather than individuated units such as "the artwork" or "the spectator" and that romance, as a literary genre, provides Morris with formal means for developing his claims against individuation and introspection.[10] Morris's attention to individuation emerges in part as a response to the individualism of Spencer and his followers, which was deeply informed by Spencer's sociobiological understanding of evolution as teleological development, in which the "fittest" individuals survived.[11] Insofar as Morris develops a physiological aesthetics, it is one that insists, by contrast, on the fundamental sharedness of human corporeality and the political necessity of assuring the availability of simple enjoyment of the body to an entire community. Shared bodily health becomes an anti-individualist alternative to physiological aesthetics.

This logic emerges by way of Morris's phenomenologies of laboring bodies—their shared states of alertness, sensory vividness, exhaustion, meditation, and dreaming. Morris's work offers a way of configuring the aesthetic domain in terms of process-based somatic practices: aesthetic experience, from this perspective, involves ongoing dispositions or ways of being in a world rather than judgments or responses. Here, I highlight three practices in particular—idling, concentrating, and noticing—that recur in his design work, his political responses to Spencer's individualism in the lectures and essays of the 1880s (particularly in the essays collected in *Signs of Change*), and in an early and late romance ("The Story of the Unknown Church" [1856] and *News from Nowhere* [1890]). Across this work, Morris portrays the relationship between bodily and mental states in ways that are broadly sympathetic to the antidualistic perspective of nineteenth-century sciences of mind but that are also far more likely to insist on the relevance of economic and social structures. In the context of this book's argument, then, Morris's conception of somatic practices politically and economically inflects what it means for a mind involved in aesthetic experience to be not contained within an individual but instead turned "outward" into physical processes.

The idea that aesthetic experience involves embodied practices of making intervenes in a longer lineage of aesthetic thought that has often puzzled over how one is to locate the social and extrapersonal dimensions of experiences of art and literature that are felt to be internal and private. Does describing aesthetic experience as routed through the body attenuate or obfuscate the extraindividual social and economic contexts that in fact determine it? Or does a materialist, embodied aesthetics

create a path to a different mode of sociality, one in which collectivity is not realized primarily within the realm of the mind or imagination but rather comes concretely into being as the shared immediacy of a commonly sensed world? These alternatives provide the conceptual impetus for my argument here about Morris, whose work represents a significant resource for exploring how human corporeality might be given a central role in an account of aesthetic experience without rendering aesthetic response a private, asocial, or dehistoricized interaction of an individual with an art object. Morris's explorations of somatic practices reveal that the claim that Adorno makes about the bourgeois affiliations of aestheticism—that an undialectical celebration of subjective aesthetic pleasure easily shades into bourgeois acquisitiveness such that "the interiors of a chic aestheticism resemble smart antique shops"—does not arrive at its target for every aesthete.[12] Morris's version of aestheticism contests both the commercial orientation implied by the "antique shop" and the association of art with "interiors"; Morris instead adopts a capacious sense of aesthetic form as the human shaping of any thing that is intended for use by another. Ultimately this logic works against the conflation of "aesthetics" with "art"; Morris's romances, in particular, follow the logic of somatic practices to the conclusion that a utopian aesthetic state is one in which art will cease to exist.

Designing an Invisible Book

Few writers have occasioned more sustained explorations of the materiality of language and of the act of reading than Morris. Jerome McGann argues for Morris's place at the origin of modernism's attention to "the physique of the poetical event: from the elementary phonic values of the letters and syllables, through the entire array of verbal imagery, to the shape of the scripts and all the physical media—material as well as social—through which poetry is realized."[13] What McGann describes as the "physique of the poetical event," encompassing both the design of the page and its apprehension by the reader's eye, runs parallel to what Nicholas Dames would describe as the "physiology of the novel," similarly encompassing the features of the printed page and the ocular demands it makes on the reader. But for Dames, "physique" is more literal: the compression of type was commonly understood as a concern of "hygiene" in the 1880s and 1890s, because the demands made on the eye were understood to cause fatigue and exhaustion.[14] Late nineteenth-century British literary culture was closely concerned not only with the physical features of the printed page but with the physical effects of the

books on the reading bodies. This intersection of book history and physiology means that Morris's many discussions of printing can be read not only as technical documents but as explorations of the embodied practicalities of literary experience: they yield a self-consciously aesthetic physiology of reading.

One of Morris's most important essays on this topic, "The Ideal Book" (1893)—originally given as a lecture to the Bibliographical Society in London and later widely reprinted—makes this resonance especially clear as it attends closely to the demands made by books on readers' bodies. Morris's title was perhaps poorly chosen. "Ideal" implies abstraction; what Morris really cares about is the material book: the best possible book that can be made of ink and paper and glue. As a result, Morris does not give any advice about plot or prose style, but he has much to say about all of those properties of a book that are generally taken to be its barest conditions of existence. He begins by directing attention to the smallest element of the printed page: not the individual letter, but the blank space between two of them: "For clearness of reading, the things necessary to be heeded are, first, that the letters should be properly put on their bodies, and, I think, especially that there should be small whites between them. . . . One thing should never be done in ideal printing, the spacing out of letters, that is, putting an extra white between them."[15] Notice that Morris explains the importance of the seemingly minor issue of letter spacing (i.e., kerning) according to principles that are implicitly corporeal. Blank space matters because it creates a feeling: specifically, a feeling of clarity and ease, as opposed to the low-contrast *Westminster Gazette*, printed on green paper, which is "very trying to the eyes."[16] The proper closeness of letters makes it easier for the reader to quickly perceive the words they make up. To Mallarmé's famous assertion to Degas that "one does not make poetry with ideas, but with *words*," Morris might have countered, that one does not make poetry with words, but with *ink*.[17]

Morris's essay on the ideal book guided the small presses that flourished in Britain and America at the turn of the twentieth century. A vibrant conversation took place in the 1890s about revitalizing book printing in the wake of the nineteenth-century explosion of print. Charles Thomas Jacobi's *On the Making and Issuing of Books* (1891), Charles Ricketts's *A Defence of the Revival of Printing* (1899), Ricketts's and Lucien Pissarro's *De la typographie et de l'harmonie de la page imprimée* (1898), and John Southward's *Artistic Printing* (1892) all called for renewed attention to the appearance of the printed page (figs. 4.1, 4.2). These works expressed a view of books as something

FIGURE 4.1 Charles Thomas Jacobi, half title page, *On the Making and Issuing of Books* (London: Chiswick, 1891). Courtesy University of Chicago Special Collections Research Center.

more than containers of ideas. Properties such as margins and serifs and paper quality were not just technical considerations; they had artistic and perhaps even literary value. Within this revival of interest in print, Morris's "The Ideal Book" is notable because it derives design principles from a consideration of the specific perceptual and physical demands involved in reading a book in all of its material aspects. So, readers learn that the small characters are not "handsome or clear to read," that the overabundance of tied letters (ligatures) causes unfortunate "difficulty"

IN the course of this note on the aims of the revival of printing, & on the conditions controlling the master-printers of the past, I would beg to be allowed to contrast the work of the great Venetian Printers & of William Morris to my own, not in any rude assumption of rivalry, but merely for convenience, since the achievement in

FIGURE 4.2 Charles S. Ricketts, *A Defence of the Revival of Printing* (London: Ballantyne Press, 1899). Courtesy University of Chicago Special Collections Research Center.

for readers, and that rightly proportioned margins are more "tolerable" to look at.[18] Furthermore, the physical properties of the book—paper and binding—are as important as graphic design for making books "comfortable"; Morris writes that "a small book should not be printed on thick paper, however good it may be. You want a book to turn over easily, and to lie quiet while you are reading it."[19] In a description of the scene of reading that will be familiar to any reader, Morris describes the distractions that are created by a book that will not stay put: "The fact is, a small book seldom does lie so quiet, & you have either to cramp your hand by holding it, or else to put it on the table with a paraphernalia of matters to keep it down, a tablespoon on one side, a knife on another, & so on, which things always tumble off at a critical moment, and fidget you out of the repose which is absolutely necessary to reading."[20] The book in this scene might well be thought of as a utensil like the tablespoon and the knife Morris describes (both of which have been notably diverted from their proper function by the recalcitrant book): a made object that is a more or less useful means to an end. Morris turns attention to reading—an experience most often described as interior and psychological—as, instead, a physical interaction between person and thing.

In this regard, Morris's essay represents a new kind of somatic attention that aesthetes paid to physical things, cultivating sensitivities to their textures, forces, and resistances; he makes practical the materialism that was often theoretical for someone like Pater. The book is an especially problematic kind of thing, though, because of its doubled relation to meaning. This tension is embedded in Morris's essay. On the one hand, Morris is offering advice for crafting a pleasing physical object, well proportioned and easily manipulable, like the chairs and rugs that his firm made in the 1870s. But Morris's conception of literary materiality is surprisingly dialectical: Morris imagines that all of this attention to physical format is ultimately a way to render the book invisible. The ideal scene of reading is one in which the materiality of the book has fully receded; a large folio, Morris writes, "lies quiet and majestic on the table, waiting kindly till you please to come to it . . . giving you no trouble of body, so that your mind is free to enjoy the literature which its beauty enshrines."[21] The scene of reading involves mutual adjustments between book and body, adjustments that can induce cramps or comfort, ocular flow or ocular disruption. Books render mind-body relations both visible and problematic; the beauty of good design is to resolve these relations into invisibility.

In the same year that Morris lectured on the ideal book, the book designer Charles Ricketts and the artist Charles Shannon published an

edition of Longus's romance *Daphnis and Chloe* at their Vale press, which embraces a different and much briefer argument—just four words—that understands the animation of the book as organic rather than mechanical. Ricketts and Shannon conclude the story of Daphnis and Chloe's induction into lovemaking with a woodcut of a woman (perhaps Venus) who is seated on a tomb while holding a book that miraculously sprouts two roses; the phrase "SUA CUM VENUSTATE RENATA" ("with its/her beauty reborn") adorns a banner floating behind her head (fig. 4.3).[22] The image argues for Ricketts's Vale Press itself as a "rebirth" of the tradition of the beautiful book—a claim that was often made by 1890s printers as they compared their renewed attention to type and design to Nicholas Jensen's transformation of typefaces in the late fifteenth century. The combination of decadent design and Renaissance vocabulary is only one of the conflations here. The image also renders unclear whether the book or the woman has been given new life: because the Latin phrase is a sentence fragment, the grammatical case and therefore its referent is unclear; "sua" might refer to the woman or to the book (or perhaps even the flower). What does it mean for a book, a physical object that never was alive, to rise from the grave? The image of the book growing flowers invests the book with organic vitality. If Morris's book betrays a certain lively animation as it falls shut at the wrong moment, Ricketts and Shannon's book is more vitally animated: its aliveness comes from organic birth, not the physics of the book's binding.

The image does more than remind readers that *Daphnis and Chloe* is a reborn book. Seen in relation to its surrounding text, it suggests a relationship to the physical book that crosses the border from sensuousness into eroticism. In the final sentences of *Daphnis and Chloe*, the two lovers lie "naked together, began to clip, and kiss, and twine, and strive with one another, sleeping no more then [*sic*] birds of the night"—an erotic intertwining that is replicated by the natural intertwining of the decorated initial *B*, penetrated by branches. As one traverses the line separating the two pages, one is met with further intertwinings: most notably, the visual intertwining of the branches that form the background of the woodcut of the reborn book. Less notable—but more interesting—is a subtextual intertwining within the colophon above the woodcut, where we learn that Ricketts and Shannon—lovers—have together authored the images within the book: "THE WOODCUTS DRAWN ON THE WOOD BY CHARLES RICKETTS FROM THE DESIGNS BY CHARLES SHANNON AND CHARLES RICKETTS HAVE BEEN ENGRAVED BY BOTH."[23] The book becomes legible as the product

HERE ENDS THIS EDITION OF THE MARVEL-
LOUS LOVES OF DAPHNIS AND CHLOE BY
LONGUS. REPRINTED FROM THE TRANSLA-
TION BY GEORGE THORNLEY GENTLEMAN
OF THE GREEK ORIGINAL. THE WOODCUTS
DRAWN ON THE WOOD BY CHARLES RICKETTS
FROM THE DESIGNS BY CHARLES SHANNON
AND CHARLES RICKETTS HAVE BEEN EN-
GRAVED BY BOTH. BEGUN IN APRIL OF THE
YEAR MDCCCXCII IT WAS FINISHED IN APRIL
OF THE YEAR MDCCCXCIII
OF THIS EDITION ONLY TWO HUNDRED AND
TEN COPIES EXIST OF WHICH TWO HUNDRED
ARE FOR SALE. THE PRINTING IS BY THE BAL-
LANTYNE PRESS LONDON AND EDINBURGH.

SOLD BY ELKIN MATHEWS AND JOHN LANE
At the Sign of the Bodley Head in Vigo Street nigh the Al-
bany.

FIGURE 4.3 Charles Ricketts and Charles Shannon's edition of Longus, *Daphnis and Chloe: A Most Sweet and Pleasant Pastoral Romance for Young Ladies* (London: E. Mathews and J. Lane, 1893). Courtesy University of Chicago Special Collections Research Center.

not just of shared labor but of shared homoerotic labor; it is not just a potential stimulus of sensory pleasure but the real, materialized off-spring of same-sex desire. To hold the book is, in some sense, to come into contact with the product of what Linda Dowling has described as late-Victorian "spiritual procreancy" between men.[24]

The notion that books, as objects, were in a position to interact un-
usually with the physiology of perception had been explored by Oscar
Wilde in 1882 when he and J. M. Stoddart published a book of Rennell
Rodd's poems, *Rose Leaf and Apple Leaf*, on pages of translucent paper
interleaved with smaller, light-green pages. (Rodd had won the presti-
gious Newdigate Prize in 1880, two years after Wilde had received the
same honor.) As the book lies open, the parchment edges frame Rodd's
poetry as well as Wilde's glowing introduction (fig. 4.4). The effect is
that the book seems almost to radiate light, a sensory effect that illus-
trates a point Wilde makes in his introduction: the "younger" school of

FIGURE 4.4 Green interleaved pages in Rennell Rodd, *Rose Leaf and Apple Leaf* (Philadelphia: J. M. Stod-
dart, 1882). Courtesy Rare Book & Manuscript Library, Columbia University in the City of New York.

aesthetes has broken with Ruskin by asserting "the primary importance of the sensuous element in art."[25] The object instantiates the theory.

To modern eyes, Wilde and Stoddart's edition of Rodd, the books of Shannon and Ricketts's Vale Press, and those of Morris's Kelmscott Press may all appear to participate in an aestheticist impulse that John Plotz has described as the "imperative to beautify the familiar" rather than reproduce it, as the realist novel often did.[26] But, distinctively, Morris is interested in beauty as a somatic state, as a variety of "comfort" or "ease"; for the more decadent Ricketts, Shannon, and Wilde, by contrast, the sensuousness of the book is implicitly eroticized. Where Morris imagines that the ideal book might lull the reader into forgetting it is even there, *Daphnis and Chloe* is too stimulating—both in the story it tells and in the images it reproduces—ever truly to disappear; *Rose Leaf and Apple Leaf* is similarly visually vibrant. For Ricketts, reading is "twining"; for Morris, it is comfort. Rather than creating a unique thing of precious beauty, Morris's lecture on the ideal book asks how his society might create a different norm for the material format of text. "The Ideal Book" reveals that Morris was thinking about the materiality of literature not only in terms of the physical properties of a book but also in terms of the physical properties of the reader. Morris's essay on book design involves a close consideration of the relationship between mental acts of realizing narrative and the bodily disposition of a reader; to a certain extent, Morris's concern with design can be described as a commitment to always insisting on routing mental acts of reading through the physical materiality of book and body. His book design works against a model in which the individual may retreat from the physical world into a domain of the imagination. This logic had implications for notions of individualism more broadly: if Morris's writing on book design implies an elision of the boundary between mind and object, his political response to Herbert Spencer's individualism in the late 1870s and 1880s involves an understanding of human corporeality itself as shared.

Shared Corporeality in Signs of Change

Morris's close attention to the physical features of the book, as it draws a contrast between the periodical and fine press, implicitly raises a philosophical problem having to do with conflicts between aesthetic and economic orders of value. It may well be the case that all readers would prefer properly spaced letters and wide margins but that this is not a choice of design but of economics. Discussing Jugendstil, the German design movement that drew inspiration from Morris's workshop and

press, Adorno writes that "its lie was the beautification of life without its transformation; beauty itself thereby . . . allowed itself to be integrated into what it negated."[27] Adorno highlights a problem of which Morris was well aware: so long as capitalism holds sway, beautiful objects are always susceptible to becoming commodities.[28] Adorno's approach to this antinomy is to emphasize the value of art's autonomy, thus driving in nearly the opposite direction as Morris's decorative, surface-oriented aesthetic. Adorno's argument is that it is only by standing apart from society as a Leibnizian monad, and thereby representing the possibility of a different order of value, that artworks can dialectically contest the present social order.[29] This quality of separateness is to be found not in beautiful decoration but among "authentic" works of genius—Beethoven's string quartets, Kafka's fiction, Beckett's plays. In *Aesthetic Theory*, then, Adorno consistently contests the notion that art unproblematically induces aesthetic pleasure, calling this "the platitude—a bowdlerized theorem of aesthetics—that art must be a direct object of pleasure, whereas instead art at every point participates in concepts."[30]

If Jacques Rancière tends to be more sympathetic to arts of design and decoration than Adorno, this is in part because his conception of the politics of these kinds of practices proceeds from a different understanding of what it means for aesthetic experience to acquire political significance. For Rancière, the connection between politics and aesthetics takes place not so much by way of the contestatory autonomy of the individual work of art as by way of art's capacity to organize what can be sensed or perceived by a community. Rancière's account of the politics of aesthetics might therefore be described as more corporeal than Adorno's, inhering "in the way in which the practices and forms of visibility of art themselves intervene in the distribution of the sensible and its reconfiguration, in which they distribute spaces and times, subjects and objects, the common and the singular."[31] Rancière's conception of the politics of aesthetics, then, is far more closely linked to the senses and the bodies of those who participate in or are excluded from a common space; the "forms of presence of singular bodies in a specific space and time" constitute a significant component of what he describes as the "distribution of the sensible."[32] Nearly inverting Adorno's conception of autonomy, Rancière argues that "art exists as a separate world since anything whatsoever can belong to it" and attends in particular to how the aesthetic regime of art "is constituted and transformed by welcoming images, objects, and performances that seemed most opposed to the idea of fine art: vulgar figures of genre painting, the exaltation of the most prosaic activities in verse freed from meter," and many other instances.[33]

I highlight this distinction between Adorno's and Rancière's under-
standings both of aesthetic autonomy and of the kinds of decorative aes-
thetic practice to which Morris was committed because it provides a
productive set of terms for articulating how Morris finds a politics in
the fundamental corporeal sharedness of human life. By contrast with a
model in which the contemplation of an artwork provides access to an
imaginatively shared community of spectators—the subjective univer-
sality of Kant's third critique—Morris imagines instead that this shared
experience might also encompass basic bodily dispositions. This leads to
a way of thinking about art that abandons individualized units such as
the artwork, the artist, the viewer, or the reader in favor of what might
be described as "artistic environments": networks of humans and things
connected by practices of making and using in which it is relations rather
than objects that become the salient units of analysis.[34] By locating the
sharedness of the aesthetic at the level of human corporeality, Morris po-
liticizes the kind of somatic response that Adorno frequently calls "culi-
nary" pleasure (i.e., oriented toward merely passive consumption) and
that nineteenth century physiological aesthetics framed as its distinctive
object of inquiry.[35]

To understand the stakes of what might be described as Morris's
transindividual conception of aesthetic experience requires attending to
the political and intellectual debates over individuation that represent
one of its contexts. In the 1880s and 1890s, the question of what consti-
tuted an "individual" was a matter of concern in a wide range of fields—
physiology, philosophy, politics—which often looked to Herbert Spen-
cer's influential claim in *Social Statics* (1851) and *Principles of Biology*
(1864, 1867) that "higher" organisms displayed a greater "tendency to
individuation."[36] Morris encountered this debate most directly through
his opposition to a position advocated by Spencer and his followers, who
had argued against what they saw as an overly statist version of political
liberalism. In a series of essays for the *Contemporary Review* in 1884,
later published as *The Man versus the State*, Spencer argued that social-
ism was "slavery": "each member of the community as an individual
would be a slave to the community as a whole. . . . The services of each
will belong to the aggregate of all. . . . So that even if the administration
is of the beneficent kind intended to be secured, slavery, however mild,
must be the outcome of the arrangement."[37] Drawing on evolutionary
theory and playing on fears of degeneration, Spencer's "natural history"
of social organization warned that if "the benefits received by each indi-
vidual were proportionate to its inferiority—if, as a consequence, multi-
plication of the inferior was furthered, and multiplication of the superior

hindered, progressive degradation would result; and eventually the degenerate species would fail to hold its ground in presence of antagonistic species and competing species."[38] *The Man versus the State* thus translates into political terms the biological theory of "tendency to individuation" that structured his understanding of evolution.

The intricacies of the debate between individualists and socialists have been traced by political and cultural historians; my aim here is to suggest that it produced a repertoire of figures that allowed Morris to develop a perspective in both his politics and his aesthetic practice from which the boundaries apparently separating individuals from one another could be treated more as an effect of language than as a valid description of the world.[39] This figural problem surfaces often in the debate around Spencerian individualism, where the challenge of describing the nature of individuality was commonly addressed by turning to metaphor. An essay collection that responded to Spencer's *The Man versus the State,* Thomas Mackay's *A Plea for Liberty,* reaffirms Spencer's essentially negative definition of freedom: arguing that "the liberty which a citizen enjoys is to be measured . . . by the relative paucity of the restraints [government] imposes on him."[40] This conception of the self as a vacancy, as defined by the absence of restraint, is then taken up by various contributors. The trade unionist George Howell's essay in the volume defines individuality in terms of a line separating private and public as well as in terms of physical atomism—"In the privacies of ordinary life there is a limit which instinct seems to indicate as a kind of boundary line, beyond which legislation should not extend"—and accuses socialists of espousing "the merging of the *man* into the *mass*; the fusion of atoms into a solid concrete body."[41] Erasing this boundary amounts to "effacing" the individual, which is taken as self-evidently problematic; Howell explicitly acknowledges the atomism of his notion of individuality as he worries about the "fusion" of individuals into a body under the control of an alien state. The laissez-faire liberal Wordsworth Donisthorpe's *Individualism: A System of Politics* similarly worries about the potential fusion resulting from socialism, which Donisthorpe figures as "individual cells or groups of cells which together constitute the human body. The cells have, so to speak, 'lost their identity.'"[42] Moments such as these reflect not only the conceptual difficulty of imagining pure individuality but also the flexible metaphorical rendering of scientific concepts—here, cells and atoms—in order to address this challenge.

It is in this context that we should understand Morris's turn to a conception of shared corporeality that served not only as a political principle but as an aesthetic principle as well. From its earliest issues,

Morris's *Commonweal* often addressed this debate directly. Nearly every issue contained attacks on individualism or self-proclaimed individualists, including frequent critiques of the annual reports of the "Liberty and Property Defence League," one of the main associations allied with political individualism.[43] With Ernest Belfort Bax, a cofounder of the Socialist League, Morris wrote an important series of articles, "Socialism from the Root Up" (1886–1887) that took the individualism/socialism opposition as historically originary, observing that medieval society was based on "the fusion of ideas of tribal communism and Roman individualism."[44] The Socialist League also frequently held debates whose topic was "individualism v. Socialism."[45] What was at stake was a political principle that had extrapolitical ramifications. Morris had learned from Marx and Ruskin alike that persons can never be understood as purely self-constituting or isolated from their natural and social environments. To understand any object or experience, whether it is a perfectly machined object or the feel of a printed page, one needs to think capaciously about the networks that contain and connect persons, things, bodies, and experiences.

Although this debate might seem to be far afield here from scientific discourses of physiological psychology and mental science, it is important to keep in mind that Spencerian individualism can be understood as the political extension of Spencer's teleological conception of evolution, which likewise grounded his work on physiological psychology. This means that Morris's aesthetic and political response to individualism, which highlights the extent to which all humans share basic bodily states of pain and pleasure, responds to this broader context in which political and scientific ideals of autonomous individuality easily infiltrated one another. Morris, however, was far less likely to call on an explicitly scientific idiom; it is, rather, through more general terms such as *health*, *bodily power*, or the *human animal* that Morris's anti-individualism begins to look something like a physiology of political life. In his 1880s lectures on socialism and the arts, collected in *Signs of Change* (1888), a volume that E. P. Thompson praised as "one of his greatest achievements, the point of confluence of the moral protest of Carlyle and Ruskin and the historical genius of Marx, backed by Morris's own lifetime of study and practice in the arts," Morris often approaches "health" not just as a political value but as the biopolitical condition of possibility for having values at all. In "How We Live and How We Might Live" (1885), Morris laments that civilization tends to prevent rather than sustain this basic possibility:

> To feel mere life a pleasure; to enjoy the moving one's limbs and exercising one's bodily powers; to play, as it were, with sun and wind and rain; to rejoice in satisfying the due bodily appetites of a human animal without fear of degradation or sense of wrong-doing: yes, and therewithal to be well-formed, straight-limbed, strongly knit, expressive of countenance—to be, in a word, beautiful—that also I claim. If we cannot have this claim satisfied, we are but poor creatures after all.[46]

As Morris moves in the essay from a phenomenology of pleasurable work and play to a conception of beautiful physique, he de-emphasizes individual particularity in favor of a characterization of the human not as an individual but as an animal; Morris's conception of "life in common" throughout the essay emphasizes rather than eschews the animality of human life.[47] Morris notes that contemporary conditions of labor often cause him to "console myself with visions of the noble communal halls of the future," whose architecture will exceed that which is possible under capitalism, because "only collective thought and collective life could cherish the aspirations which would give birth to its beauty."[48] Here and elsewhere, Morris argues that the mere fact of having bodies and being aware of their states—not the supposedly higher faculties of reflection or judgment—both binds humans together and provides the fundamental ground of aesthetic and political experience. The animal dimensions of human life provide Morris with a figural alternative to the atomized and cellular individualisms of Spencer's cohort.

Within *Signs of Change*, this conception of art as shared corporeality positively instantiates an abstract political possibility of a transformed future that had been outlined by explicitly political lectures such as "Whigs, Democrats, and Socialists" (1886), "Feudal England" (1887), and "The Hopes of Civilization" (1885). The arc of Morris's essays is often to articulate a sweeping history of class and labor in England that culminates in an aporia about what the future might hold—an aporia that in "The Hopes of Civilization," for instance, takes the undetermined and doubly displaced shape of "whatever unforeseen and unconceived-of may lie in the womb of the future."[49] In a parallel gesture, Morris also often calls on the history of art and design in order to shadow forth possible visions of this future; past versions of collective artistic expression are nascent instances of a happier future state. Thus, in "Feudal England," Morris proposes that "half a dozen stanzas of [medieval ballad poetry] are worth a cartload of the whining introspective lyrics of today" because it is the

product of collective rather than individual labor: it is poetry "of the peo-
ple," a "protest of the poor against the rich."[50] This strategy of playing
various forms of collectivity against poetic and economic individualisms
yields a utopian aesthetic vision of shared corporeality that directly count-
ers both the "introspective" qualities of nineteenth-century novel and
poetry and the competitive individualism of capitalism. In "Useless Work
versus Useless Toil" (1885), Morris's strategy is to substitute shared for
competitive labor and to highlight, as he did the same year in "How We
Live," the connection between human and animal exercise and activity:

> I think that to all living things there is a pleasure in the exercise
> of their energies, and that even beasts rejoice in being lithe and
> swift and strong. But a man at work . . . is exercising the ener-
> gies of his mind and soul as well as of his body. . . . Not only his
> own thoughts, but the thoughts of the men of past ages guide his
> hands; and, as a part of the human race, he creates.[51]

Morris not only privileges popular and collective forms such as ballad
poetry but more specifically takes pains to show that individual labor
can be understood both as the extension of a tradition (one works "as
a part of the human race") and of animal behavior ("to all living things
there is a pleasure"). It is in this sense that his political lectures take mere
corporeality as the basis for an anti-individuating aesthetic.

From this perspective, it is especially intriguing that Morris's con-
ception of collective artistic life in these essays of the 1880s occasion-
ally draws on an evolutionary logic to imagine beauty as a feature of
evolving populations—even as they militate against the forms of strong
individualism that had taken hold in most extreme fashion as a result
of Spencer's sociobiological evolutionary theory. In "How We Live and
How We Might Live," Morris embraces an apparently Lamarckian
theory of healthiness as an acquired characteristic in a population that
has eschewed dull work: "who knows where the seeds of disease which
even rich people suffer from were first sown: from the luxury of an an-
cestor, perhaps; . . . I suspect these good conditions must have been in
force for several generations before a population in general will be really
healthy . . . but also I doubt not that in the course of time they would,
joined to other conditions, of which more hereafter, gradually breed such
a population."[52] This argument joins Morris to a broader group of writ-
ers, including Annie Besant, who began to reimagine evolutionary the-
ory as potentially compatible with socialism notwithstanding its appar-
ent affinities with the individualism of Spencer.[53] While Morris's object

of political critique encompassed much more than Spencerian individu-
alism, it is nonetheless the case that his conception of shared corporeality
draws implicitly on biological and evolutionary conceptions of human
life in order to sustain a logic in which human physiology unites persons
as "animals" or "living things" rather than competitively dividing them
as atoms or cells.

Before turning in more detail to how this conception of shared corpo-
reality produces a way of thinking about the aesthetic domain as struc-
tured by practices rather than judgments, I want to highlight one further
feature of these lectures of the 1880s having to do with the particular
conception of form that follows from an aesthetics of shared corporeal-
ity. In a line of reasoning that is closely related to his attention to the con-
tinuity between human and animal labor, Morris proposes that the term
art should be understood to potentially encompass anything that bears
the traces of human intentions. Morris makes this claim most clearly in
"Art under Plutocracy," one of his first openly political lectures, given
at University College, Oxford, in 1883. *Art* does not refer to things in mu-
seums but to a whole array—perhaps even the whole array—of human
practices:

> I must ask you to extend the word art beyond those matters
> which are consciously works of art, to take in not only painting
> and sculpture, and architecture, but the shapes and colours of all
> household goods, nay, even the arrangement of the fields for till-
> age and pasture, the management of towns and of our highways
> of all kinds. . . . For I must ask you to believe that every one of
> the things that goes to make up the surroundings among which
> we live must be either beautiful or ugly . . . either a torment and
> burden to the maker of it to make, or a pleasure and a solace
> to him.[54]

This emphasis on art as radically open—as anything that has been
shaped—is the logical result of an aesthetic theory in which somatic
states connecting human bodies are the basis of aesthetic community.
Morris goes on to elaborate a distinction between intellectual art, which
"addresses itself wholly to our mental needs," and decorative art, which
is constituted by "things which are intended primarily for the service
of the body."[55] It is a claim that not only controversially stretches the
idea of "art" to its breaking point but that also highlights a way of lo-
cating the political value of the aesthetic not, as Adorno would have it,
in the autonomy of the artwork but rather in something much closer to

Rancière's conception of aesthetic autonomy as defined by the capacity of the aesthetic domain potentially to contain any object or practice.

Somatic Practices: Idling, Concentrating, Noticing

Thus far, I have suggested that Morris's writing on book design and his political lectures can be understood as attending closely to the political implications of taking the materiality of the artwork and the human body as a central matter of concern within aesthetic theory. If, as I have argued in previous chapters, materialist sciences of the mind controversially routed thought and emotion through the body, Morris's thought raises the question of how this model might encounter Marxist thought, within which "materialism" referred not to the reduction of mind to body but to "human sensuous activity, practice" as a means for changing the material conditions that bound "abstract thinking."[56] If this is the case, then Morris's frequent explorations of various states of attention, distraction, absorption, and habit become the site where his thought unfolds a distinctive repertoire of somatic practices of bodily engagement with artworks.

Idling. Aesthetes have a well-known and vexed relation to doing nothing. Laziness could be both a stylish disavowal of earnest intention and a life-threatening illness; boredom was simultaneously a social and physiological disposition. Describing the book that had a fatal influence on Dorian Gray, Wilde diagnosed idleness in French and Latin: "He was sick with that terrible ennui, that terrible taedium vitae"; another character "had absolutely nothing to do, almost died of *ennui*."[57] In his poem "Scènes de la vie de bohème," Arthur Symons's French lovers belie decadence's voluptuous reputation by boring each other into conversational silence rather than consummating their mutual desire; "they wearied each of each / And tortured ennui into hollow speech, / and yawned, to hide a frown. She jarred his nerves; he bored her—and so soon.[58]" But there is an important distinction between decadent boredom and what Morris described as idleness. The bored decadent is overstimulated by and oversensitive to the sights, sounds, and technologies of modernity, and transforms hypersensitivity into a pose. Morris, by contrast, treats idleness not as a socially performed illness, but as a crucial part of healthy function. In his essay "The Aims of Art" (1886), Morris identifies two "moods" between which he tends to oscillate: "the mood of energy" and "the mood of idleness."[59] Each involves different demands and predispositions: while

in the mood of energy, Morris feels that "I must be doing something or I become mopish and unhappy; when the mood of idleness is on me, I find it hard indeed if I cannot rest and let my mind wander."[60]

These reflections sound introspective, but Morris clarifies that moods have an importantly social aspect connected to the function of art itself: "The restraining of restlessness, therefore, is clearly one of the essential aims of art, and few things could add to the pleasure of life more than this."[61] This sort of comment takes part in Morris's ethic of the value of doing nothing. In "Useful Work versus Useless Toil," for example, Morris embraces the "animal" feeling of exhausted rest not as something low but as a reward: "Whatever pleasure there is in some work, there is certainly some pain in all work, the beast-like pain of stirring up our slumbering energies to action . . . and the compensation for this animal pain is animal rest."[62] A feeling like "animal rest" thus becomes a hinge between physiology and politics. For Morris, notably, animality here signals quietude rather than Darwinian or Spencerian competition. Aesthetic idleness becomes a form of resistance to dominating social and economic logics of competition and production.

Concentrating. Idleness as an aesthetic practice works in contrast with a related value on modes of habitual concentration. This value becomes especially apparent in Morris's design work of the 1870s. During that decade, E. P. Thompson writes, Morris was "continually busy with close study, experiments, and practical engagements with the materials of his craft. Glass-firing, the glazing of tiles, embroidery, woodcutting and engraving" were among many interests that turned Morris's attention to physical media.[63] One of Morris's many fields of expertise was the design of carpets, a difficult task that required a kind of careful attention that is intense and focused but quite different from the freedom of contemplation we usually think of as "aesthetic." By contrast, when designing carpets, Morris would first draw out the design by hand on a piece of paper one-eighth the size of the carpet and then transfer this design to "point paper," a fine graph paper where each box marked one knot of the carpet. One Victorian design manual describes this process as "intolerably irksome and tedious."[64] But Morris's intuition was that tedium might be converted into pleasure by shifting the social and economic structures that contained it. If instead of designing a carpet for wages, I were planning to use it myself or to give it away, the repetitive tasks involved—such as the repetitive patterns themselves—might become interesting rather than dull. Work highlights the intersection of

the physiological and the social: pain and pleasure are socially as well as biologically determined.

By contrast with mere idling, the pleasure of concentration—the fact that Morris could enjoy the irksome task of copying carpet designs to point paper—brings into view the difference between aesthetic perception as a moment of reception and as a moment of creation. Instead of Alexander Bain's model of the aesthetic emotions as largely receptive, for example, Morris attends to the modes of perception that take part in the process of artistic making. This attention to the active dimensions of aesthetic experience makes it more evident that social structures participate in determining how a given stimulus will feel. Like physiologists of aesthetic experience, Morris is interested in the somatic dimension of the pleasures afforded by making or experiencing art—the sharpening of the senses produced by pattern, or the "pleasure" and "solace" of well-designed towns or pots.[65] But Morris understands aesthetic emotion as always within a network of persons and things.

One can therefore characterize Morris's view of "art" both politically, as an attempt to recapture the beautiful object from the leviathan of global industrial commerce, and sensuously, as an attempt to renew those forms of human pleasure in creating and receiving, making and using, that were being eclipsed by modernity. Morris begins his lecture on "The Lesser Arts of Life" by asking, must all art "stir our emotions deeply, or strain the attention of the most intellectual part of our minds"?[66] In the essay, Morris portrays the perceived difference between greater and lesser arts as a difference between mind and body: "higher men were making things wholly to satisfy men's spiritual wants; the lower, things whose first intention was to satisfy their bodily wants."[67] Morris and other major proponents of the international Arts and Crafts movement—Walter Crane in England, Harry Clarke in Ireland, Charles Eliot Norton in the United States—contested the exclusion of decoration and craft from the category "art." An important mechanism of this argument was to return attention to physiological, embodied states.

Noticing. We can locate a third somatic practice by returning to the 1890s, when Morris is interested in typography rather than tapestries. Through his concern with typography, Morris made contact with a discourse that was more directly connected with physiology. Though Morris's typefaces are often thought of as representative of an antimodern medievalism, they are in fact closely linked to optical research and visual technologies. The French ophthalmologist (and translator of Hermann von Helmholtz) Louise Émile Javal discovered in the 1870s that when read-

ing a page of text, a person's eyes do not move continuously, but jump from one point on the line to the next—a phenomenon that later became known and studied as "saccadic jerks."[68] Less well known is Javal's contribution to typography, which he sought to modernize in order to promote ocular health and prevent myopia. The too-high contrast between black ink and white paper, the high density of characters in a line, and, of course, the smallness of the characters themselves all, Javal thought, contributed to eye deterioration.[69]

In England, the type founder Talbot Baines Reed drew on Javal's findings as a resource for designing his own typefaces. In turn, Reed's work informed the typefaces that were developed at the Kelmscott Press.[70] Morris's associate (and son-in-law) Henry Sparling described the importance to Morris of Reed's statement in his account of the Kelmscott Press. Of five of Javal's physiological principles of type design, according to Sparling, Morris adopted three: "1. That the eye, after all, is the sovereign judge of form. 2. That, in reading, the eye travels horizontally along a perfectly straight line, lying slightly below the top of the ordinary letters. So that the width of a letter is of more consequence than its height, and the upper half of it than the lower. 3. That, in reading, the eye does not take in letters, but words or groups of words."[71] (Morris was less enthusiastic about the final two principles—that there should be low contrast between thick and thin, and that "speed of comprehension" was the same thing as "legibility.")

But Morris's type designs were also based on more than the eye could see. Morris was inspired to begin creating typefaces by an 1888 lecture by Emery Walker, at which Walker had used a magic lantern to project images of Renaissance typography for the audience. This performance was technologically notable: May Morris recalled that "at that time a lecture with lantern-illustrations was not the common thing it is now."[72] The audience, May remembers, "were much struck by the beauty of the 'incunables' shown, and by the way they bore the searching test of enlargement on the screen. . . . The sight of the finely proportioned letters so enormously enlarged, and gaining rather than losing by the process" inspired Morris to begin designing his own type. Morris adapted the magic-lantern projection as a technique for designing type. In the months that followed, Morris photographically enlarged samples of Renaissance type to five times their original size in order to copy them by hand.[73] He and Walker then designed their own enlarged letters and then used photographic reduction to see how they would look on the page, using the relatively new technology of photographic enlargement and reduction to move back and forth between small and large in order to

achieve the desired appearance. William S. Peterson, a historian of the Kelmscott Press, observes that the press, "the quintessential example of an arts-and-crafts longing for the preindustrial age, was paradoxically built upon a foundation of photography, one of the most sophisticated forms of technology in late-Victorian England."[74]

One surprising effect of this intersection of new visual technologies, ophthalmology, and typography is that Morris's "Golden" typeface no longer looks so medievalist. Excavating the methods and principles behind Morris's type design reaffirms that they were not always "characterized by preindustrial methods," as Elizabeth Miller has argued.[75] But what I want to emphasize here is not merely the surprising intersection of the medieval and the modern, of craft and technology. More salient to my argument is the fact that Morris's type design depends on specific manipulations of visual perception: the fact that the eye of a reader might be able to notice automatically the details about serif thickness and letter shape that Morris has to greatly enlarge an individual letter in order to see himself. If making type involves concentration similar to designing carpets, the reader is, by contrast, imagined to inhabit a quite different experiential mode in which good design might be noticed in passing, semiconsciously, as the eye scans the page.

As a result, while typefaces train readers to notice beauty, it is beauty of a particular type. Unlike a formally complex painting or poem, a well-crafted letter is presumably the exact kind of thing that will not "stir our emotions deeply, or strain the attention of the most intellectual part of our minds."[76] It would be absurd to "read" a book printed in the Golden type by sequentially admiring each letter, one by one, as well as the carefully measured spaces between them. But precisely because the beauty of a typeface does not demand sustained, direct attention, it may be capable of exercising more pervasive and subtle capacities. Artists of type such as Morris, Walker, and Reed imagine that their art, though its only partial visibility, will train readers to recognize and appreciate beauty while they are not looking for or at it to feel art's affordance of an immediate sensory experience of comfort rather than its staging of conflict or formal difficulty. In *The Revival of Printing* (1912), Robert Steele emphasized the "training" work that typefaces could do in the service of taste. Steele writes that people sometimes object to illegible but beautiful type only because "the objector's eye has been trained to see bad type. This difficulty will only persist till his perceptions have been adjusted: a similar inertia has to be overcome in the appreciation of all good art."[77] Reading a well-crafted typeface, then, produces an automatic perceptual adjustment for the better—not just the ocular health anticipated by

Javal but the healthy beauty adumbrated by Morris's lectures. The kind
of beauty that applies to a typeface, much like the beauty of a beauti-
ful book, falls somewhere between perception and judgment. Instead
of conceiving of aesthetic experience as a fundamentally interior psy-
chological state, Morris's imagines the physical body as the universally
shared platform of experience. Something as seemingly inconsequential
as a typeface offers, in perhaps a small way, an experience of ease or
comfort.

Outwardness in Morris's Early Romances

Morris's elaboration of somatic practices generates a particular way of
thinking about how it is that aesthetic experience becomes invested with
materiality: not only in that reflection and thought are always concretely
mediated through human bodies and aesthetic objects, but that this me-
diation is processual and ongoing. Aesthetic experience thus approaches
the status of a disposition or a practice. The relevant interpretive coor-
dinates of these practices are not only the physiological operations of
the body or the nervous system but the social and economic worlds that
human bodies inhabit. Turning now to Morris's romances, I will ar-
gue that somatic practices function within the romances as a means for
transforming even those kinds of states that are most often conceived as
interior and subjective—states such as dreaming and reverie—into out-
ward manifestations.

Romance, as understood by Morris, is a literary genre particularly
well disposed to portraying what this book has been describing as the
mind's "outward turn" in nineteenth-century materialist aesthetics. This
is due both to a literary-historical situation in which romance functions
in the 1880s as an alternative to introspective realism and to the way in
which Morris treats the making of literature and the depiction of char-
acters. It has often been argued that romance reemerges as a popular
literary genre in the 1880s and 1890s in direct opposition to the intro-
spective, bourgeois, and overly inward-looking features of the realist or
psychological novel—disparaged by George Saintsbury as tedious "ana-
lytic character-drawing and observation of manners" and by H. Rider
Haggard as "labored nothingness."[78] Because Morris's romances are
partially distinct from what is often called the romance revival in that
they have roots in the 1850s rather than the 1880s and did not aim for
the mass-market appeal of Haggard, Hall Caine, or Robert Louis Ste-
venson, they have often been seen as separate from this revival. But Anna
Vaninskaya has recently argued for a much closer relationship between

Morris and other romance writers: all shared investments in heroic nar-
ratives and antiquarianism, intellectual fascinations with anthropology
and philology, and working- and middle-class markets.[79] This connection
is illuminating for positioning Morris among a wider range of writers
who were developing literary alternatives to psychologism.

It is perhaps a metaphor with which Saintsbury closes an essay pro-
moting romance against realism, "The Present State of the Novel," that
most clearly reflects why the particular kind of antirealism espoused by
romance of the 1880s and 1890s develops a conception of the mind as
outward. Saintsbury argues that "The average man and woman in En-
gland of the middle and late nineteenth century has been drawn and quar-
tered, analysed and 'introspected,' till there is nothing new to be done
with him or her either as an *écorché*, or with the skin on, or with clothes
on the skin." Saintsbury's objection not only renders realism's formal
strategies of subtly depicting character syntactically parallel to torture
(through the clever double entendre of "drawn and quartered") but also
figures the eye of the realist narrator as moving from interior to exte-
rior levels: the *écorché* (an image of muscles stripped of skin used both
by medical students and artists), then skin, and then clothing. Saints-
bury's corporeal metaphor thus figures realism's focus on character as
an inward-directed eye that pierces successive layers of clothing and body.
Realism is thus depicted as intrusively peering inward to develop minute
analyses of the contents of character's minds, here figured as the synec-
doche of muscles, bodies, and clothing.

Morris's romances take up Saintsbury's anti-introspective trope from
a number of directions. In the romances, Morris consistently challenges
the idea that poetry and narrative should be understood as apprehended
primarily by way of mental processes, thus displacing emphasis from
meaning to effect; from the abstraction of "text" to the materiality of
books and speaking or reading bodies. What distinguished Morris from
the romance revival more generally was that this displacement was often
achieved by aligning the making of literature with the making of car-
pets or typefaces rather than by turning to adventure narrative or writ-
ing for a mass audience. This often produced an indeterminacy between
semantic and material levels of writing, which is apparent, for example,
in a series of 1890 exchanges between Morris and his former publisher,
Frederick Startridge Ellis. Morris sent Ellis a specimen of the three type-
faces Morris was working on at Kelmscott. "I hope you admire its lit-
erature," Morris wrote, using the term *literature* in the typographical
sense.[80] A few months later, Morris began corresponding with Emery
Walker about some ornamental initial letters they were designing for

The Golden Legend, the first book undertaken by the Kelmscott Press. April 8, 1891: "As to the small Q & K are too small. . . . I send you another Y."[81] May 2: "Enclosed find the designs of the 2 As."[82] July 10: "The Fates insist on a new K."[83] When Morris writes on July 14, "My dear Walker / Thank you for your letter,"[84] it is almost impossible to know whether "letter" means epistle or typographical character. The unintended puns in these exchanges—literature/literature, letter/letter—collapse semantic meaning into visual appearance.[85] For many readers, Morris's literary endeavors of the 1890s are "letters" and "literature" in precisely this collapsed sense—a series of well-designed marks on a page, in which the whole is less than the sum of its parts. Describing a trajectory of print from William Blake through Morris, W. B. Yeats, and Ezra Pound, Jerome McGann observes that in certain literary works, "the distinction between physical medium and conceptual message breaks down completely"; in these exchanges between Morris and his publisher, we can see that this breakdown can take place not only at the level of the final product—the book as beautiful object—but at the very level of the individual character itself.[86]

The semantic collapse characteristic of Morris's work on typefaces finds its generic counterpart in romance. Morris's first work in the genre appeared in 1856, when he contributed eight short prose narratives and five poems to the *Oxford and Cambridge Magazine*, a joint venture of Morris and Burne-Jones that was modeled on the Pre-Raphaelite magazine the *Germ*. John William Mackail writes that Morris's "discovery that he could write prose came hard on the heels of his discovery that he could write poetry, and for some little time prose was the vehicle in which he could express his thoughts and imaginations with greater freedom."[87] Morris's name was never attached to these early romances during his life, and he resisted pressure to reprint them.[88] But, as Amanda Hodgson and Florence Boos have observed, the romances represent surprisingly complex meditations on the function of the arts that Morris would develop throughout his career.[89]

These early pieces often render the outwardness of the mind in a way that is inspired by Ruskin's thought as well as Pre-Raphaelite painting and poetry and that depicts a complex relationship between, on the one hand, seemingly interior states such as reverie and dreaming and, on the other, moments in which mind becomes a phenomenon realized in the encounter between a body and its surrounding matter. Among these early stories, "The Story of the Unknown Church" (1856) offers a particularly important set of terms for understanding how Morris's early romances trace a relationship between embodied somatic practices and

the apparently disembodied and incorporeal aspects of mental life. The story has often been singled out by Morris scholars as indicating Morris's interest in the relationship between past and present as well as his exploration of the intersection of "doing and dreaming."[90] For McGann, it represents Morris's interest in the physicalized dimensions of not only the book but of language itself: this is evident, McGann argues, because its emphasis on architectural description participates in "the famous Pre-Raphaelite attention to minute detail."[91] What for McGann registers as the "embodied" and "incarnate" aspects of language can further be understood as an exploration of how mental states like dreaming and reverie acquire physical manifestations.

The short romance, Morris's first tale for the *Oxford and Cambridge Magazine* and his first piece of narrative prose, describes a thirteenth-century mason who carves the tomb of his sister and her lover.[92] The mason, Walter, is carving the figure of Abraham on an abbey when his effort to vividly imagine Abraham merges into a "strange dream" of his friend (and his sister's lover) Amyot, who has gone to fight in religious wars.[93] A hallucinatory dream sequence ensues in which space is strangely compressed and scenes quickly shift: Walter notices that he can "see even very far off things much clearer than we see real material things on the earth," and when the far-off Amyot throws some flowers, they miraculously land near Walter.[94] When Walter emerges from his dream, he finds himself still carving the figure of Abraham. Amyot appears again, but now as a real person rather than a hallucination. Margaret and Walter are delighted, but their happiness is short lived; that autumn, Amyot dies and Margaret shortly follows suit. Walter then passes the final twenty years of his life carving their tomb and dies when he finishes the final decorative lily. The romance is thus closely concerned both with visual perception (the strange movements of space) and hallucination as well as with the material practices of carving (the ornament on the cathedral and the tomb).

The multiple moments of mental absorption in the practice of carving stone both reflect Morris's engagement with Ruskin's account of the Gothic architect and prefigure a recurrent aestheticist interest in how architecture, as a medium, is distinctively capable of materializing or metaphorizing outward manifestations of interior states—evident in later works such as Pater's "The Child in the House" and Vernon Lee's "The Child in the Vatican." By turning to a fictional portrayal of an architect, Morris's short tale aims to think through the categories of expression and character that are crucial to Ruskin's important chapter. But where Ruskin imagined a one-to-one relation between the character of

the builder and the appearance of the ornament, Morris introduces a third, complicating term: the dream. The story begins with Walter hesitating over how to carve the figure of Abraham. This small detail is politically charged: it reflects the freedom that Ruskin attributed to the Gothic architect; Walter, unlike a Renaissance architect, makes artistic decisions. What is remarkable, then, is that Walter's mode of carving ultimately reflects the suspension of agency rather than the immediacy of expression.

Where Ruskin's account of the Gothic builder depends on a strong notion of freedom, Morris suggests that a certain form of artistic creation or decorative work does not require concentrating as intently as possible. Instead, Walter gives in to the automatic processes of the mind and body as they operate in tandem. The interconnectedness of carving and dreaming are most apparent as Walter emerges from his hallucination: "When I looked again the garden was gone, and I knew not where I was, and presently all my dreams were gone. The chips were flying bravely from the stone under my chisel at last, and all my thoughts now were in my carving, when I heard my name, 'Walter,' called, and when I looked down I saw one standing below me, whom I had seen in my dreams just before—Amyot."[95] Even at the level of syntax, we can see the moderated forms of agency that operate in relation to artistic production: Morris emphasizes the activity of the material substance rather than of Walter's arm or chisel: it is the stone chips that are "flying bravely" rather than Walter's arm that is acting forcefully. But at the same time, Walter is not a passive conduit; his thoughts are "in" his carving, making him a clear representative of Ruskin's Gothic mason who expresses his individuality as the particularity of architectural ornament.

If romance, as Northrop Frye argues, "does not accept . . . categories of reality and illusion" and rejects the idea that "waking is real and dreaming unreal," Morris's attention to the materiality of labor further rejects the distinction between sensuous reality as encountered by the body and dreams as a realm of pure mind or imagination.[96] This may be true not only of the world depicted by the romance but of Morris's own creation of the narrative. Keeping in mind Walter's partially willed creative activity, we might follow Mackail's suggestion that these stories are "poured out, as it were, from a brain overloaded" and interpret Morris's narrative as a "dream" produced in this same habitual or automatic fashion.[97] Morris, in other words, is like Walter: his art is a sort of automatic output from the embodied mind. We can see this at the level of syntax. Morris's sentences, loosely strung together with "ands" and semicolons, instantiate syntactically the kind of repetitive labor in which

Walter is engaged. The following is a single sentence, describing Walter's entrance into a waking dream state:

> I did not think of these long, but began to think of Abraham, yet I could not think of him sitting there, quiet and solemn, while the Judgment-Trumpet was being blown; I rather thought of him as he looked when he chased those kings so far; riding far ahead of any of his company, with his mail-hood off his head, and lying in grim folds down his back, with the strong west wind blowing his wild black hair far out behind him, with the wind rippling the long scarlet pennon of his lance; riding there amid the rocks and the sands alone; with the last gleam of the armour of the beaten kings disappearing behind the winding of the pass; with his company a long, long way behind, quite out of sight, though their trumpets sounded faintly among the clefts of the rocks; and so I thought I saw him, till in his fierce chase he leapt, horse and man, into a deep river, quiet, swift, and smooth; and there was something in the moving of the water-lilies as the breast of the horse swept them aside, that suddenly took away the thought of Abraham and brought a strange dream of lands I had never seen; and the first was of a place where I was quite alone, standing by the side of a river, and there was the sound of singing a very long way off, but no living thing of any kind could be seen, and the land was quite flat, quite without hills, and quite without trees too, and the river wound very much, making all kinds of quaint curves, and on the side where I stood there grew nothing but long grass, but on the other side grew, quite on to the horizon, a great sea of red corn-poppies, only paths of white lilies wound all among them, with here and there a great golden sun-flower.[98]

Even as this passage describes Walter's transition into a waking dream, it retains as its syntactical structure the repetitiveness (and-and-and; with-with-with) that is the hallmark of Morris's literary and design work. It reveals a closer formal connection between tapestry and narrative than Morris's readers usually identify: it is not just that the stories are purely decorative, concerned with presenting pleasing surfaces at the expense of properties such as psychological depth or narrative tension. It is that they reproduce the rhythms of manual labor at the level of the sentence: one thing and then another; one thing with another.

The accretive narrative logic of Morris's romances begins to reveal a hidden continuity between the kind of practices and experiences

demanded and presupposed by the creation of objects such as chairs and tapestries and the highly immaterial but similarly partially automatic production of dreams, hallucinations, narratives, and romances. The phenomenon of dreaming thus becomes not an escape from bodily materiality into the mind but rather the point of connection between the corporeality of aesthetic experience and its imaginative effects. As Morris describes it, the dreaming body enters a state of suspended intention and shifts from a site of reception to a site of generation: the mind automatically makes and experiences imaginary worlds. Reading William Morris and his character Walter as analogous—both of them dreaming, both of them carving—gives us a glimpse of how somatic practices within Morris's romances render seemingly interior states as external, physical phenomena: fictional making is a practice carried out by an embodied mind. The aesthetic of Morris's romances works in parallel with physiologists' materialization of aesthetic creation or reception as cerebral or nervous activity (discussed in chap. 1); Morris's habitual and automatic modes of making seem closely aligned with what William Carpenter's mental physiology would have described as Mozart's or Coleridge's creation of music and poetry by way of "unconscious cerebration" or with the attribution of aesthetic activity to unconscious life for which E. S. Dallas argued in *The Gay Science* when he attributed the creation of art to the "hidden soul" or "hidden mind"—"a willing but unknown and tricksy worker."[99] In Morris's romance, this "worker" takes the particular shape of habitual, bodily labor. But this alignment reaches its limit in the divergence between Morris's conception of physiology and that of more scientifically minded writers such as Carpenter or Dallas—a divergence that can be located in the distinction between the "somatic" and the "physiological." For Morris, somatic practices are unavoidably inflected by economic contexts: an activity of carpet design that might be experienced as tedious and painful if it is done in the service of someone else can be rendered enjoyable if it is a medium of self-expression.

What is at stake in retrieving dream states and reverie from the domain of individual psychology is their potential reincorporation in a collective defined by its shared corporeality. This suturing of individual psychology with the realm of materiality helps to illuminate a common gesture in Morris's medievalist romances and in his literary works more generally. These are often understood as promoting an escape from the nineteenth-century industrial landscape; among his most characteristic openings is to invite readers to forget their own world to enter another: "Forget six counties overhung with smoke / Forget the snorting steam and piston stroke."[100] The layering of dream states and labor in "The

Story of the Unknown Church" highlights that this imperative to forget is also an imperative to remember: the six counties overhung with smoke are immortalized in the opening lines rather than forgotten, just as reverie and dreaming are not a retreat into a private world but blended with labor. If romance turns against introspection, for Morris this turn takes the shape, at least in part, of an emphasis on the physicalized qualities of thought and imagination. Much like the "dream churches" with which the early Morris was often fascinated, churches that were at once architecturally substantial and nonexistent, romance itself renders the outwardness of mental life at once as the rhythm of prose and the shaping of ornament.[101]

News from Nowhere's Antidualism

Morris's utopian romance News from Nowhere heightens the stakes of this question about romance's outward rendering of the mind because it engages far more self-consciously than the early romances with the formal contradictions of the nineteenth-century novel. By announcing itself as a "romance," News from Nowhere partakes in what Fredric Jameson would describe as the "diachronic construct" of genre, an abstraction within the literary field that is highly subject to reification.[102] One strategy for a materialist reading of News from Nowhere, then, would be to adopt a historicist perspective that aimed to reconnect the reification called romance with its social conditions of emergence, finding the points of contact between a narrative's structural conventions and what Jameson refers to as "the semantic raw materials of social life and language . . . the historicity of structures of feeling and perception and ultimately of bodily experience."[103] What has made News from Nowhere especially intriguing to a recent generation of critics, however, is that it seems already to be engaged in the kind of knowing self-interpretation that the Jamesonian critic would usually need to provide for the text. As some of its readers have recently observed, News from Nowhere is highly self-conscious of its generic status, systematically inverting certain literary and narrative conventions of realism in what amounts to a critique of the nineteenth-century novel tout court. For Patrick Brantlinger, Morris's novel is in effect about the impossibility of its own existence: "both structurally and thematically, News from Nowhere declares the impossibility of creating genuine art under capitalism" and through its form imagines an alternative genre of narrative prose not shaped by the pressures of capitalism.[104] To artistically depict the impossibility of art produces a recurring paradox that is manifest not only as the text but within it as well: if in fact it is

impossible to create genuine art under capitalism, then what is the status of *News from Nowhere*, a literary work of art created under capitalism? One answer is that it is a work that has to perform its own undoing, taking on the apparatus of novelistic representation only to show the thinness and inadequacy of that apparatus.

This self-undoing reveals every feature of the novel that initially looks like a failure (exposition that extends over many chapters; flat characters; stilted prose) instead to be a refusal. Tracing this refusal has been the site of rich critical work in recent years.[105] Following Brantlinger, *News from Nowhere* has generally been understood in some sense to be an "anti-novel," including within the incisive accounts of John Plotz, James Buzard, and Elizabeth Miller.[106] The most compelling question for twenty-first century readers of Morris's romance has not been whether its utopian vision is feasible, but how it works as an alternative to the realist novel's aspiration to engender identification and empathy.

This self-undoing dynamic within *News from Nowhere* allows for a reading of the novel as generating both an antidualist psychology and an antidualist account of art. By *antidualist* I mean a refusal to recognize mind and body as ontologically distinct or as conceptually aligned with antidualist physiological accounts of mind and body as, in the words of Alexander Bain, an integrated "two-sided phenomenon."[107] On the one hand, within Morris's novel, character must be understood as physicalized and process based: what distinguishes characters is not their psychological features but their external markers and preferred modes of activity. This is especially evident at the first appearance of Boffin, the dustman whom William Guest initially encounters as nothing more than the reflection of light off of clothing: "I looked over my shoulder and saw something flash and gleam in the sunlight that lay across the hall; so I turned round, and at my ease saw a splendid figure slowly sauntering over the pavement; a man whose surcoat was embroidered most copiously as well as elegantly, so that the sun flashed back from him as if he had been clad in golden armor."[108] Morris's emphasis on dazzling, reflective visual effects here represents one way in which the novel often takes outward appearance as a primary marker of individuality. The self-reflexive joke is that Boffin's antiquarianism has led him to become a writer of "reactionary novels" (i.e., regionalist novels about "some forgotten corner of the earth, where people are unhappy"), and we might recognize in the repeated emphasis on Boffin's outward physical appearance Morris's own play on what many romance writers viewed as the excessively introspective qualities of realism.[109] With regard to Boffin, it is not character but clothing that is minutely studied—a displacement

of character from psychological self-reflection to the metonymic depiction of accoutrements and activities. This emphasis on character as visual surface operates in tandem with a pattern of defining characters by what they want to do. Alongside Boffin's preference to write novels, one might, among many other instances, also think here of the "obstinate refusers" who are so attached to some kind of manual labor that they refuse to help make hay.[110] "Boffin" is a surface and a practice.

This portrayal of character as surface and practice is one component of what Plotz has described as *News from Nowhere*'s broader argument against sympathetic identification. Precisely to the extent that a novel promotes sympathy, Plotz argues, it remains intimately bound up with modes of interpersonal response that merely offset the social distortions of capitalism: "if other people are suffering in ways that we ourselves have not . . . then no amount of aesthetic work will cross that bridge."[111] By extension, modes of introspection central to realism's formal constitution of character and engendering of sympathy may no longer function, for Morris, as the basis of an ethics. An alternative is then needed, and within *News from Nowhere*, this alternative takes the shape of shared labor: practices of making that connect persons to communities while discouraging any retreat into the self. Perhaps ironically, then, it is the precise aspect of the romance that for Lionel Trilling signaled Morris's "small-minded" rejection of the humanistic tradition—namely, Morris's contempt for the novel's focus on individual struggle—that was in fact the novel's most refreshing and provocative contribution.[112] The rejection of interiority at the level of the representation of character can be understood as an aspect of Morris's more general project of building an aesthetic psychology around moments at which mind is inextricably an aspect of corporeal practices: what I have been describing as Morris's turn from aesthetic categories to somatic practices can be understood, by way of *News from Nowhere*, as at once anti-individualistic and ethically generative.

This line of reasoning has implications not only for the novel's strategies for depicting character but for its ontology of art as well—and it is in this regard that the novel can be placed in productive conversation with a longer lineage of critical and philosophical thought about what it means for works of art to exist as physical things in the world. Though Morris himself would not put it in these terms, *News from Nowhere* investigates the ethically and politically problematic implications of a post-Kantian tradition that takes the experience of art as fundamentally distinct from everyday experience either by thinking in terms of something like an aesthetic "domain" or by describing aesthetic judgment as

qualitatively distinct from other kinds of judgment. Against these silo-
ing gestures, Morris suggests through *News from Nowhere* that doing
away with the fine arts is a crucial political task. If one takes seriously
the value of physiological well-being, then there is ethical and political
value in envisioning forms of art that interact holistically with minds and
bodies in their interconnectedness instead of requiring readers to forget
their physical existence and retreat into the mind. From this perspective,
the ethical charge of *News from Nowhere* is not just negative—a rejec-
tion of sympathy or psychological depth; the romance also envisions a
positive—if disturbingly anti-intellectual—version of a changed world
in which relations to environments bear as much ethical weight as rela-
tions to persons.

In short, *News from Nowhere* is perhaps even more artistically radi-
cal than most of its critics have appreciated: it mounts a wholesale at-
tack on the category of "art" as such. It does so by continually return-
ing the reader's attention to the physical properties of both her body
and the book she holds and, within the narrative itself, by arguing for
a seemingly bizarre reduction of the category of literature to its physi-
cal substrate. Early in Guest's introduction to *Nowhere*, he interrogates
his guide, Dick, about schools. Morris gives us a joke in response: the
only meaning of "school" that Dick knows is the one that applies to fish
and painting—does Guest mean to compare children to swarms of fish?
Pressed, Dick unwittingly offers up another pun, this time on the term
"writing": "As to writing, we do not encourage them to scrawl too early
(though scrawl a little they will), because it gets them into a habit of ugly
writing; and what's the use of a lot of ugly writing being done, when
rough printing can be done so easily. You understand that handsome
writing we like, and many people will write their books out when they
make them."[113] Dick is proud of his own skills as a "fair-writer."[114] Here
we see Morris wavering between the transparency and opacity of beauti-
ful books much as he does in his 1893 essay on the ideal book. If on the
one hand, books ought to lie quiet so that they can be easily read without
any "trouble of body," at the same time the literal shape of the letters on
the page is what makes writing "handsome."[115] In *Nowhere*, even the il-
literate can appreciate good writing. These passages convey a resistance
to realism that is material as well as formal. As Leah Price has observed,
"the great realists did loathe anyone who loved the look of books," a
type of adoration that, for writers such as Elizabeth Gaskell, Wilkie Col-
lins, and George Henry Lewes, Price argues, signaled "moral shallow-
ness."[116] Morris finds an alternative politics—utopian rather than lib-
eral—in the illegible pleasures of the surface.

What might appear to be the novel's strong anti-intellectualism can be understood instead as its attempt to redefine "intellect" in corporeal terms. The puns on "school" and "writing" we see in *News from Nowhere* are versions of the same puns on "literature" and "letters" that we have encountered in Morris's correspondence from the same period; in both instances, the question at stake is the extent to which emphasis at the level of materiality requires a parallel attenuation at the level of meaning. For Morris, this does often appear to be a zero-sum game: the happy people of the future have learned that action is not a complement of but a substitute for contemplation, and therefore they view with suspicion the weaver Bob, who is bad at weaving but enjoys mathematics, reading antiquarian nineteenth-century novels, and constructing a "new science of aesthetics."[117] Nowhereians are art-historically illiterate as well: apparently failing to understand the purpose of painting or the meaning of the name "National Gallery," they have set up a number of "National Galleries" where they preserve the "curiosities" of the past out of a sense of historical duty that seems to be becoming quickly attenuated.[118] Nowhereians might be described as joyfully complicit with what Jonah Siegel has called the "museum-as-mortuary tradition," the entombing of cultural artifacts, with the caveat that they no longer even mourn art's death.[119] No melancholy here: life itself is too pleasant. So, against Bob's "science of aesthetics," Dick remarks that he prefers to "do a little practical aesthetics with my gold and steel, and the blowpipe and the nice little hammer."[120] This is a displacement from theory to practice that is the correlate of the characterological displacement from interiority to exteriority that takes place in the description of Boffin. This is not to say that the focus on physical things makes Nowhere into a world entirely devoid of meaning or signification. Rather, meaning has migrated from the printed page (abstract systems and theories) to the material substance of the world.

The rejection of art is most forcefully articulated by the character Clara, who excoriates her grandfather's predilection for books: "'Books, books! always books, grandfather! When will you understand that it is the world we live in which interests us . . . ?'" Clara then throws open a window, an action that suggests that the natural world thus enframed has replaced the beauty of painting and literature alike: "'Look!' she said, throwing open the casement . . . 'look! these are our books in these days! . . . and if we want more, can we not find work to do in the beautiful buildings that we raise up all over the country . . . wherein a man can put forth whatever is in him, and make his hands set forth his mind and

his soul."[121] The scene makes a claim that the imaginative world of narrative has been replaced by the renovated natural environment and the architectural practices that allow humans to express themselves in the shaping of matter. Physical objects are more engrossing than their textual counterparts because they carry the signs of human labor. To throw open the window in this fashion is simultaneously to reject interior domestic space for the shared space of nature and collective labor. The interiority of books aligns with the interiority of the home; the window becomes the threshold between a world of thought and reflection and a world of action and praxis.

If we can thus understand Morris's argument in *News from Nowhere* as radically questioning the politics of offering imaginary worlds as palliatives for real ones, we can also think of it as a reinterpretation of the aesthetic domain itself in a way that partially aligned with that which took place within nineteenth-century sciences of the mind. The notion that aesthetics should primarily be a philosophy of fine arts was commonly contested by psychological and physiological aesthetics, which instead advocated for attention to the basic, constituent elements of aesthetic experience. When Gustav Fechner argued in his *Vorschule der Aesthetik* (1876) that the metaphysical aesthetics of German philosophy had too often proceeded "from above," it was in order to promote a way of theorizing aesthetic experience "from below," or by conducting empiricist investigations of bodily responses to art. Fechner proceeded to measure the proportions of paintings and to conduct surveys about the association of colors with vowel sounds.[122] While Morris can be said to share both a resistance to the definition of art by way of its most refined instances and a commitment to the somatic entanglement of body and artwork, he brings into view a different sort of "below" than that of Fechner and other empirical psychologists of aesthetics. Within Fechner's science of aesthetics, it was primarily by adapting emerging methods of experimental psychology that one gained access from below to human responses to the arts and beauty; Morris's aesthetics from below was one in which this corporeality must further be understood as the site where political contradictions were worked out. In the late nineteenth century, aesthetic pleasure was more likely to be available to some bodies than others, and the reasons for this unequal distribution of the aesthetic was for Morris—but not for most science-based aesthetic theories—part of what was at stake in materialist aesthetics. The below is not just a philosophical category of the physical as opposed to the metaphysical but of the masses as opposed to the elite. Morris's aesthetics, then, is not

so much empirical as it is material and elemental, made of gold, steel, and stone as well as the workers who shape them.

One way to phrase this point is to say that the antidualism that grounds a formal treatment of character is isomorphic with the antidualism that grounds an ontology of the artwork: the plane of meaning recurrently collapses into the plane of materiality. This should be understood not as the elimination of higher-order faculties of thought or conceptual reflection but rather as a dialectical reinvestment of matter itself with conceptual force. This is a dynamic that returns us to what I described in the opening section of this chapter as Morris's interest in the relationship between the physique of the book and the physiology of the reader, and to explore how it unfolds with regard to *News from Nowhere* requires attending to the "physique" of this literary object in particular. One imagines that little tactile pleasure likely would have been derived from the material instantiation of the romance's first serialization in *Commonweal*, an eight-page penny paper. But in 1891, three editions appeared simultaneously that reflected the different ways in which the romance might be read. According to the records of Morris's bibliographer Harry Buxton Forman, a reader could have chosen a number of physical formats in which to read the book: a cheaper edition "being meant for popular reading" was "but a thick trimmed pamphlet in a paper wrapper"; "those who liked to have it in dark bottle-green cloth uncut" could pay "a few pence extra."[123] Most sumptuous was a "large-paper issue printed on a pretty French hand-made paper" in octavo, "in blue paper boards with Japanese paper backs."[124] In 1893, the Kelmscott press issued an edition of ten books that had, as Forman put it, "all the luxury of limp vellum binding with silk ties and half-sheet endpaper" and the title in gold lettering (ten guineas), and three hundred more books in paper binding (two guineas).[125]

How does one read blank endpapers, bottle-green cloth, and silk ties? These materials would seem to signal the very limits of legibility, a physically and conceptually extratextual territory into which reading simply cannot proceed. But two interpretive options are made available by Morris's own thought. On the one hand, readers have learned from the romance itself that things like these—decorative materials, formed by human intention—are in fact semantically dense. These five formats of *News from Nowhere*—*Commonweal*, pamphlet, green cloth, large paper, Kelmscott—mean that the reading public was stratified, that the book remained a piece of valuable private property, that late-Victorian England was very far indeed from the utopian world where every object

is public, free, and shared. To read matter in this way would be to extend the metonymic strategy that Elaine Freedgood has deployed in relation to objects represented within the text to the book itself, not only animating "fictional objects into historical life" but animating their material containers as well.[126]

But, on the other hand, Morris's novel also invites readers to resist this mode of interpretation, which inevitably recaptures sensuous materiality as decipherable signs: the risk is that the greenness of bottle-green cloth will become a signifier like the signifiers on the page called letters, sacrificing its charge of pleasure for a charge of meaning. If we interpret the paper of the book as legible signs of the social condition surrounding its production and consumption, we are not illiterate (like those happy youthful Nowhereians) but gloomily hyperliterate. By contrast, the romance's various material formats also invite a more radical, more anti-intellectual cast of mind: a mute appreciation of the sensory pleasures of the physical book. From within the somatic mode that the beautiful book invites, which leaves behind discursive thought and historical judgments, perhaps there is literally nothing to say.

The book's material format thereby returns its readers to the question that the romance poses at a textual level. These two readerly stances—deciphering matter and merely appreciating it—are most familiar to us through the categories of "Marxism" and "aestheticism," that seemingly intractable juxtaposition that Morris scholars have long found themselves necessarily engaged with. But at the same time they also map onto a way of conceiving the relationship between mind and body that is at once physiological and political. Morris's aestheticism is significant because instead of privileging bodily sensuousness over thoughtful reflection—the mindless pleasure of Dorian Gray in his opium den as opposed to Arnoldian culture—it seeks to understand how the interconnectedness of mind and matter might itself offer the basis for a new kind of art practice. It does so through its multiple formats by routing its argument against realism through an emphasis on the exteriority of character and the value of illiteracy. It calls for a category of readerly response that is neither the speechlessness of caressing "limp vellum binding" nor the semiotic transformation of the materiality of Morris's book into signifiers as abstract as the concept of "genre." What the world of Nowhere most significantly shares with its Victorian counterpart is the fact that matter itself is enminded; wood can bear the communicative marks of expressive decoration and yet remain sensuously material. Hence, the novel's antidualism: this enmindedness of matter is precisely what art,

in Morris's utopian vision, is capable of making present to embodied minds.

Antiaesthetic Formalism

My aim in this chapter has been to show how Morris's aesthetic thought intersected in surprising ways with a physiological or scientific aesthetics that has most often been understood as the opposite of Morris's antimodern, Pre-Raphaelite medievalism. Not only through Morris's direct adoption of contemporary visual technologies and new ideas in optical physiology but also through his elaboration of aesthetic experience as a partially intellectual mode of interaction between human bodies and made objects, we can see how book design, the genre of the romance, and practices of making coalesced into an aesthetic theory that was no less "physiological" than Grant Allen's or Alexander Bain's. If Morris thus similarly turns mind outward, having learned from Ruskin that shaped matter can externalize qualities of the self usually conceived as interior, he does so, distinctively, into a world where such matter becomes a social medium. In this regard, while Morris might be said to join Pater in resisting an Arnoldian conception of culture as ideas that are reflectively contemplated in isolation, Morris's version of a materialist aesthetics is one in which aesthetic objects are not only objects of attention but also objects of exchange.[127] Morris's matter, like Pater's, is enminded, but it is also communal. This means that the significance of Morris to the question with which I opened this chapter—what happens when somatic aesthetic experience is situated within particular social contexts?—is that he reveals that this is perhaps not a question of "situating" a particular kind of experience. If we are to take Morris seriously, we ought to understand such experiences as always already routed through networks and circuits of human bodies and aesthetic objects.

Morris's work also represents a point of origin for certain twentieth-century developments in aesthetic thought because it is an attempt to disassociate the aesthetic from a domain separate from everyday life. While Morris rejects the notion that the experience of art ought to be isolated, privileged, ineffable, he also remains hyperattentive to questions of form in the sense of practices of forming matter that are both enjoyable on their own terms and yield pleasurable shapes. In this respect, Morris anticipates pragmatist, everyday, and environmental modes of aesthetic theory that were pursued by philosophers such as John Dewey and William James. One of the most surprising aspects of Morris's utopia is how

entirely devoid it is of the kinds of cultural artifacts—painting, novels, symphonies, operas—that have since the eighteenth century most centrally constituted the domain of "art" and the object of aesthetic theory. The paradigmatic art object in the world of Morris's romance is not a painting but a piece of crockery, "rough and lacking in finish."[128] For Jameson, this aesthetic is best understood as "pastoral"; for Trilling, as a regression to "childhood."[129] I have suggested that we could also call it somatic, proceeding from a physiological perspective that sees the human mind and body as sensorially enmeshed with one another as well as with their natural and social environments.

Morris reveals an incompatibility between nineteenth-century conceptions of aesthetic experience as closely linked to biology and environment and strains of twentieth-century aesthetic thought that instead delimited or formalize the categories of "art" and "aesthetic experience." As we have seen, Morris understands form as a site of pleasurable contact between makers and users, a shaping of matter that becomes enjoyable because of certain social and physiological coordinates of the shaping practice and that produces an object that gives perceptual pleasure because of related coordinates. In the decades following Morris's romances and the Kelmscott Press, "form" remained a central category for theorizing art and literature, but what form meant was quite different. After Clive Bell defines "significant form" as an emotion-producing structure of line and color in his seminal essay *Art* (1914), he then moves immediately to the assertion that aesthetic judgment is individual, and that art is fundamentally separate from everyday life. Bell's language imagines the viewer as autonomous, intentional, and self-sufficient in ways that might well have been attractive to liberal and libertarian individualists a generation earlier but repellent to Morris. As Bell describes it, art criticism sounds much like a variety of deliberative liberal discourse in which the rational critic persuades the viewer by coming to agreement about a work's formal properties:

> The objects that provoke aesthetic emotion vary with each individual. Aesthetic judgments are, as the saying goes, matters of taste; and about tastes, as everyone is proud to admit, there is no disputing. A good critic may be able to make me see in a picture that had left me cold things that I had overlooked, till at last, receiving the aesthetic emotion, I recognise it as a work of art. To be continually pointing out those parts, the sum, or rather the combination, of which unite to produce significant form, is the

function of criticism. But it is useless for a critic to tell me that something is a work of art; he must make me feel it for myself. This he can do only by making me see; he must get at my emotions through my eyes. Unless he can make me see something that moves me, he cannot force my emotions. I have no right to consider anything a work of art to which I cannot react emotionally; and I have no right to look for the essential quality in anything that I have not *felt* to be a work of art. The critic can affect my aesthetic theories only by affecting my aesthetic experience. All systems of aesthetics must be based on personal experience— that is to say, they must be subjective.[130]

The contrast between this description of judgments about art and Morris's view of somatic response brings into relief the difference between somatic and deliberative models of the aesthetic. Bell is able to imagine two possibilities: either judgments of taste are "subjective," the private property of the person who makes them, or there must be a rubric of objective rules that would determine, independent of any one person's feeling, whether something counts as art. The final sentence in the excerpt above, which equates personal experience with the "subjective," seems uncontroversial, but it is precisely this equation that Morris's aesthetic challenges. What we learn from Morris—and what strangely links his work to both Pater and Bain—is the notion that personal experience, at a physiological or biological level, is not essentially private. The physical worlds that persons inhabit are permeated by minds that are turned outward into matter. Every formed thing bears the trace of human action and intention.

This brief passage from Bell's essay offers a representative framing of the issues that remained central in Anglo-American aesthetics through at least the middle of the century: dual emphases on formal autonomy and on the individuality of aesthetic judgment. Works such as Susanne Langer's *Feeling and Form* (1953) challenged Bell's understanding of form by turning attention to the making as well as the reception of art, and Arthur Danto's essay "The Artworld" (1964) in turn challenged critics such as Langer by turning attention to how a social medium frames a given object *as* "art." But even as these analytic philosophers elaborated alternative accounts of form and art, they left in place certain basic assumptions—that there is a distinct realm of objects and practices called art, that aesthetic theory should describe the modes of thinking and judgment that happen in relation to them—at the kernel of Bell's essay. When writers in the late twentieth century contested the politics of

aesthetic philosophy from the perspectives of deconstruction, ideology critique, and feminist theory, they took aim at the ways in which previous thinkers had imagined that art could be understood without paying attention to sociological determinants of culture and class.[131] It is still not uncommon to equate form with aesthetics and to associate both with abstraction or immaterial structure.[132]

Morris's antiaesthetic, articulated from a somatic or environmental perspective, often uses somatic materialism rather than ideology critique as its primary tool for reconceiving the aesthetic domain. Bearing sympathies with—if not direct awareness of—nineteenth-century scientific understandings of the interpenetration of body and mind, Morris draws attention to forms of physiological and environmental interconnectedness that precede the social production of concepts of "individuality," "right," and "autonomy" that implicitly guide Bell's thought. From this position one is invited, oddly, to celebrate a world in which literature and painting have happily ceased to exist: "writing" equals penmanship; paintings are cultural artifacts seemingly no more representational than architecture. Taking a position that may seem surprisingly dialectical, Morris attacks art by imagining its pervasiveness: because it is everywhere, it is also nowhere.

We might think of this as Morris's way of answering in the negative a question that I. A. Richards posed in *Principles of Literary Criticism* (1924). Richards asked whether the experience of art was "one kind of experience as different from experiences which don't so occur as, say envy is from remembering, or as mathematical calculation is from eating cherries? . . . Put this way it is plainly not an easy question to answer. . . . Yet the vast majority of post-Kantian writers, and many before him, have unhesitatingly replied, 'Yes! the aesthetic experience is peculiar and specific.'"[133] Richards criticized this belief in a "phantom aesthetic state" because he thought it implied a limited view of art as nothing more than a "private heaven for aesthetes."[134] Perhaps *News from Nowhere* does nothing more than imagine a heaven so suffused by this phantom state that it can only be imagined as an impossible utopia. But it is also possible that Morris's novel anticipates Richards's rejection of art as something to be fetishized by the privileged few. What we have begun to see is that the Victorian thought about aesthetic experience that was so forcefully rejected by Richards and others in the early twentieth century already contained the seeds of a more subversive possibility, an antiaesthetic energy that could be activated only by dissolving art into everyday life. This paradoxical gesture of putting art on a pedestal in order to make it disappear was extensively formulated by Vernon Lee, one

of the critics with whom Richards most disagreed but whose surprising affinities with Richards will require us to reconsider the story of a break with aestheticism that Richards and Fry want to tell. It is in Lee's writing that we will find what is perhaps the most searching and provocative articulation of how a materialized, corporeal aesthetics could turn the mind outward into a world of matter and objects.

5

Empathy: Counting Words with Vernon Lee and I. A. Richards

Recall, for a moment, the animosity of many New Critics toward the kinaesthetics of literary experience. Most famously, William K. Wimsatt and Monroe Beardsley cordoned off meaning from feeling in "The Affective Fallacy," which pathologized readerly affects such as "goose-flesh experience," "the 'shiver down the spine,'" and "tears, prickles, or other physiological symptoms."[1] Perhaps the pithy epigraph to their essay, the German music theorist Eduard Hanslick's observation that "we might as well study the properties of wine by getting drunk," best expresses the radical isolation of meaning from the reader's body effected by their argument.[2] It is certainly possible to read with drunken excitement, but a responsible reader, like a good student of wine, will soberly reflect on whether the imagery is earthy or fruity. Wimsatt and Beardsley's essay is a polemical expression of a depersonalized critical practice that largely originated with I. A. Richards's aesthetic theory of the 1920s and was disseminated by the successful pedagogy of the New Criticism.

At first, one might be inclined to see a direct opposition between a nineteenth-century tolerance toward the physicalized modes of aesthetic experience that the previous chapters of this book have described and an early twentieth-century turn toward the impersonality of form or meaning. But in fact this story is far more complex.

On the one hand, as Gerald Graff has observed, the perceived anti-impressionistic scientism of the New Criticism, exemplified by highly technical close reading, was itself a way of "defending the humanities against the denigrations of logical positivists and 'hard boiled-naturalists.' "[3] And on the other hand, Richards himself paid very close attention to experiences very like physiological symptoms in his early aesthetic and literary theory, which adumbrated a poetics that was highly cognizant of neurophysiology—an alliance with naturalism that made some of Richards's followers uneasy. Within philosophy, the situation is equally complex; while aesthetic theorists such as Roger Fry and Clive Bell pursued notions of form that paid little attention to a viewer's corporeal existence, American pragmatism and European phenomenology took up forms of reasoning that were in many ways sympathetic to nineteenth-century sciences of aesthetics.

What was the fate of the materialist, physiological, and somatic aesthetics pursued by many Victorians? In this chapter I approach this question via the concept of empathy, a somatic response that was widely discussed in early twentieth-century aesthetic theory. Empathy provides an especially illuminating case for a number of reasons. The first has to do with a shift in empathy's meaning. *Empathy* was originally a term denoting an unconscious physiological reaction to an object that involved either ego projection into it or physical mimicry of it. But in the first half of the twentieth century, *empathy* lost its bodily connotations and came to signify a psychological process similar to what would have been called *sympathy* in the eighteenth and nineteenth centuries.[4] This shift usefully indexes a broader transition from understanding aesthetic form as corporeal or physiological to understanding it as intellectual or cognitive. Second, empathy is a productive site of inquiry because the career of its foremost theorist, Vernon Lee, spans the period of aestheticism and New Criticism. Lee is among the few thinkers whose work seriously engaged both with Pater's aestheticism and Richards's aesthetics—engagements whose significance has long been obscured by a failure to take Lee seriously as an intellectual. Third, empathy is a response that is not limited to any of the arts; indeed, part of why it was felt to be an intellectually productive concept was that it turned attention to bodily responses to form of many types rather than to any single art. In this regard it is closely related to the somatic practices that Morris described when writing about pattern, type design, or carving or to the emotional waves that Bain located at the basis of aesthetic feeling.

As may already be clear, the version of empathy under discussion in this chapter diverges from that which may be most familiar to readers.

While there has been a resurgence of interest in empathy in the humanities and social sciences in recent years, the concept has been understood as closely related to sympathy: a "feeling with" that is much like sympathy's "feeling for."[5] The relation between literature and empathy, as a result, has usually been viewed as important in relation to ethics (in philosophy) or altruism (in psychology): empathy is commonly thought of as something one might feel toward another person or a literary character. Writing from the perspective of virtue ethics, Martha Nussbaum and Michael Slote have advocated a liberal humanist version of empathy. Especially in Nussbaum's work, the novel is an important site for cultivating empathy because it positions "readers as people who care intensely about the sufferings and bad luck of others."[6] Suzanne Keen's work on empathy and literature questions this view, discovering that actual readers empathize in unexpected ways.[7]

But this focus on empathy as a literary and ethical response related to sympathy has tended to pass over a remarkable aspect of the earlier life of empathy: it attempted to account for the material porousness between a person and the object worlds he or she inhabits. This version of empathy can perhaps best be explained by way of an example offered by Lee in the book that popularized the concept most widely. In *The Beautiful: An Introduction to Psychological Aesthetics* (1913), Lee argues that when we look at a mountain, we experience it as a triangle in motion: "It *rises* It rises and keeps on rising, never stopping unless *we* stop looking at it."[8] Lee describes this sense of rising as an "empathic movement," by which she means a compound of actual upward eye movement and a bodily memory of past feelings of rising.[9] This movement explains "the mysterious importance, the attraction or repulsion, possessed by shapes, audible as well as visible, according to their empathic character."[10] As she works with this example, Lee emphasizes the correspondence between the internal movements of a breathing, balancing body and the perceived movement of a triangle whose lines are "striving" to "arrive" at a point.[11] Lee did not deny that this type of response could have something to do with feeling for other persons, whom, like mountains, we encounter as materially substantial beings. For the purposes of this chapter, however, I use the term *object-oriented empathy* to distinguish from sympathy those aspects of Lee's theory that emphasize this formal, shape-oriented response that constituted her primary focus.

As we can begin to see from this example, Lee's object-oriented empathy is "affective" in a way that has little to do with ethical or altruistic emotion. It is closer to what Brian Massumi and others have described as affects, as distinct from emotions. *Emotion*, according to Massumi,

implies a "sociolinguistic fixing" of what an experience means, while *affect* implies an "immediately embodied," "purely autonomic" reaction.[12] As we can see from Lee's language, her understanding of empathy is rooted in experiences that precede the social domain: perceiving the formal movement of a "rising" triangle leads to feelings like excitement, vitality, or constriction. Within Lee's theory, to be uplifted by a mountain does not require that the mountain be personified or even imagined as sentient; as a result, her work articulates an unfamiliar kind of empathy whose primary orientation is not toward the social domain. Borrowing Massumi's terms, we might say that it is not yet sociolinguistically fixed. A version of Lee's empathy has recently been reanimated by cognitive scientists: Vittorio Gallese (known for his discovery of neurons that "mirror" observed actions) has used magnetic brain imaging to ground "a theory of empathetic responses to works of art that is not purely introspective, intuitive or metaphysical but has a precise and definable material basis in the brain."[13]

In the first part of this chapter, I argue that Lee's careful attention to the relationship between motional empathy and language significantly distinguishes her work from that of German psychologists who originally theorized empathy. In the second part, I argue that Lee's theory of empathy plays a significant but overlooked role in the history of literary criticism. Lee's theory of empathy was part of a much broader project that sought to take seriously a wide range of embodied aesthetic responses. As part of this project, Lee wrote a series of essays on the corporeal feeling of reading that parallel her essays on the empathic effects of painting, sculpture, and music. Lee's version of empathic reading does not easily reconcile with a received history of a break between Victorian physiological aesthetics and later literary formalisms, especially the New Criticism: Lee endorses kinesthetic responses to the rhythms of prose while still gesturing toward systematic formalist methods that characterized the New Criticism.

Einfühlung *and the Science of Aesthetics in Germany*

The German psychologists and philosophers who originally theorized empathy rarely thought of it as having a special relationship to literature or language. The term *Einfühlung*, later translated as "empathy," first appears in a dissertation by the philosopher Robert Vischer, *On the Optical Sense of Form* (1873), which proposes that humans instinctively project themselves into the objects they see. In an important passage, Vischer writes that a dreamer's body "unconsciously projects its own

bodily form—and with this also the soul—into the form of the object. From this I derived the notion that I call 'empathy' [*Einfühlung*]."[14] Not merely a dream state, *Einfühlung*, for Vischer, was provoked in everyday life by basic visual sensations such as the stimulating pleasures of curves, light, and complementary colors. More complex versions of *Einfühlung* took two forms: "physiognomic," which involved static physical forms, like a small flower that produces a feeling of compression; and "mimicking," which involved movement, like tree branches that cause a viewer to feel as though she is spreading her arms.[15]

The psychologist Theodor Lipps developed Vischer's idea, abandoning its metaphysical tenor, challenging the notion of literal physical mimicry, and suggesting the possibility of *Einfühlung* for persons in addition to objects. Like Vischer's, Lipps's version of *Einfühlung* is oriented toward visual perception: Lipps came to his study of empathy via his involvement in a debate over whether it was a cognitive or physiological defect that allowed optical illusions to trick the mind.[16] This question about how the mind interacts with embodied visual faculties then became central to his descriptions of *Einfühlung*. In his *Aesthetik: Psychologie des Schönen und der Kunst (Aesthetics: The Psychology of Beauty and Art*, 1903), Lipps observes that when we look at a line, we "create" the line with our bodies by following it from point to point with our eyes: the human body makes the line exist by performing it. Lipps emphasizes that he is not just describing a process of contemplation internal to the mind ("was mir die Reflexion sagt" [what reflection tells me]) but a feeling of being identical with the line ("ich fühle mich fortstrebend und tätig *in* der Linie" [I feel myself striving and acting *in* the line]). "As we know," Lipps writes, "this is the meaning of *Einfühlung*."[17] According to Lipps, the same sort of thing occurs when one looks at a Doric column and considers the mechanical forces that allow it to support the building; the column pleasantly "sets up an image [*bild*] of similar effort within ourselves."[18]

Whereas Grant Allen, inspired by Bain and Spencer, had developed a physiological aesthetics, Lipps developed a mechanical approach to aesthetics that was conceptually oriented by physics more than biology. As we have seen in previous chapters, many Victorian writers had described human aesthetic experience as a potentially animalistic response to stimuli, but Lipps instead mechanized the human body in order to show the resonances between its structure and the physics of the architectural column. In a summation of his aesthetic theory, Lipps outlines this notion of aesthetic experience as mechanical: "Mechanical aesthetics is certainly to be differentiated from mechanical physics. The latter shows how forms are really produced under the conditions of particular forces. Mechanical

aesthetics, conversely, has nothing to do with such real production of forms but rather with their production within our aesthetic contemplation and our aesthetic impressions. In any case, the aesthetic impression is an impression of the lawfulness of the mechanical forces that also constitute the object of our physical contemplation. It is a mechanical impression or a mechanical feeling."[19] For Lipps, aesthetic pleasure originates with the viewer's mechanical response to architectural and visual forms. This aspect of Lipps's aesthetics highlights the fact that in its early formulations, empathy is conceived as a mechanical relation to a thing rather than an emotional relation to a person.

Lipps's emphasis on the "image" of effort differentiated his theory from that of a rival, Karl Groos, who believed that physical imitation of visual form—*innere Nachahmung*, or "inner mimicry"—not just the image of movement, took place in the moment of aesthetic experience. According to Groos, perceived forms incite "movement and postural sensations (especially those of equilibrium), light muscular innervations, together with visual and respiratory movement."[20] By contrast, others argued that *Einfühlung* did not exist at all. In 1903, the psychologist Oswald Külpe placed subjects in a dark room, projected twenty-eight images of Greek architecture and sculpture on the wall for three seconds each, and discovered that no columns, Doric or otherwise, caused viewers to feel as though they were moving.[21] Though Külpe's experiment was unsuccessful, this understanding of empathy as a relation to an object gained lasting purchase, and most illustrations of the concept in the early twentieth century discuss modes of feeling oneself into physical objects. Studies of aesthetics understood the term primarily as a "motor" process of the body: in chapters 6 and 7 of *The Aesthetic Attitude*, the American psychologist Herbert Sidney Langfeld discusses empathy as a "motor attitude to the object of our perception."[22] A student of William James, Robert Session Woodworth, wrote a psychology textbook that described empathy as something one might feel for a kite: "As 'sympathy' means 'feeling with,' 'empathy' means 'feeling into,' and the idea is that the observer projects himself into the object observed, and gets some of the satisfaction from watching an object that he would get from being that object. Would it not be grand to be a kite, would it not be masterful?"[23] An article in the *Journal of Abnormal Psychology* even wonders whether the application of empathy to human situations is not a "greatly extended interpretation of the term empathy."[24] Even when this extension took place, accounts of empathy retained a focus on its physical, motional qualities: in his foundational work on personality, Gordon Allport illustrated empathy as the "imitative assumptions of the postures and fa-

FIGURE 5.1 Spectator at right expresses empathy for pole-vaulter. Gordon Allport, *Personality: A Psychological Interpretation* (New York: Henry Holt, 1937), 530.

cial expressions of other people" that could be seen in an image of spectators who were caught mimicking the posture of a pole-vaulter (fig. 5.1).[25]

Empathy as Motional Force

In the 1890s, Lee and her lover, Clementina Anstruther-Thomson, spent much of their time in museums looking at Greek art in order to conduct

what Lee calls an "objective" study of the feelings it provoked.[26] Lee was unaware of the theories of Groos, Lipps, and Vischer when she began developing this version of embodied aesthetics. But she was not scientifically naive: she developed her theory of art in relation to British physiological aesthetics and physiological psychology, including, especially the work of William James and Carl Lange, who had each proposed that physiological events preceded the subjective experience of emotion.[27] Lee's views were also indebted to Walter Pater, with whom Lee was close. Pater, as we have seen in chapter 3, had rejected metaphysics in his early essays, including in an important essay on Coleridge; he framed the central question of aesthetic criticism, in the preface to *The Renaissance*, in terms of questions about an artwork's felt effects: "What is this song or picture . . . to *me*? What effect does it really produce on me? . . . How is my nature modified by its presence, and under its influence?"[28] Lee and Anstruther-Thomson took similar questions a step further in a major essay on psychological aesthetics, "Beauty and Ugliness" (1897). The essay uses the language of physiological aesthetics to answer Pater's questions with almost parodic literal mindedness. In one representative passage, Anstruther-Thomson looks at the facade of Santa Maria Novella and notes that "the perception of the middle part [of the building] . . . involves an adjustment which prevents the thorax from collapsing as much as usual during the act of expiration," therefore producing a feeling of expansion.[29] Here, the presence of art certainly produces what Pater describes as "effects" and "modifications."

But as Lee's insistence on objectivity implies, her work departs from the mentally interior standpoint of Pater's repeatedly emphasized "me." Santa Maria Novella does not cause a flight of fancy or offer imaginative access to the past as *La Gioconda* famously does for Pater; it instead causes the viewer to shift her balance and breathe more deeply. If the "effects" of art are particular in the sense that they resonate in a specific body with muscles and lungs, an introspective analysis of such effects is imagined as a gateway to principles that might be generalized. This aspiration toward general validity meant that when Lee discovered German psychology, she recognized that *Einfühlung* was a more apt explanation than Paterian impressionism for her and Anstruther-Thomson's response to beauty. As Lee read extensively in physiological psychology and corresponded with Karl Groos, she revised and developed her early understanding of empathy, which she described in an essay following "Beauty and Ugliness" as deriving from "a novice's enthusiasm [for] the so-called Lange-James hypothesis."[30] Particularly important for Lee between 1897 and 1912 were the motor theories of mind discussed by Lipps and Groos.

Lee developed various means, including a survey (the "Questionnaire sur l'élément moteur") and extensive diaries of her experience in galleries, for empirically ascertaining the role of "motor images" (Lipps's *Einfüh-lung*) and "muscular sensations" (Groos's "inner mimicry") in making static visual forms seem to be moving or dynamic.[31] This quality of movement, for Lee, was what made forms either appealing or unappealing and therefore constituted the "central problem of aesthetics."[32] Over the next fifteen years, she published a number of essays on the topic, some of which were collected in *Beauty and Ugliness* (1912). Although it was often seen as ponderous and disorganized, *Beauty and Ugliness* was at the forefront of widespread interest in physiological empathy in Anglo-American aesthetics.[33]

Lee and Thomson develop physiological aesthetics in two directions, which can be characterized as procedural and theoretical. Both developments are oriented toward language. Procedurally, they transform empathy from an abstract theory into a critical practice that involves writing about what one feels. Studying empathy implicitly requires a transcription of semiconscious bodily responses into narrative. In Lee's work, as distinct from previous physiological aesthetics, empathy is linked with writing and expression rather than with mute response. Theoretically, Lee bases many of her arguments about empathy on language—either metaphors used in everyday speech or the figures used by other empathy theorists to describe the moment of "feeling-into." Lee's arguments proceed from a conviction that the phenomenon of empathy is not divorced from language; rather, empathy explains how human beings use and understand metaphor.

This turn to language was probably as much out of necessity as out of intellectual commitment. Lee did not have the requisite training to become a professional psychologist; nor, as a woman, could she easily have obtained it. What she and Anstruther-Thomson did have was extensive experience actually looking at art. It is very likely that Lee spent more time viewing artworks than most other writers on physiological aesthetics—perhaps more even than Pater and Ruskin, whose travels in Europe were not as extensive. Lee lived in Italy, where she spent much of her time visiting churches and museums; she often spent winters in London, where she passed her days at the British Museum, Victoria and Albert Museum, and the National Gallery. And when commuting between England and Italy, she would visit the Louvre and the churches of northern France.[34] In the 1890s, Anstruther-Thomson accompanied Lee on these travels. As she visited museums, Lee and Anstruther-Thomson kept diaries detailing the state of their bodies as they looked at art: its "palpitations," the strains of

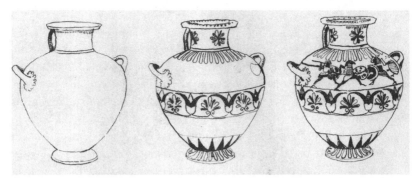

FIGURE 5.2 Clementina Anstruther-Thomson's reproduction of vases for an experiment with the effects of pattern, *Art and Man: Essays and Fragments*, ed. Vernon Lee (London: John Lane, 1924), 138.

music that were stuck in her mind, and whether she was tired or bored. Based on the lived experience of the gallery and museum, their work aspired systematically to collect data about aesthetic response in order to inductively arrive at a general aesthetic theory. Lee later describes this method as asking herself, " 'How have I perceived and felt to-day in my relations with given works of art?' until little by little I have found myself with so many introspective data to verify and compare that there has ensued a deliberate system."[35] This characterization of written records of introspection as "data" is clearly meant to elevate the diary to the status of scientific evidence. But it simultaneously, if perhaps unintentionally, transforms motional empathy into a linguistic phenomenon.

Anstruther-Thomson's first-person accounts—which take the shape of essays, lectures, and fragments on topics ranging from art restoration to the mythology of centaurs—describes her response to art in ways that reflexively theorize how an immediate, uninformed response to art might achieve relevance beyond the individual viewer. This writing formed a large part of the essay "Beauty and Ugliness," and Lee published many of Anstruther-Thomson's notes posthumously in *Art and Man* (1924). Lee scholars have noted that Anstruther-Thomson's body can be read as one origin of Lee's theory of empathy, but Anstruther-Thomson's writing has generally been read as context for Lee's theory rather than on its own terms.[36] In one evocative lecture, "What Patterns Do to Us," Anstruther-Thomson explains the precise formal mechanisms by which the two-dimensional patterns on a vase compensate for imperfections in its three-dimensional form (fig. 5.2). Anstruther-Thomson does not see the patterns as optical illusions, but as provocations for complex interactions between the viewer's body and the physical vase. The patterns on the vase, in other words, do not trick a mind conceived as separate

from the body but immediately affect the body and mind together in such a way that aesthetic pleasure is the residue manifested in consciousness. Describing what Lee would have named "empathy," Anstruther-Thomson recounts the forces and movements that join the vase and her body:

> Other parts of our body will insist on telling us about the vase, too. In fact, they insist on helping our eye by doing the shapes in some rudimentary fashion inside us to an extent we may feel almost as an actual alteration of the shape of our own body. So the addition of a lifting pattern to the base of the vase comes to us as a very real modification in the shape of the vase, because it suddenly thrusts into our own body a feeling of lifting which we cannot help realizing. And every additional shape is hammered into us so energetically by our body that we have to believe its testimony rather than that of our eye.[37]

This passage is more complex than it may at first seem. Anstruther-Thomson ruptures the distinction between subjectivity and objectivity by making aesthetic experience the result of actions and forces that are equally the formal properties of a visual form and the physical properties of a human body (the "lifting" pattern on the vase lifts Anstruther-Thomson's body). In contrast to idealist aesthetics, this type of aesthetic response shifts the role of contemplation from a consideration of the artwork as a separate thing to a close consideration of the bodily feelings it occasions (feelings, Lee emphasized, that were bound up with a sensory memory of past responses to form). The effect is that the vase is transformed into an agent that exerts forces on the viewer's body. Anstruther-Thomson takes the work of art to be just as active as the "us" who encounters it: a given pattern makes the viewer a recipient of motion as it "thrusts" its lifting feeling.

Anstruther-Thomson's language alienates the body from the speaker at a level that is not only physiological. The body "hammers" and "[does] shapes . . . inside us," but it also operates in the linguistic registers of "telling" and offering "testimony." The body thus inhabits a mode of awareness that is partially autonomous conscious mind: her body's doing and speaking is nonidentical with Anstruther-Thomson's doing and thinking. The body is further displaced as a collective possession—"our body," "our own body"—shared by the lecturer and her listeners. Through the rhetorical inclusiveness of the first-person-plural pronoun, Anstruther-Thomson presents the figure of a collective corporeality that recalls William

Morris's emphasis on the ways in which art objects create communi-
ties by speaking to the shared bodily existence of those who make and
sense it. Here, the body itself becomes an important source of knowl-
edge, awareness, and information. We can understand this scene as a
particular inflection of affective response, one that does not depend on
an intersubjective emotional economy of feelings and sentiments. Rather,
this is an interobjective motional economy of force and energy, hammer-
ing and thrusting, weighing and lifting. In this and other writing, what
Anstruther-Thomson has to say about empathy is matched in importance
by how she says it. Hers is an exhortative mode of writing whose theoriz-
ing is done implicitly through its language rather than explicitly by logi-
cal reasoning.

This instance illustrates one way in which Lee and Anstruther-
Thomson transform the notion of empathy: they make forms of para-
literary writing—the lecture, the gallery diary—central to empathic
experience. Linked to this shift in method is a second important trans-
formation, this one having to do with metaphor. Lee identified a "special
peculiarity" of empathy, its close ties to figurative language, in a 1904
Quarterly Review article:

> *Einfühlung* . . . is at the bottom of numberless words and expres-
> sions whose daily use has made us overlook this special peculiar-
> ity. We say, for instance, that hills *roll* and mountains *rise*
> We attribute movement to motionless lines and surfaces; they
> *move, spread out, flow, bend, twist*, etc. They do, to quote
> M. Souriau's ingenious formula, what we should feel ourselves
> doing if we were inside them. For we *are* inside them; we have
> felt ourselves, projected our own experience into them.[38]

Here, Lee embraces a theory that, following Ruskin, we might call the
"empathetic fallacy." Ruskin found that bad poets do exactly what Lee
describes: a person, overwhelmed by emotion, might inaccurately feel
that foam "crawls," and if he or she is a bad poet, will simply transcribe
that feeling into verse. But for Lee, there is a tremendous degree of *accu-
racy* in this kind of description. To write that foam crawls may be a poor
description of what the foam does, but it is a precise description of what
we feel when we look at it. Common "words and expressions" therefore
provide insight into the way that empathy operates, because, according
to this account, figurative language is natural and physiological, not ar-
bitrary and cultural.

Lee's attention to language also highlights the fact that taking empathy to be motional and object oriented is not to propose that embodied aesthetic responses do not depend on acts of the conscious mind. Not only did Lee argue that memory of previous experiences of form played a role in any instance of empathy, her focus on language is a method of analysis for which exacting practices of introspection and writing were fundamental.[39] More accurately, then, object-oriented empathy configures the relationship between mind and body in a particular way, depicting bodily changes as taking place before and in certain cases directly causing aesthetic feelings—a principle that Lee adapted from work on emotions in physiological psychology, particularly that of Giuseppe Sergi, Carl Lange, and William James.[40]

Lee's attention to the figures used to describe empathy extends to many other instances. A year after collecting her essays on empathy in *Beauty and Ugliness*, Lee published *The Beautiful* as part of a Cambridge University Press series that invited experts to introduce their area of knowledge to educated laypeople. Far more accessible than *Beauty and Ugliness*, this book disseminated the concept of empathy in Anglo-American aesthetics. Throughout *The Beautiful*, Lee uses everyday language to illustrate technical claims about the psychology of aesthetic experience (e.g., the first chapter addresses "The Adjective 'Beautiful'"). In a passage that prepares the reader for the strangeness of the theory of empathy—Lee is about to explain that one empathizes with the triangular form of a mountain by rising along with it—Lee observes that it is actually difficult to avoid language that betrays an original empathic relation to one's visual environment:

> Of course we all know that, objects the Reader, and of course nobody imagines that the rock and the earth of the mountain is rising, or that the mountain is getting up or growing taller! All we mean is that the mountain *looks* as if it were rising.
>
> The mountain *looks!* Surely here is a case of putting the cart before the horse. No; we cannot explain the mountain *rising* by the mountain *looking*, for the only *looking* in the business is *our* looking *at* the mountain. And if the reader objects again that these are all *figures of speech*, I shall answer that *Empathy* is what explains why we employ figures of speech at all, and occasionally employ them, as in the case of this rising mountain, when we know perfectly well that the figure we have chosen expresses the exact reverse of the objective truth.[41]

Here, Lee clarifies what it means for empathy to be "at the bottom" of familiar expressions.[42] It is not just that certain metaphors happen to be based on embodied experience but that the very possibility of figuration is the result of our visual relationship with a material environment. In noting the double attribution of the verb *looks* to the mountain and to the viewer, Lee creates a palimpsest of linguistic and visual figures that mirrors the way in which her theory writes language onto the domain of visual perception. The triangular form of the mountain expresses itself physiologically as the viewer's unconscious tendency to rise, and it expresses itself linguistically as the viewer's spoken attribution of agency to the mountain. (A similar duplication of words and force is at play in Anstruther-Thomson's vase, which testifies and hammers.) For Lee, this double relationship is the origin of figurative language. Where Lipps invites his reader to discover empathy by looking at a line, Lee asks her reader to learn about empathy by reflecting on what it means to say that something "looks."

It may seem that the emphasis on language is more pedagogical than substantive. After all, in *The Beautiful*, Lee is writing for readers who are not versed in the technical language of psychology; her concern with language may proceed from a wish to explain difficult concepts in everyday terms. But Lee turns her attention to words and phrases even when addressing the most difficult and arcane aspects of empathy theory. In a more technical essay originally published in the *Revue Philosophique*, Lee objects to Lipps's answer to what happens to the ego of a person who experiences empathy by challenging the metaphor he uses. In his *Aesthetik*, Lipps observes almost in passing that the empathic ego "lives in the thing contemplated" (es lebt in der betrachteten Sache), meaning that the self "transcends" (literally, "is lifted above" [hinausgehoben]) the individual by becoming absorbed in an external aesthetic object.[43] Latching onto this phrase, Lee parries with an extended reading, asking whether the image of an ego "living" elsewhere implies "leaving the realm of reality (imagined in some way as dimensional space) to take up its abode in 'the work of art,' to participate in its life and to detach itself from its own, after the fashion of the Lenten retreat of a Catholic escaping from the world and purifying himself in the life of a convent? This metaphor might be applied, but it would not make us forget that the *ego* is not an entity apart."[44] Just as Lee finds clues about how *Einfühlung* operates by examining metaphors in everyday speech, she articulates her disagreement by interrogating the figurative language of her scientific colleagues.

Perhaps figuration proves to be fertile ground for Lee because the theory of empathy had been caught up in tensions between language and em-

bodied perception from its inception. In *On the Optical Sense of Form*, Vischer generates multiple neologisms besides *Einfühlung* in his attempt to describe unusual modes of perception; Vischer coins the terms *Anfühlung* (attentive feeling), *Ausfühlung* (out-feeling), *Nachfühlung* (responsive feeling), *Zufühlung* (immediate feeling), and *Zusammenfühlung* (feeling-together), and also formulates all of these terms with the suffix *empfindung*, or sensation (thus "Einempfindung" [sensing-into]).[45] One senses that this proliferation of terms seeks to compensate for, through sheer abundance, the resistance to language of one's embodied response to objects. For Lee, this resistance means that the experience of empathy is usually captured unconsciously, through metaphor. Empathy is an experience that must be unearthed with the tools of linguistic analysis; it resists the scientific formula and opts instead for the obliquity of metaphor and the partiality of first-person narrative.

Distant Reading In 1887

To understand how this nexus of internal physical feelings and the analysis of language became an aspect of a much wider-ranging aesthetic theory requires turning briefly to nineteenth-century statistical philology in the United States, which represents an important but overlooked context for Lee's literary-critical project. Where Lee focuses critical attention on the linguistic mediation of corporeal experience, nineteenth-century linguists who attempted to statistically analyze literary works would initially seem to do precisely the opposite, abstracting language into decorporealized data. But these statistical methods became central to Lee's understanding of how to apprehend the physical dimensions of literary experience.

In 1851, the British mathematician Augustus de Morgan wrote a letter to a friend at Cambridge in which he suggested that the authenticity of the Pauline epistles might be tested in a quantitative way simply by averaging the letters per word in Paul's writing and seeing whether this average was consistent. "If scholars knew the law of averages as well as the mathematicians," wrote the mathematician, it would be easy to mount a study to find out whether authors leave an unconscious fingerprint simply by way of their habitually preferred word lengths.[46] "Some of these days spurious writings will be detected by this test. Mind, I told you so."[47] De Morgan, it turns out, was right. When a physicist at Ohio State University, Thomas Corwin Mendenhall, read this letter in de Morgan's 1882 biography, he set about a massive study of literary style by counting letters. Mendenhall's method was simple: using passages of several thousand

FIG. 12. — TWO GROUPS, OF TEN THOUSAND WORDS EACH, FROM DICKENS: 'OLIVER TWIST,' ——;
'CHRISTMAS CAROL,' — — — —.

FIGURE 5.3 Diagram of typical word-length distribution in Dickens. T. C. Mendenhall, "The Characteristic Curves of Composition," *Science* 9, no. 214 (March 11, 1887), 248.

words, he both calculated the average word length and graphed the frequency of word lengths from one to sixteen letters. Publishing the results in *Science*, Mendenhall explained this as a form of literary spectrometry: just as a the components of a beam of light can be divided and sorted by wavelength, so too can a passage of prose be broken down into "what may be called a 'word spectrum,' or 'characteristic curve.' "[48] Mendenhall identified the characteristic curves of *Oliver Twist*, *A Christmas Carol*, *Vanity Fair*, Mill's "Political Economy" and "Essay on Liberty," two addresses by the anti-imperialist lecturer Edward Atkinson, and Caesar's commentaries (fig. 5.3). As we have seen in chapter 1, E. S. Dallas had imagined that a science of literary criticism would eventually be realized through a physiological conception of the unconscious. Mendenhall found a different route, by way of mathematics and statistics rather than biology or physiology.

Mendenhall's labor-intensive method drew interest from readers of *Science* as well as from a patron who wished to fund research into the authorship of Shakespeare's plays.[49] Mendenhall hired two women to record the length of about four hundred thousand of Shakespeare's

words over the course of several months. Their method was notable for its bodily demands, its use of a rudimentary computing apparatus, and its strange transformations of what it could mean to read a text or recognize an author: one assistant called out lengths of words, one by one, while the other pressed buttons on a counting machine marked with the appropriate number. Here, in 1901, is a primal scene of distant reading, computer and all. Mendenhall reported that "the work was very exhausting . . . and could not be kept up satisfactorily more than three to five hours each day."[50] As the process went on, Mendenhall marveled that "the counters declared their ability to recognize Shakespeare by the mere 'run of words' without knowing what book or author was in hand, especially on account of the exceptional excess of four-letter words."[51]

The "theory of characteristic curves," as it became known, drew attention for its apparent capacity to statistically unearth unconscious habits of canonical writers. In this regard it echoes the Edinburgh Aesthetic Club's earlier conception of the production and apprehension of form as unconscious or instinctive. Many readers and academics were fascinated by the suggestion that writing was "intimately connected with mental processes that are carried on without any conscious selection" and that could in turn be quantified.[52] At the University of Nebraska, L. A. Sherman, along with a pair of graduate students, investigated whether the average length of sentences had changed in the history of English writing and found that there was indeed a "movement toward sentential simplification."[53] Robert Moritz, a mathematician at the University of Washington, argued that what Mendenhall had discovered was not a method for discerning authorship but genre: the characteristic curve of *Oliver Twist* and *Vanity Fair* resembled one another but differed from Mill's "Essay on Liberty." Turning to Goethe as an example of an author who wrote extensively in multiple genres, Moritz reported his finding that a single author might have multiple characteristic curves, which he framed as a modification of Mendenhall's theory, taking up the physicist's spectrometry metaphor: "today it is generally believed that all substances have several spectra, corresponding to the several stages of disassociation of molecular composition of their molecules": so too with authors and their curves.[54] Moritz went on to elaborate his mathematical analysis of style in numerous articles, suggesting that what was being discovered were scientific laws governing rhetoric: "There is a sentence-rhythm . . . which is the hidden mark, the cipher, the cryptogram" of a given author; "measured, it yields a number, an author-constant. . . . English prose writers conform to sentence-instinct, which has all the force of a positive law."[55] In a 1909 article in *Modern Language Notes*, Moritz

described his statistical analyses, which by then had become the basis for complicated mathematical models predicting the relationship between types of sentences in given authors. This, Moritz proposed, was the first law of a new subfield: grandly, he concluded, " 'Literametrics' may become to philology, what 'Biometrics' has already become to the biological sciences."[56] This comparison of a science of language with a science of life was characteristic of a moment when, as John Guillory has shown, philology was, in contrast with belles lettres, presenting itself as a "proto-humanistic empirical science."[57]

In the moment that he imagines his research as a form of philology, Moritz hints at how studies such as these might be something more than the ancestors of modern stylometrics or computational stylistics, the intellectual lineages in which they have usually been discussed.[58] Philology has often been described as a suppressed disciplinary origin of modern literary criticism: in 1986, Paul de Man described the turn to theory as a "return to philology" in that it aimed for "mere reading . . . prior to any theory . . . an examination of the structure of language prior to the meaning it produces."[59] Discussing a recent return to philology, Frances Ferguson describes much of present literary-critical practice as a philological inheritance insofar as it takes up the project of ascertaining what texts reveal in excess of the words written on the page. For classical philology, this excess was taken to consist of clues about historical period or authorship; after the nineteenth-century novel reimagines literature as self-reflexive, expressing its own style rather than instructing or conforming to a genre (as Jacques Rancière argues), articulating this excess becomes what we now think of as interpretation. By assuming that novels "need interpretation, need to have their meanings unpacked," the literary critic relies on the premise of an earlier philological tradition: namely, a suspicion that "the ostensible speakers of an era are saying more than they know themselves to say."[60]

If this is the case, then the quantitative philology, or "literametrics" of Mendenhall, Sherman, and Moritz can be thought of in terms other than the practitioners themselves might have imagined. They imagine that they are discovering immutable truths about authorial instincts or that literary periods might attain the status, as Sherman and Moritz both hope, of natural laws of the sort described by Herbert Spencer. But they are simultaneously making literary texts speak in ways that align with a philological impulse to make literature say more than it explicitly knows. If this is a version of "reading," though, it is one that someone like de Man, who equated philology with microscopically attentive close analysis, would certainly never recognize. Their work seeks to develop a numerical meta-

language through which texts might be spoken for—a metalanguage that we might reasonably understand to be analogous to metalanguages that have historically been more familiar to literary critics (psychoanalysis, structuralism, Marxism). The key difference, however, is that the metalanguage of quantitative philology takes the form of codes that are immediately distinguishable from what they elucidate—graphs, tables, numbers, and equations rather than words—thus differing from, and perhaps becoming unrecognizable within, the linguistic metalanguages through which critics have usually spoken for texts. Especially at a moment in the late-nineteenth century when the criticism of Pater, Symons, Wilde, and Lee aimed to communicate personal sensitivities to aesthetic objects, we might well expect that "literametrics" and "characteristic curves" simply would have looked like a diametrically opposed kind of inquiry, leaving little room for the personal impressions that were then understood to be the domain of the literary critic.

Franco Moretti often describes the application of statistical analysis to literary texts as both iconoclastic and dependent on the advent of the digital. Writing about the graphs produced by quantitative analysis of literary texts, Moretti observes that the new object of study "is not something we have found somewhere (in an archive, say); it's something we have constructed for a specific purpose; it's not a given, it's the result of a new *practice*. A new type of work that, before the advent of digital corpora and tools, was simply unimaginable."[61] Moretti's assertion needs a caveat: perhaps the "advent of digital corpora" happened around 1901, when Whitman and Mitchell began recording the lengths of Shakespeare's words at their improvised adding machine—digitally, corporeally. Furthermore, it is not just that the digital is older than we think or that Moretti's practice has been anticipated. It is that through a relationship to philology shared by deconstructive close reading and quantitative distant reading there emerge hidden connections between forms of interpretation that are normally perceived as taking place at widely divergent scales.

Were these graphs and tables fundamentally opposed to the kinds of relationships between reader and text, spectator and object, that aesthetes such as Lee and Anstruther-Thomson had described? What would it have looked like for aestheticism to take a quantitative turn? Might the New Critical practice of close reading even be haunted by forms of distant reading that preceded it? To answer these questions requires turning our attention to Lee's own literary criticism. In 1902, the London *Times* published an article on Mendenhall, "Mechanical Peculiarities of Literary Work," which concluded by suggesting that statistical analysis had finally

silenced the "Bacon-Shakespeare fanatics."[62] Among its readers was the Hungarian historian Emil Reich, who wrote to the *Times* that as a student he had conducted similar tests on the ratios of parts of speech (rather than word length) in German stylists. This, he suggested, was "more to the point than Dr. Mendenhall's purely external procedure."[63] Lee read Reich's article but took the forms of statistical analysis that had been directed toward detecting secret stylistic fingerprints of authors or tracking historical change within the language in an entirely new direction that would eventually meet up with—and be rejected by—I. A. Richards's early literary theory. Tracing this forgotten history of close reading reveals not only that quantitative analysis of literary texts preceded New Critical interpretive practices but that Vernon Lee, drawing on both quantitative stylistics and physiological theory, had already in the 1920s attempted to reconcile scales of close and distant interpretation.

Quantifying Movement across the Arts

If a close reading of Lee's aesthetics reveals her to be deeply invested in the language of empathy, her other writing of the period reveals that she is equally interested in what it would mean to empathize with language. Lee's literary criticism and her aesthetics have generally been treated separately, in part because her main work of literary criticism, *The Handling of Words* (1923), was published well after her writing on empathy. In fact, however, most of the essays collected in the volume were initially written and published decades earlier at the same time as her essays on aesthetic empathy. Reading Lee's literary criticism alongside her empathy theory allows us both to recognize coherence across Lee's critical projects and to see how her work anticipated and challenged twentieth-century literary formalisms.

Even before she began writing about visual empathy, Lee had explored how a reader might somatically respond to linguistic patterns. Beginning in the 1890s, Lee focused on literature as a psychological medium: a book, Lee writes in "Of Writers and Readers" (1891), is "a certain number of items conveyed from one mind to another, and a certain mode of conveying."[64] Framed as a conveyance, literature raises a constellation of questions that center on the cognitive mechanics of language: What uses of language convey meaning most precisely? How do readers with different sorts of minds extract similar meanings from the same poem? What are the specific qualities that make this "conveying" pleasing?

In 1903 and 1904, Lee published a three-part series of articles in the *Contemporary Review*, "Studies in Literary Psychology," that answered

these questions. The titles alert the reader that Lee's focus will be textual, even linguistic: "The Syntax of De Quincy [*sic*]," "The Rhetoric of Landor," and "Carlyle and the Present Tense." The first essay develops Reich's proposed method for evaluating prose, a strategy of interpretation that Lee would develop over the next twenty years.[65] The logic of this method is as follows. First, Lee observes that style can be thought of as a physical tic—"a kind of gesture or gait"—that symptomatically reveals the writer's temperament. If this is the case, the critic can act as a psychologist who deciphers language in order to uncover the writer's "unconscious habit."[66] To do so requires a mathematical critical practice that quantifies parts of speech. Lee therefore adds verbs, adverbs, and active participles and compares this result to the number of nouns and adjectives. Thomas de Quincey, it turns out, uses more parts of speech in the latter category (static) than in the former (active). On its own, this is perhaps not very informative, but when brought into relation with other writers, the results become more interesting: similarly quantifying the prose of Daniel Defoe and Robert Louis Stevenson produces "the exactly opposite result."[67] Inspired by this discovery, Lee writes, "It seemed to me now that I had got two categories of style—the one in which the chief part was given to action, as in Defoe and Stevenson; and the other in which, so to speak, *mere being* . . . was to the fore."[68] Lee's quantitative analysis of parts of speech in one passage leads her to the conclusion that "a certain heavy jerkiness" and "lack of movement" results from the preponderance of inactive nouns and pronouns: "the fine movement of this passage seems to begin when this crowd of pronouns . . . at last comes to an end."[69]

Nicholas Dames has suggestively compared this type of reading by numbers to nineteenth-century psychophysics and the physiological language of Victorian literary criticism: Lee's computational mode disintegrates prose into its "minimal units" just as early experimental psychologists treated perception as a sum of "just noticeable differences."[70] The psychological aspiration to quantify and mathematize relationships between stimulus and perception certainly informs Lee's thought. But perhaps her literary theory is even more clearly illuminated by early stylometrics and Lee's own theory of visual empathy. Unless we read Lee's computational literary criticism in these contexts, her determinations may seem arbitrary: what justifies the leap from a quantitative observation (a preponderance of nouns) to a particular somatic experience ("heavy jerkiness")? We can answer this question by thinking of Lee's literary theory as only one facet of her aesthetics: it is a partial articulation within a broader model of corporeal aesthetic response that Lee understands to operate across the arts, including prose, painting, sculpture,

architecture, and music. Too many pronouns produce jerkiness by the same mechanism that a triangle produces a sensation of rising or that a musical phrase gives a sense of forward movement. What aesthetic theory truly theorizes is not any individual art but the human bodies through which all arts are mediated.

Lee articulates this connection between her literary and aesthetic theory, though implicitly, in an 1894 article in the *New Review*, "The Craft of Words." Though Lee does not use the term, she describes a response resembling empathy but provoked by literary rather than visual form:

> There are words which make the Reader think and feel, in a way *live*, slowly; and there are other words which make the Reader think, feel, and live quickly, and quickly and smoothly, or quickly and jerkily, as the case may be. Above all, there are arrangements of words—combinations of action and reaction of word upon word, which, by opening up vistas or closing them, make the Reader's mind dawdle, hurry, or labour busily along. Now, by a law of our mental constitution, whatever kind of movement a picture, a piece of music, or a page of writing sets up in us, that particular kind of movement do we attribute to the objects represented or suggested by the picture, the music, or the writing; it is no idle affectation, no mere conventional desire to make things match, which makes us hate the lengthy telling of a brief moment, the jerky description of a solemn fact.[71]

The "law of our mental constitution" that Lee here describes is remarkably similar to what would eventually go under the name "empathy" in *Beauty and Ugliness*. Just as Anstruther-Thomson finds in the movement of forms on a Greek vase a sense of vitality and lively activity, Lee finds in the patterns of language rhythms of lived experience.

The appearance of this essay in 1894 emphasizes that Lee did not apply the theories of Lipps and Groos to literary analysis (which she had not yet encountered) but that her physiological aesthetics had from its origins inquired into how a physicalized sense of aesthetic motion was generated across the arts. This attribution of felt movement to language is, furthermore, the obverse of Lee's theory that we unconsciously derive metaphor from original experiences of empathy. Like other aesthetic forms, literary prose has forceful temporal effects that, if ineffectively deployed, disrupt a reader's cognitive ambulation. In a 1923 letter to the *Times*, Lee describes this feeling as a transartistic "vital tempo": "What for me corresponds to the patterns of melody and harmony of the

musician, to the patterns of lines and colours of the painter, is not the events and feelings of which [the novelist] tells us . . . but the pattern of words, the coordinations of verbal tenses . . . with which he solicits our responsive sensibility and imagination."[72] The attention to movement directly recalls Lipps's and Groos's explorations of motor imagery and inner mimicry, but where these theories were focused primarily on visual form, Lee's literary criticism adapts these theories to the shape of prose. When Lee empathizes with literature, she feels the movement of syntax. Motional empathy specifically excludes the "events and feelings" that make up narrative.

A statistical impulse similarly drives Lee's *Music and Its Lovers: An Empirical Study of Emotional and Imaginative Responses to Music* (1933), which Lee dedicated to the hundreds of respondents to questionnaires that she had invited to answer a simple question, paraphrased as follows: "When music interests you at all, has it got for you a meaning which seems beyond itself, a message? or does it remain just music?"[73] The book draws extensively on responses to these questionnaires as well as on the writing of the neurologist Henry Head, but it was again Anstruther-Thomson who took pride of place, quoted on many pages of *Music and Its Lovers* as "C. A. T." Anstruther-Thomson wrote that if music did not directly evoke feelings of, for example, triumph, it could evoke an analogous feeling, a relationship that she describes as follows: "a little baby nestling in its mother's arms produces, I imagine, a feeling of tenderness which one doesn't get from music in the same actual form; but certain passages of suspension and swinging between two notes give one the feeling of the verb of tenderness. If I may use so clumsy an expression . . . it isn't interwoven with my feelings as a human being. It is the Ancestor rather, of those feelings."[74] These ideas of a "verb of tenderness" and of an "Ancestor" of emotion provided Lee a starting point from which to theorize the intersection of emotion, language and music: here, the structure of language and evolutionary biology both modeled the relation of musical feeling to emotion. Lee suggested that the difference between actual emotion and its musical counterpart was one of conjugation: "In real experience a verb can exist only in the past, present, future or some compound tense. . . . But in the case of music, the triumph or the tenderness may be at any moment of the world's history"; music expresses "a *verb in the infinitive* of just such a manner of cherishing" as a mother might feel toward an infant.[75] What is significant is not only that *Music and Its Lovers* extrapolates Lee's theory of empathy to music, finding in musical form similar properties of movement to those which she had identified in the visual arts; it is also that language

occupies a special place in both regards despite the fact that one might expect the linguistic register to be qualitatively removed from a physiological domain that would seem to precede meaning.[76]

Given the aesthetic qualities of Lee's literary criticism (its attention to reading as sensory experience) and the literary qualities of her aesthetics (its drive toward making visual and audible forms into language), Lee's writing on literature is not literary criticism so much as one branch of a cross media critical project promoting empathy itself as a critical mode. Object-oriented empathy is not limited to the visual domain; it accounts for a wide range of responses to art, literature, and music. The body is a node where the formal properties of any art—color, sound, depth, syntax—intersect.[77] As opposed to earlier physiological aesthetics that disaggregated complex artworks into lines, curves, and angles, Lee focuses on how the body synthesizes formal qualities as feeling. This practice becomes "critical" in that the body is not a mute receptor of the stimuli of form; rather, the somatic reception of form provokes articulation unconsciously as metaphor or consciously as a gallery diary or lecture. Empathic critical response works across and between the arts without erasing the differences among them.

Lee and Richards

Lee's physiological formalism complicates the opposition between embodied feeling and disembodied formalism with which I began this chapter, allowing us to rethink a crucial transition in the history of literary criticism. Lee's *The Handling of Words* appeared a year before the book to which we usually trace modern literary analysis, I. A. Richards's *Principles of Literary Criticism* (1924). Because of its careful attention to language and form, Lee's book has occasionally been recognized for its prescience. As Vineta Colby notes in her biography, one editor of Lee's work finds in *The Handling of Words* evidence that Lee anticipated such luminaries as "I.A. Richards, the Russian formalists, Mikhail Bakhtin, Wolfgang Iser, and Roland Barthes."[78] My argument here is that Lee's empathic literary theory was unattractive to critics such as Richards precisely because it promised to reconcile Victorian physiological aesthetics with certain theories and practices that became central to the New Criticism.

Richards framed *Principles of Literary Criticism* as overcoming, rather than developing, the kind of aesthetics that Lee pursues. The titles of Richards's opening chapters vividly convey this polemical rejection: "The Chaos of Critical Theories" and "The Phantom Aesthetic State" catalog affective aesthetic theories in order to challenge their fallacies.

Lee's theory of empathy has the misfortune to appear in both: first as one of the failed attempts to explain the value of the arts, and then as an example of the misguided supposition that we can point at a something called "aesthetic experience" that is as different from everyday life as "mathematical calculation is from eating cherries."[79] A text that the American New Critics would later adopt as foundational begins in part by dismissing Lee's project as chaotic and misdirected.[80]

Tracing the fate of empathy through Richards's intellectual progeny, one finds various grounds for disregarding Lee's innovations. Wimsatt and Beardsley reject empathy in "The Affective Fallacy" (1949): "the *Einfühlung* or empathy of Lipps and related pleasure theories" are outmoded forms of criticism that confuse the emotional effect of art with art itself and therefore fail really to be criticism at all: "general affective theory at the literary level has . . . produced little actual criticism. . . . In applied criticism there would seem to be not much room for synaesthesis or for the touchy little attitudes of which it is composed."[81] A few years later, in Wimsatt and Cleanth Brooks's widely influential *Literary Criticism: A Short History* (1957), Lee at first seems simply to have disappeared between chapters twenty-two on Pater's aestheticism and twenty-three on Croce's expressionism. But she makes a belated appearance in a chapter on Richards, as a foil representing the error of taking beauty as a positive quality of an object. Lee's theory of empathy, according to Wimsatt and Brooks, is "too vague to represent any real advance over the usual hedonistic account of art."[82] René Wellek, in a 1966 essay, makes rare reference to her literary criticism and studies of style—"they seem often elementary but are full of shrewd observations unusual for the time (the 1890s) in which they were written"—but only in order to note that her scientific work on empathy is "superseded" and that Bernard Berenson (a rival of Lee) has better withstood the test of time.[83] Although one encounters occasional attempts to resuscitate Lee's theories, such as Richard Fogle's chapter on "Empathic Imagery" in *The Imagery of Keats and Shelley* (1949), her critical project was not on the whole successful.[84]

If one thinks of Lee's ideas about empathy as promoting unverifiable affective responses to art, then it is not surprising that they would be anathema to a generation of critics who were disturbed by the unruly personal interpretations of poetry that Richards had uncovered in *Practical Criticism* (1929)—a book whose dissatisfaction with readers' untutored responses exactly inverts Lee's attempts, in *Music and Its Lovers*, and her psychological surveys, to take such responses seriously. In the decades following Lee, the goal of Anglo-American criticism was not to cultivate individual sensibilities but to establish a set of principles

that would prevent as far as possible the confusion of personal feeling and poetic meaning. These critics certainly would have read Anstruther-Thomson's lecture on how a Greek vase makes her body lift upward as the visual corollary of Richards's students' inability to summarize a poem. In *Practical Criticism*, the subjectivity of response is precisely the problem that needs to be diagnosed (as, e.g., "stock response" or "irrelevant association") and then pedagogically solved.[85]

But if we understand that Lee's theory of empathy is, as I have argued, a data-based account of aesthetic and literary response, we can recognize the consistent rejection of Lee's aesthetics from Richards to Wellek as a strategic move in the service of a literary history that wants to see a clear break between a Victorian moral-aesthetic evaluative criticism and an antiromantic analytical criticism. In her literary criticism, Lee, like Richards, works toward a systematic, autonomous method. Indeed, it is so implicitly teachable that one especially clever reviewer of *The Handling of Words* applied it to Lee's own writing, discovering that she is, by her own metric, a "none too accurate writer."[86] In its most developed form, Lee's method involves the quantification of language according to parts of speech in order to explain systematically the effects of prose—not Wimsatt and Beardsley's "touchy little attitudes" or hedonism.[87] From this perspective, we can see that Richards is not trying to solve a problem that Lee created by indulging the solipsism of empathy. Rather, Lee and Richards are both aspiring toward objective literary-critical practices. But where Richards's version of objectivity rejects the body as a site of linguistic meaning, turning instead to the brain, Lee retains corporeal experience as central to her theory of reading.

We can elaborate this claim by analyzing one instance in which Lee's literary empathy provides some tools for resisting Richards's history of criticism. A long section at the core of Richards's *Principles* reveals that Richards and Lee share sympathies that are obscured by Richards's introductory chapters. Beginning with "A Sketch for a Psychology," moving through his notorious squiggly diagram of a reader's response to a line of Robert Browning's "Pan and Luna," and concluding with an application of this psychological theory to sculpture and music, Richards lays the psychological groundwork for the book's influential ethical claims about how the arts provide "finer adjustment," "increased competence and sanity," and extend the "range and complexity of the impulse-systems."[88] Richards's middle chapters on the mechanics of psychological response closely track Lee's observations on the dynamics of prose, a similarity that is perhaps partly explained by the fact that both Lee and Richards were in dialogue with the neurologist Henry Head.[89] To analyze the phys-

iological dimension of linguistic rhythm, Richards selects the same writer that Lee chose for one of her first objects of "random analysis" in 1903: the romantic poet and essayist Walter Savage Landor.[90] Quoting Landor, Richards asks questions about cadence that exemplify the close attention to language that would become a hallmark of New Criticism: "After 'obscurely green' would it be possible (quite apart from sense) to have 'deeply dark' or 'impenetrably gloom'? Why, apart from sense, can so few of the syllables be changed in vowel sound, in emphasis, in duration or otherwise, without disaster to the total effect?"[91] Richards is more hesitant than Lee to drawing conclusions from his substitutive method of close reading, but his answers likewise attend to the felt rhythms of prose: "As with all such questions about sensory form and its effects, only an incomplete answer can be given. The expectancy caused by what has gone before, a thing which must be thought of as a very complex tide of neural settings, lowering the threshold for some kinds of stimuli and raising it for others, and the character of the stimulus which does actually come, both play their part."[92] Crucially, this is not a rejection of the somatic level of aesthetic response so much as a suspension of it as "incomplete": Richards, unlike many of his New Critical heirs, remains open to the nineteenth-century possibility that aesthetic experience can be understood in terms of a stimulus and response relationship.[93]

But there is an important distinction here as well. The ebb and flow of "neural settings" relocates to the brain what Lee's 1903 analysis of Landor had identified as an effect on the body. For Lee, Landor's greatness lies in the fact that his syntax and diction do not put the reader to sleep or give her a headache. This may sound like the faintest of all possible praise, but Lee is sincere: "His structure of sentences, for instance, is both musically and grammatically a wonder. See . . . how he alternates nouns, verbs, adjectives, and even adjectives and participles. . . . Your mind is stimulated to such gentle yet vigorous exercise by the beautiful and constantly varied cadence, never putting you to sleep by one sort of repetition, nor giving you a headache by another."[94] Richards and Lee both understand prose to stimulate of the body so as to produce "exercise" (Lee) or "sanity" (Richards). But for Lee, this stimulation accords with the discourse of nineteenth-century physiological aesthetics, from Hay to Sully, that Richards frames *Principles* as having overcome. "Vigorous exercise" is much more akin to the corporeal response of Anstruther-Thomson's lifting and Spencer's evolutionary energy than to Richards's mental processing of the "articulatory verbal image," "auditory verbal image," and "tied imagery."[95] Perhaps the simplest way to grasp this divergence is by comparing Lee's tendency to illustrate the object itself in a

SKELETON DIAGRAM OF TITIAN'S "SACRED AND PROFANE LOVE." THE CONTINUOUS LINE SHOWS THE DIRECTION
THAT IS TAKEN BY THE EYE

FIGURE 5.4 Vernon Lee and Clementina Anstruther-Thomson, diagram of the path of a viewer's eye, in *Beauty and Ugliness and Other Studies in Psychological Aesthetics* (London: John Lane, 1912).

way that invited the reader to experience the motional empathy an image might provoke and Richard's now-infamous diagram of how the eye and nervous system respond to a line of poetry: Lee's diagram is of the object itself; Richards's of a process that cannot be directly seen (figs. 5.4, 5.5). Lee's literary criticism extends the nineteenth-century notion that art exercises the body, developing a modern method of computational analysis to demonstrate how this exercise takes place; Richards's scientific modernity is more neurological than computational.

It was precisely this complicated relationship with a tradition represented by Lee, and by extension with a longer line of attempts to develop a physiological aesthetics, that made many New Critics uneasy even as they admired Richards's ethical claims and practical methods. In parallel with modernist art and music theorists who, as Jonathan Crary has argued, envisioned disembodied and timeless faculties of perception, many New Critics systematically and selectively read Richards in ways that suppressed his early aspiration for an integration of a scientific model of the mind with a new type of literary criticism.[96] Richards himself moved toward a different conception of the role of science in relation to criticism. Allen Tate put it most forcefully in "The Present Function of Criticism" (1940), which denigrated positivist literary theories for failing to recognize poetry as a form of knowledge autonomous from—and "perhaps superior" to—science: "In *The Principles of Literary Criticism* there is the significant hocus-pocus of impulses, stimuli, and responses; there are even the elaborate charts of nerves and nerve systems that purport to show how the 'stimuli' of poems elicit 'responses.'" Tate went on to

praise Richards's most recent work as "the repudiation of a literal positivism by its leading representative."[97] The Comtean positivism that provided an earlier generation of literary and aesthetic theorists with the means for resisting metaphysical abstractions now becomes a cardinal sin. F. R. Leavis similarly praised Richards's account of literary form while denigrating his "pseudo-scientific pseudo-psychological" tendencies.[98] This was the New Critics' version of Richards's own rejection of the "phantom aesthetic state"—but here the "phantom" was scientism rather than aestheticism. If Richards's stance led to a pragmatic aesthetics that remained open to the ways in which neurology and literary criticism

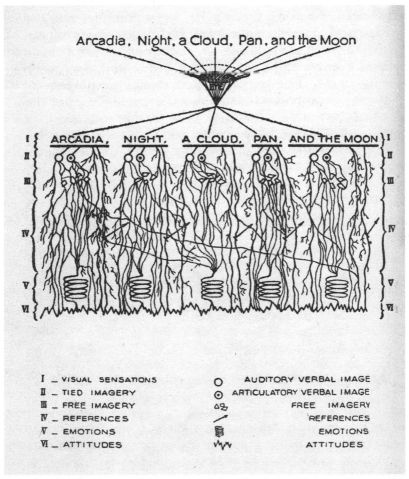

FIGURE 5.5 "A diagram, or hieroglyph" of a reader's apprehension of a line of Browning's "Pan and Luna." I. A. Richards, *Principles of Literary Criticism* (New York: Harcourt, 1961), 116.

might remain in dialogue, the effect of the New Critics' arguments was to entrench ever more deeply in a strict opposition of science and poetry. The autonomy of poetry was purchased at the expense of its commerce with psychology.

Like Lee, Richards was not only a literary theorist, though literary studies is the field that has been most shaped by his influence. It is worth considering, therefore, parallel lines of thought in which the fate of a corporealized aesthetic theory was slightly different—and where it fared slightly better. In *Art as Experience*, for example, John Dewey challenged Richards's tendency to think of the arts as producing effects within the (human) organism; Dewey instead emphasizes that minds actively engage with objects to produce aesthetic experiences: "the *picture* is the integral outcome of their interaction [i.e., the pigment, light, and atoms of the painting] with what the mind through the organism contributes. . . . [Richards's] reference to 'in us' is as much an abstraction from the total experience, as on the other side it would be to resolve the picture into mere aggregations of molecules and atoms."[99] In this passage, we can see the persistence and transformation of certain nineteenth-century lines of thought. Mind, for Dewey, is not receptive but enactive—it not only perceives but takes part in a process through which experience is made. Dewey's return to the barest elements of the artwork echoes Victorian theorists of aesthetic response such as Grant Allen, who argued that one should theorize the aesthetic from the ground up rather than the top down. Elsewhere Dewey expresses a view that concurs with what a previous generation would have phrased as a resistance to metaphysics: "in order to *understand* the esthetic in its ultimate and approved forms, one must begin with it in the raw; in the events and scenes that hold the attentive eye and ear of man, arousing his interest and affording him enjoyment as he looks and listens."[100] Dewey's examples of the origins of the aesthetic—a ball game, gardening, tending a fire—are assertively unremarkable. In this they recall the characters in Morris's *News from Nowhere*, for whom the distinction between aesthetic and nonaesthetic experience has collapsed. But, like Richards, Dewey opened his book with an argument that implicitly took aim at aesthetes; among the primary claims of *Art as Experience* is that, contra the Wildean aesthete, art should not be thought of as a privileged domain available only to sophisticated audiences. Instead, Dewey aspired to understand the arts as points of connection between humans and their environments than as producing a radical separation. What would literary studies look like today if, instead of having been shaped by a New Critical rejection of Richards's neurological rhetoric it had taken up Dewey's interest in the

way in which minds and environments collaborate to produce aesthetic experiences?

Aspects of nineteenth-century materialist aesthetics also persist, albeit in a transformed way, within the work of Susanne Langer, a philosopher of science and of aesthetics who developed a biologically based theory of mind and form. Langer took into account the sort of organism-environment relationship that was central to Dewey's *Art as Experience* but staked out a position directly opposed to previous forms of physiological, psychological, and pragmatist aesthetics. Key to this distinction were Langer's notions of form and symbol. At certain moments, it can sound like Langer is engaging in the forms of biological reductionism that characterized earlier generations of scientifically oriented aesthetic theorists, as when she connects the making of artistic forms to the evolution of mind: "the use of signs is the very first manifestation of mind. It arises as early in biological history as the famous 'conditioned reflex,' by which a concomitant of a stimulus takes over the signal function. . . . Even animal mentality, therefore, is built on a primitive semantic."[101] But, quoting the Richards of *Principles*, Langer described as an "absurd pretension" the notion that a better knowledge of the nervous system would yield a better understanding of form: "there is no elementary success that indicates the direction in which neurological aesthetics could develop," Langer determined; "so far the data furnished by galvanometers and encephalographs have not borne on artistic problems. . . . The proposition that if we knew the facts we would find them to be thus and thus is merely an article of innocent, pseudo-scientific faith."[102] This was one of many moments in which the aspiration toward physiological explanation that characterized many nineteenth-century studies of beauty and form was judged a dead end by those who looked back on it from the twentieth century—even as they crafted their own ways of drawing continuities among nature, biology, and art.

Other trajectories could be traced here. Within Edmund Husserl's phenomenology, and in the work of his student Edith Stein, Lipps's concept of empathy had a vital conceptual afterlife, though what Husserl drew from Lipps was not a theory of aesthetics but a starting point for thinking about questions of intersubjectivity and the experience of other minds.[103] Phenomenologists including Moritz Geiger, Roman Ingarden, Maurice Merleau-Ponty, José Ortega y Gasset, and Mikel Dufrenne developed accounts of art, literature, and aesthetic experience that took up certain of the conceptual challenges of thinking about the embodied, perceptual, and experiential dimensions of aesthetic experience that were central within Victorian materialist aesthetics; perhaps most relevant to

Lee's interest in literary empathy is Roman Ingarden's investigation into the ontological status of literary objects as simultaneously dependent on and irreducible to their physical substrate.[104] The type of experiential aesthetics espoused by Lee was not entirely suppressed or forgotten.

But we can also see in Dewey and Langer a certain misapprehension of the nineteenth-century tradition that dismisses it for, simultaneously, its scientism and its mysticism. Many aesthetic theorists of the early twentieth century positioned themselves as developing alternatives to aestheticism in particular and to nineteenth-century aesthetics more generally, but they often took aim at a caricature. This caricature is very clearly on display in Richards's *Principles*, when Richards places the word *Art* in a Gothic typeface to ridicule the aesthetes' fetishization of precious, exclusive experiences of beauty. Certainly some aesthetes took this position. But a broader view of nineteenth-century aesthetic thought reveals unrecognized sympathies with twentieth-century theorists who sought to distance themselves from effete aestheticism. For many Victorian aesthetic theorists, the Gothic did not only represent an escape from the real world into an imagined medieval one; in many cases, the Gothic figured the radical possibility of revitalizing an embodied relationship to craft—an anticapitalist expansion of the somatic field of the aesthetic to include everyday experience. In this aspiration to reconnect art and life and to resist the polarity of the physical and the metaphysical, they were less alien than Richards, Dewey, or Langer may have wished to acknowledge.

Toward a Statistical Phenomenology

In recent years, many scholars have begun to reconsider Lee's significance within literary and intellectual history. Lee long shared the fate of many late-Victorian female intellectuals whose contributions were systematically marginalized. Lee's obscurity has often been more specifically ascribed to her habit of alienating powerful figures in the British literary world, from Dante Gabriel Rossetti to Henry James, but I would argue that it was further compounded by her cosmopolitanism and remarkably wide range of conceptual reference. The difficulty of recognizing her contributions has often resulted from a lack of familiarity with the scientific and psychological traditions with which she was closely engaged as well as from a relative lack of attention to the important work that she continued to publish after what we call the Victorian period came to an end. Unless one is familiar with the thought of Lipps, Groos, and Vischer as well as with the British tradition of scientific aesthetics, Lee's gallery experiments and writing on the corporeal experience of aesthetic forms can

look like sui generis amateur speculation. And unless one loosens peri-
odizing tendencies, one fails to see how her writing on psychology, form,
and the relationships among the arts brings into view the continuities of
British aesthetic thought across Victorian and modernist thought. But
while I hope that this chapter will contribute to an ongoing reevaluation
of Lee, I want to close by suggesting that an equally important reason
for returning to Lee's thought is that it allows us to think more carefully
about how and why certain paths in the early development of modern
literary criticism, particularly those that valued corporeal experience and
scientific explanation, were foreclosed as well as about the continuing ef-
fects of those foreclosures.

What does it mean to read Lee at a moment when the discipline of
literary studies is once again engaged in a searching conversation about
what kinds of analysis ought to be recognized as valid interpretive pro-
tocols? As literary critics, we might say that we now find ourselves at the
opposite end of a period of professionalized academic criticism that was
initiated at the moment when Lee was conducting her experiments with
statistically analyzing passages of prose. For Lee, the methods by which
one should interpret literary language were unsettled simply because they
had not yet been institutionally established. But for present literary schol-
ars, close reading is being unsettled strategically and self-consciously as
a response to decades of close textual interpretation extending from the
new criticism through new historicism and deconstruction.[105] We might
also make the comparison from a perspective informed by a sociology of
the disciplines: if Lee's turn to scientific thought can be described as one
of the last manifestations of a Victorian intellectual world where disci-
plinary boundaries were more loosely policed, a contemporary turn to
computational and cognitive sciences might instead be thought of as a
symptom of the increasing demand for humanities scholarship to justify
itself by reaching beyond its internal methods and languages.

Looking back at Lee from this perspective, it is tempting to use a
language of anticipation: Lee's interest in scientific approaches to crit-
icism—her surveys, quantitative analyses, and rigorous psychological
introspection—almost uncannily forecast such divergent contemporary
critical trends as the distant reading advocated by Moretti and the cogni-
tive approaches to literature espoused by Lisa Zunshine, Alan Richard-
son, and others. Lee might be called on as a key figure in a new, alter-
native history of science-oriented forms of humanistic inquiry whether
those inquiries take the form of neuroaesthetics, quantitative literary
criticism, cognitive studies, or neuroscientifically oriented affect theory.
What Lee could offer to such a history is a conception of scientifically

oriented aesthetic criticism that requires a more careful consideration of which methods and languages have historically been "internal" to the humanities. Her critical methods bring into view a version of I. A. Richards that Wimsatt and Beardsley and other New Critics took pains to suppress—the Richards who risked a diagram of the sensory, neural, and cognitive operations called into play by a line of poetry. The close analysis of language that was taken for granted as central to the discipline for much of the twentieth century emerged partly in response to a self-imposed forgetfulness about quantitative philology and the science of the mind. One could return to Lee, then, to make the claim that the aspiration toward scientific validity has long operated as a standard internal to humanistic inquiry rather than as a threat from without.

But this characterization of Lee's thought risks minimizing her distinctive contributions and reducing her work to an attenuated version of current strategies. Lee's work is ultimately most forceful not for historically validating new methods, but for bringing into view what is left unimagined by positivisms of the present. Here I would suggest that what Lee allows us to imagine are forms of interpretation that would not take for granted an opposition between a phenomenological account of reading and a statistical analysis of literary texts. By "phenomenology," I have in mind both what Charles Altieri has called the "sensuous dimension of literary experience," dependent on the reader's "fundamentally active construction" of sense experience from textual cues, and what Garrett Stewart calls the "experienced primacy" of language in novelistic prose, the "sudden slippage, the give and final snap, of prose's own tensile energy."[106] These senses of literature—imagined feelings or textual feel—are, as we have seen in previous chapters, difficult to theorize and describe. And although this experiential aspect of reading necessarily structures a reader's encounter with a literary text, it is commonly set aside by quantitative and cognitive approaches that often privilege disembodied theories of mind or abstractions of a corpus of texts over a phenomenology of literary experience.[107]

It may seem very intuitive to see an irreconcilable opposition between inhabiting a text from within and analyzing its structure or its place within a structured field from without. But this opposition is in fact an artifact of a contingent history whose potential alternatives can be grasped by way of Lee's experiments with form. We can only begin to understand why we have difficulty reconciling phenomenologies of literary experience with abstract models of literary cognition if we think more carefully about how early twentieth-century critics refined practices of close reading by opting out of a nineteenth-century tradition of physiological

aesthetics. In this regard, Lee's account of object-oriented empathy has something especially important to offer to literary critics. As is evident in her interpretation of Landor, Lee's empathic reading problematizes a New Critical opposition between the reliable universality of rational deliberation and the unreliable individuality of sensation while simultaneously presenting a model that includes the feeling of reading within the practice of interpretation. Lee resists this binary simply by comfortably inhabiting both camps at once. On one page of *The Handling of Words*, she fantasizes that she might "analyse pages enough—say all the pages he ever wrote— . . . and thus arriv[e] at an average classification of all the words which every one of the Writers under comparison ever employed. *The Statistical Test applied to Literature.* . . . Let me recommend the prosecution of this study to young gentlemen and ladies anxious to fit themselves out as general Reviewers."[108] Like Mendenhall, Sherman, and Moritz, this Lee is a distant reader avant la lettre, lacking only a computer and a programming language. But, a few pages later, Lee wants critics to use the statistical analysis of words in order to explore "how" readers think: "How, meaning: is the thinking to be done *easily* or with *effort*; *quickly* or *slowly*, *smoothly* or *jerkily*? . . . How also, in the sense of a horse's paces (is it an amble or a gallop?), or a man's gesture and action, leaning or supporting, leaping or stumbling."[109] Lee offers the provocative image of what the New Criticism might have looked like had it embraced corporeality rather than cognition while still developing a systematic form of literary analysis. The surprising endpoint of Lee's statistical desire is a more rigorous literary phenomenology.

But to end on this literary note would risk losing track of Lee's deeper insight—and, indeed, of one of the generative insights of nineteenth-century sciences of aesthetics more generally: a significant implication of a physiological, materialist conception of form is that it brings into closer contact aspects of the various arts that are usually perceived as unrelated, such as the outline of a triangle and the balance of verbs and nouns in a sentence. At the same time that it provides a point of origin for a modern kinaesthetics of reading, Lee's object-oriented empathy also aims to articulate the intersections of the feeling of reading, the feeling of looking, and the feeling of hearing. Lee's work therefore challenges us to think not only about the compatibility of quantitative and somatic criticism but also about how the feeling of reading is one among many corporeal responses to the arts. In previous chapters, we have seen that reading often seems like a special kind of aesthetic experience, elusive to scientific positivism, because it depends so entirely on cognitive acts. One cannot see a poetic image in the same unmediated way that one sees a color or

hears a sound; novels and poems are therefore less immediately or obviously available to empirical analysis than are musical works or paintings. The phenomenon of empathy, as Lee understands it, provides one way of resisting this distinction between the perceptual and the cognitive, revealing that visual art, music, and literature share the project of affecting bodies—and not only in the case of famously mesmerizing novels like *The Woman in White*. Even *Marius the Epicurean*, Lee wrote in the last essay she published before her death, is a text that a reader feels, and no one who has read Pater's novel would be surprised to learn that it conveys a sense of "insufficient locomotion"—least of all John Addington Symonds Jr., who, as we have seen in chapter 3, could only image reading it in a still Venetian lagoon.[110] It is in this sense that an orientation toward objects comes to include literary objects as well, whose materiality is realized as a sensitive reader's feeling for syntax. Lee reminds us that such feelings matter just as much as it matters that wine makes you drunk, despite Wimsatt and Beardsley's influential exclusion of this kind of somatic experience as a side effect. The object of that exclusionary gesture was not a simplistic confusion of meaning and effect but a highly developed theory of how bodies mediate shapes—of triangles, of sentences, of tonal phrases—to produce meaning and emotion.

Epilogue: Wildean Neuroaesthetics

In light of the tradition that the preceding chapters have traced, it should come as no surprise that the period's most renowned aesthetic object—the picture of Dorian Gray—is also animated. We may now have a new vocabulary to articulate what it is, exactly, that animates Dorian's portrait. Readers tend to think of the painting's transfiguration as supernatural—an event that would be uncanny if it happened in this world but one that is very much at home in the confines of gothic fiction. Wilde's description of the crucial moment supports this interpretation, hinting at a threshold into another world: viewing his painted image, Dorian utters "a mad wish that he himself might remain young."[1] The 1890 text describes this as a "prayer" that is "answered," and the 1891 text as a "wish" that is "fulfilled"; whether the register is mythical or religious, it is apparent that the agency changing the portrait proceeds from a supernatural domain.[2] Wilde tweaks realism with magic, dissolving the ennui of modernity into the mystery of the uncanny.

This account of the novel, if uncontroversial, is one that overlooks some of its deeper mysteries. At the moment when Dorian detects the painting's new, cruel expression, he also has an uneasy suspicion that he has not made a Faustian bargain at all; instead, something has simply gone wrong in his brain: "Suddenly there had fallen upon his

brain that tiny scarlet speck that makes men mad. The picture had not changed. It was folly to think so."[3] As Dorian exchanges a metaphysical explanation for a physical one—a mad wish for a scarlet speck—a reader might reasonably wonder why the prospect that a particle in the brain might cause madness should be any less remarkable than the possibility that a portrait might change in sympathy with human action. And this, in fact, is a question that the novel repeatedly raises. Readers are primed to ask it by Dorian's mentor Lord Henry, who earlier has pondered over "soul and body, body and soul,—how mysterious they were! . . . How shallow were the arbitrary definitions of ordinary psychologists! . . . The separation of spirit from matter was a mystery, and the union of spirit with matter was a mystery also."[4] In a passage that attributes agency and consciousness to atoms, much as had Robert Lewins and Constance Naden's Hylo-idealism, Dorian wonders,

> Might there not be some curious scientific reason for it all? If thought could exercise its influence upon a living organism, might not thought exercise an influence upon dead and inorganic things? Nay, without thought or conscious desire, might not things external to ourselves vibrate in unison with our moods and passions, atom calling to atom in secret love or strange affinity?[5]

The difficulty of imagining a vibrating "unison" of matter and consciousness is reflected by the fact that Wilde, in a single sentence, both denies that atoms might have awareness (they are "without thought or conscious desire") and attributes to them capacities of communication and emotion ("atom calling to atom in secret love"). Perhaps the most supernatural aspect of Wilde's novel is not the mysterious process by which the portrait ages but rather the mysterious principle by which consciousness emerges from inanimate matter. If this is the case, then the aging portrait is not the novel's central mystery but a figure for it; not a solution, but a clue.

One way to describe Wilde's novel is to say that it turns to the aesthetic domain to reenchant matter—the strangely animated atoms of the human body, the rare artifacts with which Dorian surrounds himself, the shifting material specks of the painting—in the wake of positivist thinkers such as Herbert Spencer, Harriet Martineau, and George Henry Lewes, who had called on matter to do the very different work of dissolving metaphysical abstractions into concrete processes. To juxtapose the language of the brain with the language of the soul—the latter by then aban-

doned by the "ordinary psychologists" to whom Lord Henry refers—is
an act that rhetorically parallels the novel's formal juxtaposition of myth
and realism. The novel's basic gambit, in other words, is to pit psycho-
physics against metaphysics. If *The Picture of Dorian Gray* executes
this maneuver with rare style, it was not an original strategy: the novel
responds to a conundrum that was widely discussed at the end of the
century as the scientific naturalization of mind had caused ontological
planes of the ideal and the physical to collapse into one another.

Although Wilde's formative years were saturated with the thought of
William Morris, John Ruskin, and Walter Pater, Wilde had also been
puzzling over new materialist philosophies since he was an undergradu-
ate at Oxford, where he kept notebooks that commonly made reference
to theorists of mind and matter whom I have discussed in previous chap-
ters. In these notebooks, a surprisingly earnest Wilde comes into view: a
student who is pondering what modern sciences of mind might mean for
a philosophical tradition running from the pre-Socratics, Plato, and Aris-
totle to Kant, William Hamilton, and William Whewell.[6] These notebooks
record palimpsests of Wilde's own thought with passages from John Tyn-
dall, Thomas Huxley, Henry Maudsley, William Clifford, Spencer, and
many others. Wilde copied down passages from the major thinkers of his
day and posed his own questions, often having to do with the mysteries
of matter that Lord Henry and Dorian would later ponder. "It is incom-
prehensible how to a mass of nitrogen, oxygen, carbon, phosphorous and
so on it can be otherwise than indifferent how they lie and move": the
mystery of how humans or animals, as bundles of elements, come to care
for their state of being and continued existence.[7] "But modern science
has shown us that both ethics and motion are results of molecular action:
motion in one direction may be an ellipse, in the other a moral sentiment":
the question of nondistinctions between human agency and physical cau-
sality implics for ethical philosophy.[8] "We do not enough distinguish be-
tween the different kinds of *matter*, and of motion. There is no need to
assume an immaterial liver behind the hepatic structure": here, quoting a
trenchant example from Maudsley's *Body and Mind* (which itself echoes
Pierre Cabanis's definition of thought as a brain secretion), Wilde en-
counters the question of whether mind is to brain as digestion is to viscera
(fig. 6.1).[9] Cabanis—Maudsley—Wilde: by the end of the century, material-
isms were densely layered. In the essay from which Wilde quotes, Maud-
sley describes as a "miracle" the phenomenon that Lord Henry describes
as a "mystery": "Men are not sufficiently careful to ponder the wonder-
ful operations of which matter is capable, or to reflect on the miracles

We do not enough distinguish between
the different kinds of matter, and of
motion.

There is no need to assume an
immaterial liver behind the
hepatic structure.

FIGURE 6.1 Oscar Wilde, copied passage from Henry Maudsley's *Body and Mind* in Commonplace Book (ca. 1880). Courtesy William Andrews Clark Memorial Library, University of California, Los Angeles.

effected by it which are continually before their eyes."[10] Throughout his early notebooks, Wilde often returns to scientific models of mind and matter—but attends to their limitations as well.[11]

In this book I have explored how and why the phenomenon of aesthetic experience became an especially significant terrain where nineteenth-century scientists, philosophers, and writers traced questions about the physical matter of the world that Dorian and his portrait together figure: how and where was matter animated, like Dorian's portrait, rather than inert? How was it, furthermore, that mind emerged from the corporeal matter of the body such that a "speck" in the brain could cause a particular mental disposition? And to what extent did the self extend beyond the body's material enclosure into the surrounding world, as the being called "Dorian" extends into his portrait? Aesthetic experience was fundamental to these questions because the concept of the aesthetic, rooted in the sensory resonances of the Greek notion of *aisthēsis* and refracted through British empiricism and associationism, brought physiological basis of perception into contact with imaginative experiences seemingly divorced from the body.

This eroding boundary between mental acts and physiological events is what Ruskin warned about in the second volume of *Modern Painters* when he distinguished *theoria* from *aesthēsis*; and it is also what Wimsatt and Beardsley challenged nearly a century later when they excluded "tears, prickles, or other physiological symptoms" from the domain of literary interpretation.[12] The objection was that the reflective dimensions of aesthetic experience could not be reduced to biological processes or mechanical events. In this book I have explored many of the ways in which such reductions were nonetheless effected in the period between Ruskin and the New Critics as evidenced in the surprising emergence of a neurophysiological account of beauty from the purportedly antireduc-

tionist logic of natural theology; in the reframing of aesthetic pleasure as bodily responsiveness in Alexander Bain, Herbert Spencer, Grant Allen, Walter Pater, and Thomas Hardy; in the attribution of consciousness to aesthetic objects among a generation of Lucretian materialists surrounding Pater; in the exploration of states of diffuse somatic awareness in the work of William Morris; and in the empathic projections and introjections of form among art, literature, music, and bodies imagined in the aesthetic theories of Richards and Lee. For many of these writers and theorists, aesthetic experience was best understood not as a reflective judgment but as a moment of contact between a body and an object. Their writing and practice developed somatic alternatives to a Kantian aesthetics of disinterested reflective judgment, repurposing familiar aesthetic categories in ways that made them sensitive to the shared thingness of aesthetic objects and corporeality of human beings.

Physicalized accounts of aesthetic experience and of aesthetic objects drew on divergent and conflicting notions of subjectivity, matter, and society—a divergence that is especially evident in the contrast between Spencer's biological individualism and William Morris's radical socialism, both of which depend on a version of materialism. The preceding chapters have explored how the phenomenon of human aesthetic experience hinted at alternative structures and extensions of the mind, from David Ramsay Hay's visual and acoustical forms that seemed to be immediately apprehended by human bodies to Pater's aesthetic objects that took on lives of their own to Clementina Anstruther-Thomson's empathic responses that attenuated distinctions between subject and object. Victorian materialist aesthetics emphasized what the philosopher Richard Moran has recently described as the "tradition of seeing something animated or animating in the experience of the beautiful or in the actual thing found beautiful."[13] Victorian aesthetic thought, informed by physiology, psychology, and biology, rendered scientific this tradition of animating beautiful objects. I hope that what will have emerged for readers of this book is a new perspective on the aesthetic theory of the nineteenth and early twentieth centuries. While we should undoubtedly continue to view this period as a moment when the political dimensions of aesthetic experience were newly urgent and practical—no longer Schiller's speculative aesthetic state but Morris's socialist firm—we should also recognize that familiar questions about art and society were often disoriented by new physiological and materialist conceptions of the human.

Readers will have discerned many resonances between Victorian positivist and empiricist approaches to aesthetic experience and those that are being developed today within emerging fields that build alliances

between humanistic and scientific inquiry. Numerous scholars have recently argued that neuroscience, evolutionary psychology, or cognitive science can illuminate the human experience of art and literature in ways that the hermeneutic methods traditionally adopted within the humanities cannot. Such arguments often entail a rejection of certain kinds of literary or cultural theory as unsatisfactory because they are unscientific or antiscientific or describe a gulf that must be bridged between historically oriented criticism and criticism that focuses instead on how minds or brains interact with aesthetic objects within the horizon of the present.[14] In turn, some have countered assertions that literary scholars must make their theories "consilient" with contemporary sciences of mind or evolution by arguing that purportedly scientific modes of literary analysis are often grounded in science that is more controversial than literary critics wish to acknowledge; others by suggesting that the humanities ought to "poach" ideas from the sciences instead of fully adopting scientific methods of inquiry and standards of validity.[15]

In the previous chapters I argue that this debate about the relationship of scientific thought to humanistic inquiry is historically internal to many of our interpretive categories. When James Martineau read Alexander Bain's 1855 and 1859 syntheses of associationism and physiology, he recognized a disturbing possibility and tried to foreclose it in advance: "if we could turn the exterior of a man's body into a transparent case, and compel powerful magnifiers to lay bare to us all that happens in his nerves and brain,—what we should see would not be sensation, thought, affection, but some form of movement or other visible change."[16] Machines that track the flow of blood to regions of the brain have now transformed human bodies into the "transparent cases" about which Martineau speculated. But the relation between what Martineau imagined would look like "some form of movement" and what is experienced as "sensation, thought, affection" remains conceptually difficult to grasp. Philosophers of mind now call Martineau's impasse the "hard problem of consciousness."[17] While a language of neurons has replaced a Victorian language of nerve fibers and "vesicular neurine," the contest between philosophers of mind and cognitive neuroscientists is just as vibrant as was that between nineteenth-century metaphysical idealists and positivist scientists. If this is true of the philosophy and science of mind today, its implications extend to literary and aesthetic theory as well. When Grant Allen derided Ruskin for his "vague, poetical declamation" or when James Sully deplored the "unscientific condition of art-theory," fault lines began to appear that continue to divide interpretive practices.[18] Recent accounts of the attractions of scientific methods within the humanities often look toward in-

stitutional and systemic factors: the adaptation of scientific methods and concepts within literary studies, art history, and other fields cannot be separated from the defunding of humanities disciplines. These Victorian debates, however, prevent us from too quickly reducing the emergence of fields such as cognitive literary studies, neuroaesthetics, or the quantitative analysis of culture to institutional effects. Allen, Sully, Lee, and others show that exploring and questioning the role that scientific methods should play in relation to the explanation of cultural and aesthetic objects are practices that are integral to the development and professionalization of modern humanities disciplines.

Victorian sciences of aesthetics may therefore hint at productive but unexplored modes of cross-disciplinary engagement that could yet take place. Recent work in neuroaesthetics has often either assumed that there is such a thing as "the aesthetic" or "the literary" or has equated aesthetics with the philosophy of art or of beauty.[19] So long as we remain ignorant or only vaguely aware of earlier aspirations toward a science of aesthetics, these may not look like controversial assumptions. But the materialist tradition outlined in this book reveals a different kind of relationship that the sciences might have with aesthetic theory, one that not only explains a kind of experience that has already been defined by philosophers and literary critics but that poses questions about what aesthetic experience is in the first place. The nineteenth-century interface of science and aesthetics powerfully reframed and displaced the aesthetic, extending its boundaries beyond the domain of art or beauty to consider broader questions about how meaning and emotion are mediated through human bodies. This suggests that the contact between scientific and humanistic thought may become most productive in its capacity to effect mutual defamiliarization.

To attribute to Victorian thought the capacity to reframe current critical landscapes is to adopt a strategy of historical interpretation that is nonlinear and that, following Walter Benjamin, turns away from the notion that "what is past casts its light on what is present, or what is present its light on what is past" in order to recognize that "the relation of what-has-been to the now is dialectical."[20] It is not only that we discover among the Victorians "precursors" or "anticipations" of new critical practices but, further, that our intellectual world is dialectically open to that of the Victorians contra both a narrow historicism that would take as its project the accurate rendering of a distant past and a scientific presentism that divorces its claims from any hint of their historicity. From this perspective, we may draw from the nineteenth century an alternative repertoire of dispositions toward positivism and scientism. What is often

seen as unsatisfying about these "isms" within the humanities at present is that its reduction of experience or interpretation to matter, data, or facts is too quick and easy. Bruno Latour puts it thus: "Positivism is not wrong because it forgets 'human consciousness' and decides to stick with 'cold data'"; "it is wrong politically. It has reduced matters of concern into matters of fact *too fast, without due process.*"[21] A possible solution to this unreflective reductionism is, Latour elsewhere proposes, a critical spirit that is "not fighting empiricism but, on the contrary, renewing empiricism."[22] For Latour, this renewal takes the form of a new disposition of trust toward scientific institutions rather than the "starkly negative" exposure of the ways in which modern fact/value distinctions collapse.[23] But one might also say that Wilde adopts the project Latour envisions, renewing empiricism by aestheticizing it. Surrounded by the first generation of Comtean positivists and writing at the cusp of William James's radical empiricism, Wilde was well aware of what Latour describes as positivism's tendency to transform matters of concern into matters of fact. As Wilde worried in one notebook entry, under the ironic heading "Line of Dialectic," "Philosophy began with assertions about physical science and seems likely to end in the laboratory."[24] Wilde's response to this possibility was not to retreat into an aestheticized world separate from science or to accept distinctions between what literature and science might know about human experience. Rather, he playfully inhabited another possibility, a possibility from which scientific materialism allows one to recognize as even more remarkable the emergence of human self-consciousness—the mystery explored in *Dorian Gray* and Wilde's commonplace books.

Wilde models not only an aestheticized, defamiliarized empiricism but also a way of responding to the resonances between the aesthetic formation of subjectivity and the material formation of the nervous system. In this regard, Wilde's thought approaches certain of the insights of Catherine Malabou, whose recent work explores the implications of a neuronal model of the self for philosophy, deconstruction, and psychoanalysis. Malabou has argued that the brain's "plasticity" represents the territory on which critical theory and neuroscience may enter into conversation. In conversation with both Jacques Derrida and Antonio Damasio, Malabou describes the plasticity of the brain through a language of form partly inherited from aesthetics: "the word *plasticity* has two basic senses: it means at once the capacity to *receive form* (clay is called "plastic," for example) and the capacity to *give form* (as in the plastic arts or in plastic surgery). Talking about the plasticity of the brain thus amounts to thinking of the brain as something modifiable, 'formable,' and formative at the

same time."[25] While Malabou elsewhere describes her aim as "to delocal-
ize the concept of plasticity outside the field of aesthetics," this delocal-
ization, as Malabou acknowledges, reacts on aesthetic discourse itself,
countering "a restricted definition of the aesthetic and art."[26] If contem-
porary sciences of the mind give new shape to subjectivity, the languages
of literary theory and philosophy yield figural strategies for conceptual-
izing this newly shaped self.

The resonance between neural and aesthetic form that Malabou rec-
ognizes is also what allows Lord Henry, in *Dorian Gray*, to see his "cre-
ation" of Dorian as an experimental "vivisect[ion]" of him, or for Dorian
to find "a curious pleasure in tracing the thoughts and passions of men to
some pearly cell in the brain, or some white nerve in the body, delighting in
the conception of the absolute dependence of the spirit on certain physical
conditions."[27] Wilde aestheticizes the nervous system not only as a pleas-
ing object of imagined perception—a "pearly cell," a "white nerve"—but
also as the medium of aesthetic "delight." This is evident in the sentence's
embedded syntactical parallel: the pleasure of tracing others' passions
and thoughts to brains and nerves is, transitively, itself passions occur-
ring within the spectator's brains and nerves. Wilde's language stages the
ironic reflexivity of passionately contemplating the materiality of thought
and emotion. This aestheticization of the nervous system suggests that
any portrayal of the physical basis of the mind will requires strategies of
figuration, representation, and portraiture that are "aesthetic" insofar as
they aim to present to the senses a unity of mind and body that cannot be
immediately perceived. Wilde reveals the "neural self" to be an aesthetic
object susceptible to the play of figuration. To read Wilde with Malabou
or Latour is to apprehend relationships other than opposition, poaching,
or consilience that might subsist between scientific and aesthetic ways of
knowing about human experience. A Wildean neuroaesthetics would find
in scientific and materialist accounts of human experience not the elimina-
tion of something like a soul or a self but figural resources for reconceiving
the human.

What is the significance of opening a book with two forgotten Victo-
rian aesthetic theorists—Anstruther-Thomson and Hay—but closing with
one of the most canonical, Wilde? In part, this is a gesture that reflects
one of this book's gambits: that approaching aesthetic thought obliquely,
through its vernacular and noncanonical expressions, can lead to produc-
tive reconsiderations of familiar aesthetic categories. Vernon Lee outlined
an ambitious and unusual program for the study of literature, integrating
statistics, physiology, and aestheticism—but this ambitious program did

not attract many followers. Much earlier, George Field had hoped for a perfectly analogical, mathematicized account of beauty—but his framework of inquiry survived primarily as the material trace of his paint on some Pre-Raphaelite canvases. E. S. Dallas produced an account of how poetry and painting made readers and viewers forget themselves, defining aesthetic pleasure as the experience of self-loss—but Dallas's model of the unconscious has rarely been mobilized. These critical projects, adjacent to the intellectual histories usually adopted by our disciplines, become illuminating in retrospect for hinting at alternatives to guiding practices and concepts.

It is tempting to explain these projects by recourse to ideas of historical difference insofar as they are premised on scientific models that no longer hold. They might seem to represent a warning for approaches to literary and cultural analysis that rely on scientific epistemologies whose presentist horizon is bound to recede. If this is the story we tell, then the New Critics will always look like the generation that discovered that literature and literary criticism know about human experience on its own terms, timelessly, through interpretive languages unavailable to the sciences. But perhaps another perspective on our histories of literary and aesthetic criticism is available in which figures such as Field, Dallas, Allen, and Lee do not represent a unproductive turn to scientism so much as a recurring aspiration to test unconventional tools and methods for exploring the human—and nonhuman—experience of art or beauty. From such a perspective, we might recognize that we will remain chronically uncertain about which disciplines and practices persuasively account for aesthetic experience and which do not—and that it is this very uncertainty that recurrently animates sciences of art and literature.

Acknowledgments

My colleagues at the University of Chicago have shaped every aspect of this book; I am particularly indebted to Jim Chandler, Maud Ellmann, Elaine Hadley, and Elizabeth Helsinger. Lauren Berlant, Bill Brown, Larry Rothfield, and Lisa Ruddick shared transformative readings of drafts. At the University of California, Berkeley, Barbara Spackman, Tony Cascardi, Dan Blanton, Whitney Davis, and Ramona Naddaff sustained my earliest thinking about this project. This book has been enriched by the insight of Nicholas Dames, Anna Henchman, Noel Jackson, Anna Kornbluh, Meredith Martin, Jason Rudy, Jonah Siegel, Rachel Teukolsky, and Carolyn Williams. Joseph Bristow and the members of the 2012 NEH seminar on Oscar Wilde deepened my understanding of aestheticism. My thanks for thoughtful and challenging discussions of chapters with the 2013–2014 fellows of the Franke Institute, the 18th- and 19th-Century Atlantic Cultures Workshop, the History of Human Sciences workshop, the Chicago Junior Faculty Working Group, and the V21 first-book working group.

This book could not have written without the generous support of the Townsend Center for the Humanities, the Franke Institute for the Humanities, the University of Chicago Humanities Division, the American Philosophical Society, and the University of Edinburgh Institute for

Advanced Studies in the Humanities. The staff of special collections and archives at the University of Edinburgh, the Royal College of Physicians of Edinburgh, the Royal Scottish Academy, the William Andrews Clark Memorial Library, and the University of Chicago have been exceptionally generous with their assistance. Portions of Chapter Five previously appeared in *Victorian Studies*, which holds the copyright, and I am grateful for permission to republish. Three anonymous readers at the University of Chicago press offered detailed and incisive responses to the manuscript, which Karen Darling expertly guided to publication. Thank you to Alexander Ring for a world beyond the book. This book is for my parents, Joseph and Wendy Morgan.

Notes

INTRODUCTION

1. This experiment is described in David Ramsay Hay, *The Natural Principles of Beauty, As Developed in the Human Figure* (Edinburgh: William Blackwood & Sons, 1852), 25–41.

2. Clementina Anstruther-Thomson, *Art and Man: Essays and Fragments*, ed. Vernon Lee (London: John Lane, 1924), 139.

3. I borrow the term from Jonah Siegel, who describes the "culture of art" as "the network of ideas, texts, and institutions that supports the understanding of what art is in a given period." See Jonah Siegel, *Desire and Excess: The Nineteenth-Century Culture of Art* (Princeton, NJ: Princeton University Press, 2000), 279.

4. On Kant's turn away from psychological empiricism see Ernst Cassirer, *The Philosophy of the Enlightenment* (Princeton, NJ: Princeton University Press, 1951), 298; Paul Guyer, *Knowledge, Reason, and Taste: Kant's Response to Hume* (Princeton, NJ: Princeton University Press, 2008), 198–99; "The Psychology of Kant's Aesthetics," *Studies in History and Philosophy of Science Part A* 39, no. 4 (2008): 483–94.

5. Immanuel Kant, *Critique of the Power of Judgment*, trans. Paul Guyer (Cambridge: Cambridge University Press, 2000), 159.

6. Theodor W. Adorno, *Aesthetic Theory*, ed. Gretel Adorno and Rolf Tiedemann, trans. Robert Hullot-Kentor (Minneapolis: University of Minnesota Press, 1997), 11. Similarly, Derrida notes that the aesthetic pleasure Kant describes is a "somewhat arid pleasure—without concept and without enjoyment—a somewhat strict pleasure." Jacques Derrida, *The Truth in Painting* (Chicago: University of Chicago Press, 1987), 43.

7. Alexander Gottlieb Baumgarten, *Aesthetica/Ästhetik*, edited and translated by Dagmar Mirbach (Hamburg: Felix Meiner, 2007), 1:xxxii. An especially thorough reinterpretation of the history of aesthetics along these lines is James I. Porter, *The Origins of Aesthetic Thought in Ancient Greece: Matter, Sensation, and Experience* (Cambridge: Cambridge University Press, 2010). Daniel Heller-Roazen has argued that the term *aisthēsis* once included not just bodily states such as pleasure and pain but also emotions such as desire and fear and could "extend well into the terrain of the often-elusive power of awareness that would later be said to be that of consciousness." Daniel Heller-Roazen, *The Inner Touch: Archaeology of a Sensation* (New York: Zone Books, 2007), 22. As Raymond Williams points out, English speakers encountered this Greek word first in a medical context, as "anaesthesia," the absence of sensation. Raymond Williams, "Aesthetic," *Keywords: A Vocabulary of Culture and Society* (New York: Oxford University Press, 1985), 31–33.

8. Friedrich Wilhelm Nietzsche, *The Complete Works of Friedrich Nietzsche*, vol. 8, *On the Genealogy of Morality*, trans. Adrian Del Caro (Stanford, CA: Stanford University Press, 2014), 301. William James, "What Is an Emotion?," *Mind* 9, no. 34 (April 1, 1884): 202. On Nietzsche's physiological aesthetics, including the relationship between his thought and British empiricism, see Gregory Moore, *Nietzsche, Biology, and Metaphor* (Cambridge: Cambridge University Press, 2002), 85–111. Another important instance of returning the discourse of aesthetics to the sensing body is Susan Buck-Morss's reading of Walter Benjamin's "The Work of Art in the Age of its Mechanical Reproducibility": "*Aisthetikos* is the ancient Greek word for that which is 'perceptive by feeling.' *Aisthesis* is the sensory experience of perception. The original field of aesthetics is not art but reality—corporeal, material nature." Susan Buck-Morss, "Aesthetics and Anaesthetics: Walter Benjamin's Artwork Essay Reconsidered," *October* 62 (October 1992): 6.

9. Especially significant reevaluations of Kantian aesthetics include Pierre Bourdieu, *Distinction: A Social Critique of the Judgement of Taste* (Cambridge, MA: Harvard University Press, 1984); Terry Eagleton, *The Ideology of the Aesthetic* (Cambridge: Blackwell, 1990); the essays collected in Paul De Man, *Aesthetic Ideology*, ed. Andrzej Warminski (Minneapolis: University of Minnesota Press, 1996); and Derrida's reading of Kant's third critique: Derrida, *Truth in Painting*, 17–147.

10. The "return to form" or "new formalism" respond not only to critiques of aesthetic ideology but more broadly to methods of new historicism and cultural studies that supposedly disregarded aesthetic or formal qualities of cultural objects. Arguments that recover a politics of form or aesthetics include Robert Kaufman, "Red Kant; or, The Persistence of the Third 'Critique' in Adorno and Jameson," *Critical Inquiry* 26, no. 4 (Summer, 2000): 682–724; Jonathan Loesberg, *A Return to Aesthetics: Autonomy, Indifference, and Postmodernism* (Stanford, CA: Stanford University Press, 2005); and Isobel Armstrong, *The Radical Aesthetic* (Oxford: Blackwell, 2000). Important returns to beauty and form include Elaine Scarry, *On Beauty and Being Just* (Princeton, NJ: Princeton University Press, 2001); Alexander Nehamas, *Only a Promise of Happiness: The Place of Beauty in a World of Art* (Princeton, NJ: Princeton University Press, 2007); Susan J.

Wolfson, "Reading for Form," *MLQ* 61, no. 1 (2000): 1–16; W. J. T. Mitchell, "The Commitment to Form; or, Still Crazy after All These Years," *PMLA* 118, no. 2 (March, 2003): 321–25; Marjorie Levinson, "What Is New Formalism?," *PMLA* 122, no. 2 (March, 2007): 558–69; and Caroline Levine, *Forms: Whole, Rhythm, Hierarchy, Network* (Princeton, NJ: Princeton University Press, 2015).

11. Important interventions exemplifying what I am calling a bodily, affective, or neuroscientific turn within recent aesthetic theory include Sianne Ngai, *Our Aesthetic Categories: Zany, Cute, Interesting* (Cambridge, MA: Harvard University Press, 2012); Charles Altieri, *The Particulars of Rapture: An Aesthetics of the Affects* (Ithaca, NY: Cornell University Press, 2003); Peter De Bolla, *Art Matters* (Cambridge, MA: Harvard University Press, 2001); and Elizabeth A. Grosz, *Chaos, Territory, Art: Deleuze and the Framing of the Earth* (New York: Columbia University Press, 2008). Although their approaches and conceptual frameworks diverge, each of these books turns careful attention to the affective experience of aesthetic objects in ways that give central importance to the body or the senses. Accounts drawing on neuroscience and cognitive philosophy include Semir Zeki, *Splendors and Miseries of the Brain: Love, Creativity, and the Quest for Human Happiness* (Malden, MA: Wiley-Blackwell, 2009) and Mark Johnson, *The Meaning of the Body: Aesthetics of Human Understanding* (Chicago: University of Chicago Press, 2007). A turn to the body can also be discerned within analytic philosophy; see, e.g., Richard Shusterman, *Thinking through the Body: Essays in Somaesthetics* (New York: Cambridge University Press, 2012), and Jerrold Levinson, "Musical Chills," in *Contemplating Art* (Oxford: Oxford University Press, 2006), 220–36.

12. Rancière discusses and argues against the "anti-aesthetic consensus" of Badiou, Bourdieu, and Lyotard in *Aesthetics and Its Discontents*, trans. Steven Corcoran (Cambridge: Polity, 2009), 1–15, 63–87, and against Badiou's resistance to "turn[ing] art into an object for philosophy" in "Aesthetics, Inaesthetics, Anti-Aesthetics," in *Think Again: Alain Badiou and the Future of Philosophy*, ed. Peter Hallward (London: Continuum, 2004), 218–31.

13. John Ruskin, *Modern Painters*, vols. 3–7 of *The Works of John Ruskin*, ed. E. T. Cook and Alexander Wedderburn (London: George Allen, 1903), 4:42.

14. The "science of aesthetics," Hay writes, addresses how "the subject is affected by the object, and the media of communication are the sensorium and its inlets, the organs of sense." David Ramsay Hay, *On the Science of Those Proportions by Which the Human Head and Countenance, as Represented in Works of Ancient Greek Art, Are Distinguished from Those of Ordinary Nature* (Edinburgh: William Blackwood & Sons, 1849), 5.

15. In *The Ideology of the Aesthetic*, Terry Eagleton archly observes that "since much in the Anglophone tradition is in fact derivative of German philosophy, I have thought it best to have recourse here, so to speak, to the horse's mouth." Eagleton, *Ideology*, 11. More recently, Timothy Costelloe observes that "anybody writing a history of the British aesthetic tradition runs into something of an impasse when the Age of Taste comes to an end. . . . After that date [1810], 'philosophical aesthetics' in a strict sense moves across the Channel." Timothy M. Costelloe, *The British Aesthetic Tradition: From Shaftesbury to Wittgenstein* (Cambridge: Cambridge University Press, 2013), 7.

16. See Ernst Cassirer's account: "Psychology and aesthetics now enter into so intimate an alliance that for a time they appear to be completely amalgamated. In no other field was the transition from the psychological to the transcendental approach, by which Kant finally resolved this alliance, so hard to realize and burdened with so many systematic difficulties as in that of the fundamental problems of aesthetics." Cassirer, *Philosophy*, 298.

17. L. S. Jacyna, "The Physiology of Mind, the Unity of Nature, and the Moral Order in Victorian Thought," *British Journal for the History of Science* 14, no. 2 (July 1981), 111.

18. A rich field of work in the history of science has traced both how mind became a scientific object and how this knowledge was popularly disseminated. Accounts of the conceptual transition from philosophy of mind to mental science include Roger Smith, "The Background of Physiological Psychology in Natural Philosophy," *History of Science* 11, no. 2 (June 1973), 95–96; Gary Hatfield, "Remaking the Science of Mind: Psychology as Natural Science," in *Inventing Human Science: Eighteenth-Century Domains*, ed. Christopher Fox, Roy Porter, and Robert Wokler (Berkeley: University of California Press, 1995), 184–231; Robert M. Young, *Mind, Brain, and Adaptation in the Nineteenth Century: Cerebral Localization and Its Biological Context from Gall to Ferrier* (New York: Oxford University Press, 1990); Kurt Danziger, *Naming the Mind: How Psychology Found Its Language* (London: Sage, 1997), 51–65; and Rick Rylance, *Victorian Psychology and British Culture, 1850–1880* (New York: Oxford University Press, 2000). On the cultural and institutional conditions and causes of the development of the science of the mind, see esp. Alison Winter, *Mesmerized: Powers of Mind in Victorian Britain* (Chicago: University of Chicago Press, 1998); Henri F. Ellenberger, *The Discovery of the Unconscious: The History and Evolution of Dynamic Psychiatry* (New York: Basic Books, 1970); and Roger Luckhurst, *The Invention of Telepathy, 1870–1901* (Oxford: Oxford University Press, 2002).

19. George Henry Lewes, *Problems of Life and Mind*, vol. 1, *The Foundations of a Creed* (Boston: James R. Osgood, 1874), 4. Whether the mind is in fact a scientific object remains a contested question within philosophy of mind, which is attested to by the essays and interventions in Christina E. Erneling and David Martel Johnson, eds., *The Mind as a Scientific Object: Between Brain and Culture* (New York: Oxford University Press, 2005).

20. A version of this argument is now described as "the extended mind"; see Andy Clark and David Chalmers, "The Extended Mind," *Analysis* 58, no. 1 (January 1, 1998): 7–19.

21. This metaphor of "outwardness" is regularly used to signal external projections of subjectivity (often by contrast with an interior mind or soul) across a wide array of Victorian discourses, including mental science. Alexander Bain speaks regularly of the "outward display," "outward expression," and "outward manifestations" of feeling or thought; see Alexander Bain, *Mind and Body: The Theories of Their Relation* (London: Henry S. King, 1873), 7, 10, 33. Herbert Spencer often uses the inward-outward binary to distinguish between introspection and observation: "we cannot by simple outward inspection determine with exactness the relation between two objects; so we cannot by simple inward inspection determine with exactness the relation between two states of conscious-

ness." Herbert Spencer, *The Principles of Psychology* (New York: D. Appleton, 1906), 2:389. George Eliot regularly uses the term *inward* to describe deliberation and emotion that is hidden from view, as when Casaubon hides his resentment of Dorothea: "The tenacity with which he strove to hide this inward drama made it the more vivid for him; as we hear with the more keenness what we wish others not to hear," and, notably, in the opening section of *Impressions of Theophrastus Such*, titled "Looking Inward." George Eliot, *Middlemarch* (Oxford: Oxford University Press, 1997), 392.

22. On physiological novel criticism, see Nicholas Dames, *The Physiology of the Novel: Reading, Neural Science, and the Form of Victorian Fiction* (Oxford: Oxford University Press, 2007). Important discussions of the intersection of physiology and poetic theory include Jason R. Rudy, *Electric Meters: Victorian Physiological Poetics* (Athens: Ohio University Press, 2009), and Kirstie Blair, *Victorian Poetry and the Culture of the Heart* (Oxford: Oxford University Press, 2006). Important discussions of the intersection of bodily corporeality and meter more generally include the collection by Jason David Hall, ed., *Meter Matters: Verse Cultures of the Long Nineteenth Century* (Athens: Ohio University Press, 2011); Yopie Prins, *Victorian Sappho* (Princeton, NJ: Princeton University Press, 1999); and the physicality of memorization traced by Catherine Robson, *Heart Beats: Everyday Life and the Memorized Poem* (Princeton, NJ: Princeton University Press, 2012). On the relationship between physiological aesthetics and art criticism, see Rachel Teukolsky, *The Literate Eye: Victorian Art Writing and Modernist Aesthetics* (Oxford: Oxford University Press, 2009), and Kate Flint, *The Victorians and the Visual Imagination* (Cambridge: Cambridge University Press, 2000), 245–57.

23. This field is large. A brief and useful overview is given in Colin Martindale, "The Foundation and Future of the Society for the Psychology of Aesthetics, Creativity, and the Arts," *Psychology of Aesthetics, Creativity, and the Arts* 1, no. 3 (2007): 121–32. For an extensive bibliography, see Albert Richard Chandler and Edward Norton Barnhart, *A Bibliography of Psychological and Experimental Aesthetics, 1864–1937* (Berkeley: University of California Press, 1938), which lists over 1,700 books and articles under headings including "Racial Color Preferences," "Experiments on Affective Reactions and Form," and "Experiments on the Comic." Key texts include Gustav Theodor Fechner, *Vorschule der Aesthetik* (Leipzig: Breitkopf & Härtel, 1876); George Harris, *The Theory of the Arts; or, Art in Relations to Nature, Civilization and Man* (London: Trübner, 1869); Ernst Grosse, *The Beginnings of Art* (New York: D. Appleton, 1897); Jean-Marie Guyau, *Les problèmes de l'esthétique contemporaine* (Paris: Alcan, 1884); Henry Noble Day, *The Science of Aesthetics; or, The Nature, Kinds, Laws, and Uses of Beauty* (New York: Putnam, 1872); and Henry Balfour, *The Evolution of Decorative Art: An Essay upon Its Origin and Development as Illustrated by the Art of Modern Races of Mankind* (New York: Macmillan, 1893). Early experimental psychology laboratories regularly conducted experiments in aesthetics, including at Harvard, Princeton, and the University of Toronto. See those described in A. Kirschmann, ed., *University of Toronto Studies: Psychology Series*, vol. 1 (Toronto: University of Toronto Press, 1900). Accounts of the intersection of psychophysiology and aesthetics include José Argüelles, *Charles Henry and the*

Formation of a Psychophysical Aesthetic (Chicago: University of Chicago Press, 1972); Robert Michael Brain, "The Pulse of Modernism: Experimental Physiology and Aesthetic Avant-Gardes circa 1900," *Studies in History and Philosophy of Science Part A* 39, no. 3 (September 2008): 393–417; and John Tresch, *The Romantic Machine: Utopian Science and Technology after Napoleon* (Chicago: University of Chicago Press, 2012), 125–52. On the place of scientific aesthetics in the late nineteenth-century US university curriculum, see Russ Castronovo, *Beautiful Democracy: Aesthetics and Anarchy in a Global Era* (Chicago: University of Chicago Press, 2007), 9–18, 27–45.

24. Herbert Sidney Langfeld, *The Aesthetic Attitude* (New York: Harcourt, 1920), 29. This notion was common. Kate Gordon, a proponent of psychological aesthetics, opens her college textbook on aesthetics by emphasizing the centrality of observation, experiment, and law within the science of aesthetics: "Esthetics is a science because it pursues the methods of science: the esthetician gathers specimens, observes and compares them, classifies and tries to explain; when possible he examines them under conditions of control. . . . When he is able to find a constant result of any kind, there he has the rudiments of an esthetic law." Kate Gordon, *Esthetics* (New York: Henry Holt, 1909), 2. For more on Gordon and other women in the United States who wrote on aesthetics as a science, often in a reformist vein, see Castronovo, *Beautiful Democracy*, 55–64.

25. Elizabeth K. Helsinger, *Poetry and the Pre-Raphaelite Arts: Dante Gabriel Rossetti and William Morris* (New Haven, CT: Yale University Press, 2008), 3.

26. Especially significant work on the body and the senses includes William A. Cohen, *Embodied: Victorian Literature and the Senses* (Minneapolis: University of Minnesota Press, 2009); Janice Carlisle, *Common Scents: Comparative Encounters in High-Victorian Fiction* (New York: Oxford University Press, 2004); John M. Picker, *Victorian Soundscapes* (New York: Oxford University Press, 2003); Chris Otter, *The Victorian Eye: A Political History of Light and Vision in Britain, 1800–1910* (Chicago: University of Chicago Press, 2008); and Jonathan Crary, *Suspensions of Perception: Attention, Spectacle, and Modern Culture* (Cambridge, MA: MIT Press, 2001).

27. On this version of materialist aesthetics or materialist criticism, see Terry Eagleton, "Categories for a Materialist Criticism," in *Criticism and Ideology: A Study in Marxist Literary Theory* (London: Verso, 1976), 44–63. Marxist and natural materialisms are not opposed to one another; notably, they come into contact in Marx's own doctoral dissertation, "Difference Between the Democritean and Epicurean Philosophy of Nature," in *Karl Marx and Friedrich Engels: Collected Works*, vol. 1 *Marx: 1835–1843*, trans. Dirk J. Struik and Sally R. Struik (New York: International, 1975), 25–108. On Marx's engagement with Epicurus, see G. Teeple, "The Doctoral Dissertation of Karl Marx," in *Karl Marx's Social and Political Thought: Critical Assessments* (New York: Routledge, 1999), 62–104. In chap. 4 of this book, on practice, I address the connections between these two kinds of materialism by way of William Morris's book design and late romances. My primary focus on physical materiality diverges from Paul Gilmore's notion of "aesthetic materialism," which aims to keep in balance four materialities (of language, history, the human body, and the perceived ob-

ject). See Paul Gilmore, *Aesthetic Materialism: Electricity and American Romanticism* (Stanford, CA: Stanford University Press, 2009), 9–10.

28. Eve Kosofsky Sedgwick and Adam Frank, "Shame in the Cybernetic Fold: Reading Silvan Tomkins," in *Shame and Its Sisters: A Silvan Tomkins Reader*, ed. Eve Kosofsky Sedgwick and Adam Frank (Durham, NC: Duke University Press, 1995), 20.

29. Brian Massumi, *Parables for the Virtual: Movement, Affect, Sensation* (Durham, NC: Duke University Press, 2002), 20; Adrian Johnston and Catherine Malabou, *Self and Emotional Life: Philosophy, Psychoanalysis, and Neuroscience* (New York: Columbia University Press, 2013), 1–72.

30. See, respectively, Dipesh Chakrabarty, "The Climate of History: Four Theses," *Critical Inquiry* 35, no. 2 (Winter 2009): 197–222; Alain Ehrenberg, "Le Sujet Cérébral," *Esprit* 11 (November 2004): 130–55; Elizabeth A. Wilson, *Psychosomatic: Feminism and the Neurological Body* (Durham, NC: Duke University Press, 2004); Julia Adeney Thomas, "History and Biology in the Anthropocene: Problems of Scale, Problems of Value," *American Historical Review* 119, no. 5 (2014): 1587–1607.

31. See Jonathan Kramnick, "Against Literary Darwinism," *Critical Inquiry* 37, no. 2 (Winter 2011): 315–47; Ruth Leys, "The Turn to Affect: A Critique," *Critical Inquiry* 37, no. 3 (Spring 2011): 434–72; and D. N. Rodowick, "The Value of Being Disagreeable," *Critical Inquiry* 39, no. 3 (Spring 2013): 592–613.

32. Vanessa Ryan remarks on the "uncanny . . . familiarity" and "affinities" of literary Darwinism to nineteenth-century science in "Living in Duplicate: Victorian Science and Literature Today," *Critical Inquiry* 38, no. 2 (Winter 2012), 411. Critiquing the "ideology of scientism," D. N. Rodowick has argued that a commitment to what Georg Henrik von Wright calls "methodological monism" connects the present turn to cognitivism and evolutionary psychology within the humanities to this longer history of positivism (for von Wright, this importantly includes John Stuart Mill and Auguste Comte). See Rodowick, "Value," 595; and Georg Henrik von Wright, *Explanation and Understanding* (Ithaca, NY: Cornell University Press, 1971), 4.

33. On Fechner, see Nicolas J. Bullot and Rolf Reber, "The Artful Mind Meets Art History: Toward a Psycho-Historical Framework for the Science of Art Appreciation," *Behavioral and Brain Sciences* 36, no. 2 (April 2013): 123–37; Anjan Chatterjee, "Neuroaesthetics: A Coming of Age Story," *Journal of Cognitive Neuroscience* 23, no. 1 (February 22, 2010): 53–62; Helmut Leder, "Next Steps in Neuroaesthetics: Which Processes and Processing Stages to Study?," *Psychology of Aesthetics, Creativity, and the Arts* 7, no. 1 (2013): 27–37; and Thomas Jacobsen, "Bridging the Arts and Sciences: A Framework for the Psychology of Aesthetics," *Leonardo* 39, no. 2 (2006): 155–62. Suzanne Keen outlines a history of cognitive literary studies of emotion that includes Bain, Dallas, Lee, Dewey, Richards, and Lewes in "Introduction: Narrative and the Emotions," *Poetics Today* 32, no. 1 (Spring 2011): 1–53. Sully is treated as a predecessor of contemporary intersections of science and literary studies within several of the essays in Chris Danta and Helen Groth, eds., *Mindful Aesthetics: Literature and the Science of Mind* (London: Bloomsbury, 2014). Work that aims to extend and enrich contemporary theories of affect and emotion by way of nineteenth-century thought

includes Daniel M. Gross, "Defending the Humanities with Charles Darwin's *The Expression of the Emotions in Man and Animals* (1872)," *Critical Inquiry* 37, no. 1 (Autumn 2010): 34–59, and Jane F. Thrailkill, *Affecting Fictions: Mind, Body, and Emotion in American Literary Realism* (Cambridge, MA: Harvard University Press, 2007). On Mendenhall and stylometric predecessors of distant reading, see Yohei Igarashi, "Statistical Analysis at the Birth of Close Reading," *New Literary History* 46, no. 3 (Summer 2015): 485–504, and Fotis Jannidis and Gerhard Lauer, "Burrows's Delta and Its Use in German Literary History," in *Distant Readings: Topologies of German Culture in the Long Nineteenth Century*, ed. Matt Erlin and Lynne Tatlock (Rochester, NY: Camden House, 2014), 30–31.

34. Jacques Rancière, *Aisthesis: Scenes from the Aesthetic Regime of Art*, trans. Paul Zakir (London: Verso Books, 2013), xi.

35. Oscar Wilde, *Miscellanies*, ed. Robert Baldwin Ross (London: Methuen, 1908), 259.

36. Linda Dowling, for example, describes "two moral horizons that came to serve late Victorians in Britain and America as alternatives to belief in God: the scientific ethic of unbelief adopted by such figures as Leslie Stephen, Thomas Huxley, and Samuel Butler and the Romantic ideal of self-contemplation through art followed by Morris, Walter Pater, and Oscar Wilde." Linda C. Dowling, *The Vulgarization of Art: The Victorians and Aesthetic Democracy* (Charlottesville: University Press of Virginia, 1996), 51. My argument, by contrast, is more in sympathy with Gowan Dawson's resistance to Dowling's claim. Dawson observes that "this absolute demarcation was much less evident to the Victorians themselves" and that for many the "language and assumptions" of romanticism and science were "virtually interchangeable." Gowan Dawson, *Darwin, Literature and Victorian Respectability* (Cambridge: Cambridge University Press, 2007), 220. Rachel Teukolsky similarly calls attention to the importance of the sciences to Victorian aesthetics throughout her account of Victorian art writing, including by way of Ruskin's engagements with associationist psychology. See Teukolsky, *Literate Eye*, 52–57.

37. On such accusations of materialism, see Dawson, *Darwin*, 6–7.

38. Important work in this vein includes James A. Secord, *Victorian Sensation: The Extraordinary Publication, Reception, and Secret Authorship of Vestiges of the Natural History of Creation* (Chicago: University of Chicago Press, 2000); Bernard Lightman, *Victorian Popularizers of Science: Designing Nature for New Audiences* (Chicago: University of Chicago Press, 2007); and Ralph O'Connor, *The Earth on Show: Fossils and the Poetics of Popular Science, 1802–1856* (Chicago: University of Chicago Press, 2008).

39. Gillian Beer, *Darwin's Plots: Evolutionary Narrative in Darwin, George Eliot and Nineteenth-Century Fiction*, 3rd ed. (Cambridge: Cambridge University Press, 2009), 41. George Levine's approach also tends to emphasize shared patterns and ideas; as he puts it, "What I am after is a sort of gestalt of the Darwinian imagination, a gestalt detectable in novels as well as in science"; Levine then enumerates key ideas that recur across novels and evolutionary science. George Levine, *Darwin and the Novelists: Patterns of Science in Victorian Fiction* (Cambridge, MA: Harvard University Press, 1988), 13.

40. Beer describes a "shared discourse" in which "not only *ideas* but metaphors, myths, and narrative patterns could move rapidly and freely to and fro between scientists and non-scientists." Beer, *Darwin's Plots*, 5. The one-culture model is described in the collection of essays in George Levine, ed., *One Culture: Essays in Science and Literature* (Madison: University of Wisconsin Press, 1987). An alternative model is that of the "third culture," in which particular knowledge practices mediate between literature and science; see Elinor S. Shaffer, *The Third Culture: Literature and Science* (Berlin: Walter de Gruyter, 1998), 1–12. Ralph O'Connor takes scientific writing itself as "hav[ing] an aesthetic dimension." O'Connor, *Earth on Show*, 16. Adelene Buckland similarly argues that the narrative qualities of scientific practice mean that "there can be no meaningful distinction between science and literature." Adelene Buckland, *Novel Science: Fiction and the Invention of Nineteenth-Century Geology* (Chicago: University of Chicago Press, 2013), 26. Gowan Dawson has identified schisms within this shared discourse: scientists often wished to distance themselves from literary movements that were perceived as morally suspect. Dawson, *Darwin*, 220. Anne DeWitt similarly resists the two-cultures model, emphasizing that novelists were apt to "criticize and reject" the claims of scientists. Anne DeWitt, *Moral Authority, Men of Science, and the Victorian Novel* (Cambridge: Cambridge University Press, 2013), 6.

41. This approach is indebted to scholars including Jerome McGann and James A. Secord, who pioneered interpretive approaches that reconnect a text's meaning to its materiality. As Secord argues, "the most abstract ideas of nature should be approached first and foremost as material objects of commerce and situated in specific settings for reading. Mundane considerations whose importance has long been recognized by librarians, bibliographers, and printers need to become the bedrock for literary and intellectual history." Secord, *Victorian Sensation*, 4. If for Secord, the materiality of the text occasions an expansion outward into cultural history, for McGann it invites ever closer attention to each instance; as McGann has recently argued in a thirty-page reading of the title page of James Fenimore Cooper's, *The Pioneers*, "A properly critical understanding—a philological understanding—would regard every document as a special case. . . . The reason is simple . . . : on one hand, a document is a specific material object that has passed through a particular, if also vastly complex, transmission history; on the other hand, the interpreter of the document is equally, codependently shaped to a specific moment, location, and set of interests." Jerome McGann, *A New Republic of Letters: Memory and Scholarship in the Age of Digital Reproduction* (Cambridge, MA: Harvard University Press, 2014).

42. See Alan Richardson, *British Romanticism and the Science of the Mind* (Cambridge: Cambridge University Press, 2005); Rylance, *Victorian*; Sally Shuttleworth, *George Eliot and Nineteenth-Century Science: The Make-Believe of a Beginning* (Cambridge: Cambridge University Press, 1984); and Adela Pinch, *Thinking about Other People in Nineteenth-Century British Writing* (Cambridge: Cambridge University Press, 2010).

43. Lorraine Daston and Peter Galison, *Objectivity* (New York: Zone Books, 2007), 37.

44. Anstruther-Thomson, *Art and Man*, 139.

45. William Morris, "The Story of the Unknown Church," *Oxford and Cambridge Magazine* 1, no. 1 (1856): 32. Also in *The Collected Works of William Morris*, vol. 1, *The Defence of Guenevere and The Hollow Land*, ed. May Morris (London: Longmans, Green, 1910), 149–58.

46. Walter Pater, *Miscellaneous Studies: A Series of Essays*, ed. Charles Lancelot Shadwell (London: Macmillan, 1895), 160.

47. Brown describes the thing both as "the amorphousness out of which objects are materialized by the (ap)perceiving subject, the anterior physicality of the physical world" and as "what is excessive in objects, as what exceeds their mere materialization as objects or their mere utilization as objects-their force as a sensuous presence or as a metaphysical presence, the magic by which objects become values, fetishes, idols, and totems. Temporalized as the before and after of the object, thingness amounts to a latency (the not yet formed or the not yet formable) and to an excess (what remains physically or metaphysically irreducible to objects)." Bill Brown, "Thing Theory," *Critical Inquiry* 28, no. 1 (Autumn 2001): 5.

48. In addition to Asa Briggs's *Victorian Things* (Chicago: University of Chicago Press, 1989), I also have in mind three recent interventions. John Plotz identifies a "logic of portability" through which "sentiment . . . can be stored in redolent objects or practices moving through the ordinary coils of public . . . circulation." John Plotz, *Portable Property: Victorian Culture on the Move* (Princeton, NJ: Princeton University Press, 2008), 4, 12. Leah Price traces a displacement of meaning from an immaterial text to "three operations: reading (doing something with the words), handling (doing something with the object), and circulating (doing something to, or with, other persons by means of the book)." Leah Price, *How to Do Things with Books in Victorian Britain* (Princeton, NJ: Princeton University Press, 2012), 5. Elaine Freedgood espouses a literary-interpretive practice that combines "taking fictional things literally" and "metonymic research" to unearth a new "radiance or resonance of meaning." Elaine Freedgood, *The Ideas in Things: Fugitive Meaning in the Victorian Novel* (Chicago: University of Chicago Press, 2006), 5, 6. While these approaches differ with regard to their understanding of the role of literary interpretation in relation to objects, each explores how the circulation of meaning-endowed objects produced relational networks. What I am after, by contrast, might be described as a reactivity or feedback loop of things on persons. See also Daniel Hack's exploration of a fourfold model of materiality as "economic, physical, linguistic, and corporeal." Daniel Hack, *The Material Interests of the Victorian Novel* (Charlottesville: University of Virginia Press, 2005), 2.

49. Amanda Anderson, *The Powers of Distance: Cosmopolitanism and the Cultivation of Detachment* (Princeton, NJ: Princeton University Press, 2001), 152; Andrew H. Miller, *The Burdens of Perfection: On Ethics and Reading in Nineteenth-Century British Literature* (Ithaca, NY: Cornell University Press, 2008), 18. Other significant accounts of the Victorian ethos of self-cultivation include David Wayne Thomas, *Cultivating Victorians: Liberal Culture and the Aesthetic* (Philadelphia: University of Pennsylvania Press, 2004), and George Levine, *Dying to Know: Scientific Epistemology and Narrative in Victorian England* (Chicago: University Of Chicago Press, 2002).

50. William Cohen identifies a similar dynamic when he argues that a widespread attention to bodily matter in Victorian literature often complicated distinctions between an inward psyche and an outward materiality. The focus on sense perception, Cohen observes, "provides a mechanism for showing how the world of objects—including other bodies—enters the body of the subject and remakes its interior entities." Cohen, *Embodied*, 6. See also Katharina Boehm's discussion of networked bodies and things in Katharina Boehm, ed., *Bodies and Things in Nineteenth-Century Literature and Culture* (Basingstoke, UK: Palgrave Macmillan, 2012), 2.

51. In this regard, I trace a different trajectory than that which Stefano Evangelista discerns when he positions both Pater and Lee as inheritors of Kant: "Lee follows the critique of judgement formulated by Kant and adopted by Pater in *The Renaissance*, which values art precisely because it frees the spectator from moral imperatives." Stefano-Maria Evangelista, *British Aestheticism and Ancient Greece: Hellenism, Reception, Gods in Exile* (Basingstoke, UK: Palgrave Macmillan, 2009), 56. In the following chapters I will argue that Pater and Lee were anti-Kantian, at least in the important sense that they made ample room for physiological responses that violate the axiom of disinterestedness.

52. Hannah Arendt, *Lectures on Kant's Political Philosophy*, ed. Ronald Beiner (Chicago: University of Chicago Press, 1992), 70.

53. John Dewey, *Art as Experience* (New York: Perigee, 1980), 15.

54. Ibid., 14.

CHAPTER I

1. John Ruskin, *Lectures on Architecture and Painting*, vol. 12 of *The Works of John Ruskin*, ed. E. T. Cook and Alexander Wedderburn (London: George Allen, 1904), 17.

2. Ibid., 16.

3. James Young Simpson to David Ramsay Hay. Papers of David Ramsay Hay. Shelfmark Dc.2.58–59. University of Edinburgh Centre for Research Collections.

4. Ruskin, *Lectures on Architecture and Painting*, 26.

5. Collingwood offers one of the most powerful critiques of the possibility of a science of mind, one that represents nearly the opposite of the position held by many of the thinkers in this chapter. Collingwood argues that seventeenth- and eighteenth-century natural science originated the aspiration for a science of the mind that would be as schematic and observational as the physical sciences. From Collingwood's perspective, however, any science of the mind is caught in a fundamental error: "the science of human nature was a false attempt—falsified by the analogy of natural science—to understand the mind itself, and . . . whereas the right way of investigating nature is by the methods called scientific, the right way of investigating mind is by the methods of history." Collingwood's argument is that supposedly transhistorical scientific accounts of the mind only ever describe a historical situation of the human mind at present. The domain of psychology thus becomes the liminal territory of "irrational elements . . . blind forces and activities . . . sensations as distinct from thought, feelings as distinct

from conceptions, appetite as distinct from will . . . the proximate environment in which our reason lives." R. G. Collingwood, *The Idea of History*, ed. T. M. Knox (Oxford: Clarendon, 1946), 208, 231.

6. Starting from Pythagoras, Spitzer traces the long history of an ideal of world harmony that is materially instantiated by certain proportional and aesthetically pleasing arrangements of sound or color. Spitzer draws particular attention to the importance of music as a paradigm for how environmental aesthetic harmony becomes capable of producing a feeling of "tunedness." Spitzer describes this project as emerging in part from his contemporary studies of the idea of milieu and ambiance. Many of the thinkers I address in this chapter are working through the conceptual problems that Spitzer traces in his discussion of harmony and *Stimmung*. See Leo Spitzer, *Classical and Christian Ideas of World Harmony: Prolegomena to an Interpretation of the Word "Stimmung,"* ed. Anna Granville Hatcher (Baltimore: Johns Hopkins Press, 1963). My account of the ambient in this chapter is also informed by Spitzer's history of ideas of climate, *Umwelt*, and atmosphere; see Leo Spitzer, "Milieu and Ambiance: An Essay in Historical Semantics," *Philosophy and Phenomenological Research* 3, no. 1 (September 1942): 1–42.

7. *Stimmung* is a notoriously untranslatable term, referring both to a subjectively felt mood and to an atmosphere; part of its interest lies in its capacity to defamiliarize subject-object distinctions (including for Martin Heidegger, whose exploration of *Stimmung* has been a topic of many commentaries). On the untranslatability of *Stimmung*, see Spitzer, *Classical and Christian Ideas*, 5–6. The most extensive recent account of *Stimmung* is David Wellbery, "Stimmung," in *Historisches Wörterbuch Ästhetischer Grundbegriffe*, ed. Karlheinz Barck (Stuttgart: Metzler, 2003). Heidegger's notion of *Stimmung* is often taken up within work on affect; see, e.g., Jonathan Flatley, *Affective Mapping: Melancholia and the Politics of Modernism* (Cambridge, MA: Harvard University Press, 2008), 19–24.

8. Perhaps the most influential treatment of these questions is the chapter "Art and Society" in Raymond Williams, *Culture and Society, 1780–1950* (Harmondsworth: Penguin, 1975). Rachel Teukolsky discusses how the first two volumes of *Modern Painters* reflect Ruskin's attempt to navigate competing discourses of aesthetic experience, including associationism, the picturesque, photography, and color theory. See Rachel Teukolsky, *The Literate Eye: Victorian Art Writing and Modernist Aesthetics* (Oxford: Oxford University Press, 2009).

9. Williams, *Culture and Society*, 13.

10. Rancière puts it thus: after Ruskin, "all true art is decorative, since it is meant to be integrated into a building. But also, all true art is symbolic, since the buildings it works with . . . are destined to be *inhabited* by individuals, communities, and their divinities." Jacques Rancière, *Aisthesis: Scenes from the Aesthetic Regime of Art*, trans. Paul Zakir (London: Verso Books, 2013), 142–43.

11. Many of the questions explored in this chapter have recently been revitalized by work at the intersection of cognitive science and aesthetic or literary theory; significant recent interventions include G. Gabrielle Starr, *Feeling Beauty: The Neuroscience of Aesthetic Experience* (Cambridge, , MA: MIT Press, 2013); Semir Zeki, *Splendors and Miseries of the Brain: Love, Creativity, and the Quest*

for Human Happiness (Malden, MA: Wiley-Blackwell, 2009); and Paul B. Armstrong, *How Literature Plays with the Brain: The Neuroscience of Reading and Art* (Baltimore: Johns Hopkins University Press, 2013). Neural response to the arts is a recurring topic in the journal *Psychology of Aesthetics, Creativity, and the Arts*, and the Max Planck Society founded a research institute in empirical aesthetics in 2013.

12. W. J. T. Mitchell, "The Commitment to Form; or, Still Crazy after All These Years," *PMLA* 118, no. 2 (March 2003), 324. An important catalyst for this ongoing debate is Susan J. Wolfson, *Formal Charges: The Shaping of Poetry in British Romanticism* (Stanford, CA: Stanford University Press, 1997). For surveys and discussions of the "return" to form or "new formalism," see Marjorie Levinson, "What Is New Formalism?," *PMLA* 122, no. 2 (March 2007): 558–69, and Derek Attridge, "A Return to Form?," *Textual Practice* 22, no. 3 (September 2008): 563–75. *Collision* is a term for a productive dissonance of form (which I return to later in this chapter) employed by Caroline Levine, *Forms: Whole, Rhythm, Hierarchy, Network* (Princeton, NJ: Princeton University Press, 2015).

13. Robert Michael Brain, "Introduction," in *Hans Christian Ørsted and the Romantic Legacy in Science: Ideas, Disciplines, Practices*, ed. Robert Michael Brain, Robert S. Cohen, and Ole Knudsen (Dordrecht, The Netherlands: Springer, 2007), xiii.

14. Robert J. Richards, *The Romantic Conception of Life: Science and Philosophy in the Age of Goethe* (Chicago: University of Chicago Press, 2002), 12.

15. See Lorraine Daston, "Ørsted and the Rational Unconscious," in *Hans Christian Ørsted and the Romantic Legacy in Science: Ideas, Disciplines, Practices* (Dordrecht, The Netherlands: Springer, 2007), 242–45.

16. John Tyndall, *Sound: A Course of Eight Lectures Delivered at the Royal Institution of Great Britain* (New York: D. Appleton, 1867), 133.

17. Ibid., 2. Tyndall's lectures are announced in the November 6, 1865, *Notices of the Proceedings at the Meetings of the Members of the Royal Institution of Great Britain with Abstracts of the Discourses* (London: William Clowes, 1865) and were later published and reprinted several times. Tyndall opens his lectures by describing perception as the transmission of nervous motion to the brain, whether it is the "motion excited by sugar in the nerves of taste" or "the motion imparted by the sunbeams to the optic nerve." Ibid., 1, 2.

18. William Paley, *Natural Theology; or, Evidence of the Existence and Attributes of the Deity, Collected from the Appearances of Nature* (Oxford: Oxford University Press, 2006), 107, 27.

19. Thomas Chalmers, *On the Adaptation of External Nature to the Moral and Intellectual Constitution of Man* (London: William Pickering, 1833), 190.

20. William Whewell, *Astronomy and General Physics Considered with Reference to Natural Theology* (London: William Pickering, 1833), 259.

21. See Richard St John Tyrwhitt, *The Natural Theology of Natural Beauty* (London: Society for Promoting Christian Knowledge, 1882), 73–176.

22. The art historian John Gage describes Field's use of Harington in *George Field and His Circle: From Romanticism to the Pre-Raphaelite Brotherhood* (London: Christies, 1989), 29–30.

23. "Monthly Catalogue," *Critical Review* 9, no. 1 (September 1806), 98.

24. John Gage, *Color and Culture: Practice and Meaning from Antiquity to Abstraction* (Berkeley: University of California Press, 1999), 221.

25. John Ruskin, *The Elements of Drawing, the Elements of Perspective, and the Laws of Fésole*, vol. 15 of *The Works of John Ruskin*, ed. E. T. Cook and Alexander Wedderburn (London: George Allen, 1904), 338. The second half of Ruskin's sentence is less enthusiastic: "only do not attend to anything it says about principles of harmonies of colour; but only to its statements of practical serviceableness in pigments."

26. Field's first book, *Chromatics*, was in print between 1817 and 1845; *Chromatography* was published in five editions and in German translation between 1835 and 1885; *Rudiments of the Painters' Art, or, A Grammar of Colouring Applicable to Operative Painting, Decorative Architecture and the Arts* was published in four editions between 1850 and 1888. Along with these applied works, Field wrote difficult books on logic and philosophy: *Outlines of Analogical Philosophy* (1839) and *The Analogy of Logic and the Logic of Analogy* (1850). See David Brett, "The Aesthetical Science: George Field and the 'Science of Beauty,'" *Art History* 9 (September 1986): 336–50.

27. Schweizer, Paul D., "John Constable, Rainbow Science, and English Color Theory," *Art Bulletin* 64, no. 3 (September 1982), 424–45.

28. George Field, *Chromatics, Or, an Essay on the Analogy and Harmony of Colours* (London: A.J. Valpy, 1817).

29. George Field, *Chromatics; or, The Analogy, Harmony, and Philosophy of Colours* (London: David Bogue, 1845), 15.

30. Ibid., 141.

31. Ibid., 148, 143.

32. Ibid., 62–63.

33. Ibid., 63.

34. Levine calls for a version of politicized formalist criticism that would aim to "shift attention away from deep causes [i.e. intractable political structures] to a recognition of the many different shapes and patterns that constitute political, cultural, and social experience." Levine, *Forms*, 18; on the politics of collision, see 16–19 and 80–81.

35. Field's work gained traction with some scientists. John Howard Kyan, well known for inventing a method of wood preservation, used Field's instruments in a treatise on the materiality of light and, under Field's influence, revised his view of light's constituent elements from four (carbon, oxygen, nitrogen, and hydrogen) to three. Kyan also describes experiments done by the surgeon and engineer Goldsworthy Gurney, author of the popular *The Elements of Science* (1823). John Howard Kyan, *On the Elements of Light and Their Identity with Those of Matter, Radiant and Fixed* (London: Longman, 1838), 124, 33.

36. Neal C. Gillespie, "Divine Design and the Industrial Revolution: William Paley's Abortive Reform of Natural Theology," *Isis* 81, no. 2 (June 1990), 218.

37. Paley, *Natural Theology*, 45.

38. David Hume, *An Enquiry Concerning Human Understanding*, ed. Peter Millican (Oxford: Oxford University Press, 2008), 106.

39. Walter John Hipple, *The Beautiful, the Sublime, and the Picturesque in Eighteenth Century British Aesthetic Theory* (Carbondale: Southern Illinois University Press, 1957), 7.

40. Timothy M. Costelloe, *The British Aesthetic Tradition: From Shaftesbury to Wittgenstein* (Cambridge University Press, 2013), 6. Costelloe adopts these terms from the *Stanford Encyclopedia of Philosophy's* article on eighteenth-century aesthetics: James Shelley, "18th Century British Aesthetics," *Stanford Encyclopedia of Philosophy Archive*, Fall 2014, http://plato.stanford.edu/archives /fall2014/entries/aesthetics-18th-british/.

41. Edmund Burke, *A Philosophical Enquiry into the Origin of Our Ideas of the Sublime and Beautiful*, ed. Adam Phillips (New York: Oxford University Press, 2009), 102

42. David Hume, *Selected Essays*, ed. Andrew Edgar and Stephen Copley (Oxford: Oxford University Press, 1998), 136–37.

43. Rick Rylance, *Victorian Psychology and British Culture, 1850–1880* (New York: Oxford University Press, 2000).

44. Archibald Alison, *Essays on the Nature and Principles of Taste* (Edinburgh: Bell & Bradfute, 1811), 25. On associationism, see George Dickie, *The Century of Taste: The Philosophical Odyssey of Taste in the Eighteenth Century* (New York: Oxford University Press, 1996). Martha Woodmansee describes Coleridge's use of Kant to counter the possibility contained within associationist aesthetics that the greatness of great works of art is a matter of pure chance. See Martha Woodmansee, *The Author, Art, and the Market: Rereading the History of Aesthetics* (New York: Columbia University Press, 1994), 126–45.

45. Isobel Armstrong, *Victorian Poetry: Poetry, Poetics, and Politics* (New York: Routledge, 1993), 137. John Stuart Mill, "What Is Poetry?," *Monthly Repository* 7, no. 73 (January 1833), 64.

46. Mill, "What is Poetry?," 67, 69; John Stuart Mill, "The Two Kinds of Poetry," *Monthly Repository* 7, no. 80 (October 1833), 723.

47. Mill, "Two Kinds of Poetry," 714.

48. Mill, "What Is Poetry?," 63.

49. Immanuel Kant, *Critique of the Power of Judgment*, trans. Paul Guyer (Cambridge: Cambridge University Press, 2000), 125.

50. Kant, *Power of Judgment*, 158. Immanuel Kant, *Critique of Pure Reason*, ed. and trans. Paul Guyer and Allen W. Wood (Cambridge: Cambridge University Press, 1998), 156.

51. Kant, *Power of Judgment*, 108.

52. Kant addresses the notion of *Stimmung* near the end of his discussion of how aesthetic judgments produce pleasure: "A representation which, though singular and without comparison to others, nevertheless is in agreement with the conditions of universality, an agreement that constitutes the business of the understanding in general, brings the faculties of cognition into the well-proportioned disposition [*Stimmung*] that we require for all cognition and hence also regard as valid for everyone (for every human being) who is determined to judge by means of understanding and sense in combination." Kant, *Power of Judgment*, 109.

53. Monroe C. Beardsley, *Aesthetics: Problems in the Philosophy of Criticism* (New York: Harcourt, 1958), 86. For an important alternative account of the ancient conception of aesthetics as sensuous and materialist, see James I. Porter, *The Origins of Aesthetic Thought in Ancient Greece: Matter, Sensation, and Experience* (Cambridge: Cambridge University Press, 2010).

54. Teukolsky, *Literate Eye*, 58.

55. Elizabeth K. Helsinger, *Poetry and the Pre-Raphaelite Arts: Dante Gabriel Rossetti and William Morris* (New Haven, CT: Yale University Press, 2008), 109.

56. George Field, *Outlines of Analogical Philosophy: Being a Primary View of the Principles, Relations and Purposes of Nature, Science, and Art* (London: Charles Tilt, 1839), 1:21, 2:103.

57. Field, *Chromatics; or, The Analogy, Harmony, and Philosophy of Colours* (London: David Bogue, 1845), 75.

58. Ibid., xiv.

59. Ibid.

60. Rylance, *Victorian Psychology*, 25.

61. Levine, *Darwin and the Novelists*, 41.

62. "Chromatography; or, A Treatise on Colours and Pigments, &c.," *Athenaeum* 408 (August 22, 1835): 638.

63. Ibid.

64. "Literature of the Month," *Court Magazine and Belle Assemblée* 7 (October 1835), 174.

65. Nicholas Frankel makes a similar point about Owen Jones's later *Grammar of Ornament*: the plates "circumvent a purely cognitive response to them, activating the corporeal subjectivity of the book's reader." Nicholas Frankel, "The Ecstasy of Decoration: The Grammar of Ornament as Embodied Experience," *Nineteenth-Century Art Worldwide* 2, no. 1 (Winter 2003), 14.

66. Letters from these scientists are in the collection of Hay's papers: Letters of David Ramsay Hay, Shelfmark Dc.2.59, University of Edinburgh Centre for Research Collections.

67. David Ramsay Hay, *On the Science of Those Proportions by Which the Human Head and Countenance, as Represented in Works of Ancient Greek Art, Are Distinguished from Those of Ordinary Nature* (Edinburgh: Blackwood & Sons, 1849), 52; *The Science of Beauty, as Developed in Nature and Applied in Art* (Edinburgh: W. Blackwood & Sons, 1856). 44.

68. Mill, "Two Kinds of Poetry," 720.

69. Kant, *Power of Judgment*, 114.

70. Letters of David Ramsay Hay, Shelfmark Dc.2.59, University of Edinburgh Centre for Research Collections.

71. See Spitzer, *Classical and Christian Ideas*, 5. Another avenue into the concept of *Stimmung* is section 29 of Heidegger's *Being and Time*, where Heidegger's concern is to develop a concept of *Stimmung* (and of all affects or emotions) not as an inner "psychical condition" but as relational and public. Martin Heidegger, *Being and Time*, trans. Joan Stambaugh (Albany: State University of New York Press, 2010), 133. On *Stimmung* in Heidegger, see Hubert L. Dreyfus, "Affectedness," in *Being-in-the-World: A Commentary on Heidegger's Being*

and Time, *Division I* (Cambridge, MA: MIT Press, 1991), 168–83. For its relevance to Heidegger's aesthetic thought, see Giorgio Agamben, "Vocation and Voice," trans. Jeff Fort, *Qui Parle* 10, no. 2 (Spring/Summer 1997): 89–100, and Gianni Vattimo, *Art's Claim to Truth*, ed. Santiago Zabala, trans. Luca D'Isanto (New York: Columbia University Press, 2008), 57–74. For a recent, evocative exploration of how attending to *Stimmung* might guide practices of literary interpretation, see Hans Ulrich Gumbrecht, *Atmosphere, Mood, Stimmung: On a Hidden Potential of Literature*, trans. Erik Butler (Stanford, CA: Stanford University Press, 2012).

72. David Ramsay Hay, *The Laws of Harmonious Colouring, Adapted to Interior Decorations, Manufactures, and Other Useful Purposes* (Edinburgh: William and Robert Chambers, 1836).

73. Hay, *Laws of Harmonious Colouring*, 18.

74. Ibid., 26.

75. Mill, "Two Kinds of Poetry ," 716, 717.

76. Hay, *Laws of Harmonious Colouring*, 29–31.

77. John Clark, *Elements of Drawing and Painting in Water Colours* (London: Wm. S. Orr, 1838), 35, 15.

78. Letter from Macvey Napier to David Ramsay Hay, September 29, 1843, Dc.2.59, Letters of David Ramsay Hay, University of Edinburgh Centre for Research Collections.

79. Hay develops an applied version of two arguments that had recently been made in favor of an "absolute" set of principles governing beauty: Victor Cousin's *The Philosophy of the Beautiful*, which had been translated into English the same year; and David Reid's *Intellectual Powers of Man*. Reid had connected certain forms of artistic taste to reason and argued that taste could therefore be described as true or false: "there is a natural taste, which is partly animal, and partly rational. . . . That taste, which we may call rational, is that part of our constitution by which we are made to receive pleasure from the contemplation of what we conceive to be excellent in its kind. . . . This taste may be true or false. . . . And if it may be true or false, it must have first principles." Thomas Reid, "Essays on the Intellectual Powers of the Human Mind," in *Thomas Reid's Inquiry and Essays*, ed. Ronald E. Beanblossom and Keith Lehrer (Indianapolis: Hackett, 1983), 287. Following Reid and Cousin, Hay seeks to elaborate the "fixed principles" by which external forms, mediated by the body, produce pleasing effects on the mind. Because these rules are mathematical and geometrical, the study of aesthetics requires the study of proportion.

80. Quoted in David Ramsay Hay, *The Natural Principles of Beauty, As Developed in the Human Figure* (Edinburgh: William Blackwood & Sons, 1852), 3.

81. "Minute Book of the Edinburgh Aesthetic Club. Instituted 1851." Archives of the Royal Scottish Academy (uncataloged).

82. On Edinburgh scientific club culture and Forbes's connection to Hay via Goodsir, see Philip F. Rehbock, *The Philosophical Naturalists: Themes in Early Nineteenth-Century British Biology* (Madison: University of Wisconsin Press, 1983), 91–98.

83. John Goodsir, *The Anatomical Memoirs of John Goodsir*, ed. William Turner (Edinburgh: Adam & Charles Black, 1868), 1:143.

84. "Minute Book," May 29, 1852. It was through his friendship with Good-sir that Hay gained a basic knowledge of anatomy that allowed him more rigor-ously to connect his claims about proportion and harmony to particular physio-logical structures. Goodsir's biographer notes that "D.R. Hay owed a great deal to Goodsir. Devoid of anatomical knowledge, Hay could not have carried out the principles of his theory to a legitimate issue without the aid of an anatomist, and one imbued with large aesthetic vision. Goodsir . . . furnished the anatomical details for Mr. Hay's remarkable book." Goodsir, *Anatomical Memoirs*, 1:143.

85. David Ramsay Hay, *The Harmonic Law of Nature Applied to Architec-tural Design* (Edinburgh: William Blackwood & Sons, 1855), 10.

86. Hay, *Natural Principles*, 39.

87. Quoted in Hay, *Science of Beauty*, 92.

88. Jason R. Rudy, *Electric Meters: Victorian Physiological Poetics* (Athens: Ohio University Press, 2009), 51–52.

89. Nicholas Daly, *Sensation and Modernity in the 1860s* (Cambridge: Cam-bridge University Press, 2009), 4. Jonathan Loesberg, "The Ideology of Narra-tive Form in Sensation Fiction," *Representations*, no. 13 (Winter 1986): 115–38.

90. Hay, *Natural Principles*, 8.

91. Ibid., 26.

92. Ibid., 30.

93. Ibid., 36.

94. Ibid., 8.

95. Hay discusses this episode in his correspondence. Papers of David Ramsay Hay. Shelfmark Dc.2.59. University of Edinburgh Centre for Research Collections.

96. Thomas Purdie, *Form and Sound: Can Their Beauty Be Dependent on the Same Physical Laws?* (Edinburgh: Adam & Charles Black, 1849).

97. See Robert Hunt, *The Poetry of Science; or, Studies of the Physical Phe-nomena of Nature.* (London: Reeve, Benham & Reeve, 1848). Hunt's book oc-casioned Charles Dickens's reflections on geology; see Daniel Hack, *The Mate-rial Interests of the Victorian Novel* (Charlottesville: University of Virginia Press, 2005), 51–53; and Adelene Buckland, *Novel Science: Fiction and the Invention of Nineteenth-Century Geology* (Chicago: University of Chicago Press, 2013), 254.

98. Robert Hunt, "On the Application of Science to the Fine and Useful Arts," *Art Journal* 12 (1850), 358.

99. Whitney Davis, *Queer Beauty: Sexuality and Aesthetics from Winckel-mann to Freud and Beyond* (New York: Columbia University Press, 2010), 159.

100. Ibid.

101. See Tamara S. Ketabgian, *The Lives of Machines: The Industrial Imagi-nary in Victorian Literature and Culture* (Ann Arbor: University of Michigan Press, 2011), 10; and Joseph Bizup, *Manufacturing Culture: Vindications of Early Victorian Industry* (Charlottesville: University of Virginia Press, 2003).

102. "Ruskin's Seven Lamps of Architecture," *Edinburgh Aesthetic Journal* 1, no. 5 (May 1, 1850), 33.

103. John Ruskin, *The Stones of Venice*, vols. 9–11 of *The Works of John Ruskin* ed. E. T. Cook and Alexander Wedderburn (London: George Allen, 1904), 11:17.

104. David Ramsay Hay, *First Principles of Symmetrical Beauty* (Edinburgh: William Blackwood & Sons, 1846), 17.

105. House of Commons, *Report from the Select Committee on Arts and Their Connexion with Manufactures* (London: House of Commons, 1836), 37–43. On Ewart's Select Committee, see Lara Kriegel, *Grand Designs: Labor, Empire, and the Museum in Victorian Culture* (Durham, NC: Duke University Press, 2007), 24–26; Janice Carlisle, *Picturing Reform in Victorian Britain* (Cambridge: Cambridge University Press, 2012), 29–30; and Brandon Taylor, *Art for the Nation: Exhibitions and the London Public, 1747–2001* (Manchester: Manchester University Press, 1999), 44–46.

106. Hay, *First Principles*, 5.

107. George P. Landow, *The Aesthetic and Critical Theories of John Ruskin* (Princeton, NJ: Princeton University Press, 1971), 63. John Ruskin, *Modern Painters*, vols. 3–7 of *The Works of John Ruskin*, ed. E. T. Cook and Alexander Wedderburn (London: George Allen, 1904), 6:35.

108. Hay, *On the Science of Those Proportions*, 47.

109. Ibid., 50.

110. Ibid., 31 32.

111. On facial angles, see Miriam Claude Meijer, *Race and Aesthetics in the Anthropology of Petrus Camper (1722–1789)* (Amsterdam: Rodopi, 1999).

112. Robert Knox, *A Manual of Artistic Anatomy, for the Use of Sculptors, Painters, and Amateurs* (London: H. Renshaw, 1852), 52.

113. Rylance, for example, describes the interdisciplinarity of Victorian psychology in positive terms: it was "accommodating, contested, emergent, [and] energetic." Rylance, *Victorian Psychology*, 7.

114. Gillian Beer, *Darwin's Plots: Evolutionary Narrative in Darwin, George Eliot and Nineteenth-Century Fiction*, 3rd ed. (Cambridge: Cambridge University Press, 2009), 41.

115. John Addington Symonds, *The Principles of Beauty* (London: Bell & Daldy, 1857), 31.

116. Ibid.

117. See Kant, *Power of Judgment*, 104. Using a musical metaphor, Fichte describes *Stimmung* as a physical resonance between the mood of the artist and of the perceiver: "the inspired artist expresses the mood [*Stimmung*] of his nature in a flexible physical form, and the motion, action and continuity of his forms is the expression of the inner vibrations of his soul. This motion should arouse in us the same mood that was in him. He lent his soul to dead matter so that it could communicate itself to us." Johann Gottlieb Fichte, "On the Spirit and the Letter in Philosophy," in *German Aesthetic and Literary Criticism*, ed. David Simpson (Cambridge: Cambridge University Press, 1984), 90.

118. Symonds, *Principles of Beauty*, 32.

119. Thomas Laycock, "Further Researches into the Functions of the Brain," *British and Foreign Medico-Chirurgical Review, or Quarterly Journal of Practical Medicine and Surgery* 16, no. 31 (July 1855), 120.

120. Laycock, "Further Researches," 120. On the problems posed by mental science for scientific naturalism, see Lorraine Daston, "Theory of Will Versus the Science of Mind," in *The Problematic Science: Psychology in Nineteenth-*

Century Thought, ed. William R. Woodward and Mitchell G. Ash (New York: Praeger, 1982), 88–115.

121. Laycock, "Further Researches," 130.

122. A history of psychiatry explains the term as referring "to whatever was the material that constituted the central nervous system." G. E. Berrios, *The History of Mental Symptoms: Descriptive Psychopathology Since the Nineteenth Century* (Cambridge: Cambridge University Press, 1996), 155.

123. Laycock, "Further Researches," 132.

124. Ibid., 141.

125. On the accusations of materialism to which Carpenter's physiological account of the mind was subject, see Alison Winter, "The Construction of Orthodoxies and Heterodoxies in the Early Victorian Life Sciences," in *Victorian Science in Context*, ed. Bernard V. Lightman (Chicago: University of Chicago Press, 1997), 35–43. James Secord has also examined the publication context of Carpenter's work, noting that Carpenter's physiological writing, like many works on the science of life, intentionally minimized its possible associations with both atheistic materialism and evolutionary theory. See James A. Secord, *Victorian Sensation: The Extraordinary Publication, Reception, and Secret Authorship of Vestiges of the Natural History of Creation* (Chicago: University of Chicago Press, 2000), 63–67. On Carpenter's distancing of his theory from phrenology, see Roger Luckhurst, *The Invention of Telepathy, 1870–1901* (Oxford: Oxford University Press, 2002), 32–50.

126. William Benjamin Carpenter, *Principles of Human Physiology* (Philadelphia: Blanchard & Lea, 1859), 588–89.

127. Ibid., 587.

128. Ibid., 589.

129. Laycock, Thomas, *Mind and Brain; or, The Correlations of Consciousness and Organisation* (Edinburgh: Sutherland & Knox, 1860), 2:466. Laycock writes that at a meeting, Carpenter "fully acknowledged that not only the doctrine of cerebral unconscious (or reflex) action was due to Dr Laycock . . . , but also its applications to insanity, dreaming, delirium, somnambulism, hypnotism, electrobiology, reverie, &c." Ibid., 2:480.

130. On Carpenter's influence on Eliot, see Sally Shuttleworth, *Charlotte Brontë and Victorian Psychology* (Cambridge: Cambridge University Press, 1996), 75–76. Jill Matus addresses Carpenter's theories of will and the unconscious in readings of Gaskell and Dickens in *Shock, Memory and the Unconscious in Victorian Fiction* (Cambridge: Cambridge University Press, 2011), 69–79 and 89–104. Vanessa Ryan discusses Carpenter's importance to Wilkie Collins in *Thinking without Thinking in the Victorian Novel* (Baltimore: Johns Hopkins University Press, 2012), 30–47, 78–112.

131. Carpenter, *Principles*, 586. Carpenter refers to Coleridge's propensity to speak at length on loosely related topics; the account Carpenter uses as evidence of this conversational "unconscious cerebration" is Thomas Carlyle, *The Life of John Sterling* (London: Chapman & Hall, 1851), 54–58.

132. Carpenter, *Principles*, 586.

133. Ibid., 587.

134. Ibid.

135. Laycock, "Further Researches," 136.

136. Leys argues that while proponents of the reflex concept in Britain often directly objected to principles of natural theology, they were also careful to avoid implications of mechanistic materialism. See Ruth Leys, *From Sympathy to Reflex: Marshall Hall and His Opponents* (New York: Garland, 1990), 317–333.

137. In November 1856, Laycock argued before the Aesthetic Club "that in various animals there are fixed in the organisation of the nerve-centres, that such conditions may be super-induced giving rise to habits and associations of ideas. In this case pleasure is also felt, when stimuli appropriate to these conditions reach them. In applying these views to the abstract sense of the beautiful he showed that there are fixed conditions corresponding to those of the instincts in virtue of which, when present, the contemplation of the beautiful, necessarily excites an intuitive perception of the beautiful." "Minute Book."

138. Georg Wilhelm Friedrich Hegel, *Aesthetics: Lectures on Fine Art* (Oxford: Clarendon, 1988), 89.

139. Symonds, *Principles of Beauty*, 32.

140. Thomas Laycock. "Aesthetic Representative Faculties," Thomas Laycock Papers, Shelfmark LAT/1/55, Royal College of Physicians of Edinburgh.

141. Laycock, *Mind and Brain*, 2:65.

142. Laycock, "Aesthetic Representative Faculties."

143. Goodsir, *Anatomical Memoirs*, 143.

144. Gowan Dawson, "Literary Megatheriums and Loose Baggy Monsters: Paleontology and the Victorian Novel," *Victorian Studies* 53, no. 2 (2011), 209. Adela Pinch, *Thinking about Other People in Nineteenth-Century British Writing* (Cambridge: Cambridge University Press, 2010), 79–87. Nicholas Dames, *The Physiology of the Novel: Reading, Neural Science, and the Form of Victorian Fiction* (Oxford: Oxford University Press, 2007), 57–58.

145. G. C. Boase, "Dallas, Eneas Sweetland (1828–1879)," rev. Roger T. Stearn, *Oxford Dictionary of National Biography* (Oxford: Oxford University Press, 2004). Nicholas Rand, "The Hidden Soul: The Growth of the Unconscious in Philosophy, Psychology, Medicine, and Literature, 1750–1900," *American Imago* 61, no. 3 (Fall 2004), 283. Winifred Hughes, "E. S. Dallas: Victorian Poetics in Translation," *Victorian Poetry* 23, no. 1 (Spring 1985), 7.

146. E. S Dallas, *Poetics* (London: Smith, Elder, 1852), 3; E. S. Dallas, *The Gay Science* (London: Chapman and Hall, 1866), 1:53.

147. Dallas, *Gay Science*, 1:53–54.

148. Ibid., 1:61.

149. Dallas, *Poetics*, 17.

150. Hughes, "E. S. Dallas," 3.

151. Dallas, *Poetics*, 44.

152. Dallas, *Gay Science*, 1:11.

153. Ibid., 1:54.

154. Ibid., 1:57.

155. Ibid., 2:3.

156. Ibid., 1:89.

157. In this, Dallas foreshadowed some of the arguments that aesthetes would later make; Oscar Wilde's early lecture "The English Renaissance in Art"

likewise valued art as an escape from thought: "This restless modern intellectual spirit of ours is not receptive enough of the sensuous element of art. . . . Only a few, escaping from the tyranny of the soul, have learned the secret of those high hours when thought is not." Oscar Wilde, *Miscellanies*, ed. Robert Baldwin Ross (London: Methuen, 1908), 260.

158. Dallas, *Gay Science*, 1:201. Dallas uses the same example as Carpenter did in his account of unconscious cerebration, quoting several times Mozart's observation that "I write because I cannot help it." Ibid., 1:229.

159. Ibid., 1:242, 1:243.

160. Ibid., 1:316.

161. "The Gay Science," *Blackwood's Edinburgh Magazine* 101 (February 1867), 155.

162. Ibid.

163. "Mr. Dallas on Scientific Criticism," *Spectator* 2030 (May 25, 1887): 584. A similar point is made in "The Gay Science: The Science of Criticism," *Bentley's Miscellany* 61 (1867): 187–95.

164. "Mr. Dallas," 585.

165. "The Gay Science," *London Quarterly Review* 28 (April 1867), 149.

166. "Mr. Dallas," 585.

167. Ibid., 584, 585.

168. Ibid., 585.

169. "Gay Science," *London Quarterly Review* 28 (April 1867), 155.

170. Douglas Mao, *Fateful Beauty: Aesthetic Environments, Juvenile Development, and Literature 1860–1960* (Princeton, NJ: Princeton University Press, 2008), 65.

171. William James, "What Is an Emotion?," *Mind* 9, no. 34 (April 1884), 194.

172. Charles Altieri, *The Particulars of Rapture: An Aesthetics of the Affects* (Ithaca, NY: Cornell University Press, 2003), 7. Brian Massumi, *Parables for the Virtual: Movement, Affect, Sensation* (Durham, NC: Duke University Press, 2002), 28.

173. Teresa Brennan, *The Transmission of Affect* (Ithaca, NY: Cornell University Press, 2004), 1. For an overview of work on affect and atmospheres, see Ben Anderson, "Affective Atmospheres," in *Encountering Affect: Capacities, Apparatuses, Conditions* (Farnham, UK: Ashgate, 2014), 137–61.

CHAPTER 2

1. Grant Allen, *Physiological Aesthetics* (London: Henry S. King, 1877), 258.

2. Ibid., 257.

3. Ibid.

4. Ibid., 224, 223.

5. Ibid., 217.

6. John Ruskin, *Modern Painters*, vols. 3–7 of *The Works of John Ruskin*, ed. E. T. Cook and Alexander Wedderburn (London: George Allen, 1903), 3:109.

7. Allen, *Physiological Aesthetics*, vii.

8. *Harvard University Catalogue* (Cambridge, MA: Harvard University, 1892), 84. William James, "Allen's Physiological Aesthetics," *Nation* 25, no. 638 (September 1877): 185–86. On Santayana, see Barbara Larson, "Introduction," in *Darwin and Theories of Aesthetics and Cultural History*, ed. Barbara Larson and Sabine Flach (Farnham, UK: Ashgate, 2013), 6.

9. C. K. Ogden, I. A. Richards, and James Wood, *The Foundations of Aesthetics* (London: George Allen & Unwin, 1922), 42.

10. John Addington Symonds, *The Principles of Beauty* (London: Bell & Daldy, 1857), 31. Thomas Laycock, "Further Researches into the Functions of the Brain," *British and Foreign Medico-Chirurgical Review, or Quarterly Journal of Practical Medicine and Surgery* 16, no. 31 (July 1855): 130.

11. Jonathan Crary, *Suspensions of Perception: Attention, Spectacle, and Modern Culture* (Cambridge, MA: MIT Press, 2001), 174. Martha Ward, *Pissarro, Neo-Impressionism, and the Spaces of the Avant-Garde* (Chicago: University of Chicago Press, 1996), 128. See also José Argüelles, *Charles Henry and the Formation of a Psychophysical Aesthetic* (Chicago: University of Chicago Press, 1972).

12. "Deep time" is a metaphor borrowed from geology and popularized by Stephen Jay Gould, *Time's Arrow, Time's Cycle: Myth and Metaphor in the Discovery of Geological Time* (Cambridge, MA: Harvard University Press, 1987). My use of the term in this chapter follows from Daniel Lord Smail's challenge to the temporal limitation of academic history as a "human contrivance" as well as from Noah Heringman's recent discussion of the "metaphorical legacy" of deep, geological time. Daniel Lord Smail, *On Deep History and the Brain* (Berkeley: University of California Press, 2008), 15. Noah Heringman, "Deep Time at the Dawn of the Anthropocene," *Representations* 129, no. 1 (Winter 2015), 59.

13. Recent studies of Darwin and visual culture include Barbara Larson and Sabine Flach, *Darwin and Theories of Aesthetics and Cultural History* (Farnham, UK: Ashgate, 2013); Barbara Larson and Fae Brauer, eds., *The Art of Evolution: Darwin, Darwinisms, and Visual Culture* (Hanover, NH: Dartmouth College Press, 2009); Phillip Prodger, *Darwin's Camera: Art and Photography in the Theory of Evolution* (Oxford: Oxford University Press, 2009); Jonathan Smith, *Charles Darwin and Victorian Visual Culture* (Cambridge: Cambridge University Press, 2006); and Diana Donald and Jane Munro, eds., *Endless Forms: Charles Darwin, Natural Science and the Visual Arts* (New Haven, CT: Yale University Press, 2009). Relevant work on Ruskin has focused on his vexed relationships with both Darwin and John Tyndall. On Darwin and Ruskin, in addition to Smith, see George Levine, *Realism, Ethics and Secularism* (Cambridge: Cambridge University Press, 2008), 75–99. For an overview of work on Ruskin's relation to science and a reading of Ruskin's distinctive understanding of materiality, see Mark Frost, " 'The Circles of Vitality': Ruskin, Science, and Dynamic Materiality," *Victorian Literature and Culture* 39, no. 2 (2011): 367–83; Edward Alexander, "Ruskin and Science," *Modern Language Review* 64, no. 3 (July 1969); and Paul L. Sawyer, "Ruskin and Tyndall: The Poetry of Matter and the Poetry of Spirit," *Annals of the New York Academy of Sciences* 360, no. 1 (April 1981): 217–46. On Helmholtz's aesthetics and his British

reception, see Benjamin Steege, *Helmholtz and the Modern Listener* (Cambridge: Cambridge University Press, 2012), 193–205; Gary Hatfield, "Helmholtz and Classicism: The Science of Aesthetics and the Aesthetics of Science," in *Hermann von Helmholtz and the Foundations of Nineteenth-Century Science*, ed. David Cahan (Berkeley: University of California Press, 1994), 522–58; and John M. Picker, *Victorian Soundscapes* (New York: Oxford University Press, 2003), 84–99.

14. I discuss *Mind* in chap. 3. Recent work in the history of science has advocated for greater attention to Spencer; this argument is outlined in the essays in Mark Francis and Michael W. Taylor, eds., *Herbert Spencer: Legacies* (New York: Routledge, 2015).

15. Georg Wilhelm Friedrich Hegel, *Aesthetics: Lectures on Fine Art* (Oxford: Clarendon, 1988), 36–37.

16. Hegel, *Aesthetics*, 36–37.

17. L. S. Jacyna, "The Physiology of Mind, the Unity of Nature, and the Moral Order in Victorian Thought," *British Journal for the History of Science* 14, no. 02 (July 1981), 111. L. S. Hearnshaw observes, for instance that Bain "stands halfway between the mental philosophy of the eighteenth and early nineteenth centuries and the scientific psychology of the twentieth." See L. S. Hearnshaw, *A Short History of British Psychology, 1840–1940* (London: Methuen, 1964). On Bain's associationism, see Malcolm Macmillan, "Nineteenth-Century Inhibitory Theories of Thinking: Bain, Ferrier, Freud (and Phineas Gage)," *History of Psychology* 3, no. 3 (2000): 187–217. Roger Smith situates Bain in a longer series of efforts to render the mind susceptible to the explanatory methods of the natural sciences; see Roger Smith, "The Background of Physiological Psychology in Natural Philosophy," *History of Science* 11, no. 2 (June 1973), 95–96. Gary Hatfield contests the notion that the science of mind was invented in the nineteenth century, instead tracing its origins to Aristotelian theories of the soul in the seventeenth century; see Gary Hatfield, "Remaking the Science of Mind: Psychology as Natural Science," in *Inventing Human Science: Eighteenth-Century Domains*, ed. Christopher Fox, Roy Porter, and Robert Wokler (Berkeley: University of California Press, 1995), 184–231.

18. Lorraine Daston observes that psychophysiologists had to "tread a tightrope between materialism and automatism on the one side and unscientific metaphysics on the other." Lorraine Daston, "British Responses to Psycho-Physiology, 1860–1900," *Isis* 69, no. 2 (June 1978), 194.

19. Thomas M. Dixon, *From Passions to Emotions: The Creation of a Secular Psychological Category* (Cambridge: Cambridge University Press, 2003), 142. Smith observes that physiological psychology was controversial beyond the scientific community because "there was often a lively hint that viewing the mind in its physiological relations somehow shifted the balance against the self and repudiated the self's responsibility. Roger Smith, "The Physiology of the Will: Mind, Body, and Psychology in the Periodical Literature, 1855–1875," in *Science Serialized: Representations of the Sciences in Nineteenth-Century Periodicals*, ed. G. N. Cantor and Sally Shuttleworth (Cambridge, MA: MIT Press, 2004), 88.

20. In his discussion of British aesthetics, Timothy M. Costelloe divides eighteenth-century aesthetics into three thematic categories that also name presuppositions about how the human mind works: "internal sense," "imagination," and "association" theorists. See Timothy M. Costelloe, *The British Aesthetic Tradition: From Shaftesbury to Wittgenstein* (Cambridge University Press, 2013), 6. Costelloe adopts these terms from the *Stanford Encyclopedia of Philosophy*'s article on eighteenth-century aesthetics: James Shelley, "18th Century British Aesthetics," *Stanford Encyclopedia of Philosophy*, Fall 2014, http://plato.stanford .edu/archives/fall2014/entries/aesthetics-18th-british/.

21. Edwin Boring's history of experimental psychology emphasizes that Bain's thought was not entirely original, observing that "he was not a great man, in the sense that . . . Helmholtz or even Wundt was great." Edwin G. Boring, *A History of Experimental Psychology* (New York: Appleton Century, 1929), 226. Bain has recently drawn attention among scholars of Victorian literature and culture for having developed a hybrid associationist and physiological psychology that often provided a working model for literary depictions of character. See Rick Rylance, *Victorian Psychology and British Culture, 1850–1880* (New York: Oxford University Press, 2000); Nicholas Dames, *The Physiology of the Novel: Reading, Neural Science, and the Form of Victorian Fiction*. Oxford. Oxford University Press, 2007; Catherine Gallagher, *The Body Economic: Life, Death, and Sensation in Political Economy and the Victorian Novel* (Princeton, NJ: Princeton University Press, 2006); Christopher Herbert, *Victorian Relativity: Radical Thought and Scientific Discovery* (Chicago: University of Chicago Press, 2001); and Peter Garratt, *Victorian Empiricism: Self, Knowledge, and Reality in Ruskin, Bain, Lewes, Spencer, and George Eliot* (Madison, NJ: Fairleigh Dickinson University Press, 2010), 127–160.

22. See Alexander Bain, *The Senses and the Intellect* (London: John W. Parker & Son, 1855), 295–96. For a detailed account of Bain's logic, see Dixon, *From Passions to Emotions*, 135–79. George Henry Lewes praised Bain's account of volition, discussing it at length; see George Henry Lewes, *The Physiology of Common Life* (Edinburgh: Blackwood, 1859), 2:208–25.

23. Cardno observes that Bain's late claim that "no associating link can be forged, except in the fire of consciousness" conflicts with his earlier, more physicalist associationism, and he concludes that "the *tertium quid* remains so to speak, ambivalent between physical and mental. Association theory with Bain is not finally machine theory." J. A. Cardno, "Bain and Physiological Psychology," *Australian Journal of Psychology* 7, no. 2 (1955), 116.

24. Dixon, *From Passions to Emotions*, 158.

25. Alexander Bain, *The Emotions and the Will* (London: John W. Parker & Son, 1859), 6–7.

26. Bain, *Senses*, 531. Bain discusses the importance of the literary on pages 530–35.

27. Ibid., 571. On contiguity and similarity in relation to the arts, see 536; on the imaginative construction of art, see 599–609.

28. Bain, *Emotions*, 253, 251.

29. Ibid., 267.

30. Ibid., 262.

31. Ibid.

32. Ibid., 263.

33. Ibid., 400.

34. Ibid., 267.

35. Ibid., 269.

36. Jules David Law, *The Rhetoric of Empiricism: Language and Perception: From Locke to I.A. Richards* (Ithaca, NY: Cornell University Press, 1993), 133.

37. Bain, *Emotions*, 6–7.

38. Ibid., 230.

39. John Stuart Mill, "Bain's Psychology," in *The Collected Works of John Stuart Mill*, vol. 11, *Essays on Philosophy and the Classics*, ed. John M. Robson (Toronto: University of Toronto Press, 1978), 363.

40. Mill, "Bain's Psychology," 364.

41. Ibid.

42. Ibid.

43. Bain, *Emotions*, 65–66.

44. Ibid., 264.

45. Ibid.

46. Herbert, *Victorian Relativity*, xiii.

47. On the cultural politics of Bain's psychology, see Rylance, *Victorian Psychology*, 147–202.

48. Martineau's contestation of scientific materialism is described in Abraham Willard Jackson, *James Martineau: A Biography and Study* (Boston: Little, Brown, 1901), 88–106; Joseph Estlin Carpenter, *James Martineau, Theologian and Teacher: A Study of His Life and Thought* (Boston: American Unitarian Association, 1905), 462–472; and Roger Smith, "The Human Significance of Biology: Carpenter, Darwin, and the Vera Causa," in *Nature and the Victorian Imagination* (Berkeley: University of California Press), 229. Martineau's other relevant essays include "The Place of Mind in Nature and Intuition in Man," *Contemporary Review* 14 (1870): 636–44, and "Is There Any 'Axiom of Causality'?," *Contemporary Review* 19 (1872): 606–23.

49. James Martineau, "Cerebral Psychology: Bain," in *Essays, Philosophical and Theological* (New York: Henry Holt, 1883), 254.

50. Rylance, *Victorian Psychology*, 218.

51. Herbert Spencer, "Bain on the Emotions and the Will," in *Essays: Scientific, Political, and Speculative*, 2nd ser. (New York: D. Appleton, 1864), 129.

52. Spencer, "Bain," 131.

53. Wai Chee Dimock, *Through Other Continents: American Literature across Deep Time* (Princeton, NJ: Princeton University Press, 2006), 5.

54. Robert J. Richards, *Darwin and the Emergence of Evolutionary Theories of Mind and Behavior* (Chicago: University of Chicago Press, 1987), 287

55. The most important of Spencer's essays are "The Origin and Function of Music" (1857), "Use and Beauty" (1852), "Gracefulness" (1852), "Personal Beauty" (1854), "The Sources of Architectural Types" (1852), and the chapters "Aestho-physiology" and "Aesthetic Sentiments" in *The Principles of Psychology* (1872 ed.). Although Peter Allan Dale has argued that Spencer's thought involves

a "radical marginalization of art," recent work on Spencer has begun to give a clearer account of his aesthetics. See Peter Allan Dale, *In Pursuit of a Scientific Culture: Science, Art, and Society in the Victorian Age* (Madison: University of Wisconsin Press, 1989), 31, and Mark Francis, *Herbert Spencer and the Invention of Modern Life* (Ithaca, NY: Cornell University Press, 2007), 78–90.

56. Herbert Spencer, *Essays, Scientific, Political, and Speculative* (New York: D. Appleton, 1892), 2:403.

57. Spencer, *Essays*, 2:413.

58. Herbert Spencer, *The Principles of Psychology* (New York: D. Appleton, 1906), 2:647.

59. Ibid., 2:648.

60. Spencer, *Essays*, 2:413.

61. By highlighting this scalar disjuncture, Spencer anticipates recent critiques of literary Darwinism, including that of Jonathan Kramnick, who claims that Darwinian literary critics such as Joseph Carroll, Brian Boyd, and Denis Dutton usually fail to account for literary form as such, tending to instead rehearse supposedly universal plots. Kramnick writes, "In the main, the notion that some property of literary works performed some function for survival gives way to a series of plot summaries: mate selection in Austen, jealousy in Shakespeare, and so forth. If evolutionary psychology is 'relentlessly past oriented,' literary Darwinism is relentlessly *thematic*." Jonathan Kramnick, "Against Literary Darwinism," *Critical Inquiry* 37, no. 2 (Winter 2011), 344.

62. Spencer, *Essays*, 151.

63. Ibid., 157.

64. W. Proudfoot Begg, *The Development of Taste, and Other Studies in Aesthetics* (Glasgow: James Maclehose & Sons, 1887), 2.

65. Ibid., 7, 138.

66. Spencer, *Principles of Psychology*, 2:648.

67. Ibid., 2:630.

68. Ibid., 2:638.

69. Ibid., 2:627.

70. Spencer's theory of aesthetic feeling as an evolutionary adaptation arising from play was debated widely in European psychological aesthetics. Guyau objects that Spencer's theory inordinately expands the domain of the aesthetic; see *Les problèmes de l'esthétique contemporaine* (Paris: Alcan, 1884), 7–14. Sergi's physiology of aesthetic emotion defends Spencer's account against Guyau; see *Dolore e piacere: storia naturale dei sentimenti* (Milano: Dumolard, 1894), 273–76. Groos praises Spencer for having set Schiller's theory on scientific footing, but objects to the centrality of imitation for Spencer; see *The Play of Man*, trans. Elizabeth L. Baldwin (New York: Appleton, 1913), 362–63.

71. Immanuel Kant, *Critique of the Power of Judgment*, trans. Paul Guyer (Cambridge: Cambridge University Press, 2000), 102, 103

72. Ibid., 26.

73. Friedrich Schiller, *On the Aesthetic Education of Man, in a Series of Letters*, ed. and trans. Elizabeth M. Wilkinson and L. A. Willoughby (Oxford: Clarendon, 1967), 99.

74. Ibid., 107.

75. Ibid., 206 (translation modified).

76. Ibid., 207.

77. Ibid., 214 (translation modified).

78. Paul de Man, "Aesthetic Formalization: Kleist's 'Über das Marionetten-theater,'" in *The Rhetoric of Romanticism* (New York: Columbia University Press, 1984), 263–90. In "Kant and Schiller," a 1983 lecture, de Man discusses Schiller's "aesthetic state, which is the political order that would follow, as a result of that [aesthetic] education, and which would be the political institution resulting from such a conception." See Paul de Man, "Kant and Schiller," in *Aesthetic Ideology*, ed. Andrzej Warminski (Minneapolis: University of Minnesota Press, 1996), 147–55.

79. de Man, "Aesthetic Formalization," 264.

80. Ibid., 265.

81. Jacques Rancière, *Dissensus: On Politics and Aesthetics*, ed. and trans. Steven Corcoran (London: Continuum, 2010), 118.

82. Ibid., 119.

83. Ibid.

84. See Jonathan Freedman, *Professions of Taste: Henry James, British Aestheticism, and Commodity Culture* (Stanford, CA: Stanford University Press, 1993). On missionary aestheticism see Diana Maltz, *British Aestheticism and the Urban Working Classes, 1870–1900: Beauty for the People* (Basingstoke, UK: Palgrave Macmillan, 2006).

85. Charles Darwin, *The Descent of Man, and Selection in Relation to Sex* (London: Penguin, 2004), 408. On Darwin's treatment of the aesthetic sensibility of birds, see Helena Cronin, *The Ant and the Peacock: Altruism and Sexual Selection from Darwin to Today* (Cambridge: Cambridge University Press, 1991), 175–82; Smith, *Charles Darwin*, 114–17; and Laurence Shafe, "Why Is the Peacock's Tail So Beautiful?," in *Darwin and Theories of Aesthetics and Cultural History*, ed. Barbara Larson and Sabine Flach (Farnham, UK: Ashgate, 2013), 37–52.

86. Grant Allen, *The Evolutionist at Large* (London: Chatto & Windus, 1881), 143, 156.

87. James Sully, "Animal Music," *Cornhill Magazine* 40 (December 1879): 605–21.

88. See Suzy Anger, *Victorian Interpretation* (Ithaca, NY: Cornell University Press, 2005), 91–94. George Levine also discusses "disinterest" as a stance that unites Pearson and Walter Pater; see George Levine, "The Epistemology of Science and Art: Pearson and Pater," in *Dying to Know: Scientific Epistemology and Narrative in Victorian England* (Chicago: University of Chicago Press, 2002), 244–67.

89. Pearson taught his students that works of art concentrated scientific truths in symbolic form, a point he elaborated in *The Grammar of Science*. See Pearson's 1891 lecture in Egon Sharpe Pearson, *Karl Pearson: An Appreciation of Some Aspects of His Life and Work* (Cambridge: Cambridge University Press, 1938), 132–41, and Karl Pearson, *The Grammar of Science*, 2nd ed. (London: Adam & Charles Black, 1900), 34–36.

90. Pearson, *Grammar of Science*, 34–35.

91. Schreiner's exchange with Pearson involves an extended discussion of what is meant by the term *aesthetic*: Schreiner acknowledges the difficulty of defining the term but takes it to mean any pleasure for its own sake and therefore potentially encompassing a cat's delight in catching a mouse (not in order to eat it) or any nonprocreative aspect of sex. See Olive Schreiner, *Olive Schreiner Letters, Volume 1: 1871–1899*, ed. Richard Rive (Oxford: Oxford University Press, 1988), 85–87.

92. Schreiner, *Olive Schreiner Letters*, 85–95.

93. On this divergence, see Regenia Gagnier's discussion of the "aesthetics of taste or consumption," which includes such divergent figures as Thomas Hardy, Allen, Bain, Spencer, and Vernon Lee and is distinct from three other models of the aesthetic as "ethical," oriented toward "production," or oriented toward "evaluation." Regenia Gagnier, *The Insatiability of Human Wants: Economics and Aesthetics in Market Society* (Chicago: University of Chicago Press, 2000), 123–44.

94. On Allen as a popularizer, see William Greenslade and Terence Rodgers, "Resituating Grant Allen: Writing, Radicalism and Modernity," in *Grant Allen: Literature and Cultural Politics at the Fin de Siècle*, ed. William Greenslade and Terence Rodgers (Aldershot, UK: Ashgate, 2005), 1–22.

95. Richard Le Gallienne, "Grant Allen," *Fortnightly Review* 72 (1899): 1009.

96. Allen writes, "I am not myself an excessive devotee of fine art in any form. But, on the whole, I thought this as gain in attempting the psychological analysis of Aesthetics, because the worshipper of art is liable to bring with him those enthusiastic feelings which are aroused in him by its highest developments." Allen, *Physiological Aesthetics*, ix.

97. Peter Morton describes the genesis of Allen's book in *"The Busiest Man in England": Grant Allen and the Writing Trade, 1875–1900* (New York: Palgrave Macmillan, 2005).

98. For a discussion of Allen's imagined audience as well as his relation to Darwin, see Jonathan Smith, "Grant Allen, Physiological Aesthetics, and the Dissemination of Darwin's Botany," in *Science Serialized: Representations of the Sciences in Nineteenth-Century Periodicals*, ed. G. N. Cantor and Sally Shuttleworth (Cambridge, MA: MIT Press, 2004), 285–305. Allen discusses the book's origins in "Physiological Aesthetics and Philistia," in *My First Book* (London: Chatto & Windus, 1897). On Allen's relation to Ruskin, see Rachel Teukolsky, *The Literate Eye: Victorian Art Writing and Modernist Aesthetics* (Oxford: Oxford University Press, 2009), 163.

99. Allen, *Physiological Aesthetics*, viii, 2.

100. Ibid., 34.

101. Ibid.

102. Ibid., 168–70.

103. Ibid., 113.

104. Ibid., 247.

105. Ibid., 248.

106. Ibid., 250.

107. Ibid.

108. Ibid., 34, 169, 113, 116.

109. Grant Allen, "Aesthetic Evolution in Man," *Mind* 5, no. 20 (October 1880): 446. In a later essay, Allen used this narrative of aesthetic development to celebrate sexual instincts; see Grant Allen, "The New Hedonism," *Fortnightly Review* 55, no. 327 (March 1894): 377–92.

110. For a succinct account of Allen's theory of aesthetic evolution, see Annette Kern-Stähler, "Homer on the Evolutionary Scale: Interrelations between Biology and Literature in the Writings of William Gladstone and Grant Allen," in *Unmapped Countries: Biological Visions in Nineteenth Century Literature and Culture*, ed. Anne-Julia Zwierlein (London: Anthem, 2005), 107–15.

111. Allen, *Physiological Aesthetics*, 159.

112. John Ruskin, *The Stones of Venice* vols. 9–11 of *The Works of John Ruskin*, ed. E. T. Cook and Alexander Wedderburn (London: George Allen, 1904), 10:193.

113. Jonah Siegel, *Desire and Excess: The Nineteenth-Century Culture of Art* (Princeton, NJ: Princeton University Press, 2000), 216. Allen MacDuffie has recently read this passage as revealing not economic relations but the "living world of energy transformation." See Allen MacDuffie, *Victorian Literature, Energy, and the Ecological Imagination* (Cambridge: Cambridge University Press, 2014), 143.

114. Allen, *Physiological Aesthetics*, 159.

115. Grant Allen, *The Colour-Sense: Its Origin and Development* (London: Trübner, 1879), 6.

116. Bernard Lightman, *Victorian Popularizers of Science: Designing Nature for New Audiences* (Chicago: University of Chicago Press, 2007), 220.

117. Allen, *Physiological Aesthetics*, viii. Walter Pater, *The Renaissance: Studies in Art and Poetry: The 1893 Text*, ed. Donald L. Hill (Berkeley: University of California Press, 1980), ix, x.

118. Pater, *Renaissance*, xi, x.

119. Ibid., xiii.

120. John Morley, "Mr. Pater's Essays," *Fortnightly* 19 (April 1873), 473.

121. See Maureen Moran, "Walter Pater's House Beautiful and the Psychology of Self-Culture." *English Literature in Transition, 1880–1920* 50, no. 3 (2007): 291–312, and Matthew Beaumont, "Pater as Psychagogue: Psychology, Aesthetics, Rhetoric," *19: Interdisciplinary Studies in the Long Nineteenth Century*, no. 12 (2011), http://www.19.bbk.ac.uk/articles/10.16995/ntn.592/. George Levine sees Pater's scientific rhetoric as part of his resistance to metaphysics: "The resort to the language of science [in the "Conclusion"] is neither accidental nor gratuitous. That language, too, eschews metaphysics and at the same time implies a mode of knowledge not merely relativist." Levine, *Dying to Know*, 266.

122. Pater, *Renaissance*, 246, 247.

123. I. C. Small, "The Vocabulary of Pater's Criticism and the Psychology of Aesthetics," *British Journal of Aesthetics* 18, no. 1 (1978), 82, 83.

124. Jeffrey Wallen, "Physiology, Mesmerism, and Walter Pater's 'Susceptibilities to Influence,'" in *Walter Pater: Transparencies of Desire*, ed. Laurel Brake, Leslie Higgins, and Carolyn Williams (Greensboro, NC: ELT), 83.

125. Pater, *Renaissance*, 252.

126. Ibid., 53.

127. See Linda Dowling, *Hellenism and Homosexuality in Victorian Oxford* (Ithaca, NY: Cornell University Press, 1996). On the radical and dissident aspects of aestheticism's turn to ancient Greece, see Stefano-Maria Evangelista, *British Aestheticism and Ancient Greece: Hellenism, Reception, Gods in Exile* (Basingstoke, UK: Palgrave Macmillan, 2009).

128. Pater, *Renaissance*, 2.

129. Ibid., 20.

130. Ibid.

131. Ibid., 15.

132. Ibid., 193.

133. Ibid., 20.

134. Ibid., 154.

135. Jesse Matz, *Literary Impressionism and Modernist Aesthetics* (Cambridge: Cambridge University Press, 2001), 53. On Pater's impressionism and connections to modernism, see also Carolyn Williams, "Walter Pater's Impressionism," in *Knowing the Past*, ed. Suzy Anger (Ithaca, NY: Cornell University Press, 2001), 77–99; Wolfgang Iser, *Walter Pater: The Aesthetic Moment*, trans. David H. Wilson (Cambridge: Cambridge University Press, 1987), 36–46; F. C. McGrath, *The Sensible Spirit: Walter Pater and the Modernist Paradigm* (Tampa: University Presses of Florida, 1986), 55–56; and Adam Parkes, *A Sense of Shock: The Impact of Impressionism on Modern British and Irish Writing* (Oxford: Oxford University Press, 2011), 45–76.

136. Gagnier, *Insatiability*, 139.

137. Suzanne Keen, *Thomas Hardy's Brains: Psychology, Neurology, and Hardy's Imagination* (Columbus: Ohio State University Press, 2014), 6. Another study of Hardy's relationship to psychology is Lennart A. Björk, *Psychological Vision and Social Criticism in the Novels of Thomas Hardy* (Stockholm: Almqvist & Wiksell, 1987). Anna Henchman explores Hardy's engagements with optical science and astronomy and suggests that "Hardy uses the tensions between what we see and what we know in astronomy to create a system of relations between characters" in *The Starry Sky Within: Astronomy and the Reach of the Mind in Victorian Literature.* (Oxford: Oxford University Press, 2014), 130. On Hardy and Darwin, see George Levine, "Hardy and Darwin: An Enchanting Hardy?," in *A Companion to Thomas Hardy*, ed. Keith Wilson (Malden, MA: Wiley-Blackwell, 2010), 36–53, and Caroline Sumpter, "On Suffering and Sympathy: Jude the Obscure, Evolution, and Ethics," *Victorian Studies* 53, no. 4 (2011): 665–87. Two earlier studies of Hardy offer important accounts of his engagement with Darwin, Spencer, Huxley, and Maudsley: William R. Rutland, "The Background to Hardy's Thought," in *Thomas Hardy: A Study of His Writings and Their Background* (New York: Russell & Russell, 1962); and Perry Meisel, *Thomas Hardy: The Return of the Repressed* (New Haven, CT: Yale University Press, 1972).

138. George Levine discusses the relationship between Hardy's "remarkable powers of sensuous responsiveness" and social and political structures in "Shaping Hardy's Art: Vision, Class, and Sex," in *The Columbia History of the British Novel*, ed. John J. Richetti (New York: Columbia University Press, 1994), 533.

139. Elaine Scarry, *Dreaming by the Book* (New York: Farrar, Straus & Giroux, 1999), 7.

140. Ibid., 28.

141. Thomas Hardy, *The Return of the Native* (Oxford: Oxford University Press, 2008), 66.

142. Havelock Ellis, "Thomas Hardy's Novels," *Westminster Review* 119 (April 1883), 358–59.

143. Hardy, *Return of the Native*, 116, 323. For a detailed account of Hardy's relationship to the sensation novel, see Richard Nemesvari, *Thomas Hardy, Sensationalism, and the Melodramatic Mode* (New York: Palgrave Macmillan, 2011), 10–48.

144. Thomas Hardy, *Tess of the d'Urbervilles* (New York: Oxford University Press, 1998), 166; *The Woodlanders* (Oxford: Oxford University Press, 2005), 249. These descriptive tendencies are not uncommon in Hardy's fiction or in late-Victorian realism more generally. On cerebral localization and fiction, see Anne Stiles, *Popular Fiction and Brain Science in the Late-Nineteenth Century* (New York: Cambridge University Press, 2012).

145. Tess and her surroundings tend to be similarly indistinct; as Hardy writes at one moment, Tess's mind blends with her environment: "Her hopes mingled with an ideal photosphere which surrounded her." Hardy, *Tess*, 119.

146. Thomas Hardy, *A Pair of Blue Eyes* (Oxford: Oxford University Press, 2009), 202.

147. "A Pair of Blue Eyes," *Saturday Review* 36 (August 2, 1873), 159.

148. Thomas Hardy, *Desperate Remedies* (Oxford: Oxford University Press, 2009), 47, 53.

149. Elaine Scarry, "Imagining Flowers: Perceptual Mimesis (Particularly Delphinium)," *Representations*, no. 57 (January 1997), 98. Ruth Yeazell recently makes a similar argument about Hardy's style, comparing it with the "precise transcription of detail" in Dutch painting. See Ruth Bernard Yeazell, *Art of the Everyday: Dutch Painting and the Realist Novel* (Princeton, NJ: Princeton University Press, 2008), 8–9 and 125–61.

150. It is important to note that "scenic" and "pictorial" are metaphors that tend to emphasize visual perception; Hardy is often interested in multimodal perception. See David James, "Hearing Hardy: Soundscapes and the Profitable Reader," *Journal of Narrative Theory* 40, no. 2 (2010): 131–55.

151. James Krasner, *The Entangled Eye: Visual Perception and the Representation of Nature in Post-Darwinian Narrative* (New York: Oxford University Press, 1992), 107.

152. Thomas Hardy, *The Literary Notebooks of Thomas Hardy*, ed. Lennart A. Björk (New York: New York University Press, 1985), 63.

153. On scientific thought in Hardy's notebooks, see Pamela Gossin, *Thomas Hardy's Novel Universe: Astronomy, Cosmology, and Gender in the Post-Darwinian World* (Aldershot, UK: Ashgate, 2007), 45–55.

154. Hardy, *Literary Notebooks*, 108.

155. On the relationship between Hardy and Head, see L. S. Jacyna, *Medicine and Modernism: A Biography of Sir Henry Head* (London: Pickering & Chatto, 2008), 264–65.

156. Ruskin, *Modern Painters*, 5:204.

157. Hardy, *Return of the Native*, 4, 3. During the years he was writing *Return of the Native*, Hardy described in his notebooks a new conception of art: "So, then, if Nature's defects must be looked in the face and transcribed, whence arises the *art* in poetry and novel-writing? which must certainly show art. . . . I think the art lies in making these defects the basis of a hitherto unperceived beauty, by irradiating them with 'the light that never was' on their surface." Florence Emily Hardy, *The Early Life of Thomas Hardy, 1840–1891* (Cambridge: Cambridge University Press, 2011), 151.

158. Hardy, *Return of the Native*, 4, 5.

159. Hardy uses "beauty in ugliness" in *Early Life*, 158. On Hardy's aesthetic of "beauty in ugliness," see J. B. Bullen, *The Expressive Eye: Fiction and Perception in the Work of Thomas Hardy* (Oxford: Clarendon, 1986), 88–97. Gillian Beer's essay "Can the Native Return?" reads multimodal perception in relation to the heath; Beer notes that Hardy "makes the ear attentive to the particular character of the heath, and builds a landscape derived not from eye alone but from all the senses, and above all from sound and touch." Gillian Beer, *Open Fields: Science in Cultural Encounter* (Oxford University Press, 1999), 48. Hardy himself states that the "beauty of association is entirely superior to the beauty of aspect": a "battered tankard" can often be more beautiful than a Greek vase. Hardy, *Early Life*, 158.

160. Hardy, *Return of the Native*, 140.

161. In his reading of "faciality" in Hardy, William Cohen discerns in this moment both a subtle reference to Herbert Spencer's biology and an anticipation of Deleuze for its emphasis on the way that the face registers the "material qualities of the interior." William A. Cohen, *Embodied: Victorian Literature and the Senses* (Minneapolis: University of Minnesota Press, 2009), 93.

162. Elaine Scarry, *Resisting Representation* (New York: Oxford University Press, 1994), 51.

163. Pater, *Renaissance*, 186.

164. Ibid., 190.

165. Ruskin writes, "I wholly deny that the impressions of beauty are in any way sensual; they are neither sensual nor intellectual, but moral: and for the faculty receiving them, whose difference from mere perception I shall immediately endeavour to explain, no term can be more accurate or convenient than that employed by the Greeks, 'Theoretic.'" John Ruskin, *Modern Painters*, 4:42. Matthew Arnold, *Culture and Anarchy and Other Writings*, ed. Stefan Collini (Cambridge: Cambridge University Press, 1993), 37.

166. Jacyna, "Physiology of Mind," 111.

167. Nigel Thrift, for instance, describes his work on precognitive "intelligencing" as a development of "the 'superorganismal' idea that organisms are integral with the world outside them," which originates with Arthur Tansley and Albert North Whitehead; this process philosophy can equally be said to develop from Spencer's psychology. Nigel Thrift, *Non-Representational Theory: Space, Politics, Affect* (London: Routledge, 2008), 154. William James has been central to theories of affect as noncognitive thought. See Brian Massumi, *Parables for the Virtual: Movement, Affect, Sensation* (Durham, NC: Duke University Press,

2002), 208–56. Whitehead, Bergson, and James are frequent points of reference within William Connolly's conception of self-organizing processes and becoming; see William E. Connolly, *The Fragility of Things: Self-Organizing Processes, Neoliberal Fantasies, and Democratic Activism* (Durham, NC: Duke University Press, 2013), 29, 107.

168. Gilles Deleuze and Félix Guattari, *What Is Philosophy?* (London: Verso, 1994), 198, 164.

169. Deleuze and Guattari, 172.

170. Ibid., 168–69.

171. Simon O'Sullivan takes Deleuze and Guattari to be articulating a strongly materialized account of art: "Art, whether we will it or not, continues producing *affects* Affects can be described as extra-discursive and extra-textual. Affects are moments of *intensity*, a reaction in/on the body at the level of matter. We might even say that affects are *immanent* to matter." Simon O'Sullivan, "The Aesthetics of Affect: Thinking Art beyond Representation," *Angelaki* 6, no. 3 (December 2001), 126. In a reading of Deleuze's related work on Bacon, Jacques Rancière discerns the political dimension of Deleuze's notion of "figurative givens," the world of visual clichés that constrain the artist's sight, reading them as "the meaningful sensory-motor delimitation of the perceptual world as the human animal organizes it when it makes itself the center of the world. . . . [They] are also the delimitation of the visible, of the meaningful, of the credible, such as empires organize them. . . . The task of art is to undo the world of figuration or of doxa." Jacques Rancière, "Is There a Deleuzian Aesthetics?," trans. Radmila Djordjevic, *Qui Parle* 14, no. 2 (April 2004), 6.

172. Grosz's asks, "Are animals artistic? Certainly, if by that we understand that they intensify sensation (including the sensations of their human observers), that they enjoy this intensification, and that it entails a provisional stability such as the constitution of a territory implies. This animal-intensification is artistic even if it is not yet composed, not yet art (it is refrain-like): and, further, it provides the marks, the emblems, the very qualities by which a composed art becomes possible. Art is of the animal precisely to the degree that sexuality is artistic." Elizabeth A. Grosz, *Chaos, Territory, Art: Deleuze and the Framing of the Earth* (New York: Columbia University Press, 2008), 69–70.

173. Elizabeth A. Grosz, *Becoming Undone: Darwinian Reflections on Life, Politics, and Art* (Durham, NC: Duke University Press, 2011), 186.

174. Crary, *Suspensions of Perception*, 174.

175. Deleuze and Guattari, *What Is Philosophy?*, 163.

CHAPTER 3

1. Walter Pater, *Marius the Epicurean: His Sensations and Ideas* (London: Macmillan, 1885), 1:131.

2. Ibid., 1:132.

3. Ibid., 1:137.

4. Ibid., 1:150, 140.

5. Ibid., 1:139–40.

6. James Sully, "Poetic Imagination and Primitive Conception," *Cornhill Magazine* 34 (September 1876), 295.

7. Ibid., 296.

8. Ibid., 302.

9. Henry James, *The Spoils of Poynton* (New York: Charles Scribner's Sons, 1908), 31.

10. Ibid.

11. Bill Brown, *A Sense of Things: The Object Matter of American Literature* (Chicago: University of Chicago Press, 2003), 146.

12. Sally Shuttleworth, *George Eliot and Nineteenth-Century Science: The Make-Believe of a Beginning* (Cambridge: Cambridge University Press, 1984), 85. Vanessa Ryan, *Thinking without Thinking in the Victorian Novel* (Baltimore: Johns Hopkins University Press, 2012), 10.

13. Catherine Gallagher, *The Body Economic: Life, Death, and Sensation in Political Economy and the Victorian Novel* (Princeton, NJ: Princeton University Press, 2006), 50.

14. Sully, "Poetic Imagination," 297.

15. Constance Naden, *Induction and Deduction: A Historical and Critical Sketch of Successive Philosophical Conceptions Respecting the Relations between Inductive and Deductive Thought and Other Essays* (London: Bickers & Son, 1890), 161–162.

16. John Tyndall, "Address by the President," in *Report of the Forty-Fourth Meeting of the British Association for the Advancement of Science* (London: John Murray, 1875), lxxxix.

17. Douglas Mao, *Fateful Beauty: Aesthetic Environments, Juvenile Development, and Literature 1860–1960* (Princeton, NJ: Princeton University Press, 2008), 65.

18. Amanda Anderson, *The Powers of Distance: Cosmopolitanism and the Cultivation of Detachment* (Princeton, NJ: Princeton University Press, 2001), 153.

19. In *Theory of the Avant-Garde*, Bürger describes a historical process whereby the work of art acquires an increasing level of autonomy from society in tandem with the rise of the bourgeois class. Art originates as something "wholly integrated into the social institution 'religion' " but at the end of the nineteenth century is converted by the *l'art pour l'art* movement into a realm whose "apartness from the praxis of life . . . [is] its content." For Bürger, the "separation of art from the praxis of life becomes the decisive characteristic of the autonomy of bourgeois art." Peter Bürger, *Theory of the Avant-Garde* (Manchester: Manchester University Press, 1984), 47, 48, 49.

20. Julia Prewitt Brown argues that Wilde "transcends Pater's subjectivism . . . so striking was [Wilde's] departure from the solipsistic aestheticism of Pater that Pater himself designated Wilde as Arnold's true successor." Julia Prewitt Brown, *Cosmopolitan Criticism: Oscar Wilde's Philosophy of Art* (Charlottesville: University Press of Virginia, 1997), xvii–xviii.

21. Walter Pater, *The Renaissance: Studies in Art and Poetry: The 1893 Text*, ed. Donald L. Hill (Berkeley: University of California Press, 1980), 186–87.

22. Descola writes, "These [cosmologies] were reputed to be enigmatic and therefore deserving of scholarly attention, given that, in them, the demarcations between human beings and 'natural objects' seemed blurred or even nonexistent. That was a logical scandal that had to be brought to an end. But what was scarcely noticed was the fact that that frontier was hardly any clearer among ourselves, despite all the epistemological apparatus mobilized to ensure that it was impermeable." Philippe Descola, *Beyond Nature and Culture*, trans. Janet Lloyd (Chicago: University of Chicago Press, 2013), xix.

23. See George Levine, *Dying to Know: Scientific Epistemology and Narrative in Victorian England* (Chicago: University of Chicago Press, 2002), 244–67.

24. Bruno Latour, *Reassembling the Social: An Introduction to Actor-Network-Theory* (Oxford: Oxford University Press, 2005), 72.

25. Henry Mansel, "Sensation Novels," *London Quarterly Review* 113 (April 1863), 251–52. Mansel links sensation fiction to spasmodic poetry; both foregrounded the embodied qualities of forms of cognition more commonly associated with an immaterial mind. Mansel observes, "the sensation novel is the counterpart of the spasmodic poem. . . . The one aims at convulsing the reader, the other professes to owe its birth to the convulsive throes in the soul of the writer" (252).

26. "French Philosophy during the Restoration," *London Quarterly Review* 8 (April 1857), 167. Thomas Henry Huxley, *Collected Essays*, vol. 1, *Methods and Results* (New York: D. Appleton, 1899), 211.

27. "French Philosophy," 211.

28. George Henry Lewes, *Biographical History of Philosophy* (New York: Appleton, 1857), 740–49.

29. See Rachel Teukolsky, "White Girls: Avant-Gardism and Advertising after 1860," *Victorian Studies* 51, no. 3 (2009): 422–37.

30. Alison Winter, *Mesmerized: Powers of Mind in Victorian Britain* (Chicago: University of Chicago Press, 1998), 328, 329. Others make similar observations. Jenny Bourne Taylor writes that "the sensation novel was seen as a collective cultural nervous disorder, a morbid addiction within the middle class that worked directly on the body of the reader." Jenny Bourne Taylor, *In the Secret Theatre of Home: Wilkie Collins, Sensation Narrative, and Nineteenth-Century Psychology* (New York: Routledge, 1988), 4. D. A. Miller observes that it represents "one of the first instances of modern literature to address itself primarily to the sympathetic nervous system, where it grounds its characteristic adrenaline effects." D. A. Miller, "Cage Aux Folles: Sensation and Gender in Wilkie Collins's *The Woman in White*," *Representations*, no. 14 (Spring 1986), 107. Nicholas Daly connects this nervous activity to modernizing conceptions of time: "What the sensation novel was preaching to the nerves was a new time-discipline." Nicolas Daly, *Literature, Technology, and Modernity, 1860–2000* (Cambridge: Cambridge University Press, 2004), 50.

31. An equally important new historicist reading of sensation fiction's ideology similarly depends on discerning how it short-circuits thought: Jonathan Loesberg connects sensation fiction to the parliamentary reform debate of the 1850s and 1860s on the grounds that that sensation fiction creates "emotional evoca-

tion without thematic correlative" in a way that is homologous to the class fear structuring the debate over reform. Jonathan Loesberg, "The Ideology of Narrative Form in Sensation Fiction," *Representations*, no. 13 (Winter 1986), 118.

32. Pamela K. Gilbert, *Disease, Desire, and the Body in Victorian Women's Popular Novels* (Cambridge: Cambridge University Press, 1997), 4.

33. Jane Bennett, *Vibrant Matter: A Political Ecology of Things* (Durham, NC: Duke University Press, 2010), 2.

34. Wilkie Collins, *The Woman in White* (London: Penguin, 2003), 23.

35. Ann Cvetkovich, by contrast, suggests that this moment is related to anxieties of class and sexuality: "Walter becomes the sentient flesh-and-blood creature that he cannot be in the workplace." Ann Cvetkovich, *Mixed Feelings: Feminism, Mass Culture, and Victorian Sensationalism* (New Brunswick, NJ: Rutgers University Press, 1992), 79.

36. A biography recounts that "it has been said of him that 'he was born a Metaphysician.' . . . Before he was old enough to put his thoughts into language, he would lie on the ground . . . , and perplex himself with the question,—'My hand: *my* foot. But what is *me?*" John William Burgon, *Lives of Twelve Good Men* (London: John Murray, 1889), 2:157.

37. M. E. Braddon, *Lady Audley's Secret*, ed. Lyn Pykett (Oxford: Oxford University Press, 2012), 258.

38. Ellen Wood, *East Lynne* (Oxford: Oxford University Press, 2008), 30.

39. Margaret Oliphant, "Novels," *Blackwood's Edinburgh Magazine* 623, no. 102 (September 1867), 259.

40. Lyn Pykett reads Oliphant's review as "an objection to the proliferation of sensuous detail and the detailed representation of physical sensation" and notes that "Braddon's tendency to anatomise the female body was a subject of particular discussion and ridicule." Lyn Pykett, *The "Improper" Feminine: The Women's Sensation Novel and the New Woman Writing* (New York: Routledge, 1992), 35.

41. On the publishing context, see Bernard Lightman, "Scientists as Materialists in the Periodical Press: Tyndall's Belfast Address," in *Science Serialized: Representation of the Sciences in Nineteenth-Century Periodicals*, ed. Sally Shuttleworth and Geoffrey N. Cantor (Cambridge, MA: MIT Press, 2004), 199–238.

42. The Lucretian revival that began in the 1860s is described in Frank M. Turner, *Contesting Cultural Authority: Essays in Victorian Intellectual Life* (Cambridge: Cambridge University Press, 1993), 262–83. See also John Holmes, "Lucretius at the Fin de Siècle: Science, Religion and Poetry," *English Literature in Transition, 1880–1920* 51, no. 3 (2008): 266–80; Norman Vance, *The Victorians and Ancient Rome* (Oxford: Blackwell, 1997), 83–111; and Gowan Dawson, *Darwin, Literature and Victorian Respectability* (Cambridge: Cambridge University Press, 2007), 85–110. Angela Leighton and others have used Lucretius to connect Tennyson's commentary on naturalism to Pater's theory of subjectivity. Angela Leighton, *On Form: Poetry, Aestheticism, and the Legacy of a Word* (Oxford: Oxford University Press, 2007).

43. Henry Hayman, "Mr. Munro's Lucretius," *Contemporary Review* 5 (June 1867), 236.

44. "Mr. Munro's Lucretius," *Spectator* 1919 (April 8, 1865), 389.

45. Fleeming Jenkin, "The Atomic Theory of Lucretius," *North British Review* 48 (March 1868), 120. John Addington Symonds Jr., "Lucretius," *Fortnightly Review* 97 (January 1875), 58.

46. John Holmes, *Darwin's Bards: British and American Poetry in the Age of Evolution* (Edinburgh University Press, 2009), 256.

47. Robert Buchanan, "Lucretius and Modern Materialism," *New Quarterly* 6 (April 1876), 8.

48. The religious and ethical questions were particularly charged. Buchanan argued that materialist "insinuations" against Christianity are "simply absurd and self-refuting," because "religion, rightly understood, is the love of holy service"; Buchanan, "Lucretius and Modern Materialism," 22. John Masson, writing later about Epicurean materialism, identified a second ethical problem: "if the whole world of nature and man is a mechanism in which cause follows cause and motion follows motion in a fixed order from everlasting, we could not possibly have Free-will." John Masson, *The Atomic Theory of Lucretius Contrasted with Modern Doctrines of Atoms and Evolution* (London: George Bell & Sons, 1884), 225–26. Masson argues that the notion of the *clinamen*, "spontaneous movement in the atoms of the soul which alone originates and renders possible the Free-will of man" (65), contradicted the most basic theorem that mechanical force alone is responsible for atomic movement.

49. See Gilles Deleuze, *The Logic of Sense*, ed. Constantin V. Boundas, trans. Mark Lester (New York: Columbia University Press, 1990), 266–279; Michel Serres, *The Birth of Physics*, trans. Jack Hawkes (Manchester: Clinamen Press, 2000); Jonathan Goldberg, *The Seeds of Things: Theorizing Sexuality and Materiality in Renaissance Representations* (New York: Fordham University Press, 2009); Stephen Greenblatt, *The Swerve: How the World Became Modern* (New York: W. W. Norton, 2011); and Gerard Passannante, *The Lucretian Renaissance: Philology and the Afterlife of Tradition* (Chicago: University of Chicago Press, 2011).

50. William Hurrell Mallock, *The New Republic; or, Culture, Faith, and Philosophy in an English Country House* (London: Chatto & Windus, 1877), 72.

51. See the discussion of Galton and Huxley in Levine, *Dying to Know*, 104–25.

52. W. K. Clifford, "On the Nature of Things-in-Themselves," *Mind* 3, no. 9 (January 1878), 65. On the scientific and political context of Clifford's ideas, see Dawson, *Darwin*, 162–89.

53. Clifford, "Things-in-Themselves," 65.

54. Masson, *Atomic Theory*, 133.

55. Ibid.

56. Tyndall, "Address," lxxv.

57. Ruth Barton, "John Tyndall, Pantheist: A Rereading of the Belfast Address," *Osiris*, 2nd ser., 3 (1987), 134.

58. Tyndall, "Address," lxxxix.

59. Braddon, *Lady Audley's Secret*, 258.

60. Constance Naden, *The Complete Poetical Works of Constance Naden* (London: Bickers & Son, 1894), 328.

61. Charles LaPorte, "Atheist Prophecy: Mathilde Blind, Constance Naden, and the Victorian Poetess," *Victorian Literature and Culture* 34, no. 2 (2006), 437. Discussions of the relationship of science and literature in Naden's work include Marion Thain, " 'Scientific Wooing': Constance Naden's Marriage of Science and Poetry," *Victorian Poetry* 41, no. 1 (Spring 2003): 151–69; Patricia Murphy, *In Science's Shadow: Literary Constructions of Late Victorian Women* (Columbia: University of Missouri Press, 2006), 41–71; and James R. Moore, "The Erotics of Evolution: Constance Naden and Hylo-Idealism," in *One Culture: Essays in Science and Literature*, ed. George Levine (Madison: University of Wisconsin Press, 1987), 225–57.

62. Titus Carus Lucretius, *De rerum natura libri sex*, ed. and trans. Hugh A. J. Munro (Cambridge: Deighton Bell, 1866), 2:33.

63. Naden, *Induction and Deduction*, 166.

64. Galen Strawson argues that if we are made up of particles of matter and we have experience, then it is impossible to prove that particles of matter do not also have experience. On such an account, electrons have some kind of experience: "all physical stuff is energy, in one form or another, and all energy, I trow, is an experience-involving phenomenon. This sounded crazy to me for a long time, but I am quite used to it, now that I know there is no alternative short of 'substance dualism.' . . . Real physicalism, realistic physicalism, entails panpsychism." Galen Strawson, "Realistic Monism: Why Physicalism Entails Panpsychism," in *Real Materialism and Other Essays* (Oxford: Oxford University Press, 2008), 71. David Chalmers and Andy Clark offer a more moderate answer to the question, "where does the mind stop and the rest of the world begin?": on their "extended mind" model, it is not that matter itself might secretly be conscious but that prosthetics such as pen and paper are part of what "mind" is: "Cognitive processes ain't (all) in the head!" they announce. Andy Clark and David Chalmers, "The Extended Mind," *Analysis* 58, no. 1 (January 1998), 7, 8. In *Mind and Cosmos* Thomas Nagel strenuously contests the view that physical sciences in their current form have the tools to explain the human mind: "The existence of consciousness seems to imply that the physical description of the universe, in spite of its richness and explanatory power, is only part of the truth." Thomas Nagel, *Mind and Cosmos: Why the Materialist Neo-Darwinian Conception of Nature Is Almost Certainly False* (New York: Oxford University Press, 2012), 35.

65. Auguste Comte, *The Positive Philosophy of Auguste Comte*, trans. Harriet Martineau (London: John Chapman, 1853), 2.

66. See Peter Melville Logan, *Victorian Fetishism: Intellectuals and Primitives*, SUNY Series, Studies in the Long Nineteenth Century (Albany: State University of New York Press, 2009), 30–33. On the relation of positivism to British psychology see Edward Reed, *From Soul to Mind: The Emergence of Psychology from Erasmus Darwin to William James* (New Haven, CT: Yale University Press, 1997), 144–67.

67. George Henry Lewes, *Problems of Life and Mind*, vol. 1, *The Foundations of a Creed* (Boston: James R. Osgood, 1874), 4.

68. Wilhelm Max Wundt, *Outlines of Psychology*, trans. Charles Hubbard Judd (Leipzig: Wilhelm Engelmann, 1902), 6.

69. Henry Longueville Mansel, *Metaphysics; or, The Philosophy of Consciousness Phenomenal and Real*, 4th ed. (Edinburgh: Adam & Charles Black, 1883), vi.

70. Walter Pater, "Coleridge's Writings," *Westminster Review* 85 (January 1866), 49.

71. Ibid., 60.

72. Walter Pater, "Coleridge," in *Appreciations* (London: Macmillan, 1922), 87.

73. Pater, "Coleridge's Writings," 60.

74. Naden, *Induction and Deduction*, 161.

75. Walter Pater, *Letters of Walter Pater*, ed. Lawrence Evans (Oxford: Clarendon, 1970), 30. Thomas Wright records another of Pater's rare comments on the genre: "I should like . . . my *Imaginary Portraits* to be called, if only they could be, *Prose Idylls*." Thomas Wright, *The Life of Walter Pater* (New York: Putnam, 1907), 2:84.

76. "Armadale," *Saturday Review*, June 16, 1866, 726. Pater, *Letters*, 30.

77. For an argument linking Pater and Collins as figures who inherited romantic sensationalism, see Noel Jackson, *Science and Sensation in Romantic Poetry* (Cambridge: Cambridge University Press, 2011), 197–220.

78. On the publication history and generic status of the portraits, see Lene Østermark-Johansen, "Pater and the Painterly: Imaginary Portraits," *English Literature in Transition, 1880–1920* 56, no. 3 (2013): 343–54.

79. Max Saunders, *Self Impression: Life-Writing, Autobiografiction, and the Forms of Modern Literature* (Oxford: Oxford University Press, 2010), 42. Elisa Bizzotto traces a wide array of genres to which Pater's portraits are indebted, from confessional writing, aestheticist novellas, historical fiction, and nineteenth-century biography. Elisa Bizzotto, "The Imaginary Portrait: Pater's Contribution to a Literary Genre," in *Walter Pater: Transparencies of Desire*, ed. Laurel Brake, Lesley Higgins, and Carolyn Williams (Greensboro, NC: ELT, 2002), 213–223.

80. "Marius the Epicurean, His Sensations and Ideas," *Academy* 672 (March 21, 1885): 198.

81. G. E. Woodbury, "Ideal Aestheticism," *Nation* 1054 (September 10, 1885): 221.

82. Andrew Lang, "Ballade of Railway Novels," *Longman's Magazine* 4 (October 1884): 296.

83. Margaret Oliphant, "Sensation Novels," *Blackwood's Edinburgh Magazine* 91 (May 1862): 568.

84. Quoted in R. M. Seiler, *Walter Pater: The Critical Heritage* (New York: Routledge, 1980), 124.

85. Ibid.

86. Ibid.

87. Cynthia A. Freeland, *Portraits and Persons* (Oxford: Oxford University Press, 2010), 84–88.

88. This concern with the relation of mind and body bears out Lene Østermark-Johansen's suggestion that Pater's portraits are especially concerned with binaries of presence/absence and visible/invisible, especially as manifested

in the persistent presence of a dead person and the use of the term "portrait" to describe a nonvisual medium. See Østermark-Johansen, "Pater and the Painterly," 347–48.

89. Walter Pater, *Imaginary Portraits* (London: Macmillan, 1896), 151.

90. Ibid.

91. Pater, *Letters*, xxix.

92. Walter Pater, *Miscellaneous Studies: A Series of Essays*, ed. Charles Lancelot Shadwell (London: Macmillan, 1895), 173.

93. Carolyn Williams, "Walter Pater's Impressionism," in *Knowing the Past*, ed. Suzy Anger (Ithaca, NY: Cornell University Press, 2001), 87.

94. Accounts of modernism that describe Pater as an origin of literary impressionism include Jesse Matz, *Literary Impressionism and Modernist Aesthetics* (Cambridge: Cambridge University Press, 2001), 53–78, and Tamar Katz, *Impressionist Subjects: Gender, Interiority, and Modernist Fiction in England* (Urbana: University of Illinois Press, 2000), 23–42.

95. Pater, *Miscellaneous Studies*, 152.

96. Ibid., 153.

97. Ibid., 155, 160.

98. Ibid., 187.

99. Ibid.

100. Ibid.

101. Oscar Wilde, "Mr. Pater's Imaginary Portraits," *Pall Mall Gazette* 45, no. 6937 (June 11, 1887): 2.

102. Arthur Symons, "Walter Pater: Imaginary Portraits," *Time* 6, no. 17 (August 1887): 159.

103. Pater, *Imaginary Portraits*, 100.

104. Ibid., 127–28.

105. Ibid., 102.

106. Ibid., 122, 126.

107. Ibid., 126.

108. Ibid., 112, 113.

109. Ibid., 125, 115.

110. Ibid., 97.

111. Pater, *Marius the Epicurean*, 1:142.

112. Ibid.

113. Stuart Hampshire, *Spinoza and Spinozism* (Oxford: Clarendon, 2005), 60. Billie Andrew Inman's treatment of Pater's interpretation of Spinoza (" 'Sebastian van Storck': Pater's Exploration into Nihilism," *Nineteenth-Century Fiction* 30, 4 [1976]: 457–76) is especially insightful; Inman suggests that it stems from Pater's "peculiar habit of assuming that a hard, renunciatory attitude accompanied the tendencies to seek absolute truth" (461).

114. Hans Ulrich Gumbrecht, *Production of Presence: What Meaning Cannot Convey* (Stanford, CA: Stanford University Press, 2004), 98.

115. Thomas M. Dixon, *From Passions to Emotions: The Creation of a Secular Psychological Category* (Cambridge: Cambridge University Press, 2003), 141.

116. On the relation between Fechner's psychophysics and his aesthetics, see Edwin G. Boring, *A History of Experimental Psychology* (New York: Appleton-

Century, 1929), 265–87, and Henri F. Ellenberger, *The Discovery of the Unconscious: The History and Evolution of Dynamic Psychiatry* (New York: Basic Books, 1970), 215–18.

117. Gustav Theodor Fechner, *Vorschule der Aesthetik*, 2 vols. (Leipzig: Breitkopf & Härtel, 1876).

118. James Sully, "Art and Psychology," *Mind* 1, no. 4 (October 1, 1876): 467.

119. Edmund Gurney, *The Power of Sound* (London: Smith, Elder, 1880), vi.

120. James Sully, *My Life and Friends: A Psychologist's Memories* (New York : Dutton, 1918), 100.

121. On Helmholtz's aesthetic theory, see David Cahan, ed., *Hermann von Helmholtz and the Foundations of Nineteenth-Century Science* (Berkeley: University of California Press, 1994).

122. Sully describes the reception of the book in *My Life and Friends*, 147.

123. James Sully, "Aesthetics," in *Encylopaedia Britannica*, 9th ed. (New York: Charles Scribner's Sons, 1878), 1:212, 213.

124. Ibid., 1:222.

125. These studies continue to inform work in neuroaesthetics; see Elvira Brattico and Marcus Pearce, "The Neuroaesthetics of Music," *Psychology of Aesthetics, Creativity, and the Arts* 7, no. 1 (2013): 48–61.

126. On the reception of Helmholtz, see Benjamin Steege, *Helmholtz and the Modern Listener* (Cambridge: Cambridge University Press, 2012), 178–214, and John M. Picker, *Victorian Soundscapes* (New York: Oxford University Press, 2003), 84–99.

127. Sully, "Art and Psychology," 474.

128. Sully, "Poetic Imagination," 296, 297.

129. James Sully, "The Opera," *Contemporary Review* 26 (June 1875): 122.

130. Kate Flint, *The Victorians and the Visual Imagination* (Cambridge: Cambridge University Press, 2000), 251.

131. James Sully, *Sensation and Intuition: Studies in Psychology and Aesthetics* (Kegan Paul, 1880), 249.

132. James Sully, "Review of Physiological Aesthetics, by Grant Allen," *Mind* 2, no. 7 (July 1877), 392.

133. James Sully, "Review of *The Power of Sound*, by Edmund Gurney," *Mind* 6, no. 22 (April 1881), 277.

134. Ibid., 275–76.

135. Sully, *Sensation and Intuition*, 277, 268, 254, 279, 267.

136. James Sully, "George Eliot's Art," *Mind* 6, no. 23 (July 1881), 379.

137. See Vanessa Ryan's insightful reading of this essay, which shows that Sully uses Eliot to think about "the special nature of reading, which made the mind conscious of its own cognitive processes." Ryan, *Thinking without Thinking*, 624. See also Helen Groth's "The Mind as Palimpsest: Art, Dreaming and James Sully's Aesthetics of Latency" and Penelope Hone's "Muted Literary Minds: James Sully, George Eliot and Psychologized Aesthetics in the Nineteenth Century," both in Chris Danta and Helen Groth, eds., *Mindful Aesthetics: Literature and the Science of Mind* (London: Bloomsbury, 2014).

138. In 1883, Pater designated *Marius* as an imaginary portrait when he wrote to Vernon Lee of his "hopes of completing one half of my present chief work—an Imaginary Portrait of a peculiar type of mind in the time of Marcus Aurelius." Pater, *Letters*, 79.

139. George Eliot to John Blackwood, November 5, 1873, in George Eliot, *The George Eliot Letters, Vol. 5: 1869–1873*, ed. Gordon S. Haight (New Haven, CT: Yale University Press, 1954), 455.

140. Carolyn Williams, *Transfigured World: Walter Pater's Aesthetic Historicism* (Ithaca, NY: Cornell University Press, 1989), 23.

141. Walter Pater to Carl Wilhelm Ernst, January 28, 1886, in Pater, *Letters*, 65.

142. T. S. Eliot, "Arnold and Pater," in *Selected Essays* (New York: Harcourt, 1950), 403–4.

143. See Stephen Arata, "The Impersonal Intimacy of Marius the Epicurean," in *The Feeling of Reading: Affective Experience and Victorian Literature*, ed. Rachel Ablow (Ann Arbor: University of Michigan Press, 2010), 131–56.

144. Carolyn Williams, "Pater in the 1880s: Experiments in Genre," *Journal of Pre-Raphaelite Studies* 4 (1983), 39. Gowan Dawson, "Walter Pater's Marius the Epicurean and the Discourse of Science in Macmillan's Magazine. 'A Creature of the Nineteenth Century,'" *English Literature in Transition, 1880–1920* 48, no. 1 (2005), 48. Laurel Brake, *Walter Pater* (Plymouth: Northcote House, 1994), 45.

145. Williams describes this as "a wonderful example of what Paul de Man calls 'specular structure.' In the figure of specularity, two subjects determine each other by mutual reflexive substitution.'" Williams, *Transfigured World*, 187.

146. Maureen Moran and Matthew Beaumont have described Pater's sympathies with the discourse of scientific psychology. See Maureen Moran, "Walter Pater's House Beautiful and the Psychology of Self-Culture," *English Literature in Transition, 1880–1920* 50, no. 3 (2007): 291–312, and Matthew Beaumont, "Pater as Psychagogue: Psychology, Aesthetics, Rhetoric," *19: Interdisciplinary Studies in the Long Nineteenth Century*, no. 12 (2011), http://www.19.bbk.ac.uk/articles/10.16995/ntn.592/.

147. Pater, *Renaissance*, 149, 152.

148. Ibid., 148.

149. Ibid., 125, 127.

150. Pater, *Marius the Epicurean*, 1:132.

151. Ibid., 1:130–31.

152. Ibid., 1:132.

153. Ibid., 1:134.

154. Gerard Manley Hopkins, "That Nature Is Like a Heraclitean Fire and of the Comfort of the Resurrection," in *The Major Works*, ed. Catherine Phillips (Oxford: Oxford University Press, 2009), 181, lines 16–17.

155. Ibid., 5, 7.

156. Ibid., 13, 12, 19.

157. Pater, *Marius*, 1:121, 1:122.

158. Ibid., 1:212.

159. Ibid., 2:72.

160. Ibid., 1:211.

161. For a related argument that what looks like decadent withdrawal is in fact better understood as collective—"decadents do not isolate themselves, but construct a new and more amenable imagined community"—see Matthew Potolsky, *The Decadent Republic of Letters: Taste, Politics, and Cosmopolitan Community from Baudelaire to Beardsley* (Philadelphia: University of Pennsylvania Press, 2013), 6.

162. George Eliot, *Middlemarch* (Oxford: Oxford University Press, 1997) 132. On the relationship between this web and figures of fabric and tissue, see J. Hillis Miller, *Reading for Our Time: Adam Bede and Middlemarch Revisited* (Edinburgh: Edinburgh University Press, 2012), 57–59. On its relation to the imagery of webs in the sciences, see Gillian Beer, *Darwin's Plots: Evolutionary Narrative in Darwin, George Eliot and Nineteenth-Century Fiction*, 3rd ed. (Cambridge: Cambridge University Press, 2009), 156–68.

163. Shuttleworth, *George Eliot*, x. Fredric Jameson describes Eliot's webs as "the space in which we can identify a logic of dereification" insofar as this space reveals that "everything is a part, even when it affirms its individuality against an oppressive whole." Fredric Jameson, *The Antinomies of Realism* (London: Verso, 2013), 121.

164. Pater, *Marius the Epicurean*, 1:211.

165. Laura Otis, *Networking: Communicating with Bodies and Machines in the Nineteenth Century* (Ann Arbor: University of Michigan Press, 2011), 99.

166. Avrom Fleishman observes that the poem was written following visits to Cambridge and Oxford (including an 1870 visit to Oxford at which Eliot dined with Pater and others) and proposes that it can be read as a "philosophical critique of several currents in later Victorian thought." Avrom Fleishman, *George Eliot's Intellectual Life* (Cambridge: Cambridge University Press, 2010), 224.

167. Quoted in Bernard J. Paris, "George Eliot's Unpublished Poetry," *Studies in Philology* 56, no. 3 (July 1959), 544–545. This fragment is not in the published version of "A College Breakfast-Party"; Paris argues that it was originally attributed to the character Rosencranz.

168. There are further similarities to Pater's "Conclusion." Directly following this passage (as Paris positions it), the poem's aesthete, Osric, objects to these metaphysical speculations as lacking "color, form, and breath" and compares them to a butterfly speculating on the possibility of its own nonexistence rather than enjoying its short life by "sipping at the heart of flowers" and "poising in sunshine." George Eliot, *The Poems of George Eliot* (Boston: Little, Brown, and Company, 1900), 2:366.

169. Richard Menke, "Fiction as Vivisection: G. H. Lewes and George Eliot," *ELH* 67, no. 2 (Summer 2000), 645.

170. Latour, *Reassembling the Social*, 71. Bill Brown, "Objects, Others, and Us (The Refabrication of Things)," *Critical Inquiry* 36, no. 2 (Winter 2010), 188.

171. Hopkins, "That Nature," 9. Charles Altieri argues against critics he groups under the rubric of materialism as too ready to frame sensuousness and imagination as incompatible alternatives; in part, he objects to the dismissal of aestheticism and the category of the "literary" as such. See Charles Altieri, "The

Sensuous Dimension of Literary Experience: An Alternative to Materialist Theory," *New Literary History* 38, no. 1 (2007): 71–98.

CHAPTER 4

1. John William Mackail, *The Life of William Morris* (London: Longmans, Green, 1901), 1:52.

2. Ibid., 1:97.

3. Arthur Clutton-Brock, "Morris in the Present," *Times Literary Supplement*, August 8, 1912.

4. G. K. Chesterton, *The Victorian Age in Literature* (New York: Henry Holt, 1913), 198–199.

5. Jerome J. McGann, *Black Riders: The Visible Language of Modernism* (Princeton, NJ: Princeton University Press, 1993), 46, 49.

6. Lionel Trilling, "Aggression and Utopia: A Note on William Morris's 'News from Nowhere,'" *Psychoanalytic Quarterly* 42 (1973), 222. Theodor W. Adorno, *Aesthetic Theory*, ed. Gretel Adorno and Rolf Tiedemann, trans. Robert Hullot-Kentor (Minneapolis: University of Minnesota Press, 1997), 171.

7. Michelle Weinroth, "Redesigning the Language of Social Change: Rhetoric, Agency, and the Oneiric in William Morris's *A Dream of John Ball*," *Victorian Studies* 53, no. 1 (2010), 38. Discussions of the politics of Morris's print endeavors include Elizabeth Carolyn Miller, *Slow Print: Literary Radicalism and Late Victorian Print Culture* (Stanford, CA: Stanford University Press, 2013), and Caroline Arscott, "William Morris: Decoration and Materialism," in *Marxism and the History of Art: From William Morris to the New Left*, ed. Andrew Hemingway (London: Pluto, 2006), 9–27.

8. See Caroline Arscott, *William Morris and Edward Burne-Jones: Interlacings.* New Haven, CT: Yale University Press, 2008.

9. Elizabeth K. Helsinger, *Poetry and the Pre-Raphaelite Arts: Dante Gabriel Rossetti and William Morris* (New Haven, CT: Yale University Press, 2008), 3, 2.

10. Morris's perspective is often therefore described as "ecological"; see, e.g., Nicholas Frankel, "The Ecology of Decoration: Design and Environment in the Writings of William Morris," *Journal of Pre-Raphaelite Studies* 12 (2003): 58–85.

11. Herbert Spencer, *The Principles of Biology* (London: Williams & Norgate, 1864), 1:444.

12. Adorno, *Aesthetic Theory*, 171.

13. McGann, *Black Riders*, 156.

14. Nicholas Dames, *The Physiology of the Novel: Reading, Neural Science, and the Form of Victorian Fiction* (Oxford: Oxford University Press, 2007), 219.

15. William Morris, *The Ideal Book: An Address* (New York: Calumet, 1899), 3–4.

16. Ibid., 5.

17. Paul Valéry, *The Art of Poetry*, trans. Denise Folliot (Princeton, NJ: Princeton University Press, 1958), 63.

18. Morris, *The Ideal Book*, 7, 8, 9.

19. Ibid., 11.

20. Ibid., 12.

21. Ibid., 12.

22. Longus, *Daphnis and Chloe: A Most Sweet and Pleasant Pastoral Romance for Young Ladies* (London: E. Mathews & J. Lane, 1893).

23. Ibid., 107.

24. Linda Dowling, *Hellenism and Homosexuality in Victorian Oxford* (Ithaca, NY: Cornell University Press, 1996), 115.

25. Rennell Rodd, *Rose Leaf and Apple Leaf* (Philadelphia: J. M. Stoddart, 1882), 13.

26. John Plotz, *Portable Property: Victorian Culture on the Move* (Princeton, NJ: Princeton University Press, 2008), 145.

27. Adorno, *Aesthetic Theory*, 257–58.

28. Caroline Arscott observes that this was a question with which Morris was "wearily, if anxiously, familiar." See Arscott, "Decoration and Materialism," 9.

29. See Adorno, *Aesthetic Theory*, 179–81.

30. Ibid., 336.

31. Jacques Rancière, *Aesthetics and Its Discontents*, trans. Steven Corcoran (Cambridge: Polity, 2009), 25.

32. Ibid., 26.

33. Jacques Rancière, *Aisthesis: Scenes from the Aesthetic Regime of Art*, trans. Paul Zakir (London: Verso Books, 2013), x.

34. What I am describing as shared corporeality is similar to what John Plotz has described as "co-corporeality" in Morris's late romances. Plotz reads the genre of the romance as enacting a radical utopian vision that directly counters the sympathetic identification invited by realist novels: for Morris, then, "the recognition of a virtually indistinguishable humanity in all persons becomes an avatar of eventual co-corporeality." Plotz, *Portable Property*, 154.

35. Adorno expresses his suspicion of the "passive, possibly even culinary, pleasures of spectators"; similarly, he observes that "Aesthetics that does not move within the perspective of truth fails its task; usually it is culinary." Adorno, *Aesthetic Theory*, 333, 336.

36. Herbert Spencer, *Social Statics* (London: John Chapman, 1851), 440. Spencer discusses the implications of evolutionary individuation for "the future progress of civilization" in Spencer, *Principles of Biology*, 1:501–2.

37. Herbert Spencer, "The Man versus the State," in *Political Writings*, ed. John Offer (Cambridge: Cambridge University Press, 1994), 109.

38. Ibid., 138, 127.

39. On the relation of individualism to decadence, see Regenia Gagnier, *Individualism, Decadence and Globalization: On the Relationship of Part to Whole, 1859–1920* (Basingstoke, UK: Palgrave Macmillan, 2010). On the debates about individualism, see M. W. Taylor, *Men versus the State: Herbert Spencer and Late Victorian Individualism* (Oxford: Clarendon, 1992), and Mark Francis, *Herbert Spencer and the Invention of Modern Life* (Ithaca, NY: Cornell University Press, 2007), 247–60.

40. Thomas Mackay, ed., *A Plea for Liberty: An Argument against Socialism and Socialistic Legislation* (New York: D. Appleton, 1891), 77.

41. Ibid., 110.

42. Wordsworth Donisthorpe, *Individualism: A System of Politics* (London: Macmillan, 1889), 302–3.

43. Norman Kelvin notes that "Morris lectured on both *Looking Backward* . . . and Grant Allen's 'individualism and Socialism' at a meeting of the Hammersmith Branch, S.L., on the evening of May 12, 1889." William Morris, *The Collected Letters of William Morris*, vol. 3, *1889–1892*, ed. Norman Kelvin (Princeton, NJ: Princeton University Press, 1984), 60.

44. William Morris and E. Belfort Bax, "Socialism from the Root Up. Chapter II. Medieval Society," *Commonweal*, May 22, 1886, 61.

45. These are advertised, for instance, in "Branch Meeting Rooms," *Commonweal* (January 1886): 8.

46. William Morris, *Signs of Change: Lectures on Socialism*, ed. May Morris, vol. 23 of *The Collected Works of William Morris* (London: Longmans, Green, 1915), 17.

47. Ibid., 23.

48. Ibid.

49. Ibid., 79–80.

50. Ibid., 52.

51. Ibid., 100.

52. Ibid., 17.

53. Annie Besant lectured frequently on this topic, including her pamphlet *Why I Am a Socialist* (1886), *The Evolution of Society* (1886), and an 1888 address at the Hammersmith Socialist Society on "The Evolutionary Aspect of Socialism." On Morris and evolution, see Piers J. Hale, "Of Mice and Men: Evolution and the Socialist Utopia. William Morris, H.G. Wells, and George Bernard Shaw," *Journal of the History of Biology* 43, no. 1 (April 2010): 17–66, and Jessica Kuskey, "Bodily Beauty, Socialist Evolution, and William Morris's News from Nowhere," *Nineteenth-Century Prose* 38, no. 1 (Spring 2011): 142–82.

54. Morris, *Signs of Change*, 165.

55. Ibid., 165–66.

56. Karl Marx, "Theses on Feuerbach," in *Karl Marx and Friedrich Engels: Collected Works*, vol. 5, *Marx and Engels: 1845–1847*, trans. Clemens Dutt, W. Lough, and C. P. Magill (New York: International, 1976), 6, 7.

57. Oscar Wilde, *The Picture of Dorian Gray*, ed. Joseph Bristow and Ian Small, vol. 3 of *The Complete Works of Oscar Wilde* (Oxford: Oxford University Press, 2005), 123, 94.

58. Arthur Symons, *Days and Nights* (London: Macmillan, 1889), 105.

59. Morris, *Signs of Change*, 81.

60. Ibid.

61. Ibid., 82.

62. Ibid., 99.

63. E. P. Thompson, *William Morris: Romantic to Revolutionary* (New York: Pantheon Books,, 1977), 101.

64. The carpet designer Alexander Millar notes, "It is, I think, generally admitted that there is no fabric for which it is so difficult to design successfully as a carpet. And it will frequently be found that those who have been conspicuously

successful in other branches of decorative art, have either failed in carpet design-
ing, or, possibly deterred by its difficulties, have avoided it altogether." Alexander
Millar, "Carpet Designing," in *Practical Designing: A Handbook on the Prepara-
tion of Working Drawings*, ed. Gleeson White (London: G. Bell, 1893), 3.

65. Morris, *Signs of Change*, 165.

66. William Morris, "The Lesser Arts of Life," in *Lectures on Art* (London:
Macmillan, 1882), 174.

67. Ibid., 176.

68. On the discovery of saccadic jerks and the resulting "hygienics of read-
ing," see Dames, *Physiology of the Novel*, 211–31.

69. Émile Javal, *Physiologie de la lecture et de l'écriture* (Paris: F. Alcan,
1905), 181–16.

70. Talbot Reed, "Old and New Fashions in Typography," *Caslon's Circular*
54, no. 15 (Summer 1890): 1–3.

71. Henry Halliday Sparling, *The Kelmscott Press and William Morris Master-
Craftsman* (London: Macmillan, 1924), 17.

72. William Morris, *The Roots of the Mountains*, ed. May Morris, vol. 15 of
The Collected Works of William Morris (London: Longmans, Green, 1912), xv.

73. Morris describes his use of photography in detail: "this type I studied with
much care, getting it photographed to a big scale, and drawing it over many times
before I began designing my own letter; so that though I think I mastered the es-
sence of it, I did not copy it servilely." Morris, *Roots of the Mountains*, xvii.

74. William S. Peterson, *The Kelmscott Press: A History of William Morris's
Typographical Adventure* (Berkeley: University of California Press, 1991), 82.

75. Miller, *Slow Print*, 53.

76. Morris, "Lesser Arts of Life," 174.

77. Robert Steele, *The Revival of Printing; a Bibliographical Catalogue of
Works Issued by the Chief Modern English Presses*, (London: Macmillan, 1912),
xxiii.

78. George Saintsbury, "New Novels," *Academy* 19 (March 1881): 204;
H. Rider Haggard, "About Fiction," *Contemporary Review* 51 (1887), 175.

79. See Anna Vaninskaya, *William Morris and the Idea of Community: Ro-
mance, History and Propaganda, 1880–1914* (Edinburgh: Edinburgh University
Press, 2010), 34–48.

80. Morris, *Collected Letters*, 3:198.

81. Ibid., 286.

82. Ibid., 299.

83. Ibid., 316.

84. Ibid., 318.

85. Morris's friend Walter Crane recalled a visit to Morris's Merton Abbey
Works when Morris called from another room, "I'm dyeing, I'm dyeing, I'm dye-
ing," only to emerge stained with blue dye from his experiments with vegetable
dyes. Walter Crane, *William Morris to Whistler: Papers and Addresses on Art
and Craft and the Commonweal* (London: Bell, 1911), 24.

86. Jerome J. McGann, *The Textual Condition* (Princeton, NJ: Princeton
University Press, 1991), 77.

87. Mackail, *Life of William Morris*, 1:61.

88. The textual history of the early romances is described in William Morris, *The Hollow Land and Other Contributions to the Oxford and Cambridge Magazine*, ed. Eugene D. LeMire (Bristol: Thoemmes, 1996), v–xxx.

89. See Amanda Hodgson, *The Romances of William Morris* (Cambridge: Cambridge University Press, 1987), 19–49, and Florence S. Boos, "The Structure of Morris's Tales for the *Oxford and Cambridge Magazine*," *Victorian Periodicals Review* (1987): 2–12.

90. Ingrid Hanson, *William Morris and the Uses of Violence, 1856–1890* (London: Anthem, 2013), 26. Jan Marsh reads what I am describing as the relationship between the materiality of architectural labor and the immateriality of dream states as reflecting Morris's engagement with a binary between action and making as coded masculine and dreaming and artistic activity as coded feminine. See Jan Marsh, "William Morris and Victorian Manliness," in *William Morris: Centenary Essays*, ed. Peter Faulkner and Peter Preston (Exeter: University of Exeter Press, 1999), 191.

91. McGann, *Black Riders*, 49. It is with regard to this tale that McGann claims that Morris understands "poetry as language incarnate" and in meaning "not as a conception but as an embodiment."

92. The origins of the story are briefly recounted in Georgiana Burne-Jones, *Memorials of Edward Burne-Jones* (London: Macmillan, 1904), 126. Morris laments that he has "failed signally" in this story in a July 6, 1855, letter to his friend Cormell Price. See William Morris, *The Collected Letters of William Morris*, vol. 1, *1848–1880*, ed. Norman Kelvin (Princeton, NJ: Princeton University Press, 1984), 13.

93. William Morris, "The Story of the Unknown Church," in *The Collected Works of William Morris*, vol. 1, *The Defence of Guenevere and The Hollow Land*, ed. May Morris (Longmans, Green, 1910), 152.

94. Ibid., 154–55.

95. Ibid., 155.

96. Northrop Frye, *The Secular Scripture and Other Writings on Critical Theory, 1976–1991*, ed. Jean Wilson and Joseph Adamson (Toronto: University of Toronto Press, 2006), 38.

97. Mackail, *Life of William Morris*, 1:97.

98. Morris, "Story of the Unknown Church," 152–53.

99. E. S. Dallas, *The Gay Science* (London: Chapman & Hall, 1866), 1:201.

100. William Morris, *The Collected Works of William Morris*, vol. 3, *The Earthly Paradise: A Poem, Vol. I*, ed. May Morris (London: Longmans, Green, 1910), 3.

101. On Morris's interest in dream churches see Morris, *Collected Letters*, 3:57.

102. Fredric Jameson, *The Political Unconscious: Narrative as a Socially Symbolic Act* (Ithaca, NY: Cornell University Press, 1981), 154.

103. Ibid., 147.

104. Patrick Brantlinger, "'News from Nowhere': Morris's Socialist Anti-Novel," *Victorian Studies* 19, no. 1 (September 1975): 44.

105. In an 1891 letter, Morris downplays the validity of *News from Nowhere*'s political vision: "As to the future as foreshadowed by my book, one can only in

such a work say what one likes oneself. . . . I am pleased to see that a good many people think my own aspirations pleasant at least, and perhaps not wholly unreasonable." Morris, *Collected Letters*, 3:310.

106. Plotz argues that Morris "is rejecting . . . the novelistic assumption that there is any mode of representation capable of making a suffering character's feelings present to the reader." Plotz, *Portable Property*, 151. Buzard argues that *News from Nowhere* "radicaliz[es]" rather than fully rejects certain features of the nineteenth-century novel, particularly "narrative disjunction or interruption." Buzard, *Disorienting Fiction: The Autoethnographic Work of Nineteenth-Century British Novels* (Princeton, NJ: Princeton University Press, 2005), 7, 299–314. Miller attends to the "flatness" of *News* and its resonances with deconstructive self-undoing. Miller, *Slow Print*, 75–81.

107. Alexander Bain, *Mind and Body: The Theories of Their Relation* (London: Henry S. King, 1873), 131.

108. William Morris, *News from Nowhere; or, An Epoch of Rest: Being Some Chapters from a Utopian Romance*, ed. David Leopold (Oxford: Oxford University Press, 2003), 18.

109. Morris, *News from Nowhere*, 22.

110. Ibid., 172–73.

111. Plotz, *Portable Property*, 150–51.

112. Citing one character's antipathy to novels, Trilling writes, "it is with this petulant, small-minded response that Morris ends the debate and seeks to bring into contempt an idea which is definitive of the high culture of humanism: that a chief value of life lies in its ability to make itself, and especially its various forms of aggressivity, the object of its own admiring contemplation." Trilling, "Aggression and Utopia," 221–22.

113. Morris, *News from Nowhere*, 25–26.

114. Ibid., 26.

115. Morris, *Ideal Book*, 12; *News from Nowhere*, 26.

116. Leah Price, *How to Do Things with Books in Victorian Britain* (Princeton, NJ: Princeton University Press, 2012), 3.

117. Morris, *News from Nowhere*, 18.

118. Nowherians recognize, as Morris observed in his first lecture, that "there is something melancholy about a museum, such a tale of violence, destruction, and carelessness, as its treasured scraps tell us." Morris, "Lesser Arts of Life," 45. In this sense Morris gives early expression to an argument that Adorno would later articulate: "the German word *museal* [*museumlike*] has unpleasant overtones. It describes objects to which the observer no longer has a vital relationship and which are in the process of dying. They owe their preservation more to historical respect to the needs of the present. Museum and mausoleum are connected by more than phonetic association. Museums are the family sepulchres of works of art." Theodor W. Adorno, "Valéry Proust Museum," in *Prisms*, trans. Samuel and Shierry Weber (Cambridge, MA: MIT Press, 1981), 175.

119. Jonah Siegel, *Desire and Excess: The Nineteenth-Century Culture of Art* (Princeton, NJ: Princeton University Press, 2000), 9.

120. Morris, *News from Nowhere*, 18.

121. Ibid., 129.

122. Gustav Theodor Fechner, *Vorschule der Aesthetik* (Leipzig, Germany: Breitkopf & Härtel, 1876), 1:1, 2:317.

123. Harry Buxton Forman, *The Books of William Morris: Described with Some Account of His Doings in Literature and in the Allied Crafts* (N.p., F. Hollings, 1897), 149. For a full bibliography of editions of *News from Nowhere*, see Eugene D. LeMire, *A Bibliography of William Morris* (London: British Library, 2006), 139–48.

124. Forman, *Books of William Morris*, 149.

125. Ibid., 150. Prices are cited in Peterson, *Kelmscott Press*, 317.

126. Elaine Freedgood, *The Ideas in Things: Fugitive Meaning in the Victorian Novel* (Chicago: University of Chicago Press, 2006), 17.

127. Arnold writes, "Let us think of quietly enlarging our stock of true and fresh ideas, and not, as soon as we get an idea or half an idea, be running out with it into the street, and trying to make it rule there. Our ideas will, in the end, shape the world all the better for maturing a little." Matthew Arnold, *Culture and Anarchy and Other Writings*, ed. Stefan Collini (Cambridge: Cambridge University Press, 1993), 48.

128. Morris, *News from Nowhere*, 87.

129. Trilling, "Aggression and Utopia," 222.

130. Clive Bell, *Art* (New York: Frederick A. Stokes, 1914), 6–7.

131. In this sense, Morris's theory of art approaches Hal Foster's characterization of the antiaesthetic: " 'Anti-aesthetic' also signals that the very notion of the aesthetic, its network of ideas, is in question here: the idea that aesthetic experience exists apart, without 'purpose,' all but beyond history, or that art can now effect a world at once (inter)subjective, concrete and universal—a symbolic totality. . . . 'Anti-aesthetic' also signals a practice . . . that is sensitive to cultural forms . . . that deny the idea of a privileged aesthetic realm." Foster, "Introduction," in *The Anti-Aesthetic: Essays on Postmodern Culture* (Port Townsend, WA: Bay Press, 1983), xv.

132. Work that resists this equation includes Samuel Otter, "An Aesthetics in All Things," *Representations* 104, no. 1 (November 2008): 116–25, and Caroline Levine's recent turn to the notion of form as *affordance*, a term from design theory that gives attention to the material and embodied qualities of form. Caroline Levine, *Forms: Whole, Rhythm, Hierarchy, Network* (Princeton, NJ: Princeton University Press, 2015).

133. I. A. Richards, *Principles of Literary Criticism* (New York: Harcourt, 1961), 15.

134. Ibid., 17.

CHAPTER 5

1. William K. Wimsatt and Monroe C. Beardsley, "The Affective Fallacy," *Sewanee Review* 57, no. 1 (1949), 43, 47.

2. Wimsatt and Beardsley, "Affective," 31.

3. Gerald Graff, "What Was New Criticism? Literary Interpretation and Scientific Objectivity," *Salmagundi*, no. 27 (Summer/Fall 1974), 80. Graff is quoting Cleanth Brooks.

4. On the history of empathy and its relation to sympathy, see Louis Agosta, *Empathy in the Context of Philosophy* (New York: Palgrave Macmillan, 2010); Carolyn Burdett, " 'The Subjective inside Us Can Turn into the Objective Outside': Vernon Lee's Psychological Aesthetics," *19: Interdisciplinary Studies in the Long Nineteenth Century* 12 (2011), http://www.19.bbk.ac.uk/articles/10.16995/ntn.610/; D. Rae Greiner, "Thinking of Me Thinking of You: Sympathy versus Empathy in the Realist Novel," *Victorian Studies* 53, no. 3 (2011): 417–26; Gustav Jahoda, "Theodor Lipps and the Shift from 'Sympathy' to 'Empathy,' " *Journal of the History of the Behavioral Sciences* 41, no. 2 (Spring 2005): 151–63; Samuel Moyn, "Empathy in History, Empathizing with Humanity," *History and Theory* 45, no. 3 (October 1, 2006): 397–415; and George W. Pigman, "Freud and the History of Empathy," *International Journal of Psychoanalysis* 76 (April 1995): 237–56.

5. Psychologist Nancy Eisenberg notes that empathy is "comprehension of another's emotional state . . . and is similar to what the other person is feeling"; sympathy "is not the same as what the other person is feeling . . . but consists of feelings of sorrow or concern." Nancy Eisenberg, "Emotion, Regulation, and Moral Development," *Annual Review of Psychology* 51 (2000), 671, 672.

6. Martha Nussbaum, *Poetic Justice: The Literary Imagination and Public Life* (Boston: Beacon, 1995), 66.

7. Suzanne Keen, *Empathy and the Novel* (Oxford: Oxford University Press, 2007), 65–99. On empathy toward beings other than characters, see Suzanne Keen, "Empathetic Hardy: Bounded, Ambassadorial, and Broadcast Strategies of Narrative Empathy," *Poetics Today* 32, no. 2 (Summer 2011): 349–89.

8. Vernon Lee, *The Beautiful: An Introduction to Psychological Aesthetics*, Cambridge Manuals of Science and Literature (Cambridge: Cambridge University Press, 1913), 72.

9. Ibid., 73.

10. Ibid., 74.

11. Ibid., 72. Writing about Lee's gallery diaries, Lynda Nead emphasizes these dynamic qualities (and of physiological aesthetics), connecting them to early technologies of the moving image. See Nead, *The Haunted Gallery: Painting, Photography, Film c.1900* (New Haven, CT: Yale University Press, 2007), 35–40.

12. Brian Massumi, *Parables for the Virtual: Movement, Affect, Sensation* (Durham, NC: Duke University Press, 2002), 25. The distinctions among affect, emotion, and feeling are debated among theorists of affect. Rei Terada, like Massumi, distinguishes emotion, "a psychological, at least minimally interpretive experience," from affect, its "physiological aspect." See Rei Terada, *Feeling in Theory: Emotion after the "Death of the Subject"* (Cambridge, MA: Harvard University Press, 2001), 4. Jonathan Flatley helpfully makes this distinction in terms of "reducibility": "In contrast to affects, then, we might distinguish emotions as the result of the inevitable interaction of affects with thoughts, ideas, beliefs, habits, instincts, and other affects. If affects are not reducible, emotions are, and it is emotions that vary from context to context, person to person." Jonathan Flatley, *Affective Mapping: Melancholia and the Politics of Modernism* (Cambridge, MA: Harvard University Press, 2008), 16. For a critique of claims

that there is an irreducibly presemantic domain of bodily experience, see Ruth Leys, "The Turn to Affect: A Critique," *Critical Inquiry* 37, no. 3 (Spring 2011): 434–72.

13. David Freedberg and Vittorio Gallese, "Motion, Emotion and Empathy in Esthetic Experience," *Trends in Cognitive Sciences* 11, no. 5 (May 2007): 201.

14. Robert Vischer, "On the Optical Sense of Form," in *Empathy, Form, and Space: Problems in German Aesthetics, 1873–1893*, ed. Harry Francis Mallgrave and Eleftherios Ikonomou (Santa Monica, CA: Getty Center for the History of Art and the Humanities, 1994), 97.

15. Ibid., 104–5.

16. Liliana Albertazzi notes that optical illusions were at the center of debates about aesthetics at the turn of the century: "The importance of the topic rested on the fact that it involved questions not only of *visual perception* but also of *ontology*: What type of *object* is a perceptive illusion? . . . What is its relationship with *sensory content* (*Gehalt*) and *aesthetic sentiment* (*Gefühl*)?" Liliana Albertazzi, "The Aesthetics of Particulars: A Case of Intuitive Mechanics," *Axiomathes* 1/2 (1998): 180. Albertazzi offers a detailed overview of Lipps's theories of aesthetics and perception, which are so complex, Albertazzi argues, that Lipps and his interlocutors often did not recognize whether they agreed or disagreed.

17. Theodor Lipps, *Aesthetik: Psychologie des Schönen und der Kunst* (Hamburg: Leopold Voss, 1903), 1:236–37 (my translation).

18. Theodor Lipps, *Raumaesthetik und geometrisch-optische Täuschungen* (Leipzig, Germany: J. A. Barth, 1897), 7 (my translation).

19. Lipps, *Aesthetik*, 408–9.

20. Karl Groos, *The Play of Man*, trans. Elizabeth L. Baldwin (New York: Appleton, 1913), 328.

21. Oswald Külpe, "Ein Beitrag zur experimentellen Aesthetik," *American Journal of Psychology* 14, no. 3/4 (October 1903): 215–31.

22. Herbert Sidney Langfeld, *The Aesthetic Attitude* (New York: Harcourt, 1920), 111.

23. Robert Sessions Woodworth, *Psychology: A Study of Mental Life* (New York: H. Holt, 1924), 491.

24. E. E Southard, "The Empathic Index in the Diagnosis of Mental Diseases," *Journal of Abnormal Psychology* 13, no. 4 (1918), 204.

25. Gordon Allport, *Personality: A Psychological Interpretation* (New York: Henry Holt, 1937), 530.

26. Vernon Lee and Clementina Anstruther-Thomson, *Beauty and Ugliness and Other Studies in Psychological Aesthetics* (London: John Lane, 1912), 276.

27. On Lee's relation to physiological aesthetics, see Susan Lanzoni, "Practicing Psychology in the Art Gallery: Vernon Lee's Aesthetics of Empathy," *Journal of the History of the Behavioral Sciences* 45, no. 4 (2009): 330–54, and Burdett, " 'Subjective inside Us.' "

28. Walter Pater, *The Renaissance: Studies in Art and Poetry: The 1893 Text*, ed. Donald L. Hill (Berkeley: University of California Press, 1980), xix–xx.

29. Vernon Lee and Clementina Anstruther-Thomson, "Beauty and Ugliness," *Contemporary Review* 72 (October 1897), 560.

30. Lee and Anstruther-Thomson, *Beauty and Ugliness and Other Studies*, 64–65.

31. For a description of this questionnaire, see Vernon Lee and Clementina Anstruther-Thomson, "Le rôle de l'élément moteur dans la perception esthétique visuelle," in *IVe Congrès international de psychologie: Compte rendu des séances et texte des mémoires* (Paris: Felix Alcan, 1901), 468–73, and Lee and Anstruther-Thomson, *Beauty and Ugliness and Other Studies*, 98–105. Lee's privately circulated summary of this questionnaire is held at the British Library: Vernon Lee and Clementina Anstruther-Thomson, *Le rôle de l'élément moteur dans la perception esthétique visuelle: Mémoire et questionnaire soumis au quatrième Congrès de psychologie* (Imola: Cooperative Typographique, 1901), General Reference Collection 8461.f.2.

32. Lee and Anstruther-Thomson, *Beauty and Ugliness and Other Studies*, 81.

33. Among the works that made some version of Lee's theory central to their argument are Bernard Berenson, *The Florentine Painters of the Renaissance* (New York: G.P. Putnam's Sons, 1896), 11 ("to realize form we must give tactile values to retinal sensations"); Yrjö Hirn, *The Origins of Art* (London: Macmillan, 1900), 75–77, which connects empathy to the imitative impulse expressed within aesthetic activities; and Hugo Münsterberg, *The Principles of Art Education: A Philosophical, Aesthetical and Psychological Discussion of Art Education* (New York: Prang, 1904), 87. Münsterberg writes, "we ourselves are contracting our muscles, but we feel as if the lines were pulling and piercing, bending and lifting" (87). Kate Gordon, an American theorist of psychological aesthetics, observed in a review of Lee's volume that "Much more, however, has been done in this field [of psychological experiments on the appreciation of form], particularly in America, than the author seems to recognize." Kate Gordon, "Beauty and Ugliness and Other Studies in Psychological Aesthetics," *Psychological Bulletin* 9, no. 11 (November 15, 1912): 431.

34. Peter Gunn, *Vernon Lee: Violet Paget, 1856–1935* (Oxford: Oxford University Press, 1964), 148.

35. Lee and Anstruther-Thomson, *Beauty and Ugliness and Other Studies*, 242.

36. See Diana Maltz, "Engaging 'Delicate Brains': From Working-Class Enculturation to Upper-Class Lesbian Liberation in Vernon Lee and Kit Anstruther-Thomson's Psychological Aesthetics," in *Women and British Aestheticism*, ed. Talia Schaffer and Kathy Alexis Psomiades (Charlottesville: University of Virginia Press, 1999), 211–29, and Kathy Alexis Psomiades, " 'Still Burning from This Strangling Embrace': Vernon Lee on Desire and Aesthetics," in *Victorian Sexual Dissidence*, ed. Richard Dellamora (Chicago: University of Chicago Press, 1999).

37. Clementina Anstruther-Thomson, *Art and Man: Essays and Fragments*, ed. Vernon Lee (London: John Lane, 1924), 140.

38. Vernon Lee, "Recent Aesthetics," *Quarterly Review* 199, no. 398 (April 1904), 433, emphasis in original.

39. In a summary of how her views of empathy had developed (as of 1912), Lee emphasizes that the "attribution of our life to seen shapes" also calls up

"previous experience" and involves a "reviviscence" of "particular dynamic and emotional experiences." Lee and Anstruther-Thomson, *Beauty and Ugliness and Other Studies*, 29. These views developed, in part, from Théodule Ribot's influential notion of affective/emotional memory (*mémoire affective*), which emphasized memory not as the recall of events but as the spontaneous or willed revival of sensory and emotional states. See Ribot, *La psychologie des sentiments*, 5th ed. (Paris: Félix Alcan, 1905), 140–70.

40. In the 1897 essay "Beauty and Ugliness," Lee proposes the work of Lange, James, and Sergi as the primary scientific explanation for the phenomena she and Anstruther-Thomson had observed. By 1912, when it was republished with later work, Lee believed that the earlier essay had confused three separate principles; the other two were the "motor images" of Groos and the "inner mimicry" of Lipps. See Lee and Anstruther-Thomson, *Beauty and Ugliness and Other Studies*, 96.

41. Lee, *The Beautiful*, 61–62.

42. Lee, "Recent Aesthetics," 433.

43. Lipps, *Aesthetik*, 2:87.

44. Lee and Anstruther-Thomson, *Beauty and Ugliness and Other Studies*, 59.

45. These are Mallgrave and Ikonomou's translations. See Vischer, "On the Optical Sense," 89–123.

46. Sophia Elizabeth De Morgan, *Memoir of Augustus De Morgan* (London: Longmans, Green, 1882), 216.

47. Ibid., 216.

48. T. C. Mendenhall, "The Characteristic Curves of Composition," *Science* 9, no. 214 (March 11, 1887), 238.

49. See Appleton Morgan, "The Characteristic Curves of Composition," *Science* 13, no. 313 (February 1, 1889): 92, and H. T. Eddy, "The Characteristic Curves of Composition," *Science* 9, no. 216 (March 25, 1887): 297.

50. T. C. Mendenhall, "A Mechanical Solution to a Literary Problem," *Popular Science Monthly* 60 (1901:, 102.

51. Ibid., 103.

52. T. C. Mendenhall, "Mechanical Peculiarities of Literary Work," *Times*, January 3, 1902, 10. For a discussion of the relationship between quantitative stylistics and authorial personality, see Jason Camlot, *Style and the Nineteenth-Century British Critic: Sincere Mannerisms* (Aldershot, UK: Ashgate, 2008), 139–144.

53. L. A. Sherman, "Some Observations upon the Sentence-Length in English Prose," *University Studies* 1, no. 2 (October 1888): 119–30. Similar studies include L. A. Sherman, "On Certain Facts and Principles in the Development of Form in Literature," *University Studies* 1, no. 4 (July 1892), and G. W. Gerwig, "On the Decrease of Predication and of Sentence Weight in English Prose," *University Studies* 2, no. 1 (July 1894): 17–44.

54. Robert E. Moritz, "On the Significance of Characteristic Curves of Composition," *Popular Science Monthly* 65 (June 1904), 147.

55. Robert E. Moritz, "On the Variation and Functional Relation of Certain Sentence-Constants in Standard Literature," *University Studies* 3, no. 1 (July 1903), 230.

56. Robert E. Moritz, "On a Quantitative Relation Governing Certain Linguistic Phenomena," *Modern Language Notes* 24, no. 8 (December 1909), 241.

57. John Guillory, "Literary Study and the Modern System of the Disciplines," in *Disciplinarity at the Fin de Siècle* (Princeton, NJ: Princeton University Press, 2002), 28.

58. Treatments of the early application of statistics to literary interpretation that situate it as an ancestor to stylometry include C. B. Williams, "A Note on an Early Statistical Study of Literary Style," *Biometrika* 43, no. 3/4 (December 1956): 248–56; "Mendenhall's Studies of Word-Length Distribution in the Works of Shakespeare and Bacon," *Biometrika* 62, no. 1 (April 1975): 207–12; and David I. Holmes, "Authorship Attribution," *Computers and the Humanities* 28, no. 2 (April 1994): 87–106.

59. Paul de Man, "The Return to Philology," in *The Resistance to Theory* (Minneapolis: University of Minnesota Press, 1986), 24. Sheldon Pollock argues that de Man's characterization of philology is "outlandish" because it evacuates the discipline of philology; Pollock argues instead that philology is "the theory of textuality as well as the history of textualized meaning." Sheldon Pollock, "Future Philology? The Fate of a Soft Science in a Hard World," *Critical Inquiry* 35, no. 4 (Summer 2009): 947, 934. For an extended discussion of the philological origins of literary study, see James Turner, *Philology: The Forgotten Origins of the Modern Humanities* (Princeton, NJ: Princeton University Press, 2014).

60. Frances Ferguson, "Philology, Literature, Style," *ELH* 80, no. 2 (Summer 2013), 332, 335.

61. Franco Moretti, "Changes," *Public Books* (March 1, 2014), http://www.publicbooks.org/briefs/changes. One might contest Moretti's assumption that archives are found and models are made, but here I am more interested in his periodizing move.

62. Mendenhall, "Mechanical Peculiarities," 3.

63. Emil Reich, "Mechanical Tests of Literary Authorship," *Times*, January 7, 1902, 5.

64. Vernon Lee, "Of Writers and Readers," *New Review* 5 (December 1891), 529.

65. This is discussed briefly in the "Editor's Introduction" to Vernon Lee, *The Handling of Words and Other Studies in Literary Psychology*, ed. David Seed (Lewiston, NY: Edwin Mellen Press, 1992).

66. Vernon Lee, "The Syntax of De Quincy [sic]," *Contemporary Review* 84 (November 1903), 713.

67. Ibid.

68. Ibid.

69. Ibid., 717.

70. Nicholas Dames, *The Physiology of the Novel: Reading, Neural Science, and the Form of Victorian Fiction* (Oxford: Oxford University Press, 2007), 189.

71. Vernon Lee, "The Craft of Words," *New Review* 11 (December 1894), 577.

72. Vernon Lee, "Vital Tempo: Art and Human Life," *Times*, November 14, 1924.

73. Vernon Lee, *Music and Its Lovers* (New York: E. P. Dutton, 1933), 25.

74. Ibid., 72.

75. Ibid., 75–76.

76. Lee reviewed Edmund Gurney's *The Power of Sound* in 1882, concurring with Gurney's view that music was more concerned with formal demands intrinsic to the medium rather than with the expression of a composer's emotion. Lee's review reveals her to be intrigued by Gurney's account, based in evolutionary psychology, of how music provokes emotion. See Vernon Lee, "Impersonality and Evolution in Music," *Contemporary Review* 42 (1882): 840–58. A later review connects Gurney's and Eduard Hanslick's accounts of musical form to Lipps's theory of empathy, asserting that "there is no irreducible difference between the form existing through the eye and the form existing through the ear" (220). See Vernon Lee, "The Riddle of Music." *Quarterly Review* 204 (1906): 207–27.

77. My understanding of Lee's account of form diverges from that of Angela Leighton, who emphasizes the relationship between ghostliness and form in Lee's writing: "form is a ghost: a ghost of the body, or a ghost of intention, message, meaning. It has been 'abstracted' from all of those, but it also draws on them like a distant reminiscence." Angela Leighton, *On Form: Poetry, Aestheticism, and the Legacy of a Word* (Oxford: Oxford University Press, 2007), 168. I understand Lee to be drawing on contemporary psychology in order to describe form as a corporeal event more than as a ghostly effect.

78. Vineta Colby, *Vernon Lee: A Literary Biography* (Charlottesville: University of Virginia Press, 2003), 200.

79. I. A. Richards, *Principles of Literary Criticism* (New York: Harcourt, 1961), 14.

80. Joseph North persuasively argues that many scholars have mistakenly conflated Richards's pragmatist aesthetics with the neo-Kantian views of his New Critical followers. See Joseph North, "What's 'New Critical' about 'Close Reading'?: I. A. Richards and His New Critical Reception," *New Literary History* 44, no. 1 (2013): 141–57.

81. Wimsatt and Beardsley, "Affective Fallacy," 28, 45.

82. William K. Wimsatt and Cleanth Brooks, *Literary Criticism: A Short History* (New York: Knopf, 1964), 615.

83. René Wellek, *Discriminations: Further Concepts of Criticism.* (New Haven, CT: Yale University Press, 1970), 185.

84. See Richard Harter Fogle, *The Imagery of Keats and Shelley: A Comparative Study* (Chapel Hill: University of North Carolina Press, 1949).

85. I. A. Richards, *Practical Criticism* (New York: Harcourt, 1957), 223.

86. "Words, Words, Words!," *Spectator* 130, no. 4947 (April 21, 1923): 671.

87. Wimsatt and Beardsley, "Affective Fallacy," 43.

88. Richards, *Principles of Literary Criticism*, 234, 235, 237.

89. On Head, see L. S. Jacyna, *Medicine and Modernism: A Biography of Sir Henry Head* (London: Pickering & Chatto, 2008).

90. Vernon Lee, "The Rhetoric of Landor," *Contemporary Review* 84 (December 1903), 856.

91. Richards, *Principles of Literary Criticism*, 135.

92. Ibid.

93. On Richards's relation to physiological novel criticism, see Dames, *Physiology of the Novel*, 247–55. Dames argues that "the reading that Richards pursued in these years [i.e., the 1920s] seems to have been far more rooted in Victorian physiology than any biographer has previously noted, or that Richards himself was willing to admit" (249).

94. Lee, "Rhetoric," 859.

95. Richards, *Principles of Literary Criticism*, 116.

96. On the modernists' suppression of the physiological body, see Jonathan Crary, *Suspensions of Perception: Attention, Spectacle, and Modern Culture* (Cambridge, MA: MIT Press, 2001), 46.

97. Allen Tate, "The Present Function of Criticism," in *Essays of Four Decades* (Wilmington, DE: ISI Books, 1999), 204, 205.

98. F. R. Leavis, *English Literature in Our Time and the University* (London: Chatto & Windus, 1969), 17.

99. John Dewey, *Art as Experience* (New York: Perigee, 1980), 251.

100. Ibid., 3.

101. Susanne Langer, *Feeling and Form: A Theory of Art* (New York: Scribner, 1953), 36.

102. Ibid., 38, 39.

103. On empathy in phenomenology, see Evan Thompson, *Mind in Life: Biology, Phenomenology, and the Sciences of Mind* (Cambridge, MA: Belknap, 2007), 382–411; Edith Stein, *On the Problem of Empathy* (Washington, DC: ICS, 1989); and Agosta, *Empathy in the Context of Philosophy*. On Heidegger's rejection of Husserl's notion of empathy, see Michael F. Andrews, "Edmund Husserl: Empathy and the Transcendental Constitution of the World," in *Does the World Exist?*, ed. Anna-Teresa Tymieniecka, Analecta Husserliana 79 (The Netherlands: Springer, 2004), 217–37.

104. For an overview of how Lipps's thought was taken up within phenomenological aesthetics see Hans Rainer Sepp and Lester E. Embree, eds., *Handbook of Phenomenological Aesthetics* (Dordrecht, The Netherlands: Springer, 2010). Two of Ingarden's four "strata" constituting literary works are of particular relevance to earlier accounts of empathy: the stratum of "linguistic sound formations," or the phonetic qualities of literary language, and the stratum of "schematized aspects," or represented things that are perceived "quasi-sensorially." See Roman Ingarden, *The Literary Work of Art: An Investigation of the Borderlines of Ontology, Logic, and Theory of Language*, trans. George G. Grabowicz (Evanston, IL: Northwestern University Press, 1979) 34, 256.

105. On the persistence of close reading, see Jane Gallop, "The Historicization of Literary Studies and the Fate of Close Reading," *Profession* (2007): 181–86.

106. Charles Altieri, "The Sensuous Dimension of Literary Experience: An Alternative to Materialist Theory," *New Literary History* 38, no. 1 (2007), 71; Garrett Stewart, *Novel Violence: A Narratography of Victorian Fiction* (Chicago: University of Chicago Press, 2009), 6.

107. Important exceptions to this general trend in cognitive literary studies include Ellen Spolsky, "An Embodied View of Misunderstanding in *Macbeth*,"

Poetics Today 32, no. 3 (Fall 2011): 489–520; E. J. Esrock, "Embodying Art: The Spectator and the Inner Body," *Poetics Today* 31, no. 2 (Summer 2010): 217–50; and Marco Caracciolo, "Embodiment at the Crossroads: Some Open Questions between Literary Interpretation and Cognitive Science," *Poetics Today* 34, no. 1/2 (Spring/Summer 2013): 233–53.

108. Lee, *Handling of Words*, 188–89.

109. Ibid., 191.

110. Vernon Lee, "The Handling of Words: A Page of Walter Pater," *Life and Letters* 9, no. 50 (1933), 303.

EPILOGUE

1. Oscar Wilde, *The Picture of Dorian Gray*, ed. Joseph Bristow and Ian Small, vol. 3 of *The Complete Works of Oscar Wilde* (Oxford: Oxford University Press, 2005), 67.

2. Ibid., 67, 246.

3. Ibid., 68.

4. Ibid., 48.

5. Ibid., 258.

6. Two of these notebooks have been published: Philip E. Smith and Michael S. Helfand, eds., *Oscar Wilde's Oxford Notebooks: A Portrait of Mind in the Making* (New York: Oxford University Press, 1989). Other manuscripts revealing early influences, held at the University of California, Los Angeles's William Andrews Clark Library, include the "Notebook on Philosophy" (1874/6), including notes on Whewell, pre-Socratics, Hamilton, and Kant's *Critique of Pure Reason*; "Notes on the Ethics of Aristotle" (1874/6); and essays on "Greek Women," "Hellenism," and "Plato's Psychology." In the latter, Wilde describes Plato's thought in a way that seems to mirror the relation of the soul and the senses described in *Dorian Gray*: "We must fly from the many of sense to the unity of reason, but this implies a moral change as well: by that flight we become like God, holy and just and wise." Oscar Wilde and His Literary Circle Collection: Manuscripts and Miscellaneous Materials, f MS.2002.004. William Andrews Clark Memorial Library, University of California, Los Angeles.

7. Smith and Helfand, *Oscar Wilde's Oxford Notebooks*, 126.

8. Ibid., 131.

9. Ibid., 136. Smith and Helfand misattribute this passage to Wilde.

10. Henry Maudsley, *Body and Mind: An Inquiry into Their Connection and Mutual Influence, Specially in Reference to Mental Disorders* (London: Macmillan, 1873), 325.

11. Excellent recent accounts of Wilde's engagement with scientific materialism include Carolyn Lesjak, "Oscar Wilde and the Art/work of Atoms," *Studies in the Literary Imagination* 43, no. 1 (Spring 2010): 1–26; Michael Davis, "Mind and Matter in *The Picture of Dorian Gray*," *Victorian Literature and Culture* 41, no. 3 (2013): 547–60; and Elisha Cohn, "'One Single Ivory Cell': Oscar Wilde and the Brain," *Journal of Victorian Culture* 17, no. 2 (June 2012): 183–205.

12. William K. Wimsatt and Monroe C. Beardsley, "The Affective Fallacy," *Sewanee Review* 57, no. 1 (1949), 47.

13. Richard Moran, "Kant, Proust, and the Appeal of Beauty," *Critical Inquiry* 38, no. 2 (Winter 2012), 301.

14. The cognitive literary critic Alan Palmer, e.g., focusing on "literary universals," explicitly distinguishes his project from that of "literary criticism" and "the historicized approach"; his aim is "to theorize an aspect of the process of reading and not the end product." See Alan Palmer, *Fictional Minds* (Lincoln: University of Nebraska Press, 2004), 4, 21. Brian Boyd describes Darwinian literary criticism as an alternative to "theory": "a biological approach to the human has been anathematized for the last four decades by the recently dominant paradigm that calls itself 'Theory' or 'Critique.'" Brian Boyd, *On the Origin of Stories: Evolution, Cognition, and Fiction* (Cambridge, MA: Harvard University Press, 2009), 2. Similarly, Lisa Zunshine subordinates literary theory as a whole to the evolution of cognitive capacities: "We would not have been able to make sense of a single page of *He, She, and It* nor interpret the novel with any other literary-theoretical framework had we not subconsciously relied on our differential conceptualization of living beings and artifacts as a function of our cognitive evolutionary heritage." Lisa Zunshine, *Strange Concepts and the Stories They Make Possible: Cognition, Culture, Narrative* (Baltimore: Johns Hopkins University Press, 2008), 115–16.

15. *Consilience* is E. O. Wilson's term for reconciling different forms of knowledge—a term that many have seen as subordinating all knowledge to scientific knowledge. See Edward O. Wilson, *Consilience: The Unity of Knowledge* (New York: Knopf, 1998). Paul B. Armstrong adopts a version of the consilience argument when he asserts that "The areas of neuroscience where the 'facts' are well established should cause humanists to take notice and revise their views accordingly." Paul B. Armstrong, *How Literature Plays with the Brain: The Neuroscience of Reading and Art* (Baltimore: The Johns Hopkins University Press, 2013), 8. Brian Massumi by contrast describes cross-disciplinary "poaching" as a strategy not meant to convince scientists: "Defenders of the disciplinary purity of the sciences consider it shameless poaching. I wholeheartedly agree. It's not science anymore, they say, once those silly humanities people get their hands on it. It's all 'wrong.' As well it should be. Getting it 'right' could only mean one thing: applying the results of science to the humanities." Brian Massumi, *Parables for the Virtual: Movement, Affect, Sensation* (Durham, NC: Duke University Press, 2002), 19.

16. James Martineau, "Cerebral Psychology: Bain," in *Essays, Philosophical and Theological* (New York: Henry Holt, 1883), 1:254.

17. Classic formulations of this problem are David J. Chalmers, "Facing up to the Problem of Consciousness," *Journal of Consciousness Studies* 2, no. 3 (1995): 200–219; and Thomas Nagel, "What Is It Like to Be a Bat?," *Philosophical Review* 83, no. 4 (October 1974): 435–50.

18. Grant Allen, *Physiological Aesthetics* (London: Henry S. King, 1877), viii. James Sully, "Art and Psychology," *Mind* 1, no. 4 (October 1876), 467.

19. Work within neuroaesthetics not only tends to explicitly define aesthetics as the philosophy of art (as, e.g., in V. S. Ramachandran and W. Hirstein, "The Science of Art: A Neurological Theory of Aesthetic Experience," *Journal of Consciousness Studies* 6, no. 6/7 [June/July 1999]: 15–51); it also tends to focus on

an accepted canon of Western art. Semir Zeki's instances include Michelangelo, Cézanne, Rimbaud, Wagner, and Mann; G. Gabrielle Starr focuses her inquiry on the "Sister Arts of music, painting and poetry" with Keats's "Ode on a Grecian Urn" as a recurring test case. See Semir Zeki, *Splendors and Miseries of the Brain: Love, Creativity, and the Quest for Human Happiness* (Malden, MA: Wiley-Blackwell, 2009), and G. Gabrielle Starr, *Feeling Beauty: The Neuroscience of Aesthetic Experience* (Cambridge, MA: MIT Press, 2013). Correspondingly, cognitive studies commonly juxtapose texts from a wide range of historical periods whose status as "literature" is uncontroversial; among many such examples is Joshua Landy's provocative *How to Do Things with Fictions* (Oxford: Oxford University Press, 2012), which addresses Chaucer, Mark, Mallarmé, Plato, and Beckett. My point is not that there is nothing to be learned by focusing on canonical works but that conflating "aesthetics" with the philosophy of art is often unnecessarily limiting. A similar argument is developed by Patrick Colm Hogan: "What is actually taken to be art is a function of history." See Patrick Colm Hogan, "Art Appreciation and Aesthetic Feeling as Objects of Explanation," *Behavioral and Brain Sciences* 36, no. 2 (April 2013), 147.

20. Walter Benjamin, *The Arcades Project*, ed. Rolf Tiedemann, trans. Howard Eiland and Kevin McLaughlin (Cambridge, MA: Harvard University Press, 2002), 463.

21. Bruno Latour, *Reassembling the Social: An Introduction to Actor-Network-Theory* (Oxford: Oxford University Press, 2005), 256.

22. Bruno Latour, "Why Has Critique Run out of Steam? From Matters of Fact to Matters of Concern," *Critical Inquiry* 30, no. 2 (Winter 2004), 231.

23. Bruno Latour, *An Inquiry into Modes of Existence: An Anthropology of the Moderns* (Cambridge, MA: Harvard University Press, 2013), 10.

24. Smith and Helfand, *Oscar Wilde's Oxford Notebooks*, 135.

25. Catherine Malabou, *What Should We Do with Our Brain?* (New York: Fordham University Press, 2008), 5.

26. Catherine Malabou, *Plasticity at the Dusk of Writing: Dialectic, Destruction, Deconstruction* (New York: Columbia University Press, 2010), 54, 55.

27. Wilde, *Picture of Dorian Gray*, 219, 280.

Bibliography

Adorno, Theodor W. *Aesthetic Theory*. Edited by Gretel Adorno and Rolf Tiedemann. Translated by Robert Hullot-Kentor. Minneapolis: University of Minnesota Press, 1997.
———. "Valéry Proust Museum." In *Prisms*, translated by Samuel and Shierry Weber, 173–86. Cambridge, MA: MIT Press, 1981.
Agamben, Giorgio. "Vocation and Voice." Translated by Jeff Fort. *Qui Parle* 10, no. 2 (Spring/Summer 1997): 89–100.
Agosta, Louis. *Empathy in the Context of Philosophy*. New York: Palgrave Macmillan, 2010.
Albertazzi, Liliana. "The Aesthetics of Particulars: A Case of Intuitive Mechanics." *Axiomathes* 1/2 (1998): 169–96.
Alexander, Edward. "Ruskin and Science." *Modern Language Review* 64, no. 3 (July 1969): 508–21.
Alison, Archibald. *Essays on the Nature and Principles of Taste*. Edinburgh: Bell & Bradfute, 1811. First published 1790.
Allen, Grant. "Aesthetic Evolution in Man." *Mind* 5, no. 20 (October 1880): 445–64.
———. *The Colour-Sense: Its Origin and Development*. London: Trübner, 1879.
———. *The Evolutionist at Large*. London: Chatto & Windus, 1881.
———. "The New Hedonism." *Fortnightly Review* 55, no. 327 (March 1894): 377–92.
———. *Physiological Aesthetics*. London: Henry S. King, 1877.
———. "Physiological Aesthetics and Philistia." In *My First Book*. London: Chatto & Windus, 1897.
Allport, Gordon. *Personality: A Psychological Interpretation*. New York: Henry Holt, 1937.

Altieri, Charles. *The Particulars of Rapture: An Aesthetics of the Affects*. Ithaca, NY: Cornell University Press, 2003.

———. "The Sensuous Dimension of Literary Experience: An Alternative to Materialist Theory." *New Literary History* 38, no. 1 (2007): 71–98.

Anderson, Amanda. *The Powers of Distance: Cosmopolitanism and the Cultivation of Detachment*. Princeton, NJ: Princeton University Press, 2001.

Anderson, Ben. "Affective Atmospheres." In *Encountering Affect: Capacities, Apparatuses, Conditions*, 137–61. Farnham, UK: Ashgate, 2014.

Andrews, Michael F. "Edmund Husserl: Empathy and the Transcendental Constitution of the World." In *Does the World Exist?*, edited by Anna-Teresa Tymieniecka, 217–37. Analecta Husserliana 79. The Netherlands: Springer, 2004.

Anger, Suzy. *Victorian Interpretation*. Ithaca, NY: Cornell University Press, 2005.

Anstruther-Thomson, Clementina. *Art and Man: Essays and Fragments*. Edited by Vernon Lee. London: John Lane, 1924.

Arata, Stephen. "The Impersonal Intimacy of Marius the Epicurean." In *The Feeling of Reading: Affective Experience and Victorian Literature*, edited by Rachel Ablow, 131–56. Ann Arbor: University of Michigan Press, 2010.

———. "On Not Paying Attention." *Victorian Studies* 46, no. 2 (2004): 193–205.

Arendt, Hannah. *Lectures on Kant's Political Philosophy*. Edited by Ronald Beiner. Chicago: University of Chicago Press, 1992.

Argüelles, José. *Charles Henry and the Formation of a Psychophysical Aesthetic*. Chicago: University of Chicago Press, 1972.

"Armadale." *Saturday Review*, June 16, 1866, 726–27.

Armstrong, Isobel. *The Radical Aesthetic*. Oxford: Blackwell, 2000.

———. *Victorian Poetry: Poetry, Poetics, and Politics*. New York: Routledge, 1993.

Armstrong, Paul B. *How Literature Plays with the Brain: The Neuroscience of Reading and Art*. Baltimore: Johns Hopkins University Press, 2013.

Arnold, Matthew. *Culture and Anarchy and Other Writings*. Edited by Stefan Collini. Cambridge: Cambridge University Press, 1993. First published 1869.

Arscott, Caroline. *William Morris and Edward Burne-Jones: Interlacings*. New Haven, CT: Yale University Press, 2008.

———. "William Morris: Decoration and Materialism." In *Marxism and the History of Art: From William Morris to the New Left*, edited by Andrew Hemingway, 9–27. London: Pluto, 2006.

Attridge, Derek. "A Return to Form?" *Textual Practice* 22, no. 3 (September 2008): 563–75.

Bain, Alexander. *The Emotions and the Will*. London: John W. Parker & Son, 1859.

———. *Mind and Body: The Theories of Their Relation*. London: Henry S. King, 1873.

———. *The Senses and the Intellect*. London: John W. Parker & Son, 1855.

Balfour, Henry. *The Evolution of Decorative Art: An Essay upon Its Origin and Development as Illustrated by the Art of Modern Races of Mankind*. New York: Macmillan, 1893.

Barton, Ruth. "John Tyndall, Pantheist: A Rereading of the Belfast Address." *Osiris*, 2nd ser., 3 (1987): 111–34.

Baumgarten, Alexander Gottlieb. *Aesthetica/Ästhetik*. 2 vols. Edited and translated by Dagmar Mirbach. Hamburg: Felix Meiner, 2007.

Beardsley, Monroe C. *Aesthetics: Problems in the Philosophy of Criticism*. New York: Harcourt, 1958.

Beaumont, Matthew. "Pater as Psychagogue: Psychology, Aesthetics, Rhetoric." *19: Interdisciplinary Studies in the Long Nineteenth Century*, no. 12 (2011). http://www.19.bbk.ac.uk/articles/10.16995/ntn.592/.

Beer, Gillian. *Darwin's Plots: Evolutionary Narrative in Darwin, George Eliot and Nineteenth-Century Fiction*. 3rd ed. Cambridge: Cambridge University Press, 2009.

———. *Open Fields: Science in Cultural Encounter*. Oxford: Oxford University Press, 1999.

Begg, W. Proudfoot. *The Development of Taste, and Other Studies in Aesthetics*. Glasgow: James Maclehose & Sons, 1887.

Bell, Clive. *Art*. New York: Frederick A. Stokes, 1914.

Benjamin, Walter. *The Arcades Project*. Edited by Rolf Tiedemann. Translated by Howard Eiland and Kevin McLaughlin. Cambridge, MA: Harvard University Press, 2002.

Bennett, Jane. *Vibrant Matter: A Political Ecology of Things*. Durham, NC: Duke University Press, 2010.

Berenson, Bernard. *The Florentine Painters of the Renaissance*. New York: G. P. Putnam's Sons, 1896.

Berrios, G. E. *The History of Mental Symptoms: Descriptive Psychopathology since the Nineteenth Century*. Cambridge: Cambridge University Press, 1996.

Bizup, Joseph. *Manufacturing Culture: Vindications of Early Victorian Industry*. Charlottesville: University of Virginia Press, 2003.

Bizzotto, Elisa. "The Imaginary Portrait: Pater's Contribution to a Literary Genre." In *Walter Pater: Transparencies of Desire*, edited by Laurel Brake, Lesley Higgins, and Carolyn Williams, 73–89. Greensboro, NC: ELT Press, 2002.

Björk, Lennart A. *Psychological Vision and Social Criticism in the Novels of Thomas Hardy*. Stockholm: Almqvist & Wiksell, 1987.

Blair, Kirstie. *Victorian Poetry and the Culture of the Heart*. Oxford: Oxford University Press, 2006.

Boase, G. C., and Roger T. Stearn. "Dallas, Eneas Sweetland (1828–1879)." In *The Oxford Dictionary of National Biography*, edited by H. C. G. Matthew and B. Harrison. Oxford: Oxford University Press, 2004.

Boehm, Katharina, ed. *Bodies and Things in Nineteenth-Century Literature and Culture*. Basingstoke, UK: Palgrave Macmillan, 2012.

Boos, Florence S. "The Structure of Morris's Tales for the *Oxford and Cambridge Magazine*." *Victorian Periodicals Review* (1987): 2–12.

Boring, Edwin G. *A History of Experimental Psychology*. New York: Appleton-Century, 1929.

Bourdieu, Pierre. *Distinction: A Social Critique of the Judgement of Taste*. Cambridge, MA: Harvard University Press, 1984.

Boyd, Brian. *On the Origin of Stories: Evolution, Cognition, and Fiction.* Cambridge, MA: Harvard University Press, 2009.

Braddon, M. E. *Lady Audley's Secret.* Edited by Lyn Pykett. Oxford: Oxford University Press, 2012. First published 1862.

Brain, Robert Michael. "The Pulse of Modernism: Experimental Physiology and Aesthetic Avant-Gardes circa 1900." *Studies in History and Philosophy of Science Part A* 39, no. 3 (September 2008): 393–417.

Brain, Robert Michael, Robert S. Cohen, and Ole Knudsen, eds. *Hans Christian Ørsted and the Romantic Legacy in Science: Ideas, Disciplines, Practices.* Dordrecht, The Netherlands: Springer, 2007.

Brake, Laurel. *Walter Pater.* Plymouth: Northcote House, 1994.

"Branch Meeting Rooms." *Commonweal,* January 1886, 8.

Brantlinger, Patrick. "'News from Nowhere': Morris's Socialist Anti-Novel." *Victorian Studies* 19, no. 1 (September 1975): 35–49.

Brattico, Elvira, and Marcus Pearce. "The Neuroaesthetics of Music." *Psychology of Aesthetics, Creativity, and the Arts* 7, no. 1 (2013): 48–61.

Brennan, Teresa. *The Transmission of Affect.* Ithaca, NY: Cornell University Press, 2004.

Brett, David. "The Aesthetical Science: George Field and the 'Science of Beauty.'" *Art History* 9 (September 1986): 336–50.

Briggs, Asa. *Victorian Things.* Chicago: University of Chicago Press, 1989.

Brown, Bill. "Objects, Others, and Us (The Refabrication of Things)." *Critical Inquiry* 36, no. 2 (Winter 2010): 183–217.

———. *A Sense of Things: The Object Matter of American Literature.* Chicago: University of Chicago Press, 2003.

———. "Thing Theory." *Critical Inquiry* 28, no. 1 (Autumn 2001): 1–22.

Brown, Julia Prewitt. *Cosmopolitan Criticism: Oscar Wilde's Philosophy of Art.* Charlottesville: University Press of Virginia, 1997.

Buchanan, Robert. "Lucretius and Modern Materialism." *New Quarterly* 6 (April 1876): 1–30.

Buckland, Adelene. *Novel Science: Fiction and the Invention of Nineteenth-Century Geology.* Chicago: University of Chicago Press, 2013.

Buck-Morss, Susan. "Aesthetics and Anaesthetics: Walter Benjamin's Artwork Essay Reconsidered." *October* 62 (October 1992): 3–41.

Bullen, J. B. *The Expressive Eye: Fiction and Perception in the Work of Thomas Hardy.* Oxford: Clarendon, 1986.

Bullot, Nicolas J., and Rolf Reber. "The Artful Mind Meets Art History: Toward a Psycho-Historical Framework for the Science of Art Appreciation." *Behavioral and Brain Sciences* 36, no. 2 (2013): 123–37.

Burdett, Carolyn. "'The Subjective inside Us Can Turn into the Objective Outside': Vernon Lee's Psychological Aesthetics." *19: Interdisciplinary Studies in the Long Nineteenth Century,* no. 12 (2011). http://www.19.bbk.ac.uk/articles/10.16995/ntn.610/.

Bürger, Peter. *Theory of the Avant-Garde.* Manchester: Manchester University Press, 1984.

Burgon, John William. *Lives of Twelve Good Men.* Vol. 2. London: John Murray, 1889.

Burke, Edmund. *A Philosophical Enquiry into the Origin of Our Ideas of the Sublime and Beautiful.* Edited by Adam Phillips. New York: Oxford University Press, 2009. First published 1757.

Burne-Jones, Georgiana. *Memorials of Edward Burne-Jones.* London: Macmillan, 1904.

Buzard, James. *Disorienting Fiction: The Autoethnographic Work of Nineteenth-Century British Novels.* Princeton, NJ: Princeton University Press, 2005.

Cahan, David, ed. *Hermann von Helmholtz and the Foundations of Nineteenth-Century Science.* Berkeley: University of California Press, 1994.

Camlot, Jason. *Style and the Nineteenth-Century British Critic: Sincere Mannerisms.* Aldershot, UK: Ashgate, 2008.

Caracciolo, Marco. "Embodiment at the Crossroads: Some Open Questions between Literary Interpretation and Cognitive Science." *Poetics Today* 34, no. 1/2 (Spring/Summer 2013): 233–53.

Cardno, J. A. "Bain and Physiological Psychology." *Australian Journal of Psychology* 7, no. 2 (1955): 108–20.

Carlisle, Janice. *Common Scents: Comparative Encounters in High-Victorian Fiction.* New York: Oxford University Press, 2004.

———. *Picturing Reform in Victorian Britain.* Cambridge: Cambridge University Press, 2012.

Carpenter, Joseph Estlin. *James Martineau, Theologian and Teacher: A Study of His Life and Thought.* Boston: American Unitarian Association, 1905.

Carpenter, William Benjamin. *Principles of Human Physiology.* Philadelphia: Blanchard & Lea, 1859.

Cassirer, Ernst. *The Philosophy of the Enlightenment.* Princeton, NJ: Princeton University Press, 1951.

Castronovo, Russ. *Beautiful Democracy: Aesthetics and Anarchy in a Global Era.* Chicago: University of Chicago Press, 2007.

Chakrabarty, Dipesh. "The Climate of History: Four Theses." *Critical Inquiry* 35, no. 2 (Winter 2009): 197–222.

Chalmers, David J. "Facing Up to the Problem of Consciousness." *Journal of Consciousness Studies* 2, no. 3 (1995): 200–219.

Chalmers, Thomas. *On the Adaptation of External Nature to the Moral and Intellectual Constitution of Man.* London: William Pickering, 1833.

Chandler, Albert Richard, and Edward Norton Barnhart. *A Bibliography of Psychological and Experimental Aesthetics, 1864–1937.* Berkeley: University of California Press, 1938.

Chatterjee, Anjan. "Neuroaesthetics: A Coming of Age Story." *Journal of Cognitive Neuroscience* 23, no. 1 (February 2010): 53–62.

Chesterton, G. K. *The Victorian Age in Literature.* New York: Henry Holt, 1913.

"Chromatography; or, A Treatise on Colours and Pigments, &c." *Athenaeum* 408 (August 22, 1835): 637–38.

Clark, Andy, and David Chalmers. "The Extended Mind." *Analysis* 58, no. 1 (January 1998): 7–19.

Clark, John. *Elements of Drawing and Painting in Water Colours.* London: Wm. S. Orr, 1838.

Clifford, W. K. "On the Nature of Things-in-Themselves." *Mind* 3, no. 9 (January 1878): 57–67.

Clutton-Brock, Arthur. "Morris in the Present." *Times Literary Supplement.* August 8, 1912.

Cohen, William A. *Embodied: Victorian Literature and the Senses.* Minneapolis: University of Minnesota Press, 2009.

Cohn, Elisha. "'One Single Ivory Cell': Oscar Wilde and the Brain." *Journal of Victorian Culture* 17, no. 2 (June 2012): 183–205.

Colby, Vineta. *Vernon Lee: A Literary Biography.* Charlottesville: University of Virginia Press, 2003.

Collingwood, R. G. *The Idea of History.* Edited by T. M. Knox. Oxford: Clarendon, 1946.

Collins, Wilkie. *The Woman in White.* London: Penguin, 2003. First published 1859.

Comte, Auguste. *The Positive Philosophy of Auguste Comte.* Translated by Harriet Martineau. London: John Chapman, 1853.

Connolly, William E. *The Fragility of Things: Self-Organizing Processes, Neoliberal Fantasies, and Democratic Activism.* Durham, NC: Duke University Press, 2013.

Costelloe, Timothy M. *The British Aesthetic Tradition: From Shaftesbury to Wittgenstein.* Cambridge: Cambridge University Press, 2013.

Crane, Walter. *William Morris to Whistler: Papers and Addresses on Art and Craft and the Commonweal.* London: Bell, 1911.

Crary, Jonathan. *Suspensions of Perception: Attention, Spectacle, and Modern Culture.* Cambridge, MA: MIT Press, 2001.

Cromwell, Oliver. *The Life of John Sterling.* London: Chapman & Hall, 1851.

Cronin, Helena. *The Ant and the Peacock: Altruism and Sexual Selection from Darwin to Today.* Cambridge: Cambridge University Press, 1991.

Csordas, Thomas J. "Somatic Modes of Attention." *Cultural Anthropology* 8, no. 2 (May 1993): 135–56.

Cvetkovich, Ann. *Mixed Feelings: Feminism, Mass Culture, and Victorian Sensationalism.* New Brunswick, NJ: Rutgers University Press, 1992.

Dale, Peter Allan. *In Pursuit of a Scientific Culture: Science, Art, and Society in the Victorian Age.* Madison: University of Wisconsin Press, 1989.

Dallas, E. S. *The Gay Science.* 2 vols. London: Chapman & Hall, 1866.

———. *Poetics.* London: Smith, Elder, 1852.

Daly, Nicholas. *Literature, Technology, and Modernity, 1860–2000.* Cambridge: Cambridge University Press, 2004.

———. *Sensation and Modernity in the 1860s.* Cambridge: Cambridge University Press, 2009.

Dames, Nicholas. *The Physiology of the Novel: Reading, Neural Science, and the Form of Victorian Fiction.* Oxford: Oxford University Press, 2007.

Danta, Chris, and Helen Groth, eds. *Mindful Aesthetics: Literature and the Science of Mind.* London: Bloomsbury, 2014.

Danto, Arthur. "The Artworld." *Journal of Philosophy* 61, no. 19 (October 15, 1964): 571–84.

Danziger, Kurt. *Naming the Mind: How Psychology Found Its Language*. London: Sage, 1997.

Darwin, Charles. *The Descent of Man, and Selection in Relation to Sex*. London: Penguin, 2004. First published 1871.

Daston, Lorraine. "British Responses to Psycho-Physiology, 1860–1900." *Isis* 69, no. 2 (June 1978): 192–208.

———. "Ørsted and the Rational Unconscious." In *Hans Christian Ørsted and the Romantic Legacy in Science: Ideas, Disciplines, Practices*, 235–46. Dordrecht, The Netherlands: Springer, 2007.

———. "Theory of Will versus the Science of Mind." In *The Problematic Science: Psychology in Nineteenth-Century Thought*, edited by William R. Woodward and Mitchell G. Ash, 88–115. New York: Praeger, 1982.

Daston, Lorraine, and Peter Galison. *Objectivity*. New York: Zone Books, 2007.

Davis, Michael. *George Eliot and Nineteenth-Century Psychology: Exploring the Unmapped Country*. Aldershot, UK: Ashgate, 2006.

———. "Mind and Matter in *The Picture of Dorian Gray*." *Victorian Literature and Culture* 41, no. 3 (2013): 547–60.

Davis, Whitney. *Queer Beauty: Sexuality and Aesthetics from Winckelmann to Freud and Beyond*. New York: Columbia University Press, 2010.

Dawson, Gowan. *Darwin, Literature and Victorian Respectability*. Cambridge: Cambridge University Press, 2007.

———. "Literary Megatheriums and Loose Baggy Monsters: Paleontology and the Victorian Novel." *Victorian Studies* 53, no. 2 (2011): 203–30.

———. "Walter Pater's Marius the Epicurean and the Discourse of Science in Macmillan's Magazine: 'A Creature of the Nineteenth Century.'" *English Literature in Transition, 1880–1920* 48, no. 1 (2005): 38–54.

Day, Henry Noble. *The Science of Aesthetics; or, The Nature, Kinds, Laws, and Uses of Beauty*. New York: Putnam, 1872.

De Bolla, Peter. *Art Matters*. Cambridge, MA: Harvard University Press, 2001.

Deleuze, Gilles. *The Logic of Sense*. Edited by Constantin V. Boundas. Translated by Mark Lester. New York: Columbia University Press, 1990.

Deleuze, Gilles, and Félix Guattari. *What Is Philosophy?* London: Verso, 1994.

De Man, Paul. "Aesthetic Formalization: Kleist's 'Über das Marionettentheater.'" In *The Rhetoric of Romanticism*, 263–90. New York: Columbia University Press, 1984.

———. *Aesthetic Ideology*. Edited by Andrzej Warminski. Minneapolis: University of Minnesota Press, 1996.

———. "Kant and Schiller." In *Aesthetic Ideology*, edited by Andrzej Warminski, 129–62. Minneapolis: University of Minnesota Press, 1996.

———. "The Return to Philology." In *The Resistance to Theory*, 21–26. Minneapolis: University of Minnesota Press, 1986.

De Morgan, Sophia Elizabeth. *Memoir of Augustus De Morgan*. London: Longmans, Green, 1882.

Derrida, Jacques. *The Truth in Painting*. Chicago: University of Chicago Press, 1987.

Descola, Philippe. *Beyond Nature and Culture*. Translated by Janet Lloyd. Chicago: University of Chicago Press, 2013.

Dewey, John. *Art as Experience*. New York: Perigee, 1980.

DeWitt, Anne. *Moral Authority, Men of Science, and the Victorian Novel*. Cambridge: Cambridge University Press, 2013.

Dickie, George. *The Century of Taste: The Philosophical Odyssey of Taste in the Eighteenth Century*. New York: Oxford University Press, 1996.

Dimock, Wai Chee. *Through Other Continents: American Literature across Deep Time*. Princeton, NJ: Princeton University Press, 2006.

Dixon, Thomas M. *From Passions to Emotions: The Creation of a Secular Psychological Category*. Cambridge: Cambridge University Press, 2003.

Donald, Diana, and Jane Munro, eds. *Endless Forms: Charles Darwin, Natural Science and the Visual Arts*. New Haven, CT: Yale University Press, 2009.

Donisthorpe, Wordsworth. *Individualism: A System of Politics*. London: Macmillan, 1889.

Dowling, Linda C. *Hellenism and Homosexuality in Victorian Oxford*. Ithaca, NY: Cornell University Press, 1996.

———. *The Vulgarization of Art: The Victorians and Aesthetic Democracy*. Charlottesville: University Press of Virginia, 1996.

Dreyfus, Hubert L. "Affectedness." In *Being-in-the-World: A Commentary on Heidegger's* Being and Time, *Division I*, 168–83. Cambridge, MA: MIT Press, 1991.

Eagleton, Terry. "Categories for a Materialist Criticism." In *Criticism and Ideology: A Study in Marxist Literary Theory*, 44–63. London: Verso, 1976.

———. *The Ideology of the Aesthetic*. Cambridge: Blackwell, 1990.

Eddy, H. T. "The Characteristic Curves of Composition." *Science* 9, no. 216 (March 25, 1887): 297.

Ehrenberg, Alain. "Le sujet cérébral." *Esprit* 11 (November 2004): 130–55.

Eisenberg, Nancy. "Emotion, Regulation, and Moral Development." *Annual Review of Psychology* 51 (2000): 665–97.

Eliot, George. *The George Eliot Letters, Vol. 5: 1869–1873*, edited by Gordon S. Haight. New Haven. CT: Yale University Press, 1954.

———. *Middlemarch*. Oxford: Oxford University Press, 1997.

———. *The Poems of George Eliot*. 2 vols. Boston: Little, Brown, 1900.

Eliot, T. S. "Arnold and Pater." In *Selected Essays*, 393–405. New York: Harcourt, 1950. First published 1930.

Ellenberger, Henri F. *The Discovery of the Unconscious: The History and Evolution of Dynamic Psychiatry*. New York: Basic Books, 1970.

Ellis, Havelock. "Thomas Hardy's Novels." *Westminster Review* 119 (April 1883): 334–64.

Erneling, Christina E., and David Martel Johnson, eds. *The Mind as a Scientific Object: Between Brain and Culture*. New York: Oxford University Press, 2005.

Esrock, E. J. "Embodying Art: The Spectator and the Inner Body." *Poetics Today* 31, no. 2 (Summer 2010): 217–50.

Evangelista, Stefano-Maria. *British Aestheticism and Ancient Greece: Hellenism, Reception, Gods in Exile*. Basingstoke, UK: Palgrave Macmillan, 2009.

Fechner, Gustav Theodor. *Vorschule der Aesthetik*. 2 vols. Leipzig: Breitkopf & Härtel, 1876.

Ferguson, Frances. "Philology, Literature, Style." *ELH* 80, no. 2 (Summer 2013): 323–41.

Fichte, Johann Gottlieb. "On the Spirit and the Letter in Philosophy." In *German Aesthetic and Literary Criticism*, edited by David Simpson, 74–93. Cambridge: Cambridge University Press, 1984.

Field, George. *Chromatics; or, An Essay on the Analogy and Harmony of Colours*. London: A. J. Valpy, 1817.

———. *Chromatics; or, The Analogy, Harmony, and Philosophy of Colours*. London: David Bogue, 1845.

———. *Chromatography; or, A Treatise on Colours and Pigments: And of Their Powers in Painting*. London: Tilt & Bogue, 1841.

———. *Outlines of Analogical Philosophy: Being a Primary View of the Principles, Relations and Purposes of Nature, Science, and Art*. 2 vols. London: Charles Tilt, 1839.

Fisher, Philip. *The Vehement Passions*. Princeton, NJ: Princeton University Press, 2002.

Flatley, Jonathan. *Affective Mapping: Melancholia and the Politics of Modernism*. Cambridge, MA: Harvard University Press, 2008.

Fleishman, Avrom. *George Eliot's Intellectual Life*. Cambridge: Cambridge University Press, 2010.

Flesch, William. *Comeuppance: Costly Signaling, Altruistic Punishment, and Other Biological Components of Fiction*. Cambridge, MA: Harvard University Press, 2007.

Flint, Kate. *The Victorians and the Visual Imagination*. Cambridge: Cambridge University Press, 2000.

Fogle, Richard Harter. *The Imagery of Keats and Shelley: A Comparative Study*. Chapel Hill: University of North Carolina Press, 1949.

Forman, Harry Buxton. *The Books of William Morris: Described with Some Account of His Doings in Literature and in the Allied Crafts*. N.p.: F. Hollings, 1897.

Foster, Hal. "Introduction." In *The Anti-Aesthetic: Essays on Postmodern Culture*, ix–xvi. Port Townsend, WA: Bay Press, 1983.

Francis, Mark. *Herbert Spencer and the Invention of Modern Life*. Ithaca, NY: Cornell University Press, 2007.

Francis, Mark, and Michael W. Taylor, eds. *Herbert Spencer: Legacies*. New York: Routledge, 2015.

Frankel, Nicholas. "The Ecology of Decoration: Design and Environment in the Writings of William Morris." *Journal of Pre-Raphaelite Studies* 12 (2003): 58–85.

———. "The Ecstasy of Decoration: The Grammar of Ornament as Embodied Experience." *Nineteenth-Century Art Worldwide* 2, no. 1 (Winter 2003).

Freedberg, David, and Vittorio Gallese. "Motion, Emotion and Empathy in Esthetic Experience." *Trends in Cognitive Sciences* 11, no. 5 (May 2007): 197–203.

Freedgood, Elaine. *The Ideas in Things: Fugitive Meaning in the Victorian Novel*. Chicago: University of Chicago Press, 2006.

Freedman, Jonathan. *Professions of Taste: Henry James, British Aestheticism, and Commodity Culture*. Stanford, CA: Stanford University Press, 1993.

Freeland, Cynthia A. *Portraits and Persons*. Oxford: Oxford University Press, 2010.

"French Philosophy during the Restoration." *London Quarterly Review* 8 (April 1857): 165–97.

Frost, Mark. "'The Circles of Vitality': Ruskin, Science, and Dynamic Materiality." *Victorian Literature and Culture* 39, no. 2 (2011): 367–83.

Frye, Northrop. *The Secular Scripture and Other Writings on Critical Theory, 1976–1991*. Edited by Jean Wilson and Joseph Adamson. Toronto: University of Toronto Press, 2006.

Gage, John. *Color and Culture: Practice and Meaning from Antiquity to Abstraction*. Berkeley: University of California Press, 1999.

———. *George Field and His Circle: From Romanticism to the Pre-Raphaelite Brotherhood*. London: Christies, 1989.

Gagnier, Regenia. *Individualism, Decadence and Globalization: On the Relationship of Part to Whole, 1859–1920*. Basingstoke, UK: Palgrave Macmillan, 2010.

———. *The Insatiability of Human Wants: Economics and Aesthetics in Market Society*. Chicago: University of Chicago Press, 2000.

Gallagher, Catherine. *The Body Economic: Life, Death, and Sensation in Political Economy and the Victorian Novel*. Princeton, NJ: Princeton University Press, 2006.

Gallop, Jane. "The Historicization of Literary Studies and the Fate of Close Reading." *Profession* (2007): 181–86.

Garratt, Peter. *Victorian Empiricism: Self, Knowledge, and Reality in Ruskin, Bain, Lewes, Spencer, and George Eliot*. Madison, NJ: Fairleigh Dickinson University Press, 2010.

"The Gay Science." *Blackwood's Edinburgh Magazine* 101 (February 1867): 155.

"The Gay Science." *London Quarterly Review* 28 (April 1867): 140–66.

"The Gay Science: The Science of Criticism." *Bentley's Miscellany* 61 (1867): 187–95.

Gerwig, G. W. "On the Decrease of Predication and of Sentence Weight in English Prose." *University Studies* 2, no. 1 (July 1894): 17–44.

Gilbert, Pamela K. *Disease, Desire, and the Body in Victorian Women's Popular Novels*. Cambridge: Cambridge University Press, 1997.

Gillespie, Neal C. "Divine Design and the Industrial Revolution: William Paley's Abortive Reform of Natural Theology." *Isis* 81, no. 2 (June 1990): 214–29.

Gilmore, Paul. *Aesthetic Materialism: Electricity and American Romanticism*. Stanford, CA: Stanford University Press, 2009.

Goldberg, Jonathan. *The Seeds of Things: Theorizing Sexuality and Materiality in Renaissance Representations*. New York: Fordham University Press, 2009.

Goodsir, John. *The Anatomical Memoirs of John Goodsir*. Edited by William Turner. 2 vols. Edinburgh: Adam & Charles Black, 1868.

———. Papers. The University of Edinburgh Centre for Research Collections.

Gordon, Kate. "Beauty and Ugliness and Other Studies in Psychological Aesthetics." *Psychological Bulletin* 9, no. 11 (November 15, 1912): 430–31.

————. *Esthetics*. New York: Henry Holt, 1909.

Gossin, Pamela. *Thomas Hardy's Novel Universe: Astronomy, Cosmology, and Gender in the Post-Darwinian World*. Aldershot, UK: Ashgate, 2007.

Gould, Stephen Jay. *Time's Arrow, Time's Cycle: Myth and Metaphor in the Discovery of Geological Time*. Cambridge, MA: Harvard University Press, 1987.

Graff, Gerald. "What Was New Criticism? Literary Interpretation and Scientific Objectivity." *Salmagundi*, no. 27 (Summer/Fall 1974): 72–93.

Greenblatt, Stephen. *The Swerve: How the World Became Modern*. New York: W. W. Norton, 2011.

Greenslade, William, and Terence Rodgers. "Resituating Grant Allen: Writing, Radicalism and Modernity." In *Grant Allen: Literature and Cultural Politics at the Fin de Siècle*, edited by William Greenslade and Terence Rodgers, 1–22. Aldershot, UK: Ashgate, 2005.

Greiner, D. Rae. "Thinking of Me Thinking of You: Sympathy versus Empathy in the Realist Novel." *Victorian Studies* 53, no. 3 (2011): 417–26.

Groos, Karl. *The Play of Man*. Translated by Elizabeth L. Baldwin. New York: Appleton, 1913.

Gross, Daniel M. "Defending the Humanities with Charles Darwin's *The Expression of the Emotions in Man and Animals* (1872)." *Critical Inquiry* 37, no. 1 (Autumn 2010): 34–59.

Grosse, Ernst. *The Beginnings of Art*. New York: D. Appleton, 1897.

Grosz, Elizabeth A. *Becoming Undone: Darwinian Reflections on Life, Politics, and Art*. Durham, NC: Duke University Press, 2011.

————. *Chaos, Territory, Art: Deleuze and the Framing of the Earth*. New York: Columbia University Press, 2008.

Guillory, John. "Literary Study and the Modern System of the Disciplines." In *Disciplinarity at the Fin de Siècle*. Princeton, NJ: Princeton University Press, 2002.

Gumbrecht, Hans Ulrich. *Atmosphere, Mood, Stimmung: On a Hidden Potential of Literature*. Translated by Erik Butler. Stanford, CA: Stanford University Press, 2012.

————. *Production of Presence: What Meaning Cannot Convey*. Stanford, CA: Stanford University Press, 2004.

Gunn, Peter. *Vernon Lee: Violet Paget, 1856–1935*. Oxford: Oxford University Press, 1964.

Gurney, Edmund. *The Power of Sound*. London: Smith, Elder, 1880.

Guyau, Jean-Marie. *Les problèmes de l'esthétique contemporaine*. Paris: Alcan, 1884.

Guyer, Paul. *Knowledge, Reason, and Taste: Kant's Response to Hume*. Princeton, NJ: Princeton University Press, 2008.

————. "The Psychology of Kant's Aesthetics." *Studies in History and Philosophy of Science Part A* 39, no. 4 (Winter 2008): 483–94.

Hack, Daniel. *The Material Interests of the Victorian Novel*. Charlottesville: University of Virginia Press, 2005.

Haggard, H. Rider. "About Fiction." *Contemporary Review* 51 (1887): 172–80.

Hale, Piers J. "Of Mice and Men: Evolution and the Socialist Utopia. William

Morris, H.G. Wells, and George Bernard Shaw." *Journal of the History of Biology* 43, no. 1 (April 2010): 17–66.

Hall, Jason David, ed. *Meter Matters: Verse Cultures of the Long Nineteenth Century*. Athens: Ohio University Press, 2011.

Hampshire, Stuart. *Spinoza and Spinozism*. Oxford: Clarendon, 2005.

Hanson, Ingrid. *William Morris and the Uses of Violence, 1856–1890*. London: Anthem, 2013.

Hardy, Florence Emily. *The Early Life of Thomas Hardy, 1840–1891*. Cambridge: Cambridge University Press, 2011. First published 1928 by Macmillan.

Hardy, Thomas. *Desperate Remedies*. Oxford: Oxford University Press, 2009.

———. *The Literary Notebooks of Thomas Hardy*. Edited by Lennart A. Björk. New York: New York University Press, 1985.

———. *A Pair of Blue Eyes*. Oxford: Oxford University Press, 2009.

———. *The Return of the Native*. Oxford: Oxford University Press, 2008.

———. *Tess of the d'Urbervilles*. New York: Oxford University Press, 1998.

———. *The Woodlanders*. Oxford: Oxford University Press, 2005.

Harris, George. *Theory of the Arts; or, Art in Relation to Nature, Civilization and Man*. London: Trübner, 1869.

Harvard University Catalogue. Cambridge, MA: Harvard University, 1892.

Hatfield, Gary. "Helmholtz and Classicism: The Science of Aesthetics and the Aesthetics of Science." In *Hermann von Helmholtz and the Foundations of Nineteenth-Century Science*, edited by David Cahan, 522–58. Berkeley: University of California Press, 1994.

———. "Remaking the Science of Mind: Psychology as Natural Science." In *Inventing Human Science: Eighteenth-Century Domains*, edited by Christopher Fox, Roy Porter, and Robert Wokler, 184–231. Berkeley: University of California Press, 1995.

Hay, David Ramsay. *First Principles of Symmetrical Beauty*. Edinburgh: William Blackwood & Sons, 1846.

———. *The Harmonic Law of Nature Applied to Architectural Design*. Edinburgh: William Blackwood & Sons, 1855.

———. *The Laws of Harmonious Colouring, Adapted to Interior Decorations, Manufactures, and Other Useful Purposes*. 3rd ed. Edinburgh: William & Robert Chambers, 1836.

———. *The Natural Principles of Beauty, As Developed in the Human Figure*. Edinburgh: William Blackwood & Sons, 1852.

———. *On the Science of Those Proportions by Which the Human Head and Countenance, as Represented in Works of Ancient Greek Art, Are Distinguished from Those of Ordinary Nature*. Edinburgh: William Blackwood & Sons, 1849.

———. Papers. University of Edinburgh Centre for Research Collections.

———. *The Science of Beauty, as Developed in Nature and Applied in Art*. Edinburgh: W. Blackwood & Sons, 1856.

Hayman, Henry. "Mr. Munro's Lucretius." *Contemporary Review* 5 (June 1867): 222–36.

Hearnshaw, L. S. *A Short History of British Psychology, 1840–1940*. London: Methuen, 1964.

Hegel, Georg Wilhelm Friedrich. *Aesthetics: Lectures on Fine Art*. Oxford: Clarendon, 1988.

Heidegger, Martin. *Being and Time*. Translated by Joan Stambaugh. Albany: State University of New York Press, 2010.

Heller-Roazen, Daniel. *The Inner Touch: Archaeology of a Sensation*. New York: Zone Books, 2007.

Helsinger, Elizabeth K. *Poetry and the Pre-Raphaelite Arts: Dante Gabriel Rossetti and William Morris*. New Haven, CT: Yale University Press, 2008.

Henchman, Anna. *The Starry Sky Within: Astronomy and the Reach of the Mind in Victorian Literature*. Oxford: Oxford University Press, 2014.

Herbert, Christopher. *Victorian Relativity: Radical Thought and Scientific Discovery*. Chicago: University of Chicago Press, 2001.

Heringman, Noah. "Deep Time at the Dawn of the Anthropocene." *Representations* 129, no. 1 (Winter 2015): 56–85.

Hipple, Walter John. *The Beautiful, the Sublime, and the Picturesque in Eighteenth Century British Aesthetic Theory*. Carbondale: Southern Illinois University Press, 1957.

Hirn, Yrjö. *The Origins of Art*. London: Macmillan, 1900.

Hodgson, Amanda. *The Romances of William Morris*. Cambridge: Cambridge University Press, 1987.

Hogan, Patrick Colm. "Art Appreciation and Aesthetic Feeling as Objects of Explanation." *Behavioral and Brain Sciences* 36, no. 2 (April 2013): 147–48.

Holmes, David I. "Authorship Attribution." *Computers and the Humanities* 28, no. 2 (April 1994): 87–106.

Holmes, John. *Darwin's Bards: British and American Poetry in the Age of Evolution*. Edinburgh: Edinburgh University Press, 2009.

———. "Lucretius at the Fin de Siècle: Science, Religion and Poetry." *English Literature in Transition, 1880–1920* 51, no. 3 (2008): 266–80.

Hopkins, Gerard Manley. "That Nature Is Like a Heraclitean Fire and of the Comfort of the Resurrection." In *The Major Works*, edited by Catherine Phillips, 180–81. Oxford: Oxford University Press, 2009.

House of Commons. *Report from the Select Committee on Arts and Their Connexion with Manufactures*. London: House of Commons, 1836.

Hughes, Winifred. "E. S. Dallas: Victorian Poetics in Transition." *Victorian Poetry* 23, no. 1 (Spring 1985): 1–21.

Hume, David. *An Enquiry Concerning Human Understanding*. Edited by Peter Millican. Oxford: Oxford University Press, 2008. First published 1748.

———. *Selected Essays*. Edited by Andrew Edgar and Stephen Copley. Oxford: Oxford University Press, 1998.

Hunt, Robert. "On the Application of Science to the Fine and Useful Arts." *Art Journal* 12 (1850): 357–59.

———. *The Poetry of Science; or, Studies of the Physical Phenomena of Nature*. London: Reeve, Benham & Reeve, 1848.

Huxley, Thomas Henry. *Collected Essays*, vol. 1, *Methods and Results*. New York: D. Appleton, 1899.

Igarashi, Yohei. "Statistical Analysis at the Birth of Close Reading." *New Literary History* 46, no. 3 (Summer 2015): 485–504.

Ingarden, Roman. *The Literary Work of Art: An Investigation of the Border-lines of Ontology, Logic, and Theory of Language.* Translated by George G. Grabowicz. Evanston, IL: Northwestern University Press, 1979.

Inman, Billie Andrew. "'Sebastian van Storck': Pater's Exploration into Nihilism." *Nineteenth-Century Fiction* 30, no. 4 (March 1976): 457–76.

Iser, Wolfgang. *Walter Pater: The Aesthetic Moment.* Translated by David H. Wilson. Cambridge: Cambridge University Press, 1987.

Jackson, Abraham Willard. *James Martineau: A Biography and Study.* Boston: Little, Brown, 1901.

Jackson, Noel. *Science and Sensation in Romantic Poetry.* Cambridge: Cambridge University Press, 2011.

Jacobi, Charles Thomas. *On the Making and Issuing of Books.* London: Chiswick, 1891.

Jacobsen, Thomas. "Bridging the Arts and Sciences: A Framework for the Psychology of Aesthetics." *Leonardo* 39, no. 2 (2006): 155–62.

Jacyna, L. S. *Medicine and Modernism: A Biography of Sir Henry Head.* London: Pickering & Chatto, 2008.

————. "The Physiology of Mind, the Unity of Nature, and the Moral Order in Victorian Thought." *British Journal for the History of Science* 14, no. 2 (July 1981): 109–32.

Jahoda, Gustav. "Theodor Lipps and the Shift from 'Sympathy' to 'Empathy.'" *Journal of the History of the Behavioral Sciences* 41, no. 2 (Spring 2005): 151–63.

James, David. "Hearing Hardy: Soundscapes and the Profitable Reader." *Journal of Narrative Theory* 40, no. 2 (2010): 131–55.

James, Henry. *The Spoils of Poynton.* New York: Charles Scribner's Sons, 1908. First published 1896.

James, William. "Allen's Physiological Aesthetics." *Nation* 25, no. 638 (September 1877): 185–86.

————. "What Is an Emotion?" *Mind* 9, no. 34 (April 1884): 188–205.

Jameson, Fredric. *The Antinomies of Realism.* London: Verso, 2013.

————. *The Political Unconscious: Narrative as a Socially Symbolic Act.* Ithaca, NY: Cornell University Press, 1981.

Jannidis, Fotis, and Gerhard Lauer. "Burrows's Delta and Its Use in German Literary History." In *Distant Readings: Topologies of German Culture in the Long Nineteenth Century,* edited by Matt Erlin and Lynne Tatlock, 29–54. Rochester, NY: Camden House, 2014.

Javal, Émile. *Physiologie de la lecture et de l'écriture.* N.p.: F. Alcan, 1905.

Jenkin, Fleeming. "The Atomic Theory of Lucretius." *North British Review* 48 (March 1868): 111–28.

Johnson, Mark. *The Meaning of the Body: Aesthetics of Human Understanding.* Chicago: University of Chicago Press, 2007.

Johnston, Adrian, and Catherine Malabou. *Self and Emotional Life: Philosophy, Psychoanalysis, and Neuroscience.* New York: Columbia University Press, 2013.

Kant, Immanuel. *Critique of Pure Reason.* Edited and translated by Paul Guyer and Allen W. Wood. Cambridge: Cambridge University Press, 1998. First published 1781.

———. *Critique of the Power of Judgment*. Translated by Paul Guyer. Cambridge: Cambridge University Press, 2000. First published 1790.

Katz, Tamar. *Impressionist Subjects: Gender, Interiority, and Modernist Fiction in England*. Urbana: University of Illinois Press, 2000.

Kaufman, Robert. "Red Kant; or, The Persistence of the Third 'Critique' in Adorno and Jameson." *Critical Inquiry* 26, no. 4 (Summer 2000): 682–724.

Kawabata, Hideaki, and Semir Zeki. "Neural Correlates of Beauty." *Journal of Neurophysiology* 91, no. 4 (April 2004): 1699–1705.

Keen, Suzanne. "Empathetic Hardy: Bounded, Ambassadorial, and Broadcast Strategies of Narrative Empathy." *Poetics Today* 32, no. 2 (Summer 2011): 349–89.

———. *Empathy and the Novel*. Oxford: Oxford University Press, 2007.

———. "Introduction: Narrative and the Emotions." *Poetics Today* 32, no. 1 (Spring 2011): 1–53.

———. *Thomas Hardy's Brains: Psychology, Neurology, and Hardy's Imagination*. Columbus: Ohio State University Press, 2014.

Kern-Stähler, Annette. "Homer on the Evolutionary Scale: Interrelations between Biology and Literature in the Writings of William Gladstone and Grant Allen." In *Unmapped Countries: Biological Visions in Nineteenth Century Literature and Culture*, edited by Anne-Julia Zwierlein, 107–15. London: Anthem, 2005.

Ketabgian, Tamara S. *The Lives of Machines: The Industrial Imaginary in Victorian Literature and Culture*. Ann Arbor: University of Michigan Press, 2011.

Kirschmann, A., ed. *University of Toronto Studies: Psychology Series*. Vol. 1. Toronto: University of Toronto Press, 1900.

Knox, Robert. *A Manual of Artistic Anatomy, for the Use of Sculptors, Painters, and Amateurs*. London: H. Renshaw, 1852.

Kramnick, Jonathan. "Against Literary Darwinism." *Critical Inquiry* 37, no. 2 (Winter 2011): 315–47.

Krasner, James. *The Entangled Eye: Visual Perception and the Representation of Nature in Post-Darwinian Narrative*. New York: Oxford University Press, 1992.

Kriegel, Lara. *Grand Designs: Labor, Empire, and the Museum in Victorian Culture*. Durham, NC: Duke University Press, 2007.

Külpe, Oswald. "Ein Beitrag zur experimentellen Aesthetik." *American Journal of Psychology* 14, no. 3/4 (October 1903): 215–31.

Kuskey, Jessica. "Bodily Beauty, Socialist Evolution, and William Morris's News from Nowhere." *Nineteenth-Century Prose* 38, no. 1 (Spring 2011): 142–82.

Kyan, John Howard. *On the Elements of Light and Their Identity with Those of Matter, Radiant and Fixed*. London: Longman, 1838.

Landow, George P. *The Aesthetic and Critical Theories of John Ruskin*. Princeton, NJ: Princeton University Press, 1971.

Landy, Joshua. *How to Do Things with Fictions*. Oxford: Oxford University Press, 2012.

Lang, Andrew. "Ballade of Railway Novels." *Longman's Magazine* 4 (October 1884): 296.

Langer, Susanne. *Feeling and Form: A Theory of Art*. New York: Scribner, 1953.

Langfeld, Herbert Sidney. *The Aesthetic Attitude*. New York: Harcourt, 1920.

Lanzoni, Susan. "Practicing Psychology in the Art Gallery: Vernon Lee's Aesthetics of Empathy." *Journal of the History of the Behavioral Sciences* 45, no. 4 (2009): 330–54.

LaPorte, Charles. "Atheist Prophecy: Mathilde Blind, Constance Naden, and the Victorian Poetess." *Victorian Literature and Culture* 34, no. 2 (2006): 427–41.

Larson, Barbara. "Introduction." In *Darwin and Theories of Aesthetics and Cultural History*, edited by Barbara Larson and Sabine Flach, 1–16. Farnham, UK: Ashgate, 2013.

Larson, Barbara, and Fae Brauer, eds. *The Art of Evolution: Darwin, Darwinisms, and Visual Culture*. Hanover, NH: Dartmouth College Press, 2009.

Larson, Barbara, and Sabine Flach, eds. *Darwin and Theories of Aesthetics and Cultural History*. Farnham, UK: Ashgate, 2013.

Latour, Bruno. *An Inquiry into Modes of Existence: An Anthropology of the Moderns*. Cambridge, MA: Harvard University Press, 2013.

———. *Reassembling the Social: An Introduction to Actor-Network-Theory*. Oxford: Oxford University Press, 2005.

———. "Why Has Critique Run Out of Steam? From Matters of Fact to Matters of Concern." *Critical Inquiry* 30, no. 2 (Winter 2004): 225–48.

Law, Jules David. *The Rhetoric of Empiricism: Language and Perception : From Locke to I.A. Richards*. Ithaca, NY: Cornell University Press, 1993.

Laycock, Thomas. "Aesthetic Representative Faculties." Thomas Laycock Papers. Shelfmark LAT/1/55. Royal College of Physicians of Edinburgh.

———. "Further Researches into the Functions of the Brain." *British and Foreign Medico-Chirurgical Review, or Quarterly Journal of Practical Medicine and Surgery* 16, no. 31 (July 1855): 120–44.

———. *Mind and Brain; or, The Correlations of Consciousness and Organisation*. 2 vols. Edinburgh: Sutherland & Knox, 1860.

Leavis, F. R. *English Literature in Our Time and the University*. London: Chatto & Windus, 1969.

Leder, Helmut. "Next Steps in Neuroaesthetics: Which Processes and Processing Stages to Study?" *Psychology of Aesthetics, Creativity, and the Arts* 7, no. 1 (2013): 27–37.

Lee, Vernon. *The Beautiful: An Introduction to Psychological Aesthetics*. Cambridge Manuals of Science and Literature. Cambridge: Cambridge University Press, 1913.

———. "The Craft of Words." *New Review* 11 (December 1894): 571–80.

———. *The Handling of Words and Other Studies in Literary Psychology*. Edited by David Seed. Lewiston, NY: Edwin Mellen Press, 1992. First published 1923 by John Lane, London.

———. "The Handling of Words: A Page of Walter Pater." *Life and Letters* 9, no. 50 (1933): 287–310.

———. "Impersonality and Evolution in Music." *Contemporary Review* 42 (1882): 840–58.

———. *Music and Its Lovers: An Empirical Study of Emotional and Imaginative Responses to Music*. New York: E. P. Dutton, 1933.

————. "Of Writers and Readers." *New Review* 5 (December 1891): 528–36.

————. "Recent Aesthetics." *Quarterly Review* 199, no. 398 (April 1904): 420–43.

————. "The Rhetoric of Landor." *Contemporary Review* 84 (December 1903): 856–64.

————. "The Riddle of Music." *Quarterly Review* 204 (1906): 207–27.

————. "The Syntax of De Quincy [*sic*]." *Contemporary Review* 84 (November 1903): 713–23.

————. "Vital Tempo: Art and Human Life." *Times* (London), November 14, 1924.

Lee, Vernon, and Clementina Anstruther-Thomson. "Beauty and Ugliness." *Contemporary Review* 72 (October 1897): 544–69.

————. *Beauty and Ugliness and Other Studies in Psychological Aesthetics*. London: John Lane, 1912.

————. "Le rôle de l'élément moteur dans la perception esthétique visuelle." In *IVe Congrès international de psychologie: Compte rendu des séances et texte des mémoires*, 468–73. Paris: Felix Alcan, 1901.

Le Gallienne, Richard. "Grant Allen." *Fortnightly Review* 72 (1899): 1005–25.

Leighton, Angela. *On Form: Poetry, Aestheticism, and the Legacy of a Word*. Oxford: Oxford University Press, 2007.

LeMire, Eugene D. *A Bibliography of William Morris*. London: British Library, 2006.

Lesjak, Carolyn. "Oscar Wilde and the Art/work of Atoms." *Studies in the Literary Imagination* 43, no. 1 (Spring 2010): 1–26.

Levine, Caroline. *Forms: Whole, Rhythm, Hierarchy, Network*. Princeton, NJ: Princeton University Press, 2015.

Levine, George. *Darwin and the Novelists: Patterns of Science in Victorian Fiction*. Cambridge, MA: Harvard University Press, 1988.

————. *Dying to Know: Scientific Epistemology and Narrative in Victorian England*. Chicago: University of Chicago Press, 2002.

————. "Hardy and Darwin: An Enchanting Hardy?" In *A Companion to Thomas Hardy*, edited by Keith Wilson, 36–53. Malden, MA: Wiley-Blackwell, 2010.

————. ed. *One Culture: Essays in Science and Literature*. Madison: University of Wisconsin Press, 1987.

————. *Realism, Ethics and Secularism*. Cambridge: Cambridge University Press, 2008.

————. "Shaping Hardy's Art: Vision, Class, and Sex." In *The Columbia History of the British Novel*, edited by John J. Richetti, 533–59. New York: Columbia University Press, 1994.

Levinson, Jerrold. "Musical Chills." In *Contemplating Art*, 220–36. Oxford: Oxford University Press, 2006.

Levinson, Marjorie. "What Is New Formalism?" *PMLA* 122, no. 2 (March 2007): 558–69.

Lewes, George Henry. *Biographical History of Philosophy*. Library ed. New York: Appleton, 1857.

————. *The Physiology of Common Life*. 2 vols. Edinburgh: Blackwood, 1859.

———. *Problems of Life and Mind*, vol. 1, *The Foundations of a Creed*. Boston: James R. Osgood, 1874.

Leys, Ruth. *From Sympathy to Reflex: Marshall Hall and His Opponents*. New York: Garland, 1990.

———. "The Turn to Affect: A Critique." *Critical Inquiry* 37, no. 3 (Spring 2011): 434–72.

Lightman, Bernard. "Scientists as Materialists in the Periodical Press: Tyndall's Belfast Address." In *Science Serialized: Representation of the Sciences in Nineteenth-Century Periodicals*, edited by Sally Shuttleworth and Geoffrey N. Cantor, 199–238. Cambridge, MA: MIT Press, 2004.

———. *Victorian Popularizers of Science: Designing Nature for New Audiences*. Chicago: University of Chicago Press, 2007.

Lipps, Theodor. *Aesthetik: Psychologie des Schönen und der Kunst*. 2 vols. Hamburg: Leopold Voss, 1903.

———. *Raumaesthetik und geometrisch-optische Täuschungen*. Leipzig: J. A. Barth, 1897.

"Literature of the Month." *Court Magazine and Belle Assemblée* 7 (October 1835): 170–74.

Loesberg, Jonathan. "The Ideology of Narrative Form in Sensation Fiction." *Representations*, no. 13 (Winter 1986): 115–38.

———. *A Return to Aesthetics: Autonomy, Indifference, and Postmodernism*. Stanford, CA: Stanford University Press, 2005.

Logan, Peter Melville. *Victorian Fetishism: Intellectuals and Primitives*. SUNY Series, Studies in the Long Nineteenth Century. Albany: State University of New York Press, 2009.

Longus. *Daphnis and Chloe: A Most Sweet and Pleasant Pastoral Romance for Young Ladies*. London: E. Mathews & J. Lane, 1893.

Luckhurst, Roger. *The Invention of Telepathy, 1870–1901*. Oxford: Oxford University Press, 2002.

Lucretius, Titus Carus. *De rerum natura libri sex*. Edited and translated by Hugh A. J. Munro. 2 vols. Cambridge: Deighton Bell, 1866.

MacDuffie, Allen. *Victorian Literature, Energy, and the Ecological Imagination*. Cambridge: Cambridge University Press, 2014.

Mackail, John William. *The Life of William Morris*. 2 vols. London: Longmans, Green, 1901.

Mackay, Thomas, ed. *A Plea for Liberty: An Argument against Socialism and Socialistic Legislation*. New York: D. Appleton, 1891.

Macmillan, Malcolm. "Nineteenth-Century Inhibitory Theories of Thinking: Bain, Ferrier, Freud (and Phineas Gage)." *History of Psychology* 3, no. 3 (2000): 187–217.

Malabou, Catherine. *Plasticity at the Dusk of Writing: Dialectic, Destruction, Deconstruction*. New York: Columbia University Press, 2010.

Mallock, William Hurrell. *The New Republic; or, Culture, Faith, and Philosophy in an English Country House*. London: Chatto & Windus, 1877.

———. *What Should We Do with Our Brain?* New York: Fordham University Press, 2008.

Maltz, Diana. *British Aestheticism and the Urban Working Classes, 1870–1900: Beauty for the People*. Basingstoke, UK: Palgrave Macmillan, 2006.

———. "Engaging 'Delicate Brains': From Working-Class Enculturation to Upper-Class Lesbian Liberation in Vernon Lee and Kit Anstruther-Thomson's Psychological Aesthetics." In *Women and British Aestheticism*, edited by Talia Schaffer and Kathy Alexis Psomiades, 211–29. Charlottesville: University of Virginia Press, 1999.

Mansel, Henry Longueville. *Metaphysics; or, The Philosophy of Consciousness Phenomenal and Real*. 4th ed. Edinburgh: Adam & Charles Black, 1883.

———. "Sensation Novels." *London Quarterly Review* 113 (April 1863): 251–68.

Mao, Douglas. *Fateful Beauty: Aesthetic Environments, Juvenile Development, and Literature 1860–1960*. Princeton, NJ: Princeton University Press, 2008.

"Marius the Epicurean, His Sensations and Ideas." *Academy* 672 (March 21, 1885): 197–99.

Marsh, Jan. "William Morris and Victorian Manliness." In *William Morris: Centenary Essays*, edited by Peter Faulkner and Peter Preston, 185–99. Exeter: University of Exeter Press, 1999.

Martindale, Colin. "The Foundation and Future of the Society for the Psychology of Aesthetics, Creativity, and the Arts." *Psychology of Aesthetics, Creativity, and the Arts* 1, no. 3 (2007): 121–32.

Martineau, James. "Cerebral Psychology: Bain." In *Essays, Philosophical and Theological*, vol. 1, 244–79. New York: Henry Holt, 1883.

———. "Is There Any 'Axiom of Causality'?" *Contemporary Review* 19 (1872): 606–23.

———. "The Place of Mind in Nature and Intuition in Man." *Contemporary Review* 14 (1870): 636–44.

Marx, Karl. "Difference between the Democritean and Epicurean Philosophy of Nature." In *Karl Marx and Friedrich Engels: Collected Works*. Vol. 1, *Marx: 1835–1843*, translated by Dirk J. Struik and Sally R. Struik, 25–108. New York: International, 1975.

———. "Theses on Feuerbach." In *Karl Marx and Friedrich Engels: Collected Works*. Vol. 5, *Marx and Engels: 1845–1847*, translated by Clemens Dutt, W. Lough, and C.P. Magill, 6–8. New York: International, 1976.

Masson, John. *The Atomic Theory of Lucretius Contrasted with Modern Doctrines of Atoms and Evolution*. London: George Bell & Sons, 1884.

Massumi, Brian. *Parables for the Virtual: Movement, Affect, Sensation*. Durham, NC: Duke University Press, 2002.

Matus, Jill L. *Shock, Memory and the Unconscious in Victorian Fiction*. Cambridge: Cambridge University Press, 2011.

Matz, Jesse. *Literary Impressionism and Modernist Aesthetics*. Cambridge: Cambridge University Press, 2001.

Maudsley, Henry. *Body and Mind: An Inquiry into Their Connection and Mutual Influence, Specially in Reference to Mental Disorders*. London: Macmillan, 1873.

McGann, Jerome J. *Black Riders: The Visible Language of Modernism*. Princeton, NJ: Princeton University Press, 1993.

———. *A New Republic of Letters: Memory and Scholarship in the Age of Digital Reproduction*. Cambridge, MA: Harvard University Press, 2014.

———. *The Textual Condition*. Princeton, NJ: Princeton University Press, 1991.

McGrath, F. C. *The Sensible Spirit: Walter Pater and the Modernist Paradigm*. Tampa: University Presses of Florida, 1986.

Meijer, Miriam Claude. *Race and Aesthetics in the Anthropology of Petrus Camper (1722–1789)*. Amsterdam: Rodopi, 1999.

Meisel, Perry. *Thomas Hardy: The Return of the Repressed*. New Haven, CT: Yale University Press, 1972.

———. "Mechanical Peculiarities of Literary Work." *Times* (London), January 3, 1902.

———. "A Mechanical Solution to a Literary Problem." *Popular Science Monthly* 60 (1901): 97–105.

Menke, Richard. "Fiction as Vivisection: G. H. Lewes and George Eliot." *ELH* 67, no. 2 (Summer 2000): 617–53.

Mill, John Stuart. "Bain's Psychology." In *The Collected Works of John Stuart Mill*. Vol. 11, *Essays on Philosophy and the Classics*, edited by John M. Robson, 339–74. Toronto: University of Toronto Press, 1978.

———. "The Two Kinds of Poetry." *Monthly Repository* 7, no. 80 (October 1833): 714–24.

———. "What Is Poetry?" *Monthly Repository* 7, no. 73 (January 1833): 60–70.

Millar, Alexander. "Carpet Designing." In *Practical Designing: A Handbook on the Preparation of Working Drawings*, edited by Gleeson White, 1–32. London: G. Bell, 1893.

Miller, Andrew H. *The Burdens of Perfection: On Ethics and Reading in Nineteenth-Century British Literature*. Ithaca, NY: Cornell University Press, 2008.

Miller, D. A. "Cage Aux Folles: Sensation and Gender in Wilkie Collins's *The Woman in White*." *Representations*, no. 14 (Spring 1986): 107–36.

Miller, Elizabeth Carolyn. *Slow Print: Literary Radicalism and Late Victorian Print Culture*. Stanford, CA: Stanford University Press, 2013.

Miller, J. Hillis. *Reading for Our Time:* Adam Bede *and* Middlemarch *Revisited*. Edinburgh: Edinburgh University Press, 2012.

"Minute Book of the Edinburgh Aesthetic Club. Instituted 1851." Archives of the Royal Scottish Academy, Edinburgh.

Mitchell, W. J. T. "The Commitment to Form; or, Still Crazy after All These Years." *PMLA* 118, no. 2 (March 2003): 321–25.

"Monthly Catalogue." *Critical Review* 9, no. 1 (September 1806): 98–112.

Moore, Gregory. *Nietzsche, Biology, and Metaphor*. Cambridge: Cambridge University Press, 2002.

Moore, James R. "The Erotics of Evolution: Constance Naden and Hylo-Idealism." In *One Culture: Essays in Science and Literature*, edited by George Levine, 225–57. Madison: University of Wisconsin Press, 1987.

Moran, Maureen. "Walter Pater's House Beautiful and the Psychology of Self-Culture." *English Literature in Transition, 1880–1920* 50, no. 3 (2007): 291–312.

Moran, Richard. "Kant, Proust, and the Appeal of Beauty." *Critical Inquiry* 38, no. 2 (Winter 2012): 298–329.

Moretti, Franco. "Changes." *Public Books*, March 1, 2014, http://www.public books.org/briefs/changes.

Morgan, Appleton. "The Characteristic Curves of Composition." *Science* 13, no. 313 (February 1, 1889): 92.

Moritz, Robert E. "On a Quantitative Relation Governing Certain Linguistic Phenomena." *Modern Language Notes* 24, no. 8 (December 1909): 234–41.

———. "On the Significance of Characteristic Curves of Composition." *Popular Science Monthly* 65 (June 1904): 132–47.

———. "On the Variation and Functional Relation of Certain Sentence-Constants in Standard Literature." *University Studies* 3, no. 1 (July 1903): 229–53.

Morley, John. "Mr. Pater's Essays." *Fortnightly* 19 (April 1873): 469–77.

Morris, William. *The Collected Letters of William Morris*, Vol. 1, *1848–1880*. Edited by Norman Kelvin. Princeton, NJ: Princeton University Press, 1984.

———. *The Collected Letters of William Morris*. Vol. 3, *1889–1892*. Edited by Norman Kelvin. Princeton, NJ: Princeton University Press, 1996.

———, *The Collected Works of William Morris*. Vol. 3, *The Earthly Paradise: A Poem, Vol. I*. Edited by May Morris. London: Longmans, Green, 1910.

———. "Gertha's Lovers." In *The Collected Works of William Morris*. Vol. 1, *The Defence of Guenevere and The Hollow Land*, edited by May Morris, 176–225.. London: Longmans, Green, 1910.

———. *The Hollow Land and Other Contributions to the Oxford and Cambridge Magazine*. Edited by Eugene D. LeMire. Bristol: Thoemmes, 1996.

———. *The Ideal Book: An Address*. New York: Calumet, 1899.

———. "The Lesser Arts." In *The Political Writings of William Morris*, edited by A. L. Morton, 31–56. Berlin: Seven Seas, 1973.

———. "The Lesser Arts of Life." In *Lectures on Art*, 174–232. London: Macmillan, 1882.

———. *News from Nowhere; or, An Epoch of Rest: Being Some Chapters from a Utopian Romance*. Edited by David Leopold. Oxford: Oxford University Press, 2003. First published 1890.

———. *The Roots of the Mountains*. Edited by May Morris. Vol. 15 of *The Collected Works of William Morris*. London: Longmans, Green, 1912. First published 1889.

———. *Signs of Change: Lectures on Socialism*. Edited by May Morris. Vol. 23 of *The Collected Works of William Morris*. London: Longmans, Green, 1915.

———. "The Story of the Unknown Church." In *The Collected Works of William Morris*. Vol. 1, *The Defence of Guenevere and The Hollow Land*, edited by May Morris, 149–58. London: Longmans, Green, 1910.

Morris, William, and E. Belfort Bax. "Socialism from the Root Up. Chapter II. Medieval Society." *Commonweal*, May 22, 1886, 61.

Morton, Peter. *"The Busiest Man in England": Grant Allen and the Writing Trade, 1875–1900*. New York: Palgrave Macmillan, 2005.

Moyn, Samuel. "Empathy in History, Empathizing with Humanity." *History and Theory* 45, no. 3 (October 2006): 397–415.

"Mr. Dallas on Scientific Criticism." *Spectator* 2030 (May 25, 1887): 584–85.

"Mr. Munro's Lucretius." *Spectator* 1919 (April 8, 1865): 388–89.

Münsterberg, Hugo. *The Principles of Art Education: A Philosophical, Aesthetical and Psychological Discussion of Art Education.* New York: Prang, 1904.

Murphy, Patricia. *In Science's Shadow: Literary Constructions of Late Victorian Women.* Columbia: University of Missouri Press, 2006.

Naden, Constance. *The Complete Poetical Works of Constance Naden.* London: Bickers & Son, 1894.

———. *Induction and Deduction: A Historical and Critical Sketch of Successive Philosophical Conceptions Respecting the Relations between Inductive and Deductive Thought and Other Essays.* London: Bickers & Son, 1890.

Nagel, Thomas. *Mind and Cosmos: Why the Materialist Neo-Darwinian Conception of Nature Is Almost Certainly False.* New York: Oxford University Press, 2012.

———. "What Is It Like to Be a Bat?" *Philosophical Review* 83, no. 4 (October 1974): 435–50.

Nead, Lynda. *The Haunted Gallery: Painting, Photography, Film c. 1900.* New Haven, CT: Yale University Press, 2007.

Nehamas, Alexander. *Only a Promise of Happiness: The Place of Beauty in a World of Art.* Princeton, NJ: Princeton University Press, 2007.

Nemesvari, Richard. *Thomas Hardy, Sensationalism, and the Melodramatic Mode.* New York: Palgrave Macmillan, 2011.

Ngai, Sianne. *Our Aesthetic Categories: Zany, Cute, Interesting.* Cambridge, MA: Harvard University Press, 2012.

———. *Ugly Feelings.* Cambridge, MA: Harvard University Press, 2005.

Nietzsche, Friedrich Wilhelm. *On the Genealogy of Morality.* Translated by Adrian Del Caro. Vol. 8 of *The Complete Works of Friedrich Nietzsche.* Stanford, CA: Stanford University Press, 2014.

North, Joseph. "What's 'New Critical' about 'Close Reading'?: I. A. Richards and His New Critical Reception." *New Literary History* 44, no. 1 (2013): 141–57.

Notices of the Proceedings at the Meetings of the Members of the Royal Institution of Great Britain with Abstracts of the Discourses. London: William Clowes, 1865.

Nussbaum, Martha. *Poetic Justice: The Literary Imagination and Public Life.* Boston: Beacon, 1995.

O'Connor, Ralph. *The Earth on Show: Fossils and the Poetics of Popular Science, 1802–1856.* Chicago: University of Chicago Press, 2008.

Ogden, C. K., I. A. Richards, and James Wood. *The Foundations of Aesthetics.* London: George Allen & Unwin, 1922.

Oliphant, Margaret. "Novels." *Blackwood's Edinburgh Magazine* 623, no. 102 (September 1867): 257–80.

———. "Sensation Novels." *Blackwood's Edinburgh Magazine* 91 (May 1862): 564–84.

Østermark-Johansen, Lene. "Pater and the Painterly: Imaginary Portraits." *English Literature in Transition, 1880–1920* 56, no. 3 (2013): 343–54.

O'Sullivan, Simon. "The Aesthetics of Affect: Thinking Art beyond Representation." *Angelaki* 6, no. 3 (December 2001): 125–35.

Otis, Laura. *Networking: Communicating with Bodies and Machines in the Nineteenth Century*. Ann Arbor: University of Michigan Press, 2011.

Otter, Chris. *The Victorian Eye: A Political History of Light and Vision in Britain, 1800–1910*. Chicago: University of Chicago Press, 2008.

Otter, Samuel. "An Aesthetics in All Things." *Representations* 104, no. 1 (November 2008): 116–25.

"A Pair of Blue Eyes." *Saturday Review* 36 (August 2, 1873): 158–59.

Paley, William. *Natural Theology; or, Evidence of the Existence and Attributes of the Deity, Collected from the Appearances of Nature*. Oxford: Oxford University Press, 2006.

Palmer, Alan. *Fictional Minds*. Lincoln: University of Nebraska Press, 2004.

Paris, Bernard J. "George Eliot's Unpublished Poetry." *Studies in Philology* 56, no. 3 (July 1959): 539–58.

Parkes, Adam. *A Sense of Shock: The Impact of Impressionism on Modern British and Irish Writing*. Oxford: Oxford University Press, 2011.

Passannante, Gerard. *The Lucretian Renaissance: Philology and the Afterlife of Tradition*. Chicago: University of Chicago Press, 2011.

Pater, Walter. "Coleridge." In *Appreciations*, 65–104. London: Macmillan, 1922.

———. "Coleridge's Writings." *Westminster Review* 85 (January 1866): 48–60.

———. *Imaginary Portraits*. London: Macmillan, 1896.

———. *Letters of Walter Pater*. Edited by Lawrence Evans. Oxford: Clarendon, 1970.

———. *Marius the Epicurean: His Sensations and Ideas*. 2 vols. London: Macmillan, 1885.

———. *Miscellaneous Studies: A Series of Essays*. Edited by Charles Lancelot Shadwell. London: Macmillan, 1895.

———. *The Renaissance: Studies in Art and Poetry: The 1893 Text*. Edited by Donald L. Hill. Berkeley: University of California Press, 1980.

Pearson, Egon Sharpe. *Karl Pearson: An Appreciation of Some Aspects of His Life and Work*. Cambridge: Cambridge University Press, 1938.

Pearson, Karl. *The Grammar of Science*. 2nd ed. London: Adam & Charles Black, 1900.

Peterson, William S. *The Kelmscott Press: A History of William Morris's Typographical Adventure*. Berkeley: University of California Press, 1991.

Picker, John M. *Victorian Soundscapes*. New York: Oxford University Press, 2003.

Pigman, George W. "Freud and the History of Empathy." *International Journal of Psychoanalysis* 76 (April 1995): 237–56.

Pinch, Adela. *Thinking about Other People in Nineteenth-Century British Writing*. Cambridge: Cambridge University Press, 2010.

Plotz, John. *Portable Property: Victorian Culture on the Move*. Princeton, NJ: Princeton University Press, 2008.

Pollock, Sheldon. "Future Philology? The Fate of a Soft Science in a Hard World." *Critical Inquiry* 35, no. 4 (Summer 2009): 931–61.

Porter, James I. *The Origins of Aesthetic Thought in Ancient Greece: Matter, Sensation, and Experience*. Cambridge: Cambridge University Press, 2010.

Potolsky, Matthew. *The Decadent Republic of Letters: Taste, Politics, and Cosmopolitan Community from Baudelaire to Beardsley*. Philadelphia: University of Pennsylvania Press, 2013.

Price, Leah. *How to Do Things with Books in Victorian Britain*. Princeton, NJ: Princeton University Press, 2012.

Prins, Yopie. *Victorian Sappho*. Princeton, NJ: Princeton University Press, 1999.

Prodger, Phillip. *Darwin's Camera: Art and Photography in the Theory of Evolution*. Oxford: Oxford University Press, 2009.

Psomiades, Kathy Alexis. "'Still Burning from This Strangling Embrace': Vernon Lee on Desire and Aesthetics." In *Victorian Sexual Dissidence*, edited by Richard Dellamora, 21–41. Chicago: University of Chicago Press, 1999.

Purdie, Thomas. *Form and Sound: Can Their Beauty Be Dependent on the Same Physical Laws?* Edinburgh: Adam & Charles Black, 1849.

Pykett, Lyn. *The "Improper" Feminine: The Women's Sensation Novel and the New Woman Writing*. New York: Routledge, 1992.

Ramachandran, V. S., and W. Hirstein. "The Science of Art: A Neurological Theory of Aesthetic Experience." *Journal of Consciousness Studies* 6, no. 6/7 (June/July 1999): 15–51.

Rancière, Jacques. *Aesthetics and Its Discontents*. Translated by Steven Corcoran. Cambridge: Polity, 2009.

———. "Aesthetics, Inaesthetics, Anti-Aesthetics." In *Think Again: Alain Badiou and the Future of Philosophy*, edited by Peter Hallward, 218–31. London: Continuum, 2004.

———. *Aisthesis: Scenes from the Aesthetic Regime of Art*. Translated by Paul Zakir. London: Verso Books, 2013.

———. *Dissensus on Politics and Aesthetics*. Edited and translated by Steven Corcoran. London: Continuum, 2010.

———. "Is There a Deleuzian Aesthetics?" Translated by Radmila Djordjevic. *Qui Parle* 14, no. 2 (April 2004): 1–14.

Rand, Nicholas T. "The Hidden Soul: The Growth of the Unconscious in Philosophy, Psychology, Medicine, and Literature, 1750–1900." *American Imago* 61, no. 3 (Fall 2004): 257–89.

Reed, Edward. *From Soul to Mind: The Emergence of Psychology from Erasmus Darwin to William James*. New Haven, CT: Yale University Press, 1997.

Reed, Talbot. "Old and New Fashions in Typography." *Caslon's Circular* 54, no. 15 (Summer 1890): 1–3.

Rehbock, Philip F. *The Philosophical Naturalists: Themes in Early Nineteenth-Century British Biology*. Madison: University of Wisconsin Press, 1983.

Reich, Emil. "Mechanical Tests of Literary Authorship." *Times* (London), January 7, 1902.

Reid, Thomas. "Essays on the Intellectual Powers of the Human Mind." In *Thomas Reid's Inquiry and Essays*, edited by Ronald E. Beanblossom and Keith Lehrer, 127–360. Indianapolis: Hackett, 1983.

Ribot, Théodule. *La psychologie des sentiments*. 5th ed. Paris: Félix Alcan, 1905.

Richards, I. A. *Practical Criticism*. New York: Harcourt, 1957.

————. *Principles of Literary Criticism*. New York: Harcourt, 1961.

Richards, Robert J. *Darwin and the Emergence of Evolutionary Theories of Mind and Behavior*. Chicago: University of Chicago Press, 1987.

————. *The Romantic Conception of Life: Science and Philosophy in the Age of Goethe*. Chicago: University of Chicago Press, 2002.

Richardson, Alan. *British Romanticism and the Science of the Mind*. Cambridge: Cambridge University Press, 2005.

Ricketts, Charles S. *A Defence of the Revival of Printing*. London: Ballantyne, 1899.

Robson, Catherine. *Heart Beats: Everyday Life and the Memorized Poem*. Princeton, NJ: Princeton University Press, 2012.

Rodd, Rennell. *Rose Leaf and Apple Leaf*. Philadelphia: J. M. Stoddart, 1882.

Rodowick, D. N. "The Value of Being Disagreeable." *Critical Inquiry* 39, no. 3 (Spring 2013): 592–613.

Rudy, Jason R. *Electric Meters: Victorian Physiological Poetics*. Athens: Ohio University Press, 2009.

Ruskin, John. *The Elements of Drawing, the Elements of Perspective, and the Laws of Fésole*. Vol. 15 of *The Works of John Ruskin*. Edited by E. T. Cook and Alexander Wedderburn. London: George Allen, 1904.

————. *Lectures on Architecture and Painting*. Vol. 12 of *The Works of John Ruskin*. Edited by E. T. Cook and Alexander Wedderburn. London: George Allen, 1904.

————. *Modern Painters*. Vols. 3–7 of *The Works of John Ruskin*. Edited by E. T. Cook and Alexander Wedderburn. London: George Allen, 1903–1905.

————. *The Stones of Venice*. Vols. 9–11 of *The Works of John Ruskin*, Edited by E. T. Cook and Alexander Wedderburn. London: George Allen, 1903–1904.

"Ruskin's Seven Lamps of Architecture." *Edinburgh Aesthetic Journal* 1, no. 5 (May 1, 1850): 33–37.

Rutland, William R. "The Background to Hardy's Thought." In *Thomas Hardy: A Study of His Writings and Their Background*. New York: Russell & Russell, 1962.

Ryan, Vanessa. "Living in Duplicate: Victorian Science and Literature Today." *Critical Inquiry* 38, no. 2 (Winter 2012): 411–17.

————. *Thinking without Thinking in the Victorian Novel*. Baltimore: Johns Hopkins University Press, 2012.

Rylance, Rick. *Victorian Psychology and British Culture, 1850–1880*. New York: Oxford University Press, 2000.

Saintsbury, George. "New Novels." *Academy* 19 (March 1881): 204.

Saunders, Max. *Self Impression: Life-Writing, Autobiografiction, and the Forms of Modern Literature*. Oxford: Oxford University Press, 2010.

Sawyer, Paul L. "Ruskin and Tyndall: The Poetry of Matter and the Poetry of Spirit." *Annals of the New York Academy of Sciences* 360, no. 1 (April 1981): 217–46.

Scarry, Elaine. *Dreaming by the Book*. New York: Farrar, Straus & Giroux, 1999.

————. "Imagining Flowers: Perceptual Mimesis (Particularly Delphinium)." *Representations*, no. 57 (January 1997): 90–115.

———. *On Beauty and Being Just*. Princeton, NJ: Princeton University Press, 2001.

———. *Resisting Representation*. New York: Oxford University Press, 1994.

Schiller, Friedrich. *On the Aesthetic Education of Man, in a Series of Letters*. Edited and translated by Elizabeth M. Wilkinson and L. A. Willoughby. Oxford: Clarendon, 1967.

Schreiner, Olive. *Olive Schreiner Letters, Volume 1: 1871–1899*. Edited by Richard Rive. Oxford: Oxford University Press, 1988.

Schweizer, Paul D. "John Constable, Rainbow Science, and English Color Theory." *Art Bulletin* 64, no. 3 (September 1982): 424–45.

Secord, James A. *Victorian Sensation: The Extraordinary Publication, Reception, and Secret Authorship of Vestiges of the Natural History of Creation*. Chicago: University of Chicago Press, 2000.

Sedgwick, Eve Kosofsky, and Adam Frank. "Shame in the Cybernetic Fold: Reading Silvan Tomkins." In *Shame and Its Sisters: A Silvan Tomkins Reader*, edited by Eve Kosofsky Sedgwick and Adam Frank, 1–28. Durham, NC: Duke University Press, 1995.

Seiler, R. M. *Walter Pater: The Critical Heritage*. New York: Routledge, 1980.

Sepp, Hans Rainer, and Lester E. Embree, eds. *Handbook of Phenomenological Aesthetics*. Dordrecht, The Netherlands: Springer, 2010.

Sergi, Giuseppe. *Dolore e piacere: storia naturale dei sentimenti*. Milan: Dumolard, 1894.

Serres, Michel. *The Birth of Physics*. Translated by Jack Hawkes. Manchester: Clinamen Press, 2000.

Shafe, Laurence. "Why Is the Peacock's Tail So Beautiful?" In *Darwin and Theories of Aesthetics and Cultural History*, edited by Barbara Larson and Sabine Flach, 37–52. Farnham, UK: Ashgate, 2013.

Shaffer, Elinor S. *The Third Culture: Literature and Science*. Berlin: Walter de Gruyter, 1998.

Shelley, James. "18th Century British Aesthetics." *Stanford Encyclopedia of Philosophy Archive*, Fall 2014. http://plato.stanford.edu/archives/fall2014/entries/aesthetics-18th-british/.

Sherman, L. A. "On Certain Facts and Principles in the Development of Form in Literature." *University Studies* 1, no. 4 (July 1892): 337–66.

———. "Some Observations upon the Sentence-Length in English Prose." *University Studies* 1, no. 2 (October 1888): 119–30.

Shimamura, Arthur P., and Stephen E. Palmer, eds. *Aesthetic Science: Connecting Minds, Brains, and Experience*. New York: Oxford University Press, 2012.

Shusterman, Richard. *Thinking through the Body: Essays in Somaesthetics*. New York: Cambridge University Press, 2012.

Shuttleworth, Sally. *Charlotte Brontë and Victorian Psychology*. Cambridge: Cambridge University Press, 1996.

———. *George Eliot and Nineteenth-Century Science: The Make-Believe of a Beginning*. Cambridge: Cambridge University Press, 1984.

Siegel, Jonah. *Desire and Excess: The Nineteenth-Century Culture of Art*. Princeton, NJ: Princeton University Press, 2000.

Smail, Daniel Lord. *On Deep History and the Brain*. Berkeley: University of California Press, 2008.

Small, I. C. "The Vocabulary of Pater's Criticism and the Psychology of Aesthetics." *British Journal of Aesthetics* 18, no. 1 (1978): 81–87.

Smith, Jonathan. *Charles Darwin and Victorian Visual Culture*. Cambridge: Cambridge University Press, 2006.

———. "Grant Allen, Physiological Aesthetics, and the Dissemination of Darwin's Botany." In *Science Serialized: Representations of the Sciences in Nineteenth-Century Periodicals*, edited by G. N. Cantor and Sally Shuttleworth, 285–305. Cambridge, MA: MIT Press, 2004.

Smith, Philip E., and Michael S. Helfand, eds. *Oscar Wilde's Oxford Notebooks: A Portrait of Mind in the Making*. New York: Oxford University Press, 1989.

Smith, Roger. "The Background of Physiological Psychology in Natural Philosophy." *History of Science* 11, no. 2 (June 1973).

———. "The Human Significance of Biology: Carpenter, Darwin, and the Vera Causa." In *Nature and the Victorian Imagination*, 216–30. Berkeley: University of California Press, 1977.

———. "The Physiology of the Will: Mind, Body, and Psychology in the Periodical Literature, 1855–1875." In *Science Serialized: Representations of the Sciences in Nineteenth-Century Periodicals*, edited by G. N. Cantor and Sally Shuttleworth, 81–110. Cambridge, MA: MIT Press, 2004.

Southard, E. E. "The Empathic Index in the Diagnosis of Mental Diseases." *Journal of Abnormal Psychology* 13, no. 4 (1918): 199–214.

Sparling, Henry Halliday. *The Kelmscott Press and William Morris Master-Craftsman*. London: Macmillan, 1924.

Spencer, Herbert. "Bain on the Emotions and the Will." In *Essays: Scientific, Political, and Speculative*, 2nd ser., 120–42. New York: D. Appleton, 1864.

———. *Essays, Scientific, Political, and Speculative*. 3 vols. New York: D. Appleton, 1892.

———. "The Man versus the State." In *Political Writings*, edited by John Offer, 59–171. Cambridge: Cambridge University Press, 1994.

———. *The Principles of Biology*. 2 vols. London: Williams & Norgate, 1864–1867.

———. *The Principles of Psychology*. 2 vols. New York: D. Appleton, 1906.

———. *Social Statics*. London: John Chapman, 1851.

Spitzer, Leo. *Classical and Christian Ideas of World Harmony: Prolegomena to an Interpretation of the Word "Stimmung."* Edited by Anna Granville Hatcher. Baltimore: Johns Hopkins Press, 1963.

———. "Milieu and Ambiance: An Essay in Historical Semantics." *Philosophy and Phenomenological Research* 3, no. 1 (September 1942): 1–42.

Spolsky, E. "An Embodied View of Misunderstanding in *Macbeth*." *Poetics Today* 32, no. 3 (Fall 2011): 489–520.

Starr, G. Gabrielle. *Feeling Beauty: The Neuroscience of Aesthetic Experience*. Cambridge, MA: MIT Press, 2013.

Steege, Benjamin. *Helmholtz and the Modern Listener*. Cambridge: Cambridge University Press, 2012.

Steele, Robert. *The Revival of Printing: A Bibliographical Catalogue of Works Issued by the Chief Modern English Presses*. London: Macmillan, 1912.

Stein, Edith. *On the Problem of Empathy*. Washington, DC: ICS, 1989.

Stewart, Garrett. *Novel Violence: A Narratography of Victorian Fiction*. Chicago: University of Chicago Press, 2009.

Stiles, Anne. *Popular Fiction and Brain Science in the Late-Nineteenth Century*. New York: Cambridge University Press, 2012.

Stolte, Tyson. "'What Is Natural in Me': David Copperfield, Faculty Psychology, and the Association of Ideas." *Victorian Review* 36, no. 1 (2010): 55–71.

Strawson, Galen. "Realistic Monism: Why Physicalism Entails Panpsychism." In *Real Materialism and Other Essays*, 53–74. Oxford: Oxford University Press, 2008.

Sully, James. "Aesthetics." In *Encylopaedia Britannica*, 9th ed. New York: Charles Scribner's Sons, 1878.

———. "Animal Music." *Cornhill Magazine* 40 (December 1879): 605–21.

———. "Art and Psychology." *Mind* 1, no. 4 (October 1876): 467–78.

———. "Dreams." In *Aesthetics, Dreams and Association of Ideas*, by George Croom Robertson and James Sully, 25–40. Humboldt Library of Science 101. New York: Humboldt, 1888.

———. "George Eliot's Art." *Mind* 6, no. 23 (July 1881): 378–94.

———. *My Life and Friends: A Psychologist's Memories*. New York : Dutton, 1918.

———. "The Opera." *Contemporary Review* 26 (June 1875): 103–22.

———. "Poetic Imagination and Primitive Conception." *Cornhill Magazine* 34 (September 1876): 294–306.

———. "Review of *Physiological Aesthetics*, by Grant Allen." *Mind* 2, no. 7 (July 1877): 387–92.

———. "Review of *The Power of Sound*, by Edmund Gurney." *Mind* 6, no. 22 (April 1881): 270–78.

———. "Review of *Vorschule der Aesthetik*, by Gustav Theodor Fechner." *Mind* 2, no. 5 (January 1877): 102–8.

———. *Sensation and Intuition: Studies in Psychology and Aesthetics*. Kegan Paul, 1880.

Sumpter, Caroline. "On Suffering and Sympathy: Jude the Obscure, Evolution, and Ethics." *Victorian Studies* 53, no. 4 (2011): 665–87.

Symonds, John Addington. "Death." In *The Cyclopædia of Anatomy and Physiology*, edited by Robert Bentley Todd. London: Sherwood, Gilbert, and Piper, 1836.

———. *The Principles of Beauty*. London: Bell & Daldy, 1857.

Symonds, John Addington, Jr. "Lucretius." *Fortnightly Review* 97 (January 1875): 44–62.

Symons, Arthur. *Days and Nights*. London: Macmillan, 1889.

———. "Walter Pater: Imaginary Portraits." *Time* 6, no. 17 (August 1887): 157–62.

Tate, Allen. "The Present Function of Criticism." In *Essays of Four Decades*, 197–210. Wilmington, DE: ISI Books, 1999.

Tate, Gregory. *The Poet's Mind: The Psychology of Victorian Poetry 1830–1870.* Oxford: Oxford University Press, 2012.

Taylor, Brandon. *Art for the Nation: Exhibitions and the London Public, 1747–2001.* Manchester: Manchester University Press, 1999.

Taylor, Jenny Bourne. *In the Secret Theatre of Home: Wilkie Collins, Sensation Narrative, and Nineteenth-Century Psychology.* New York: Routledge, 1988.

Taylor, M. W. *Men versus the State: Herbert Spencer and Late Victorian Individualism.* Oxford: Clarendon, 1992.

Teeple, G. "The Doctoral Dissertation of Karl Marx." In *Karl Marx's Social and Political Thought: Critical Assessments,* 62–104. New York: Routledge, 1999.

Terada, Rei. *Feeling in Theory: Emotion after the "Death of the Subject."* Cambridge, MA: Harvard University Press, 2001.

Teukolsky, Rachel. *The Literate Eye: Victorian Art Writing and Modernist Aesthetics.* Oxford: Oxford University Press, 2009.

———. "White Girls: Avant-Gardism and Advertising after 1860." *Victorian Studies* 51, no. 3 (2009): 422–37.

Thain, Marion. "'Scientific Wooing': Constance Naden's Marriage of Science and Poetry." *Victorian Poetry* 41, no. 1 (Spring 2003): 151–69.

Thomas, David Wayne. *Cultivating Victorians: Liberal Culture and the Aesthetic.* Philadelphia: University of Pennsylvania Press, 2004.

Thomas, Julia Adeney. "History and Biology in the Anthropocene: Problems of Scale, Problems of Value." *American Historical Review* 119, no. 5 (2014): 1587–1607.

Thompson, E. P. *William Morris: Romantic to Revolutionary.* New York: Pantheon Books, 1977.

Thompson, Evan. *Mind in Life: Biology, Phenomenology, and the Sciences of Mind.* Cambridge, MA: Belknap, 2007.

Thrailkill, Jane F. *Affecting Fictions: Mind, Body, and Emotion in American Literary Realism.* Cambridge, MA: Harvard University Press, 2007.

Thrift, Nigel. *Non-Representational Theory: Space, Politics, Affect.* London: Routledge, 2008.

Tresch, John. *The Romantic Machine: Utopian Science and Technology after Napoleon.* Chicago: University of Chicago Press, 2012.

Trilling, Lionel. "Aggression and Utopia: A Note on William Morris's 'News from Nowhere.'" *Psychoanalytic Quarterly* 42 (1973): 213–25.

Turner, Frank M. *Contesting Cultural Authority: Essays in Victorian Intellectual Life.* Cambridge: Cambridge University Press, 1993.

Turner, James. *Philology: The Forgotten Origins of the Modern Humanities.* Princeton, NJ: Princeton University Press, 2014.

Tyndall, John. "Address by the President." In *Report of the Forty-Fourth Meeting of the British Association for the Advancement of Science,* lxvi–xcvii. London: John Murray, 1875.

———. *Sound: A Course of Eight Lectures Delivered at the Royal Institution of Great Britain.* New York: D. Appleton, 1867.

Tyrwhitt, Richard St John. *The Natural Theology of Natural Beauty*. London: Society for Promoting Christian Knowledge, 1882.

Tylor, Edward Burnett. *Primitive Culture: Researches into the Development of Mythology, Philosophy, Religion, Art, and Custom*. London: John Murray, 1871.

Valéry, Paul. *The Art of Poetry*. Translated by Denise Folliot. Princeton, NJ: Princeton University Press, 1958.

Vance, Norman. *The Victorians and Ancient Rome*. Oxford: Blackwell, 1997.

Vaninskaya, Anna. *William Morris and the Idea of Community: Romance, History and Propaganda, 1880–1914*. Edinburgh: Edinburgh University Press, 2010.

Vattimo, Gianni. *Art's Claim to Truth*. Edited by Santiago Zabala. Translated by Luca D'Isanto. New York: Columbia University Press, 2008.

Vischer, Robert. "On the Optical Sense of Form." In *Empathy, Form, and Space: Problems in German Aesthetics, 1873–1893*, edited by Harry Francis Mallgrave and Eleftherios Ikonomou, 89–123. Santa Monica, CA: Getty Center for the History of Art and the Humanities, 1994.

Wallen, Jeffrey. "Physiology, Mesmerism, and Walter Pater's 'Susceptibilities to Influence.'" In *Walter Pater: Transparencies of Desire*, edited by Laurel Brake, Lesley Higgins, and Carolyn Williams, 73–89. Greensboro, NC: ELT, 2002.

Ward, Martha. *Pissarro, Neo-Impressionism, and the Spaces of the Avant-Garde*. Chicago: University of Chicago Press, 1996.

Weinroth, Michelle. "Redesigning the Language of Social Change: Rhetoric, Agency, and the Oneiric in William Morris's *A Dream of John Ball*." *Victorian Studies* 53, no. 1 (2010): 37–63.

Wellbery, David. "Stimmung." In *Historisches Wörterbuch ästhetischer Grundbegriffe*. Edited by Karlheinz Barck. Stuttgart: Metzler, 2003.

Wellek, René. *Discriminations: Further Concepts of Criticism*. New Haven, CT: Yale University Press, 1970.

Whewell, William. *Astronomy and General Physics Considered with Reference to Natural Theology*. London: William Pickering, 1833.

Wilde, Oscar. *Miscellanies*. Edited by Robert Baldwin Ross. London: Methuen, 1908.

———. "Mr. Pater's Imaginary Portraits." *Pall Mall Gazette* 45, no. 6937 (June 11, 1887): 2–3.

———. *The Picture of Dorian Gray*. Edited by Joseph Bristow and Ian Small. Vol. 3 of *The Complete Works of Oscar Wilde*. Oxford: Oxford University Press, 2005.

———. "Plato's Psychology." Oscar Wilde and His Literary Circle Collection: Manuscripts and Miscellaneous Materials, f MS.2002.004. William Andrews Clark Memorial Library, University of California, Los Angeles.

Williams, Carolyn. "Pater in the 1880s: Experiments in Genre." *Journal of Pre-Raphaelite Studies* 4 (1983): 39–51.

———. *Transfigured World: Walter Pater's Aesthetic Historicism*. Ithaca, NY: Cornell University Press, 1989.

———. "Walter Pater's Impressionism." In *Knowing the Past*, edited by Suzy Anger, 77–99. Ithaca, NY: Cornell University Press, 2001.

Williams, C.B. "A Note on an Early Statistical Study of Literary Style."
 Biometrika 43, no. 3/4 (December 1956): 248–56.
———. "Mendenhall's Studies of Word-Length Distribution in the Works of
 Shakespeare and Bacon." *Biometrika* 62, no. 1 (April 1975): 207–12.
Williams, Raymond. *Culture and Society, 1780–1950*. Harmondsworth: Pen-
 guin, 1975.
———. *Keywords: A Vocabulary of Culture and Society*. New York: Oxford
 University Press, 1985.
Wilson, Edward O. *Consilience: The Unity of Knowledge*. New York: Knopf,
 1998.
Wilson, Elizabeth A. *Psychosomatic: Feminism and the Neurological Body*. Dur-
 ham, NC: Duke University Press, 2004.
Wimsatt, William K., and Monroe C. Beardsley. "The Affective Fallacy." *Se-
 wanee Review* 57, no. 1 (1949): 31–55.
Wimsatt, William K., and Cleanth Brooks. *Literary Criticism: A Short History*.
 New York: Knopf, 1964.
Winter, Alison. "The Construction of Orthodoxies and Heterodoxies in the
 Early Victorian Life Sciences." In *Victorian Science in Context*, edited by Ber-
 nard V. Lightman, 24–50. Chicago: University of Chicago Press, 1997.
———. *Mesmerized: Powers of Mind in Victorian Britain*. Chicago: University
 of Chicago Press, 1998.
Wolfson, Susan J. *Formal Charges: The Shaping of Poetry in British Romanti-
 cism*. Stanford, CA: Stanford University Press, 1997.
———. "Reading for Form." *MLQ* 61, no. 1 (2000): 1–16.
Wood, Ellen. *East Lynne*. Oxford: Oxford University Press, 2008. First pub-
 lished 1861.
Woodbury, G. E. "Ideal Aestheticism." *Nation* 1054 (September 10, 1885):
 219–21.
Woodmansee, Martha. *The Author, Art, and the Market: Rereading the History
 of Aesthetics*. New York: Columbia University Press, 1994.
Woodworth, Robert Sessions. *Psychology: A Study of Mental Life*. New York:
 H. Holt, 1924.
"Words, Words, Words!" *Spectator* 130, no. 4947 (April 21, 1923): 671.
Wright, Georg Henrik von. *Explanation and Understanding*. Ithaca, NY: Cor-
 nell University Press, 1971.
Wright, Thomas. *The Life of Walter Pater*. 2 vols. New York: Putnam, 1907.
Wundt, Wilhelm Max. *Outlines of Psychology*. Translated by Charles Hubbard
 Judd. Leipzig: Wilhelm Engelmann, 1902.
Yeazell, Ruth Bernard. *Art of the Everyday: Dutch Painting and the Realist
 Novel*. Princeton, NJ: Princeton University Press, 2008.
Young, Robert M. *Mind, Brain, and Adaptation in the Nineteenth Century:
 Cerebral Localization and Its Biological Context from Gall to Ferrier*. New
 York: Oxford University Press, 1990.
Zeki, Semir. *Splendors and Miseries of the Brain: Love, Creativity, and the Quest
 for Human Happiness*. Malden, MA: Wiley-Blackwell, 2009.
Zunshine, Lisa. *Strange Concepts and the Stories They Make Possible: Cogni-
 tion, Culture, Narrative*. Baltimore: Johns Hopkins University Press, 2008.

Index